I10938992

Studebaker

Stude

MIDWESTERN HISTORY AND CULTURE

General Editors

James H. Madison and Thomas J. Schlereth

baker

The Life and Death
of an American
Corporation

DONALD T. CRITCHLOW

INDIANA UNIVERSITY PRESS
Bloomington • Indianapolis

The paper used in this publication meets the
minimum requirements of American National
Standard for Information Sciences—Permanence
of Paper for Printed Library Materials, ANSI
Z39.48-1984.

Manufactured in the United States of America

Library of Congress Cataloging-in-Publication Data

Critchlow, Donald T., date
 Studebaker : the life and death of an American corporation /
Donald T. Critchlow.
 p. cm. — (Midwestern history and culture)
 Includes bibliographical references and index.
 ISBN 0-253-33065-3 (cl : alk. paper)
 1. Studebaker Corporation—History. 2. Automobile industry and
trade—United States—History. I. Title. II. Series.
HD9710.U54S834 1996
339.7′6292222—dc20 95-52639

1 2 3 4 5 01 00 99 98 97 96

TO MY WIFE PATRICIA AND OUR TWO DAUGHTERS
AGNIESZKA AND MAGDALENA

Contents

SIX

STUDEBAKER ATTEMPTS TO REVERSE COURSE,
1954–1957

Tradition Rejected
139

SEVEN

STUDEBAKER HALTS U.S. PRODUCTION,
1957–1963

Tradition Abandoned
160

EPILOGUE
Tradition as Contested Terrain
182

preface

Although Henry Ford once repudiated history as bunk, Studebaker executives found history unavoidable. History permeated the corporation. As a consequence, the corporation developed a unique institutional mentality that was shaped by its history. This history, however, was by no means static. As each generation of managers encountered it, they imparted new meanings to the Studebaker tradition. And, as these managers constructed and reconstructed this tradition, what emerged was a proud, self-conscious, and didactic history that provided a framework for articulating corporate policies and strategies.

This book is as much about the place of *tradition* within a corporation as it is a narrative of the life and death of an American automobile company. Based on extensive records found in the Studebaker National Museum, as well as twenty-five other archival collections, this study explores managerial choice and corporate tradition as it shaped Studebaker's history. I hope this will not disappoint automobile enthusiasts or business historians. Car buffs tend to focus on the machine. As one enthusiast put it in a book review that appeared in *Motor Trends*, "It's just that I want to read about automobiles," not culture and sociology.[1] In turn, historians are fond of the latter.

This book, I believe, has something to say about both machines and the people who built them, but the focus of this study is on how organizational beliefs, developed over time and shaped by managerial regimes, influenced and reflected corporate strategies concerning product development, investment policy, employee relations, and the allocation of resources. This study is about the way upper management made *choices* concerning corporate strategy while operating within an institutional environment that embodied company tradition and responded to market forces. By examining the relationship between environment and historical perception, this study places the history of the Studebaker Corporation within a broad interpretative framework that emphasizes the importance of ideas in shaping institutions in modern America.

I began this study with a simple premise: Just as men and women shape their own history, so do they shape the historical perceptions of institutions. While the "objective" factors of history—class, race, and gender—are important, the so-called subjective conditions—culture,

ideology, religion, tradition, and custom—are equally decisive forces in shaping history.

My work as a historian has focused on the subjective. In this way, much of my work has been concerned with the sociology of knowledge in a democratic society. This study of the Studebaker Corporation expresses a continuing interest in how people construct and use history and how people's perceptions influence their history, institutions, culture, and society.

acknowledgments

Research support for this project was provided by the Woodrow Wilson International Center for Scholars, the National Endowment for the Humanities, and the Institute for Scholarship in the Liberal Arts at the University of Notre Dame. I would also like to thank Marsha Mullin, the former archivist at the Studebaker National Museum, for inviting me to take a look at the corporate files.

I want to thank a small group of my friends and colleagues who read the manuscript in various forms over the course of many years. I especially want to acknowledge William J. Rorabaugh, Mark Neeley, Thomas Madden, and Thomas Curran. Austin Kerr's reading an early draft proved exceptionally helpful. Joan Catapano, my editor at Indiana University Press, convinced me in the end that this book should be at Indiana. Finally, I want to thank my wife, Patricia, who helped research and write this book. In typical modesty, she refused to list her name on the cover, although this book is as much hers as it is mine.

.

Studebaker

Introduction

The phrase "the evolution of American business" finds frequent expression in the study of American history. While suggesting a competitive business world in which there are inevitable winners and losers, the survivors and the extinct, this term is misleading in its implicit assumption that there is a design to the "evolution" of American industry.[1] Instead of the determinist world of "natural selection" in which business, propelled by ever more sophisticated technologies, developed from simple units of production to complex and rational managerial hierarchies, the history of American business has been one of making choices concerning aspects of production and management. These choices are often shaped by corporate ideology and managerial culture.[2]

The history of Studebaker and the automobile industry in general should be seen in terms of managerial choice and corporate culture. As one student of the automobile industry noted, "In the evolution of the United States auto industry, organizational choice and internal structure were critical factors in determining not only the industry's shape, but also the particular fate of each automaker."[3] Those who see the history of the automobile industry as uniform have missed its richness, complexity, and diversity. The automobile industry became increasingly concentrated in its early years, but companies nonetheless pursued different paths of development. Thus while the industry came to be dominated by Ford, General Motors, and Chrysler, these companies differed considerably in managerial structure and corporate policy, just as Studebaker did from other independents and the Big Three.

As a consequence, this book stresses the importance of managerial decisions and corporate culture in shaping a company's fate. This is not to repudiate the importance of external factors such as capital resources, firm size, consumer tastes, and government policy, but this study shows that managers made real choices within a context of this external environment in ways that impart a complexity to corporate history not readily discernible by those who see the world of the corporation as uniform.

This is not to deny that there are technological forces in manufacturing industries that tend to drive productive units toward high-volume operation. Clearly, since there are benefits to be gained from economies of scale, managements have sought ever-greater product standardization.[4] In developing technologies for high volume and standardized production, managerial organizations have instituted hierarchical structures to ensure efficient operations in production, distribution, engineering, and finance. Nevertheless, at each point in the history of an industry, managers have actively made choices as to what technologies to use, what products to produce, and how best to encourage their employees to work harder while remaining loyal to the firm. These decisions were made within an institutional context unique to the firm.

In this study, therefore, I raise a different set of questions than have other scholars as to how we study institutions in modern America. I am more interested in corporate mentality and managerial choice than I am in how organizational structures become rationalized (as is Alfred Chandler), or how production technologies develop (as is David Hounshell), or how specialized industry is more efficient than large integrated organization (Charles Sabel and Michael Piore).[5]

In pursuing a different line of inquiry than have other scholars interested in the evolution of corporate America, I want to suggest that this narrative of Studebaker's history reveals other ways of studying business history. In doing this, I do not directly challenge the work of other scholars; indeed, their influence on my thinking is quite evident in this study.[6] Nevertheless, from this narrative readers should understand that I have nuanced, albeit significant, differences from other approaches to business history.

For example, Alfred D. Chandler, Jr., the dean of American business history, and his students have portrayed the evolution of modern business organization in terms of strategy (the planning and carrying out of growth) and structure (the organization devised to administer these enlarged activities and resources).[7] In a series of seminal studies, Chandler argued that strategic growth of modern industrial enterprises resulted from the opportunities and needs—created by changing population, income, and technology—to employ existing or expanding resources more profitably. In pursuing new strategies for expansion, managers were required to implement new organizational structures, or to refashion existing organizational structures, if their enterprises were to be operated efficiently. Growth without structural adjustment led inevitably to economic inefficiency.

Chandler deduced, therefore, that structure follows strategy. The most complex type of structures that emerged in modern business was

the result of several basic strategies concerned with the expansion of volume and growth through geographical dispersion. The managerial decision to expand a business either through vertical integration or diversification, Chandler argued, entailed the creation of a new corporate organization built around a central office that oversaw the administration of a multidepartmental and multidivisional structure.[8]

Chandler presents the development of modern business as a rational progression that often seems inevitable. His depiction of the development of the modern American corporation shifted the study of American business history away from biography, individual firm histories, and the American "business mind." Prior to Chandler, business history had focused in large part on the question of whether American business leaders, especially in the period from 1865 to 1900, were a set of rascals who cheated investors and consumers, corrupted government, and conducted themselves in a predatory manner comparable to those robber barons of medieval Europe.[9]

By showing that the development of the modern business corporation was a logical and rational response to the emergence of an integrated national and international market, Chandler moved the focus of business history away from the moral character and actions of individual figures. Firms, in order to expand, developed hierarchical, multidepartmental/multidivision organizations; those that did not, failed. He downplayed the influence of charismatic business leaders and the force of ideas and culture in shaping institutions. In his account, there was little room for chance and contingency as a mechanism for change. While his model of big business does not preclude the role of individuals, ideas, or chance in history, his emphasis is on bureaucratic rationality.

Chandler's powerful portrayal of modern business organization has dominated the study of American corporate history in recent years. The extensive empirical basis of his research and the breadth of his analysis offers a persuasive account of the evolution of modern business. He has found a following even among Marxist scholars who have been attracted to the functionalism explicit in his work.[10]

The most serious challenge to Chandler has come from social scientists such as Charles Sabel and Michael Piore who argue for an alternative view of industrial development. While they do not disagree with the accuracy of Chandler's historical description, they challenge the necessity and economic value of developing large, hierarchical organizations that offer a diversity of products. Instead, Sabel and Piore propose a strategy based on "flexible specialization" in which small firms compete by offering specialized products that can be readily adjusted to changing market conditions in a post-industrial economy no

longer dominated by large, mass producers. In this way, "flexible specialization" is seen as a strategy that combines pliant production processes aimed at smaller but lucrative markets.

The flexible specialization approach maintains that the large, hierarchical organizations that Chandler and others have seen as the natural results of industrial evolution have become archaic both as managerial structures and market strategies. Smaller, more highly specialized firms that allow greater employee participation and provide greater production flexibility are—or should be—the wave of the future.[11]

This Piore-Sabel model is primarily concerned with offering a prescription for contemporary managers and policy makers. In this way, Piore and Sabel are less interested in history as such. They have taken exception, however, to the idea that the specific form of corporate enterprise was inevitable. Recently, students of Piore and Sabel, most notably Gerald Berk and Stephen Amberg, have begun to explore an "alternative" history that maintains the development of the American railroad and automobile industry might have been different if industrial and political leaders had not made the choices they did to protect and promote large, concentrated industries.[12]

This historical challenge to Chandler, while provocative, still remains in the realm of "what might have been." Chandler's portrait of corporate America remains the fullest account of what appears actually to have occurred historically. What is important about the Piore-Sabel approach, however, is that it maintains that corporate history is by no means predestined.

For example, managerial organization and labor relations within the American automobile industry did not follow a uniform development. While complex technological systems and a mass market necessitated new hierarchical managerial structures within the automobile industry in order to rationalize production, distribution, research and development, and financial operations, individual companies were surprisingly diverse in their organizations. Individual companies evolved slowly, often by trial and error, and often this development occurred within a context of intense power struggles within the organization. Furthermore, "charismatic" leaders played decisive roles in creating new strategies and structures. While the Big Three automobile companies—General Motors, Ford, and Chrysler—came to dominate the industry, the history of the early industry is characterized by a wide array of companies competing in the market. Historical hindsight suggests a teleological development in which only the large, multimodel producers would survive, but it is worth noting that independent companies continued to compete in the marketplace, employing thousands of workers, well into the 1960s and later. The point is not that

these smaller companies would ultimately fail, but that some of them remained in business for decades. If their failure was inevitable, it took a long time for history to record their failure.

As Chandler has told us, Alfred Sloan, who came to General Motors shortly before World War I, is the acknowledged founder of modern corporate management. He developed the divisional structure in which each division manufactured its own product and operated as its own profit center. This structure offered the advantages of decentralization, flexibility, and incentives at all levels of management. Centralized control was maintained through a corporate headquarters that oversaw the financial operations of the entire corporation. At the same time Sloan was instituting his management system, Irénée DuPont introduced almost the identical organizational plan at his company. The Sloan-DuPont management system became a model for corporate organization. The similarity in development occurring within the same period suggests more than coincidence: it seems to indicate rational design.[13]

Nevertheless, what now appears logical was by no means certain. For instance, Ford, Chrysler, and Studebaker chose to follow managerial structures quite different from the G.M.-DuPont model, albeit often to the detriment of their companies. Indeed, Sloanism only found its way to Ford and Chrysler in the post–World War II era. Following World War II, Henry Ford's grandson, Henry Ford II, brought in a new management team of young systems analysts and management control specialists who had gained experience managing large-scale enterprises for the United States Army Air Corps during the war. These so-called Whiz Kids, including Robert S. McNamara and Arjay Miller, transformed the corporation. At the same time, Ford lured Ernest R. Breech, the head of Bendix Aviation and a close associate of General Motors, to the company. Breech and the Whiz Kids imposed new financial controls and instituted new labor policies. Still Henry Ford II continued to insist on executive control of the corporation. Only his retirement in the late 1970s allowed the Ford Motor Company to become a fully "modern management system."

The Chrysler Corporation, in turn, became a full-line producer in 1928, but Walter Chrysler, the company's founder, and his successor K. T. Keller remained autocrats within the corporation. In the early 1960s, "Tex" Colbert tried to reorganize the corporation along modern managerial lines, but the result was organizational chaos. Only in the 1970s was a multidivisional structure adopted. Even so, when Lee Iacocca joined Chrysler in 1978 he found the organizational arrangement antiquated, inefficient, and, indeed, bizarre.[14]

Industrial relations within the automobile industry also reveal a diverse development. If American automobile producers showed genius

in developing new techniques of mass production, they revealed far less ability in handling relations with their industrial employees. Detroit became a center of automobile production in part because of its reputation as an antiunion town. In the 1880s Detroit businessmen had effectively broken organized labor and made the city an "open shop" town. The auto industry, after fending off rather lame organizing drives by the Industrial Workers of the World (IWW) and the American Federation of Labor, continued this antiunion tradition well into the 1930s.[15]

Yet to describe the automobile industry as simply "antiunion" and obsessed with shop-floor control misses the great variations in industrial policies among the auto companies themselves. Clearly companies such as Studebaker and American Motors, with their long histories of paternalism, differed profoundly from the Big Three in terms of industrial relations. Indeed, industrial relations differed among the Big Three producers—General Motors, Ford, and Chrysler—before the advent of industrial unionism and afterward. General Motors only recognized the CIO in 1937 after a bitter strike, while Ford remained bitterly antiunion until World War II. It took a world war and the intervention of the federal government in 1941 before Ford finally accommodated itself to the CIO.

A strong argument can be made that the G.M. model for industrial relations—high wages and high fringe benefits in exchange for union stability—only gained hold for a brief period in the immediate postwar years. Nevertheless, in the immediate postwar years General Motors came to be regarded by the others in the industry as tough, pragmatic, and shrewd.[16] As a consequence, General Motors often set the pattern for other companies in their negotiations with labor.[17]

This policy paid off initially for the major producers.[18] In the 1950s and 1960s productivity among the Big Three improved 4 percent annually. The G.M. model, however, proved to be less successful for the independents. While Studebaker workers demanded equal pay and benefits comparable to General Motors employees, their productivity was 15 percent below their counterparts. Wildcat strikes plagued Studebaker through the decade. Even more notable were conditions at the Nash-Kelvinator plant. As Robert M. Macdonald observed in his study of the plant, workers took time off to prepare their own breakfasts in a kitchen they had assembled from company parts; poker games flourished; and employees worked literally half the time they were paid for.[19]

Problems at Studebaker and Nash should not be attributed to the G.M. model itself as much as to its application by corporations with long histories of paternalism. This was especially the case with Studebaker. At each stage in Studebaker's history, management made criti-

cal decisions involving the future of the company. Because of Studebaker's strong sense of its past, essential in shaping corporate culture within the top management, these choices took on a peculiarity unique to the corporation and its tradition.

Thus the general theme that emerges from this history of the Studebaker Corporation is that tradition—as construed by management—played a fundamental role in molding corporate culture, rhetoric, and strategy at Studebaker. Historical perspective and corporate tradition were closely interwoven as management sought to construct an outlook that rationalized corporate strategy and employee relations. A secondary point follows from this general theme: Just as Studebaker must be seen in terms of its own unique nature, the automobile industry in general must be seen as multidimensional and varied.

While Chandler emphasizes rationality in corporate structure, the history of Studebaker suggests that individual managers often made decisions within the context of corporate culture and tradition that were incongruent with "the logic of the marketplace." Chandler's model, of course, does not exclude the significance of culture, tradition, and irrationality within a corporation, but less importance is given to these factors than the history of Studebaker warrants. Studebaker ultimately failed, and perhaps this failure was inevitable given the dominance of the Big Three, but inevitability does not tell us much about the company's successes, how it failed, or whether the corporation would have failed earlier or would have survived longer if management had not made the decisions it did. The Studebaker story does not propose a counter-model to Chandler's account of modern business history, but instead suggests the importance of individual choice, corporate culture, and managerial perception in shaping the firm's history.

The Studebaker tradition, as it emerged in the late nineteenth century, offered a means for subsequent managerial regimes to articulate their own goals and vision for the corporation. While this study places the history of the Studebaker Corporation in the larger industrial and economic context of the time—thereby offering more than simply an institutional history of a specific corporation—Studebaker must be seen in terms of its own unique character. The corporation, from its founding in 1852 through its emergence in the late nineteenth century as the world's leading wagon producer, developed a distinct identity, largely the creation of its founders, the Studebaker brothers.

Raised by German Dunkard parents who followed the pacifist and utopian teachings of Johann Conrad Beissel, the Studebaker brothers brought to the enterprise a belief in communal piety and community obligation, combined with a nineteenth-century faith in industrial

capitalism. This interplay between Christian principles and entrepreneurial values created its own ambiguities within the firm.

The brothers viewed themselves as Christian businessmen who espoused harmony between the social orders through community obligation and social responsibility. At the same time they believed individual achievement and company profit benefitted the entire community. Often these sentiments were translated into paternalism at the workplace. Studebaker employees remained the highest paid in the community, while the Studebakers fiercely resisted unionization of their company.

The brothers deliberately crafted an image as poor Christian boys who had made good through hard work, entrepreneurial drive, and a benevolent concern for their employees, the community, and the nation. Much of this image rested on a use of history that was conveyed in company advertising, newspaper interviews, and public appearances.

Clearly, this constructed history derived in large measure from good marketing. Corporate publicists cultivated an image of the Studebaker brothers as industrialists who cared about their employees and the community. Marketing promoted a historical portrait of a company run by enlightened management. Still, the Studebaker tradition was founded on more than sales rhetoric.

This Studebaker tradition provided later managers with a framework for articulating new corporate policies and strategies. As is the case with most legacies, company tradition offered both a source of strength and a constraint for the institution, and contained features that were both verifiable and mythical.

As the Studebaker Corporation entered the automobile age in the late 1890s, the remaining Studebaker brothers, Clement and John Mohler, resisted leaving the wagon industry to enter into automobile production. At the time the automobile appeared to be a fad, a rich man's toy, without long-term potential. Only the determined efforts of John Mohler's son-in-law, Frederick Fish, transformed the company from a wagon manufacturer into an automobile maker. In this transition, Fish downplayed tradition, although he did not directly repudiate the brothers' use of history. Instead of dismissing tradition, he simply ignored it.

Fish's successor, Albert R. Erskine, a protégé of Wall Street financier Henry Goldman, found tradition relevant, however. In a conscious public relations effort, Erskine refashioned tradition so that it translated the brothers' paternalism into the corporate welfarism of the 1920s. Erskine's faith in the use of tradition found coherent expression in his *History of the Studebaker Corporation* (1918), the first full history of the company. Revised and enlarged following World War I,

Erskine's history consciously linked the brothers' paternalism with the corporate welfarism of the modern business enterprise.[20]

This use of tradition was designed to ensure stable labor relations as Erskine challenged the majors on their own grounds by producing a multiline of models, especially with Studebaker's entrance into the low-priced, high-volume market. Unfortunately this strategy failed. Declining profits, the failure of its new lines to catch on with the public, and Erskine's insistence (supported by Wall Street) on paying high dividends after the stockmarket crash of 1929, finally forced Studebaker into receivership in 1934.

Economic depression in the 1930s forced Studebaker management under Paul Hoffman and Harold Vance to reconstruct a new tradition that allowed the corporation to accept industrial unionism. Under the Hoffman-Vance regime, the corporation in the 1930s and the 1940s openly welcomed and encouraged organized labor within the company. Hoffman and Vance sought continuity with the past, but the paternalism of the Studebaker brothers and the corporate welfarism of Erskine had deliberately excluded organized labor. In this way, Hoffman and Vance reinterpreted the Studebaker tradition in ways that served the modern corporation.

The vision of Studebaker as an enlightened employer became a common theme in these years. Company advertising and publicity played upon this image of Studebaker as an enlightened employer. Hoffman, in speech after speech, used the theme of enlightened management at Studebaker as a rhetorical device to instruct employees, managers, and fellow industrialists. During their reign, Hoffman and Vance commissioned two corporate histories, Kathleen Ann Smallzried and Dorothy James Roberts's *More Than You Promise* (1942); and Stephen Longstreet's centennial history, *A Century on Wheels* (1953), which praised "the confident tradition of Studebaker."[21]

Hoffman and Vance held that "a great tradition is the greatest of all heritages, because it gives men an ideal against which they can measure themselves and their work." As they celebrated Studebaker's centennial history, they proclaimed that "the significance of Studebaker's first century is that in the ideas of those who today plan for Studebaker's tomorrow, we find a point of view not held by men of younger companies."[22] Studebaker, they believed, had a tradition that enabled them to focus their vision for the future.

This tradition came under attack when Studebaker was forced to merge with another independent, Packard, in late 1954. This consolidation forced management to pursue new market strategies and to confront its relations with organized labor. Faced with a declining market share in the industry, the head of the newly formed corpora-

tion, James Nance, a former G.E. executive and CEO of Packard, was placed in a position of reevaluating its business and market strategy. Once again Studebaker management was forced to address the question of whether the company should try, as it had briefly in the 1920s, to compete toe-to-toe with the majors, or to gamble with a specialized car, as American Motors was attempting to do with its Rambler. Nance chose the multimodel approach. At the same time, he consciously rejected Studebaker's tradition of employer-employee (management-union) cooperation. Instead, the Studebaker legacy was reinterpreted as having led to the debacle that had forced Studebaker to merge with Packard.

Under Nance's direction, management undertook a campaign to bring Studebaker labor costs and labor standards under control. Anxious to impose a General Motors model on Studebaker, Nance alienated both Studebaker managers and employees alike. While Studebaker managers resisted change, the union entered into a bitter strike that further contributed to huge financial losses by the corporation. In the end, Nance learned that tradition could not be easily overturned.

The remaining ten years saw management desperately struggle to remain in automobile production. Unable to compete with the Big Three automobile producers, Studebaker management, under the direction of New York and Chicago banking interests, pursued a deliberate strategy of diversifying corporate holdings through the acquisition of other companies. Shortly before Christmas 1963, Studebaker closed its doors. History had been abandoned.

The death of Studebaker posed a major problem for analysts who would offer myriad reasons why the corporation had failed. For those who liked their history in prescriptive doses, Studebaker offered a poignant example of corporate failure in modern America. Studebaker's rapid decline from the boom years of the immediate post–World War II market into a market characterized by fierce competition with the Big Three, declining market share, and huge financial losses drew pathologists from the business press and academia. "What went wrong with Studebaker?" elicited extensive answers from economists, sociologists, political scientists, and historians. In 1947 Frederick H. Harbison and Robert Dubin, two leading industrial relations experts, had depicted Studebaker management as a model in flexibility and pragmaticism.[23] Less than fifteen years later, the Studebaker experience was being treated as a classic example of mismanagement.[24] As a result, Studebaker's tradition became contested terrain.

Studebaker's history appears as a record of broken promises and lost dreams. Often Studebaker management made choices that were poor or ill-timed, so opportunities that might have enabled the company to prosper were lost. Whether Studebaker could have survived in

a market dominated by the Big Three is questionable, but surely a reci-
tation of key decisions that hurt the company leaves a melancholic feel-
ing that Studebaker history might have been different: the company's
delayed entrance into the automobile market that was emerging at the
turn of the century and its failure to commit itself at the outset to
gasoline powered engines allowed competitors to get a head start in
an industry in rapid change. The decision to remain in South Bend
meant that the company would be left with poor plant facilities in
a location where other, more modern existing facilities could not be
readily purchased as their Detroit rivals were able to do; Studebaker's
merger with Garford and then EMF and not with another more es-
tablished company in this period further set the company back. The
attempt to establish itself in the high-volume, low-priced market in
the 1920s came too late, as did its move into the high-priced market
with the acquisition of Pierce-Arrow right on the verge of a major de-
pression. Erskine's misreading of the Great Depression and his policy
of paying high dividends in this economic environment placed the
company in bankruptcy. Management's easy accommodation to or-
ganized labor in the 1930s and World War II years meant that Stude-
baker would experience high labor costs and poor work standards in
the immediate postwar years that prevented it from competing with
the Big Three. The merger with Packard, its failure to merge with
Nash, and its attempt to become a multimodel producer in the 1950s,
ensured the eventual collapse of the company within a decade. And,
if the company had developed the Avanti earlier, Studebaker might
have remained in the automobile business longer instead of closing its
doors in 1963.

Yet, to read the company's history as only one of failure misses a
salient point: Studebaker experienced a long life as a company. Span-
ning over a century, from 1852 to 1963, Studebaker survived in a
marketplace marred by the remains of other enterprises that experi-
enced much earlier deaths. If Studebaker failed in the long run, the
company did make the transition into the automobile industry; it
made a commitment to the South Bend community; it accepted un-
ionism when other automobile companies bitterly fought collective
bargaining; and it produced a line of cars that were distinguished in
a market singularly noted for its uniformity of design. Most of all, the
company elicited a loyal following that even today proudly drive their
Studebakers. Few companies enjoy such enduring romance, love, and
devotion.

One final point should be made concerning the nature of this his-
tory of Studebaker. This history consciously focuses on the role of
managerial elites in shaping corporate history and organizational cul-
ture. Managerial leadership responded to external market forces and

the internal forces of production and employee relations. Nonetheless, management decisively shaped the character of the corporation within this larger context. Ultimately, managerial perception was as important as, if not more important than, the "objective" forces of the market or class relations.

This study assumes, therefore, that if our view of the corporate world is to be comprehensive, we must study the history of elite groups and their role and power, as well as studying the history of the masses from below. Of course, neither can be understood fully without the other, but if I can tell as interesting a story of the managerial elite as the one told by historians of the "plain folks," I will have achieved a major objective—the imparting of some knowledge and a little pleasure to the reader.

ONE

The Birth of a Corporation, 1852–1905

Tradition as Moral Vision

The Studebaker brothers—the founders of a small blacksmith shop in 1852 that became the world's largest wagon manufacturer after the Civil War—projected a moral vision that continued to influence the corporation long after the demise of the wagon industry and their own deaths. Later generations of managers who assumed control of the company made the Studebaker brothers into a symbol of the firm's integrity. Founding fathers often elicit, if only in word, such deference. In the Studebakers' case, however, what is so unusual is that the founders' vision, which was neither well articulated nor consistently practiced in its own day, continued to exert a pronounced influence on a modern automobile corporation in the twentieth century.

The Studebaker tradition as it emerged in the nineteenth century was configured by two important determinants: the Studebakers' own religious backgrounds as direct descendants of a pacificist, communal religious sect established in the eighteenth century, and the highly competitive wagon industry in the nineteenth century.

The Studebaker brothers sought to reconcile the social principles of Protestant Christianity with the values of competitive capitalism in the nineteenth-century United States. Theirs was an optimistic faith that the harsh aspects of industrial capitalism could be tempered through enlightened management. In turn, successful enterprise could serve to better community and society.

The five Studebaker brothers—John, Clement, Peter, Jacob, and Henry—sought to imbue their business with a Christian faith, while they pursued a relentless drive for the riches that came with mass production, intensive capital investment, and extensive national marketing. This interplay between communal religious values and the competitive marketplace created its own historical ambiguities. The Studebaker brothers promulgated a belief that their company should embody values that benefitted workingmen, consumers, and the com-

munity. The brothers actively participated in community affairs and leading business organizations, including the Carriage Builders National Association, the National Association of Manufacturers, and the National Civic Federation. Yet, even while professing the principles of enlightened management, the Studebakers could be as ruthless as any other nineteenth-century capitalists in suppressing organized labor within their own company.

In many ways, the Studebakers were typical of those nationally prominent corporate leaders in the late nineteenth century—men such as steel magnate Andrew Carnegie, oil tycoon John D. Rockefeller, and railroad builder Leland Stanford—who separated their national roles as industrial statesmen and philanthropists from the affairs of their own corporations. Only when corporate operations gained public notice that came with labor upheavals (Carnegie with the Homestead steel strike in 1892 and Rockefeller with the Ludlow mine strike in 1914) would these businessmen seek to reconcile their public postures with company practices. The Studebakers proved more consistent— perhaps because of their religious background and because they were more dependent on skilled labor that could always find work elsewhere—in integrating their public positions with company practice.

The Studebaker brothers played a crucial role in constructing this tradition. The brothers deliberately constructed a history of themselves as poor boys who set about through hard work, entrepreneurial drive, and benevolent concern for their fellow man, to build a company committed to quality production and community service.

The Studebakers Seek Perfection,
Only to Find South Bend, Indiana

Ancestors of the Studebakers came to America in 1736 to join a communitarian religious settlement in Ephrata, Pennsylvania. Founded in 1732 by German mystic Johann Conrad Beissel, the Ephrata Community envisioned an egalitarian society of true Christians who held property in common, separated themselves from civil society and its wars, and worked for the good of the whole. Beissel had fled his native region of the Palatinate (Germany), a hotbed of Protestant radicalism intensified by the Thirty Years' War (1618–48), in search of spiritual peace. In America, he became a minister of the German Baptist Brethren, known as Dunkards for their belief in baptism through total immersion.[1]

Beissel's own radical views concerning sabbath worship on Saturday led to the formation of the Ephrata Community in 1732 shortly after his arrival in America. Established in Lancaster County, the Ephrata Community embraced an odd combination of fringe beliefs including

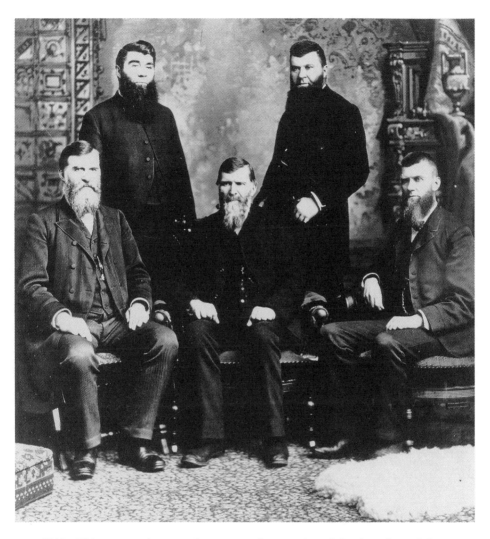

1880s. This group photograph captures the tenacity of the founders of the Studebaker Corporation. Henry Studebaker (in the center) would leave the firm because his pacifist beliefs would not allow him to participate in manufacturing wagons for the military. His other four brothers were less principled on this matter, although they proclaimed themselves to be Christian businessmen. Archives, Studebaker National Museum, South Bend, Indiana.

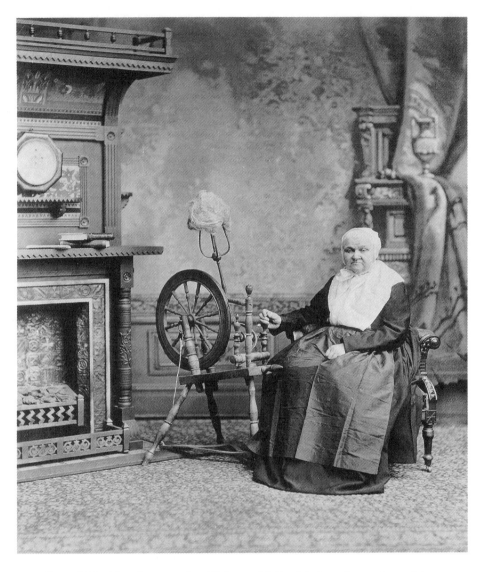

Circa 1880. The photograph of Rebecca M. Studebaker, the mother of the Studebaker brothers, shows her in typical Dunkard dress. The spinning wheel beside her is in sharp contrast to the ostentatious Victorian decor behind her. Archives, Studebaker National Museum, South Bend, Indiana.

THE CELEBRATED

STUDEBAKER WAGON

Farmers and Teamsters, there are Nine Reasons why you should Buy the above Wagon.

1st. They are made of the best selected INDIANA TIMBER

2d. They are made by first class Mechanics.

3d. The lightest running Wagon in the Market.

4th. The most Durable Wagon in the Market.

5th. The most uniform Wagon in the Market.

6th. The only wagon in which the SLOPE SHOULDER SPOKE is used. hence they have the best wheel, which is actually the foundation of the wagon and should be carefully examined by persons buying.

7th. They are sold only by responsible parties, and every wagon warranted to give entire satisfaction.

8th. Because they are invariably preferred by Freighters.

9th. Last but not least: Studebaker Brothers are practical workmen, attend to their business personally, and do not entrust it to the Foreman, as is generally the case in large Factories, hence the superiority of their work over all others.

A NEW YEAR'S PRESENT FOR 1870

Studebaker Brothers, in consideration of the very liberal patronage received from the Farmers and teamsters of the Northwest, propose to give them the celebrated Premium Wagon that has been exhibited at the different Fairs and always carried off the honors. They will dispose of it by issuing numbered cards, one of which will draw the wagon. The drawing will take place January 1st 1870, and farmers can select a committee to superintend it. Remember, there is no charge for a card. All you have to do is to call at our office, in the New Brick Shop, on Fourth street, in St Joseph, Mo, where you can get one.

1870. This Studebaker advertisement proclaims the durability of the Studebaker wagon and the close involvement of the brothers in manufacturing a vehicle for the common person, especially farmers and teamsters. Archives, Studebaker National Museum, South Bend, Indiana.

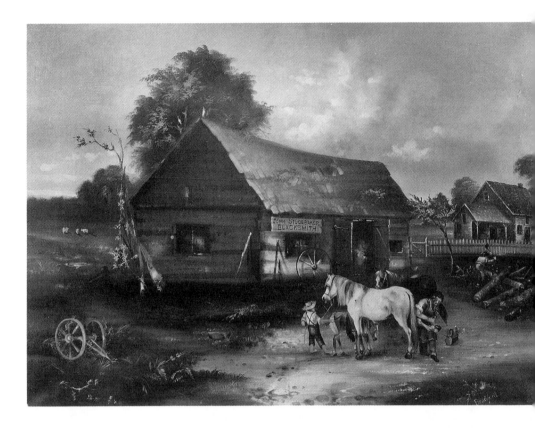

1880s. This painting of John Studebaker's blacksmith shop in Ashland, Ohio, in the 1830s was commissioned by the brothers in the 1870s and later used in advertising over the next decades. The painting projects the humble origins of the Studebaker Corporation, even as the brothers became scions of society. Archives, Studebaker National Museum, South Bend, Indiana.

Anabaptism, Rosicrucianism, spiritualism, and gnosticism. Beissel established a semi-monastic community which divided members into three categories, celibate brothers, celibate sisters, and married householders who were expected to practice continence. Celibates wore monastic garb and lived in separate quarters, where they slept on wooden benches, and attended daily prayer including a midnight service that involved secret rites, alchemy, magic, and esoteric ritual. To become a celibate, members had to undergo a rigorous forty-day initiation that involved beatings and the administration of toxic drugs that led to the loss of hair, memory, and often sanity.

Beissel's religious influence reached beyond Ephrata as his followers led revivals throughout the Middle Colonies. By the 1750s the community had grown to several hundred members. Ephrata combined deep spirituality with entrepreneurial endeavor. The community constructed grist, paper, lumber, and oil mills that were among the largest in colonial Pennsylvania. The elders of Ephrata imposed an enslaving work regime on community members. The tannery supplied an extensive shoemaking enterprise and one of the largest bookbinderies in colonial America. The sawmills supplied lumber throughout the region. Ephrata flour found a ready market in growing Philadelphia. The Ephrata Press offered a steady flow of pamphlets, broadsides, and books, including the first American edition in German of Bunyan's *Pilgrims' Progress* and the largest work published in colonial America, *Martyr's Mirror*, a 1,514-page account of Protestant martyrs. In 1740 the community established a classical academy that drew students from as far away as Baltimore. By the mid-1740s the mills were working overtime, leading to the employment of outside labor.

Material prosperity proved incompatible with Beissel's spiritual vision, however. In 1746 he summarily dismissed all outside labor and closed the sawmill and flour mill to all outside trade. Only the paper mill and the press were allowed to continue. Within a year, self-imposed poverty had once again replaced the industrial system. This was the price of constructing a cooperative community of saints on earth. The death of Beissel in 1768 marked a decline in the fortunes of the community, although in the early 1800s Ephrata experienced renewed, albeit modest, growth. A small body of "sisters" continued to survive as late as the 1840s.

Beissel's community was only a remnant of its former self when John Clement Studebaker met Rebecca Mohler, the daughter of a prominent member of the communitarian sect, at a Dunkard gathering in 1820.[2] Married a short time later, the couple brought a deep religiosity to their marriage. This religiosity played a significant part in their five sons' lives, but John Clement's failures as a businessman also left an equally important mark on his five sons. As a result, the

eighteenth-century Dunkard vision of a cooperative Christian moral order was to be tempered by fierce entrepreneurial aspirations more suitable to industrial America in the nineteenth century.

Born in 1799 in Pinetown, Pennsylvania (one of many settlements that failed to survive into the twentieth century), John Clement Studebaker owned his own farm and blacksmith shop by the time he married Rebecca Mohler. Yet John Clement's early promise of success soured in subsequent years. His problems began when he co-signed loans for members of the Ephrata Community with whom he had become acquainted over the years. Most repaid their loans, but when a few defaulted in 1836, John Clement was forced to sell his farm. Packing all of his possessions and his family into a Conestoga wagon he had constructed (patterned after the wagons built by the Conestoga Dunkards), he headed to Ashland, Ohio, another center of Dunkard activity. There he purchased a small farm and a grinding mill. His home bustled with Dunkard activity, but bad luck continued to follow him. Plagued by Pennsylvania debts and unfamiliar with the mill business, John Clement was forced to sell his 160-acre farm within the year. At the age of thirty-eight, John Clement began life anew. He opened a wagon repair and blacksmith shop over which he hung a biblical quotation, "Owe no man anything but to love one another." Unfortunately, his creditors did not see things this way. His neighbors later recalled that John Clement was a "man who worked hard, but was being sued once every year for debt. He owed every man in town."[3]

A sense of humiliation appears to have profoundly marked his sons. Clement was later quoted as describing his father as "industrious, economical and sympathetic, but history proves his failure."[4] The sons took over running the business, often working from four in the morning to nine at night. Jacob, the youngest son, remembered that "I can tell you there was no ten or eight hour system then; it was work, work, work," work for mere barter, for "butter, eggs, and other country production, known then as 'store pay.' "[5] Their father's failure in business tempered the brothers' religious fervor. While the brothers remained devout Christians, business often subsumed religious principle.

In 1848, the impoverished Studebaker family again looked west to a new settlement located along the St. Joseph River in northern Indiana—South Bend—where John and Rebecca's eldest daughter had moved with her husband.[6] Settled in the 1840s as an Indian trading post by L. M. Taylor and Alexis Coquillard, the town of South Bend, with its small population of seven hundred people, was located in what many hoped would become a major center for western settlement. Clement Studebaker, the second son of John Clement, traveled ahead to make arrangements for the rest of the family to follow. The next

year he brought his father and his mother, his older brother Henry, and his younger brothers, John Mohler, Peter, and the youngest, Jacob, to Indiana. Clement Studebaker took a job as the local schoolteacher, while Henry worked at the local blacksmith shop. After two years of hard work, Henry and Clement combined their assets— $68.00 and some equipment—to open a full-time blacksmith shop and repair shop. In the evenings, they began to build wagons.[7]

South Bend proved to be an ideal place to start a business. The St. Joseph River, which flowed from Michigan through northern Indiana before emptying into Lake Michigan, provided adequate waterpower and a perfect transportation route connecting Michigan with Indiana. By late 1851, the Michigan Southern and Northern Indiana Railroad connected South Bend to Toledo, Ohio. By 1856 four trains stopped daily at the South Bend station, two headed east and two headed west. At the same time, packet boats along the St. Joseph, shortly followed by steamboats, connected South Bend with the Great Lakes. This transportation system enabled the town to emerge as a regional manufacturing center. At the outbreak of the Civil War in 1861 over ninety manufacturing firms were located in the area, including the St. Joseph Reaper and Machine Company (later the Oliver Chilled Plow Company), as well as two other wagon companies, including Elberhart-Platt Company and the Milburn Wagon Company.[8]

As the century drew to a close, South Bend had become, as a local newspaper declared, "a mecca of manufacturing." Oliver Chilled Plow employed 945 workers, followed by Singer Sewing Machines with 1,000 employees. Other firms included Indiana Paper, South Woolen, Economist Plow, Sandagee Steel, and Coquillard Wagon.[9] As South Bend prospered, so did the Studebakers. By 1900 the city had grown to a population of over 40,000 people.

In 1852, few would have predicted Studebaker's success. In the beginning the Studebaker blacksmith and wagon business remained a small family-owned concern that lacked the necessary capital to become anything more than a local shop. A strange set of circumstances that began with the discovery of gold in California in 1848 transformed the Studebaker enterprise. As the gold fever swept across the nation, the lure of gold caught the imagination of local South Bend residents. In 1853 even the nearby Catholic academy of Notre Dame organized an expedition of priests to explore for gold in California. Dunkards, too, succumbed to the lure of riches, when the third brother, John Mohler—J. M. as he was called by the family—joined an overland party headed to California in 1853. After a five-month ordeal, with Indian skirmishes in Utah and the loss of the party's leader from a scorpion bite in Nevada, J. M. arrived in Placerville, California, in August 1853.

In his later years, J. M. loved to tell the story of how, as a young greenhorn from Indiana, he arrived in Placerville, having been milked of his money by gamblers in Missouri, only to find wealth not in the mines but in the making of wheelbarrows. Instead of mining for gold, as John recounted the story, he accepted work at the local blacksmith's shop making wheelbarrows. J. M. soon rose to become partner of the firm that employed nine other workers. The town was a place where fortunes could be made. Running the local butcher shop was Philip Armour, while Mark Hopkins, later of Southern Pacific fame, owned the local grocery store. Over in Michigan Bluff, Leland Stanford ran the dry goods store. Within five years, J. M. had acquired his own substantial capital of $8,000. In the East, where a skilled worker earned about $600 a year at best, it would have taken a lifetime to save that amount of money.

In 1858 he returned to South Bend for a visit with no intention of staying. California agreed with him. He discovered, however, that he was needed in Indiana. The Studebaker wagon shop had grown in J. M.'s absence, but it remained in a precarious financial state. Shortly before his return, George Milburn's Wagon Company, located in nearby Mishawaka, subcontracted with the brothers for a large order of army wagons for the so-called Mormon War in Utah. To fill the order, which called for the building of a hundred wagons in ninety days, the brothers expanded their firm by adding new forges, a new building, and a kiln to dry green timber. The industrious Studebakers met the order ahead of schedule, but the expansion left the firm short on cash when a financial panic struck the nation in 1857. Crowded by creditors, the Studebaker enterprise was expected to fail.[10]

J. M.'s timely arrival saved the company. He agreed to invest some of his $8,000 in the firm. The infusion of capital laid the foundation for Studebaker Company to expand. J. M.'s entry into the firm was significant in another respect as well: Henry, the oldest and most religiously conservative of the brothers, was anxious to sell his interest in the firm after a group of Brethren deacons had admonished the brothers for agreeing to produce wagons for military use. Therefore, Henry's departure marked a break within the family over religious principles. The principle of pacifism had been replaced by the principle of profit.[11]

In turn, the brothers drifted away from the Dunkard congregation. Clement became a Methodist, while J. M. became a Presbyterian, Peter, an Episcopalian, and Jacob joined a local First Baptist church. In their later years, the brothers reconstructed a different history that emphasized their entrepreneurial spirit and overlooked their family's pacifist roots.

Studebaker Becomes a National Firm

The wagon industry that the Studebakers entered proved highly competitive and capital intensive. Because industry records remain incomplete, historians have generally overlooked the American wagon industry in the nineteenth century. Contemporary industry publications provide only generalized and impressionistic information. The carriage builders of the United States organized a national association in 1872, but its mandate to collect national statistics remained unfulfilled. Initially dominated by smaller firms and with a membership of less than one hundred altogether, the national association had limited access to resources for collecting national figures.[12]

The most thorough survey of horse-drawn vehicle manufacturing came only in 1905 when the United States Bureau of Census collected national data of the industry on a state-by-state basis, but this survey covered only a fifteen-year period from 1890 to 1905, a time when wagon manufacturers were challenged by the introduction of the automobile. As a consequence, little is known about Studebaker competitors—their markets, production technologies, costs, distribution systems, or employees.[13]

Much can be garnered about the industry, however, from Studebaker's own records and a close reading of contemporary periodical literature. The most salient feature of the industry in these years was its transformation from a labor-intensive into a capital-intensive industry, as manufacturers turned to mass production through automated equipment. By 1880, American manufacturers produced more carriages than Great Britain, Italy, France, or Germany. Once dominated by interests along the eastern seaboard, the industry shifted to the Midwest.[14]

By the 1880s the Midwest had emerged as a major center for vehicle manufacturing, although stiff competition from eastern concerns remained ever present. The Midwest, with its abundance of natural resources, central market location, ample transportation facilities, and relatively low labor costs, soon became the heartland of industrial activity.[15] By 1905, the Midwest (the North Central region) of the wagon industry held 60 percent of total capital invested and produced 58 percent of the value of products. Indiana showed the largest increase in the value of vehicles produced from 1890 to 1905. In wagon production, Indiana ranked first, producing over 16 percent of all vehicles made in the United States.[16]

Studebaker contributed significantly to the state's success. The key to Studebaker's rise lay in their products—high-quality wagons built

for an expanding western market. At the same time, the brothers showed remarkable business acumen. They divided managerial responsibilities among themselves, established a well-coordinated distribution system, and undertook a persistent program of capital expansion to enlarge production capacity. They also revealed a voracious desire for new technological innovations, whether it was installing the first telephone in South Bend or using electric arc welding.

Studebaker's growth followed western agricultural expansion. They specifically targeted the growing agricultural sector by producing farm wagons. As Clement Studebaker noted, "We thought every farmer must have at least one farm wagon," and it was on that basis that they ran their business.[17] Meeting the needs of this expanding market, the Studebakers developed a "spring" wagon that soon gained fame among Midwestern farmers for its durability and design. In the early 1800s carriages had undergone a number of technological changes including the introduction of "bow and string" suspension. This suspension allowed the axle to be attached to flexible cords or braces.[18] The Studebakers applied the principle of spring suspension to the farm wagon.

The brothers ran their growing company with a clear division of management.[19] The prudent, fastidious Clement served as president, worked in the front office, and oversaw the company's financial operations. He constantly looked over the shoulder of his clerks to make sure the job was done correctly. His exasperating scrutiny over the smallest details often astounded those who worked for him. As one longtime employee of the company during these early years remarked, "I have never met a man who, considering the vast interests that he had to look after, was more careful as to the small details as Mr. Clem Studebaker."[20] It was this concern with perfection that impressed others in business, especially financial interests on Wall Street. In the next decade, Clem took the Studebakers into a variety of other business concerns including utilities and banking.[21]

The task of running the manufacturing side of the business fell to J. M. In this role he supervised an "army of men," hiring thousands of employees who built between seventy-five thousand and one hundred thousand vehicles a year. His responsibilities also included the purchasing of all manufacturing materials and supplies.[22]

Peter Studebaker, after having become a partner in the company in 1863, infused a speculative spirit that Clement lacked. Taking over sales, he had signed a two-sentence contract with Clem that read, "I, Peter Studebaker, agree to sell all the wagons my brother Clem can make." Clem countersigned, "I agree to make all he can sell." To further western sales, the gregarious Peter assumed management of a branch sales office in St. Joseph, Missouri. Here, he equipped the

waves of settlers moving west. Peter sent agents throughout the country to set up an extensive distribution system. Studebaker offices could be found in every Union Pacific station, with key locations along the Mississippi River and in smaller towns through the Midwest and West. When he was finished, the company had a distribution system that had staked out the western market "almost to the exclusion of the other manufacturers."[23]

The youngest brother, Jacob, joined the firm in 1870 after completing a two-year business course at the University of Notre Dame. He immediately assumed control of the carriage department. By this time the firm produced a full line of vehicles nationally renowned for their beauty of design, which was matched only by their construction.[24]

The Civil War marked an important point in the company's history. A committed pacifist and a leading figure in the Brethren community, John Studebaker, Sr., refused to let Jacob, then seventeen, enlist in the army. Furthermore, he joined his oldest son, Henry, in accusing the other brothers of profiting from the war.[25] The brothers welcomed the opportunity to profit from the war. In 1862, Clement accepted the first of what became many government orders for transport wagons, gun caissons, and meat and ammunition wagons. The Studebaker factory began working day and night shifts. The brothers expanded their facilities by constructing new shops and a new forge.

The results of the war, so devastating to many, brought prosperity to the once struggling firm. As the war drew to a close in 1865, the Studebaker plant covered four acres and employed 130 men. The firm consisted of a two-story steam-powered factory, a two-story brick building that housed a blacksmith shop and carriage painting facilities, and a new four-story building for painting wagons. Another building served to store finished wagons and carriages. The company had opened two large lumber yards and a drying house for undressed materials. Annual profits reached a quarter of a million dollars.

In March 1868 the firm was incorporated, under the statutes of Indiana, as the Studebaker Brothers Manufacturing Company. The company, founded on an initial investment of $68, now held capital stock valued at $75,000, with Clement, John, and Peter contributing a third each.[26] Still, Studebaker was not the largest wagon producer in the area. That same year George Milburn incorporated his company with stock of $100,000. In 1873, however, a severe fire led Milburn to move his company to Toledo, Ohio, leaving Studebaker the principal wagon producer in the region. By 1870 the federal census listed Studebaker as the government's largest supplier of wagons. And five years later, in 1875, Studebaker joined the ranks of an elite group of companies earning gross profits of one million dollars. With a capacity

of 75,000 vehicles annually, Studebaker was able to produce a wagon every ten minutes. Production had nearly tripled since the end of the war. The firm employed 500 men and now could rightfully claim to be the largest producer of wagons not only in the United States but in the world.[27]

This performance proved to be all the more remarkable in that Studebaker experienced two devastating fires in a little over two years from 1872 to 1874. The first fire occurred on June 20, 1872, and destroyed an estimated $70,000 worth of property. Insurance covered most of the loss, but equipment and supplies were lost and buildings gutted.[28] Then two years later in the summer of 1874 fire once again ravaged the plant, destroying 2,100 finished wagons and material valued at $300,000, of which less than half was insured.[29] Immediately following the fire, the company received offers from Chicago and Cincinnati to relocate to their cities. Such enticements were typical as Midwestern cities competed for new industry by offering tax breaks, new buildings, and nonunion labor—anything to lure new companies into an area.[30]

Studebaker remained committed to South Bend, however. Even with the setbacks caused by these fires, business was going too well to consider a move. In 1874 Studebaker expanded its stock holdings to $1,000,000 by issuing 20,000 shares at par value of $50, although major shareholders in the company continued to be family members. To prevent future fires, Studebaker installed an extensive, state-of-the-art fire protection system that included 30,000 sprinklers, 71 valves, 2,700 feet of fire hoses, 54 fire hydrants, 6 miles of underground water pipes, and an arrangement of fire blinds and doors.[31]

The success of the enterprise stemmed from volume production, technological innovation, and national marketing. The science of reducing prices, as Clement noted, rested on the improvement of machinery. Thus to maintain volume production the company was driven to mechanize. The brothers seemed to be always looking for new technological advances. In 1876 alone the company took out six patents on various processes. To house this new machinery, the Studebakers constructed a new plant that allowed trains to run alongside the main buildings.[32] In 1880 electric lights were installed throughout the plant.[33] By 1890 the Studebakers had built one of the most modern factories in the world. The South Bend factory produced nearly thirty different types of vehicles on ninety-five acres.[34]

Work began in the woodworking department, composed of three large rooms. The sanding, planing, and scrapping of the lumber used in the building of hundreds of wagons a day was completed by machine, including an automatic mortising machine with a capacity of cutting and fitting the spokes into holes. Over 600 hubs a day could

be produced. The department cut an estimated 126,000 feet of lumber a day. Next to the woodworking department stood the blacksmith shops, which housed a three-thousand-pound-capacity steam hammer and other machinery used in forging the metal used in wagon manufacturing. The blacksmith's shop combined the forge department, punch and hammer department, thread cutting department, and finishing department, where skeins were set and gears put together.

The gear finishing department covered another 25,000 square feet and completed all boring and sand-belting of gears. Box making for the wagons was divided into separate departments for each wagon. Sides and bottoms were duplicated for each type of wagon to be used for interchangeable assembly. This division was capable of delivering to the paint and varnish shop an estimated 250 completed wagon beds a day. Painting was still done by hand, but the department had the capacity of turning out 300 wagons a day, which would be stored in finished storerooms. Usually, 12,000 complete wagons remained in store.[35]

To ensure that sales kept up with production the company continued to expand its distribution system. For example, during the depression of 1884 in which sales dropped $152,000, the company aggressively built an impressive new showroom in Chicago. When completed, the outlet housed a fancy showroom displaying Studebaker's fanciest carriages. The upper floor provided room for the manufacture and repair of carriages. The Studebaker showroom further enhanced the firm's reputation in the Chicago market and helped Studebaker get through the depression.

Meanwhile, Studebaker expanded its sales offices by opening branches in Sioux Falls, Iowa (1884); Helena, Montana; Tucson, Arizona; Santa Fe, New Mexico; Denver, Colorado (1885); and Las Vegas, Nevada (1886). By 1887 Studebaker sales had climbed to the $2 million mark.[36]

The Brothers Proclaim Themselves
Christian Industrialists

As their firm prospered, the Studebaker brothers assumed prominent places in business and political circles. Priding themselves on their commitment to Christian service, they became actively involved in business organizations and the Republican party. As early settlers in South Bend, the Studebaker family remained committed to the political, religious, and cultural life of the community. As bourgeois entrepreneurs, the Studebakers espoused the values of business sobriety, punctuality, and the craft integrity of their employees. At the same time, they sought to translate these values nationally. In this endeavor,

they combined attributes of moral certainty with self-aggrandizement. These roles, as Christians, citizens, and industrialists, enabled the Studebakers to express an optimistic faith in progress and advancement. Progress in industry ensured a better life for all social classes. As one company resolution at the board meeting in 1887 expressed it, the company's owners were determined to "do our duty toward each other, toward our fellow men and toward our heavenly Father, so that when we too shall hear the summons . . . the call will find us ready and waiting."[37] To have suggested to the Studebakers that their views were only a guise to pacify working-class discontent and to promote worker productivity would have deeply offended them and probably would have been dismissed by most of their employees as well. The brothers sincerely saw themselves as Christian businessmen. This Christian concern to serve their fellow man expressed a morality that allowed them to undertake great acts of generosity, even while imbuing their employees with a value-laden code of hard work, individual self-advancement, and company loyalty. Nevertheless, the Studebaker Company itself was not totally immune from disruptive union activity. And when confronted by militant workers, the Studebakers showed another side—one far less becoming than their public face.

In their roles as industrial statesmen, the Studebaker brothers assumed leading positions in the nation's business circles. Clement Studebaker was instrumental in organizing a national trade association of wagon manufacturers, the Carriage Builders National Association. The primary purposes of the trade association were to create uniform railroad tracks and to guarantee the improvement of wagon production. At the same time, he warned the group to avoid the "labor question."[38]

In 1894, Clement's position as a national business leader was confirmed when he was elected president of the National Association of Manufacturers. That following autumn he supported his brother Peter's efforts to organize the Implement Manufacturers Association, a lobbying group aimed at imposing tariff duties on foreign implement manufacturers, especially Canadians, whom the Studebakers accused of undercutting the American market.[39]

Clement's involvement in national business circles appeared ceaseless. In 1889, he represented the United States as one of ten delegates to the Pan-American Congress. The following year, upon his return to Indiana, Clement emerged as a leading force behind the National League for the Protection of American Institutions, whose goal was the establishment of a common school system for Indiana. The league sought to secure the absolute separation of religious and state institutions and to arouse "public sentiment concerning the perils of unregulated and unrestricted immigration."[40] This latter concern ap-

peared especially peculiar given that the Studebaker Company relied heavily on immigrant Poles and Hungarians as a ready supply of labor.

Clement's business activities were easily translated into Republican politics. An active party member since the 1850s, Clement remained deeply committed to the party. Throughout his life he remained a tenacious partisan who expressed no doubts about his political principles. During the tumultuous convention of 1880, Clement became one of the famous 306 delegates who stood firm for Grant.[41] (That same year J. M. Studebaker switched parties and voted Republican for the first time in his life.) Their mother remained sympathetic to the Democratic party.[42]

By 1891 many spoke of Clement as the next Republican governor of Indiana. Clement's support for Maine's James Blaine over Indiana's Benjamin Harrison for the presidential nomination, however, damaged his chances for receiving nomination for the state's highest office. Nevertheless, he remained a power in Indiana Republican politics. When Albert Beveridge began his campaign for U.S. Senator in 1898 he sought out Clement's endorsement.[43] Clement might not be able to become governor in his own right, but he had a decisive say in Indiana politics.

Prominent in business and political circles, the Studebaker brothers presented themselves as a model for enlightened management. During the Pullman strike of 1894, Peter Studebaker audaciously intervened in the strike as a self-appointed arbitrator between George Pullman and Eugene Debs, the president of the striking American Railway Union. In July 1894, he arranged a series of meetings with Debs in Chicago to discuss settlement of the strike. Peter told the press that "I don't want any notoriety, but I have talked several times with Mr. Debs, who is a friend of mine, and I will do anything I can to bring about a compromise and settlement of the trouble."[44] In the end these meetings accomplished little, but they did enhance the Studebaker Company's reputation as a progressive employer. Debs was quoted in the newspapers praising Peter. "If all employers of labor," he declared, "were like Peter Studebaker, there would be no strikes. He is a true friend of workingmen. . . . The highest compliment I can pay him is that he is a direct opposite of George M. Pullman."[45]

Despite Debs's backhanded compliment, the brothers remained intolerant of labor radicalism. Indeed, shortly before Peter's meeting with Debs, Clement had denounced demonstrations by unemployed workers across the country. He was particularly severe with Coxey's Army, a group of unemployed workers organized by Jacob Coxey, a small-town businessman from Massillon, Ohio.[46] Coxey organized a march on Washington to deliver a petition to Congress for a roads building program to relieve unemployment across the nation. Clement

told the press that the march was "insignificant" and that newspapers were sensationalizing the march in order to sell newspapers. In this way, he said, newspapers have rendered "great assistance to the visionary leaders [of the march]." He added, "If the press all over the country had advocated the principle of every community taking care of its own unemployed the bubble would have burst long ago."[47]

Shortly after the Pullman strike, Clement was selected to be one of the three delegates from Indiana to serve as a member of the advisory council of the National Civic Federation (NCF), a business organization formed in 1900 in Chicago to promote industrial arbitration and municipal reform.[48]

Seeking to show their fellow industrialists that they practiced what they preached, the Studebakers experimented with progressive measures within their own company. The brothers carefully noted efforts to promote industrial cooperation at other wagon companies. As early as 1871 the Brewster Company in New York City had initiated a profit-sharing plan among its employees. The plan provided each employee with a "half a yearly dividend of one-tenth of the net profits of the firm," thereby encouraging employees to become "directly interested in the quality of their production."[49] Studebaker also expressed an interest in profit sharing, but did not pursue the discussion. Still, it instituted other policies such as purchasing for each ten employees a weekly newspaper of their choice.[50] Later, it considered the possibility of providing accident insurance for its employees, although this benefit remained in the talking stage until the turn of the century.

The Studebaker brothers prided themselves on their harmonious relations with their employees. All four brothers expected their clerks and factory operatives to work a full day, although a comfortable atmosphere prevailed within the company in its early years. Often a lunch hour would be spent with J. M. or Jacob joining the workers in a friendly game of cards around an unfinished hub.[51]

The Studebakers also encouraged their workers to inculcate the values of family. The Studebakers built a large tract of homes for their workers to purchase at cost. The brothers realized the practical values of having a workforce rooted in the community. As J. M. observed, "The man that [*sic*] owns his own home is not given to roaming; he is not given to spending his hours in the dram shop; and on the contrary he finds pleasure in frugal living and saving that promises well for his future independence."[52]

While expressing such beliefs, the Studebakers could be hard taskmasters on the factory floor. Their obsession with quality craftsmanship entailed the maintenance of stern standards for their workmen, often to the point of dismissing the fallibility of being human. J. M., for example, loved to tell a story in his later years of how he always

insisted on high quality work from his employees. "Years ago," he would begin, "I called a German foreman into the office and told him of some things I saw wrong in his department. He said, 'Vell, Mr. Studebaker, you ish neber satisfied.' My answer was 'Jo, I never expect to be, are you satisfied?' 'Yes, Mr. Studebaker, I ish satisfied.' On pay day I paid him off. He came to me and said, 'Mr. Studebaker, I vork for you ten years, for vat you discharge me?' My answer was, 'Jo, you told me you were satisfied, that being the case, you are a dead one. I am sorry for you.' "[53] The story itself revealed how history could be used to translate lessons from the past into contemporary moral lessons.

That J. M. told the story with such pride also suggests a man certain of his values. If he was arbitrary in his treatment of his employees, his company paid high wages relative to local conditions and maintained good working conditions for its employees. This kind of paternalism in the nineteenth-century factory was common in both England and America.[54] Although paternalism can be seen as a means of promoting productivity and preventing unionism, the Studebakers saw themselves as factory owners concerned with more than dollars and cents. Clearly the brothers saw the utilitarian value in having a workforce imbued with those values of temperance, frugality, and the work ethic, but the brothers also perceived themselves as enlightened businessmen with a social responsibility to their workers. As a consequence, the company promised to ensure job security, create opportunities for advancement, and protect family and community stability in South Bend.[55]

Yet behind the facade of social tranquility, industrial relations at Studebaker—carefully hidden from the general public—periodically revealed sharp contradictions between the enlightened rhetoric and actual practice.

Throughout the late nineteenth century, organized labor targeted Studebaker. Often labor organizers confronted a workforce that remained generally conservative and fiercely loyal to their employer. For example, Polish workers, many of whom had migrated to South Bend in the early seventies, attempted to organize a loosely defined industrial union in 1885, only to fail. Shortly afterwards, Albert Parsons, the well-known anarchist and Chicago labor leader who was later hanged after the Haymarket riot, came to South Bend to help the Polish workers. Speaking before a crowd of three hundred workers he declared, "The Studebakers, Olivers, Singers, and other capitalist czars who own this town, have so completely subjugated their wage slaves to the despots that no persons dare belong to a labor organization, and if suspected of being connected with such are at once discharged." He then called Martin Paulinski, an employee recently discharged after eight

years of service, forward to speak. Paulinski described how the Stude-
baker brothers arranged for supplies to be sent to his family during
the previous winter when he had become ill. Yet when Paulinski had
accepted a cord of wood from organized labor, he declared, the Stude-
bakers "turned him adrift to starve and freeze." Parsons then stepped
forward to attack Studebaker and Oliver for building a church. "Their
victims were taught they must be content with that station in life in
which it had pleased God to call them." At that point a riot broke out
when the crowd, sympathetic to the Studebakers, turned on Par-
sons. Only the intervention of the police saved Parsons from being
lynched.[56]

In 1892 workers at Studebaker went on strike in support of the
Homestead strike when the firm continued to use material purchased
from the Carnegie Steel Company. The strike proved to be shortlived,
thereby strengthening South Bend's reputation as a hard town to or-
ganize.[57] Instead, organized labor found that it had more success by
targeting Studebaker's Chicago branch. The year after the Homestead
strike, nine hundred carriage and wagon workers in Chicago went out
on strike. Led by the Carriage and Wagon Builders Union, the strike
was aimed at organizing the entire wagon industry in the Chicago
area. Smaller wagon companies quickly capitulated to the union by
agreeing to a 10 percent wage increase and a nine-hour day for
employees. The larger manufacturing concerns, led by Studebaker,
continued to resist the union. The number of strikers at Studebaker's
Chicago repository remains uncertain. Newspaper accounts show a
tough-minded management at work. Studebaker led the way in organ-
izing a lockout of workers throughout the Chicago area. As the strike
continued, many predicted "riots and bloodshed." Meanwhile the un-
ion enlisted the Illinois Federation of Labor in a national boycott of
Studebaker goods.[58] Begun in early March 1893, the strike continued
into the late spring, but the failure of the boycott and the inability of
the union to spread the strike to Studebaker's home base in South
Bend spelled doom for the strikers. The Illinois Federation of Labor
made one last attempt to resuscitate the strike by issuing ten thousand
leaflets directed to the Farmers Alliance urging a boycott of Stude-
baker wagons. But once again the attempt to boycott Studebaker
products failed.[59]

Following the strike, the American Federation of Labor continued
to see the Studebaker Company as antilabor, and periodically the AFL
warned its members not to buy Studebaker products.[60] Such accusa-
tions were not quite fair since certain crafts including woodworkers
and painters were organized at the South Bend plant. Nevertheless,
Studebaker continued to confront periodic labor difficulties, which led

the company to undertake actions that belied the brothers' image as industrial statesmen.

Most revealing in this respect was a strike in their harness department in 1899. A December 15, 1899, strike of thirty-three leather workers in the department brought the State Labor Commissioner to South Bend to investigate the problems. An investigation revealed that the department had only been established two years earlier when a local harness factory had gone bankrupt. Studebaker had purchased the stock from the company and had set up a small department within its factory. The running of the department, which failed to make profits in its first two years, fell primarily to a shop foreman. As J. M. testified, "It is the only department of our business whose details I am not familiar with, and for this reason almost its entire management, except only the question of wages, is in charge of Mr. Irwin. I was unaware of any difficulty until the men were out. Had they called upon me, I am certain I would have adjusted the differences without the necessity of a strike."

Subsequent arbitration, however, showed a recalcitrant management. J. M. refused to recognize the union or rehire discharged employees. Finally, after two months of negotiation, the strikers returned to the job, although Studebaker agreed only to advance the wage scale on certain items. Moreover, he refused to recognize the union, the United Brotherhood of Leather Workers on Horse Goods. The major concession Studebaker made was the rehiring of all the discharged employees with the exception of one. The Indiana Labor Commission later complimented the workers on their conduct. The official report concluded, "Their [the employees'] upright demeanor is the more significant and commendable from the fact (to them well known) that the Studebaker Company had two secret detectives in its employ who, pretending to be union men, attended the daily meetings of the organization, fraternized with the men, and then from day to day reported to the company the secrets thus dishonestly obtained."[61]

The Studebakers could appear inconsistent in other respects. For example, while the Studebakers built houses for some of their workers and while they claimed to pay the highest wages in South Bend, their employees lived in a district known as Studebaker Row. Located at the southernmost limits of the city, the district was a notorious haven for prostitutes, criminals, and "ne'er-do-wells." Studebaker Row consisted of two blocks of houses, all constructed identically. Police, the local paper reported, were frequently called to the district to quell incipient riots and other disturbances.[62] It was another side of Studebaker's South Bend that was not discussed openly.

Still, the community of South Bend for the most part showed little

signs of class tension. A comfortable harmony existed in the industrial
city of South Bend, which by the 1890s was the fourth largest in the
state. Many local merchants in the city had landed their first jobs at
Studebaker.[63] This civic harmony was typical of Labor Day celebra-
tions. Labor Day, declared a national holiday by Grover Cleveland in
1894, became a day of festivity and civic pride in South Bend. The
day usually opened with a parade—often extending three miles—filled
with company floats, ethnic associations, labor unions, and school
marching bands. After the morning parade, civic leaders from both
business and labor provided a full day of speeches lauding the contri-
butions of labor to the growth of American industry. The day con-
cluded with contests, baseball games, and picnics in which labor and
capital rubbed shoulders as presumed equals.[64]

The Studebakers actively participated in the civic affairs of the city.
As early settlers of the city and its leading employers, they fashioned
a prominent role for themselves as cultural and political leaders of this
medium-sized industrial town. In this role they carefully cultivated an
image as civic leaders concerned with social betterment and industrial
progress.

The Studebaker family stood as symbols of success for their fellow
citizens. Clem Studebaker remained an active member of the local
Methodist Church, donating the funds for the building of the Mil-
burn Memorial Chapel building, named for his late father-in-law
George Milburn. He also belonged to the Masons, the Odd Fellows,
and the prestigious Indiana Club of South Bend. He was a major
benefactor to Epworth Memorial Hospital, one of the largest hospitals
in the region. He also served as a trustee of DePauw University and
was president of the Chautauqua Assembly, which brought him into
contact with the nation's leading intellectual, religious, and cultural
figures of the day.

The Studebaker family members became models of philanthropy
within the community. For example, the family donated $250,000 for
the building of a new YMCA building in downtown South Bend.[65]
In turn, the Studebakers' deeds in aiding the poor and their frequent
donations to the indigent and transients became well known in the
city.[66] Similarly, the Studebaker wives engaged in the Women's Relief
Society and other charitable organizations in South Bend. During the
depression of 1893, Mrs. Peter Studebaker organized auctions, teas,
and a number of other social events to raise funds for the relief of
the poor. She donated twenty barrels of flour herself to be distributed
to the poor during the Christmas season of 1893.[67] Her sister-in-law,
Mrs. J. M. Studebaker, frequently opened her mansion, Sunnyside, to
lectures for the poor on such topics as "Being a Model Husband."[68]

The Studebaker family's involvement in the community required

service to the poor without eschewing the virtues of hard work and its benefits. As a consequence, the Studebakers conspicuously displayed the symbols of wealth that assumably came from their hard work and entrepreneurial success. In this way, conspicuous consumption was translated into a moral display. Standing as the symbol of the family's social standing in the community was Clement Studebaker's imposing and ostentatious mansion, Tippecanoe. Completed in 1888, Tippecanoe was described by the local newspaper as "massive in its appointments, so elegant in its luxuriousness that by old world standards it would be called a palace."[69]

At Tippecanoe Clem showed what hard work could bring in the way of "the good life." In late 1891, Clem offered South Bend a stunning display of his affluence when he hosted a marriage reception for his daughter Anne and her new husband, Charles Carlisle, a railroad executive from Toledo. Over three thousand guests attended the reception that honored the blonde, blue-eyed Anne, who, having been educated in Philadelphia and New York, was well acquainted with Eastern and Midwestern social circles. Clem spent lavishly on the affair. Anne's wedding dress was specially designed for her in Paris. As a wedding present, Clem presented his daughter with a solid silver tea chest containing two hundred twenty-five pieces of silver. Special railway cars were rented to carry guests from Toledo and Chicago to South Bend. Following the reception, the newlyweds began a yearlong honeymoon which took them to the most fashionable resorts in Canada, the United States, and Mexico.

Following their return, Charles Carlisle joined the Studebaker firm as a vice president of advertising. He quickly became a close ally of Clement's on the board. He also represented Studebaker interests in the South Bend Fuel and Gas Company, the South Bend Malleable Iron Company, and the American Trust Company. He was to serve as an officer for the Carriage Builders Association and for the National Association of Manufacturers. A staunch Republican, he also became active in Indiana political circles.[70]

Clement's social life and involvement in civic affairs was matched only by his younger brother, J. M., whose mansion Sunnyside, located a mile south of Tippecanoe, stood as another landmark in the city. Less assuming than his brother, J. M. was a Presbyterian who also remained an active civic leader. In 1896, when his only son, John M., Jr., a former football and track star for Purdue, married Lillian Lingle of Lafayette, Indiana, northern Indiana witnessed yet another magnificent show of wealth—only three years after a disheartening depression that had forced severe wage cuts at the factory.

The festivities of the occasion, as the newspapers reported, kept South Bend society "agog for nearly six months, and culminated in

one of the greatest social events in recent years in this part of Indiana."[71] The nation's leading business and political leaders attended a wedding conspicuous in its display of wealth. The bride, a daughter of one of Indiana's wealthiest newspaper owners, wore a gown of heavy white satin, with pearl lace trimmings. A diamond sunburst crown added the final touch. Each of the bridesmaids was given a cut glass salt bottle with a gold top, set with amethysts and tiny miniatures. The ushers received gold match boxes set with amethysts bearing the monograms of the nuptials. Following a honeymoon to Eastern resorts, the newlyweds returned to take up residence at Sunnyside in a suite of rooms especially prepared for them.

These wedding celebrations showed that the Studebakers' social standing reached well beyond the small circle of South Bend, Indiana. Indeed, Peter Studebaker resided in Chicago much of his life before he returned to South Bend. He became a prominent member of Chicago society. The Studebaker Opera House in Chicago, built under Peter's guidance, provided more private boxes than any other theater in the city, and soon "box parties" became a fad among the elite.[72]

When Peter returned to South Bend, he too constructed a large mansion for which he imported over 100 carloads of marble. He and his wife also played an important role in South Bend's social and political life. Mrs. Peter Studebaker helped organize the nonpartisan Progress Club, which provided a political forum for women in the community. Under her leadership the club actively supported the effort to have a woman appointed to the local school board.[73] Some saw in Peter the next Republican governor of Indiana. He encouraged such talk through extensive speaking engagements and with frequent contributions to newspapers and magazines on political issues of the day.[74]

By 1890 the Studebakers had reached the pinnacle of their success. The death of the youngest brother, Jacob, in 1887 at the age of 43, cast an Acheronic shadow on the brothers' triumph. Still Clement, now 56, and his brothers J. M., 54, and Peter, 51, had found glittering success. The year of Jacob's death, the company declared a dividend of $200,000 on sales of $2 million.

Frederick Fish Reorganizes the Corporation

The company's very success in the 1890s, however, called for reorganization. Clearly the size of the corporation had grown beyond the capacity of the brothers to manage successfully. As the company had grown over the years, the brothers had failed to establish detailed procedures or structures for reporting managers' activities to upper management. Realizing this, the Studebakers in late 1892 called upon a New York corporate lawyer, Frederick Fish, to draft new organiza-

tional plans for the firm. Fish had married John M. Studebaker's daughter in 1887, so he brought the skills of a Wall Street lawyer into the family.

In 1893, fresh from New York, Fish began his task. At the center of Fish's organizational plan was the creation of a board of directors. This, in effect, shifted power away from family interests to outside investors. At the same time, Fish established a seven-member executive committee to direct corporate strategy. The executive committee was supported by an elaborate subcommittee system that extended vertically and across divisional lines within the corporation. Divisional committees included a manufacturing committee (consisting of two groups representing wagon production and carriage production), a sales committee with direct links to production, an advertising committee, and a separate finance committee to oversee corporate accounting. Each of these committees reported quarterly to the executive committee. Each committee was given power to carry out day-to-day decisions, but long-term policy remained within the domain of the executive committee.[75] By the year's end, Fish's plans had been instituted. Studebaker had emerged as a modern corporation.

Shortly after Fish initiated his reorganization plan, the company faced its greatest economic challenge—a national depression beginning in 1893 that soon brought havoc to the entire wagon industry.[76] By the spring of 1893 Clem Studebaker solemnly warned that "fierce competition in the industry was forcing the company to sell goods at times at lower prices than afford such a margin as we ought to have. . . . " As a consequence, work was cut from a normal ten-hour day to an eight-hour day. Shortly afterward the plant was closed for a five-week shutdown. When it reopened wages had been reduced by 5 percent.[77] In August, Studebaker announced that it was cutting back on all credit extensions, except for its most creditworthy customers. "It is not a question of orders for us," H. D. Johnson, vice president of manufacturing, told *The Hub*, the national trade journal, "it is entirely a matter of collections. We are throwing out all but the most desirable orders and are manufacturing only for immediate shipment." Still, for whatever problems the company faced, Studebaker's board announced that it would issue a 10 percent dividend, but it was to be issued in three installments and was to be taken from its surplus account of $50,000.[78]

As good Republicans, the Studebakers blamed the depression on the Democratic administration of Grover Cleveland for enacting lower tariff duties. Speaking at the annual convention of wagon manufacturers, Clement attacked the recently enacted Wilson tariff as a measure designed to "unleash Canadian manufactured goods which would undersell American products in every town and village of this coun-

try."[79] Peter Studebaker echoed his brother's sentiments shortly afterward by criticizing the repeal of reciprocity agreements by the Cleveland administration as "political idiocy" that only resulted, as Peter put it, in "vast damage to American interests" in South America and the exclusion of American meats in the European market.[80]

The Studebakers, however, were by no means insensitive to the devastation wrought by the depression. Indeed, Clement urged Congress to undertake a massive road construction program through a volunteer work army. Such a program, he said, would benefit the farmers, while putting men to work. "I believe," he declared, "that in a country as rich as this it should not be said that any man need beg for bread. A country as rich as this should give every honest man that is out of employment something to do to earn his bread."[81]

In the election of 1896, Clement and Peter naturally emerged as national spokesmen and financial backers of the Republican presidential nominee William McKinley. Mark Hanna, McKinley's campaign manager, personally thanked Clement for his large financial contribution to the campaign and assured him that he would be "pleased to hear from you at any time with such suggestions as you have to offer."[82] Frightened by the possibilities of William Jennings Bryan's election to the White House, Clement and his brother J. M. actively took to the stump to denounce the Democrats for their radicalism. The Studebakers proved especially effective in organizing Polish-Americans under the Republican banner.[83] At the same time, Peter arranged for Swedish McKinley Clubs of South Bend and Mishawaka to be given U.S. flags for Republican demonstrations.

Political opponents tried to mount attacks on the Studebakers by organizing boycotts of their products among Democratic farmers in Texas and other southern states. By 1896, however, the Studebaker Corporation was too large, its distribution system too well organized, and its products too well respected to be hurt by such attacks.

McKinley easily won the election of 1896, but political activity did little to address the Studebakers' immediate financial problems. Furthermore, working capital proved insufficient to continue financing merchandise to the dealers. The board directed Peter to meet with representatives of the Morgan Company in London to raise additional funds. On August 20, 1896, the board approved the deal with Morgan. Studebaker increased its capitalization from $1 million to $3.6 million. It increased shares from 20,000 to 72,000 at a rate of $50 par value and issued $2 million in bonds. In return Morgan interests acquired a stake in the company and placed two representatives on the board of directors.[84]

With this increased capitalization, the corporation undertook an extensive expansion of its production facilities. Occurring shortly before

the outbreak of the Spanish-American War, the expansion was timely. War once again brought new prosperity to the firm. Within days after the declaration of war, the Studebaker Corporation received a military order for 500 wagons to be shipped within thirty-six hours. The order was filled, thereby ensuring a continuation of orders throughout the war. New machines were purchased to meet production needs. These included a new skein-setting machine and a new electrical generator.[85]

The Spanish-American War also marked the first time a member of the Studebaker family actively enlisted in the war effort. George Studebaker, Clement's son, organized a company of men from the plant. To encourage this recruiting effort the board of directors passed a resolution that stated that all men who served in the military during the war would be employed by the company upon their return. Furthermore, paychecks for employees serving in the military would continue for support of their families.[86]

As America entered the twentieth century Studebaker stood as a major corporate power. Backed by Morgan interests, operating with the latest technology, and organized along the lines of an efficient, modern corporation, the Studebaker Brothers Manufacturing Corporation looked toward continued success.

Well-established, prosperous, and assured of their position in the wagon industry, the Studebakers, now led by Clement and J. M. following the death of Peter in 1897, were reluctant to take chances that might endanger their hard-earned success. Wealth and fame had been achieved through prudent investment and cautious expansion over many years.

In 1902 J. M. spoke before the employees who had gathered to celebrate the fiftieth anniversary of the company. He drew on the past to express a projected future for the corporation. He recalled that his brothers had "worked day and night" to build the corporation. "Our success," he reflected, was "the result of judicious economy in the first place, by hard work, and by trying to be surrounded by honest employees. . . . " Then, pointing to a group of longtime employees in the audience (one had worked at the company 38 years), he declared, "These men could not have worked here that length of time unless they were good men who were looking after our interests as well as their own. . . . " When others take charge of the corporation, he concluded, "I hope they will always take the same interest in their employees that our original five brothers have always done." If these men have the "same thought and the same Christian spirit as the brothers . . . this institution will be run for time immemorial."[87]

Yet the new century, whatever its promise, brought a new challenge to the Studebakers—the automobile. And this challenge tested the meaning of the past.

TWO

Studebaker Enters the Automobile Age, 1897–1913

Tradition Ignored

Writing in 1929, the Austrian economist Joseph Schumpeter observed that "new production functions do not typically grow out of an old business," although, he added, "if a new man takes hold of an old firm, they may." He concluded that business "innovations are always associated with the rise to leadership of New Men."[1]

Schumpeter might very well have pointed to the Studebaker Corporation and its entry into the automobile corporation as a case in point. Confronted with the arrival of the automobile that would directly challenge the horse drawn wagon and carriage industry, the Studebaker brothers resisted entry into the automobile industry. This crucial decision to join the growing ranks of automobile producers came only through the singular efforts of Frederick Fish, legal counsel to the corporation and John M. Studebaker's son-in-law. In pushing the company into automobile production, Fish assumed the role of what Schumpeter called the "New Man," the visionary who saw that the older company must accept innovation or die a "natural," albeit lingering, death.

Studebaker's entry into the automobile industry presents a fascinating lesson on how the Studebaker Company met the challenge of a profound technological revolution and a new industrial environment created by the development of the automobile. The transformation of Studebaker from a wagon manufacturer into an automobile maker was not inevitable, however. A deliberate decision was made to enter the automobile industry. Without the leadership of Fish, the company might have remained in the horse drawn vehicle industry, as Clement Studebaker and his supporters wanted.

In this debate, each side used rational economic arguments. At the center of the debate, however, lay a profound discussion of the

meaning of the company's past. And, as Clement Studebaker so often pointed out, his faction had history on their side. After all, the Studebaker brothers had built the world's largest wagon manufacturing company, a company with a tradition of steady leadership in business. They had established a corporation that prided itself on protecting its employees and serving the South Bend community. In turn, while Frederick Fish downplayed the past, he carefully avoided any direct repudiation of Clement's use of history. Such an argument would have only insulted and alienated his in-laws, Clement and John Studebaker. Instead of dismissing history as meaningless in the age of the automobile that was about to dawn, Fish spoke of the future and rapid technological change. He argued for entering the automobile industry, while remaining in the wagon industry. Still, in these years of transition, Fish relegated the past to irrelevance. He represented the new corporate man who insisted that the company look ahead. The past held little importance in the hurly-burly world of automobile production. A new industrial world was dawning, and to dwell on the past meant certain demise.

In the end, after a long and involved debate, Fish convinced the corporation to enter the ranks of automobile manufacturers. This marked a victory for Frederick Fish and his vision for the Studebaker Corporation. Yet the decision left much undecided in a rapidly changing industry and a volatile market characterized by a high degree of failure, changing product lines, and rampant speculation. The Studebaker Corporation therefore entered this new market cautiously, leaving open such basic questions as the company's commitment to the new industry, the relationship of the automobile division to the wagon division, and even what kind of cars to produce—electric or gasoline. Under the leadership of Fish, the corporation moved steadily into automobile production, carefully proceeding in an industry that did not allow much room for caution. As the automobile industry left behind a trail of failed companies and product lines, Fish pushed Studebaker forward, first into electrics, followed by high-priced gasoline cars with the Garford Company in Ohio, then into mass produced medium-priced autos with Everitt-Metzger-Flanders, and finally into the manufacture of its own multimodel line under its own name. At each step Fish made crucial decisions that at the time neither seemed obvious nor inevitable. The only certainty for Fish was that the corporation not look to the past.

The New Managerial Man Enters the Age of the Automobile

In this new world of the automobile, Frederick Fish cut a much different figure than did other industry leaders—the mechanic Henry

Ford, the speculator and founder of General Motors William Durant, or those wild brothers, both men of production, Horace and John Dodge. Fish represented the new managerial man, a corporate lawyer with close ties to Wall Street. Fish realized early that the automobile industry would be dominated by three or four major companies whose power would not come solely from product line, but from financial clout. Those companies that could mobilize financial resources would be the victors in this war of survival.

As Studebaker changed from a family business to a modern corporation, managed by professionals and backed by Wall Street interests, Fish emerged as the dominant force in the organization. In his drive to complete Studebaker's entrance into the age of the automobile he came to rely heavily on Wall Street. Control of the company was taken away from the Studebaker family. Thus within a decade, the Studebaker Corporation was transformed from a family-controlled company to a publicly owned corporation. Blinded by the great wealth to be gained in automobiles, the Studebaker family finally relinquished control of the company.

For his part, Fish made the transition into the new era. He continued to play an active role in Studebaker's affairs throughout the twenties. Fish's style fit the modern age of corporatism. This red-haired, well-mannered, always dapper man remained a figure behind the scenes, rarely appearing before the press or in public relations promotions. He reserved his talents for the boardroom. Indeed, when he died in 1936 his obituary received less space in the *New York Times* than would his wife's when she died a decade later.[2] As the son-in-law of John M. Studebaker, Fish understood the traditions of the company, its reputation for quality products and its image as a progressive employer, but unlike the company's founders, he held little infatuation with the past.

Fish moved to South Bend in 1891, as he later reported, only at "the repeated insistence of J. M. together with Clem and Peter."[3] Fish joined Studebaker as the company's corporate counsel, with the primary task of assisting the brothers in financial matters. Although he came with the understanding that he would be placed on "equal footing" with the brothers, he was "loath" to leave New Jersey, where he had established a career as a corporate lawyer with prospects of a continued career in politics.

Born in 1852, a son of a nationally prominent Baptist minister, Henry Clay Fish, Frederick had attended Rochester University before being admitted to the bar in 1876. Fish rose quickly in Republican politics, first as city attorney of Newark in 1880 and then as a state assemblyman in 1885. One year later in 1886, Fish won a seat in the state senate, where he emerged as one of the party's up and coming

young reformers. This reputation enabled the thirty-five-year-old Fish
to become the president of the New Jersey Senate in 1887.[4]

Fish emerged as an active participant in the reform wing of the
Republican party.[5] In the mid-1880s the New Jersey Republicans
had consciously set out to establish themselves as a party of progress
sympathetic to the laboring classes. Fish, as a representative of Es-
sex county, whose rapid industrialization had created a population of
immigrant workers (who by 1900 would account for over half the
county's population), was all too ready to carry the banner of reform.

Under Fish's leadership, the Republican-controlled senate passed
legislation for the protection of labor from prison factory production,
the establishment of a state board of agriculture, a women's factory
law, the opening of a state school for mutes, and the protection of
the oyster and fishing industry. Fish also helped engineer a tax on
railroad and canal corporations. His success was short-lived, however.
In 1888 the Democrats made a comeback, and Fish lost his seat to a
Democrat.

That same year this young corporate attorney met and married
Grace Studebaker, J. M.'s daughter. When the couple left Newark
three years later, the local press observed that Fish had firmly estab-
lished himself as "a churchman, member of society, and citizen."[6]

Fish's reputation as a man with close ties to Wall Street and a Re-
publican concerned with the laboring classes fit the Studebaker broth-
ers' perception of themselves as enlightened capitalists and progressive
employers. The arrival of Fish therefore contributed to the further
shaping of the corporation's identity, even as family interests were be-
ing replaced by a new management.

Fish quickly emerged as the leading force in the corporation. Using
his skills in finance and management, he reorganized the company's
structure along corporate lines, arranged for new capitalization, and
in 1900, with the assistance of the accounting firm Haskell-Sells of
Chicago, moved to install a new factory accounting system that intro-
duced expert accountants and an office staff of approximately seventy
men and women.[7]

Within a short time after moving to South Bend, perhaps as early
as 1896, Fish began urging Clement and J. M. to explore automobile
production, if only on an experimental basis. From the outset Clement
and J. M., especially the former, proved reluctant. Fish, however, re-
mained steadfast in his conviction that the age of the auto had arrived.
As a consequence, he approached the issue cautiously. In the end, the
decision to test the water occurred at the persistence of Frederick Fish
and only after years of bitter discussion and maneuvering on the ex-
ecutive board.

The debate took place with both sides basing their arguments on

rational expectations. Although the Studebaker brothers agreed that the firm had the manufacturing capacity, the labor force, and the sales system to enable them to enter the automobile industry, they warned that the auto industry had not yet proven itself. To commit resources of a profitable company to an industry whose future remained uncertain seemed not only unwise, but an act of bad faith by men ultimately responsible to their stockholders and their employees. The automobile industry proved to be a dangerous investment. The obituary record of early automobile concerns was extremely long.[8]

Furthermore, Clement enlisted history on his side when he pointed to the recent crash of the bicycle boom as an example of how today's boom could be tomorrow's bust. In 1895 a bicycle fad had swept across the nation and lured many wagon manufacturers—many of whom were still experiencing idle capacity from the depression—into a market that promised huge profits. The Pope Company's big wheel bicycle, Columbia, had set off a fad that gained further momentum with the development of the modern "safety" bicycle. By 1896 an estimated 300 companies had entered the market. But as quickly as the fad began, the bicycle craze ended. By 1899 bicycle sales had declined so rapidly that many companies were left in bankruptcy.[9] Before the downturn in the market, Studebaker, for a brief moment, had considered entering the bicycle market, going so far as to look for a proper man to run such a plant, but in the end prudence kept them out.[10] The parallels to the automobile industry seemed obvious; only the stakes would be larger given the capital investment necessary to produce cars.

Moreover, Clem Studebaker held in his hand the strongest suit: The wagon business was booming. By the turn of the century, the Midwest had emerged as the nation's leading center for the carriage and wagon industry, with 60 percent of total capital investment now concentrated in the region.[11] Indiana stood next to Ohio in total number of family and pleasure carriages produced but led the nation in value and number of wagons produced. And in the forefront of production was the Studebaker Brothers Manufacturing Corporation.

Studebaker was in the process of rebuilding its capital reserve, so the firm's founders felt little inclination to increase debt further by gambling on a new and relatively untried industry. Profits ranged between 17 percent and 25 percent on Studebaker wagons, whose popularity among buyers allowed the company to keep its prices 5 percent over those of its competitors.[12] Moreover, the company held contracts with the federal government to provide mail wagons, as well as annual contracts with Standard Oil, Armour, and U.S. and American Express.

One final observation reinforced the brothers' reluctance to produce automobiles. This observation, at least to many at the time, ap-

peared to be a truism: The horse was here to stay. The horse was durable, inexpensive, and an efficient means of transportation during all seasons and in most conditions. These sentiments were shared by most in the wagon industry. Attending the Carriage Builders Association meeting in Philadelphia in 1899, Clement discovered that the automobile was on the minds of many of the delegates. And clearly sentiment ran against the automobile. To many, it was just another rich man's toy.

Speaking before the convention in his presidential address, Morris Woodhull expressed the typical attitude of the wagon industry toward this new contraption, the automobile. To those who claimed that the automobile would replace the horse, he replied, "This is a fallacy too absurd to be mentioned by intelligent men." The horse drawn carriage would always be a cheaper source of power than gasoline, steam, or electricity. "The horse," he added, "is and to all appearances will continue to be for years to come the cheapest motive power other than mechanically prepared tracks such as the railroad." He concluded, the "prudent" American consumer will continue to favor the wagon, as evidenced by the fact that in New York City over the previous five years 350,000 carriages had been sold as against 125 cars.[13]

The minister's son, Frederick Fish, was hardly a wild-eyed gambler, however. He remained, above all else, the objective legal counsel who realized that American business was about to experience a technological revolution. Fish's curiosity about the automobile had been heightened considerably after a series of discussions with top officials in the United States Postmaster General's Office who were taking an interest in the new invention. Charles Neilson, assistant postmaster general, had initiated experiments with a "horseless wagon" in 1896. As a representative of a company that had a major contract for supplying wagons to the U.S. Postal Service, Fish naturally expressed an interest in these experiments.[14]

Shortly after these discussions Fish initiated a series of experiments conducted by an electrical engineer George Strong, one of those many figures later forgotten in the history of automobile development.[15] Two months later Strong's experiments were still not completed.

At the directors' meeting on November 6, 1896, Fish reported that Strong needed an additional $4,000 to continue his experiments on the "motor wagon." Clement, joined by the head of manufacturing, H. D. Johnson, voted against providing further money for this experiment, but they were overruled.[16] That following spring, Fish reported that Strong was continuing his work, but this was to be the last mention of Strong or his experiment.[17]

Studebaker's entrance into the automobile business, despite Fish's efforts to move directly into the industry, came in a roundabout way

when the New York Electric Vehicle Company contracted with Studebaker for the construction of a hundred bodies for their electric cabs. Electric power attracted a strong following among the early automobile pioneers, and this was reflected in the formation of the Electric Vehicle Company. The company had been started by New York financier William C. Whitney and the Pope Manufacturing Company to operate a fleet of electric taxicabs in New York City in 1897.

A short while later, Studebaker entered into another contract to manufacture a thousand vehicles with everything except "electric machinery."[18] In the meanwhile, electric cab companies started in Chicago and Los Angeles to tap the urban market for electric cabs. Whitney's attempt to monopolize the taxi industry failed, however. The cabs, operating in normal conditions, proved costly and inefficient. After each cab run a new battery had to be installed—no simple matter since a single battery weighed a ton.[19] Although the Electric Vehicle Company failed, Studebaker had taken its first step into automobiles. Indeed, by 1900 rumors circulated in the industry that Studebaker was negotiating to purchase the Munson Car Company. Studebaker representatives reported that their auto production was "growing rapidly."[20] Studebaker projected an aura of optimism about the future of the automobile. In 1895 Studebaker wrote an open letter thanking the sponsors of the *Chicago Times-Herald* automobile race.[21]

The facts behind the scene were quite different, however. Indeed, the board was divided on the issue of the automobile. For example, C. A. Carlisle had gone out of his way to assure other wagon manufacturers and stockholders that Studebaker's participation in the electric cab industry was only an experiment designed not to "interfere with our general carriage and wagon departments. . . . " The company did not propose to be "non-progressive in any way," he added, but until the horseless carriage proved itself viable for mass production, the Studebaker company would not devote its energy to automobile production.[22]

Clement showed even greater ambivalence toward the automobile. When the directors met in early February 1900, Clement formally brought to the board a motion that "the company give their [*sic*] entire energy and time to the making of horse-drawn vehicles."[23] The vote on the motion revealed sharp differences in the board. Clement, Charles Carlisle, and George Studebaker supported the motion, while four other board members, including J. M. Studebaker and Frederick Fish, opposed it. Thus the 3–4 vote did little to resolve the differences on the board.

Following a visit to the Chicago Auto Show a few months later, Fish renewed discussions concerning the automobile's potential.

Fish moved that the company should "keep in touch with the automobile business with a view toward reaping the greatest possible benefit. . . . " Once again the vote divided along factional lines: Clement led the opposition against Fish's motion. When J. M. abstained, Fish was forced to retreat—but only momentarily. A month later discussions were once again renewed in the board. A decision was not reached at this time, but in the meanwhile Fish continued to explore the possibilities of automobile production.[24]

These differences on the board still had not been resolved when Clement Studebaker died in November 1901. This decade seemed to bring other tragedies to the family. In 1905 Peter's son, Wilbur, died in New York City at age 49, shortly after filing for bankruptcy in 1902. Two years before the bankruptcy his 19-year-old daughter had married a wealthy heir to a Pennsylvania fortune "to gain freedom from her parents" so that she could pursue a career as a comic opera star.[25]

J. M. replaced Clement as the president of the company. Although J. M. was not an automobile enthusiast, he deferred to Fish on this issue. By February 1902, rumors already were circulating in the trade that the Studebaker Corporation planned to cooperate with Westinghouse Electric and a Cleveland firm, the Automobile and Cycle Parts Company, to begin construction of an experimental car. "It is understood," *Motor Review* reported, "that the well known wagon building firm will produce steam and gasoline vehicles, as well as electrics. . . . " These rumors proved false, but within months Fish had pushed Studebaker's entrance into automobile production further.[26] He got the board to agree to hire E. L. Kuhns to head a new automobile department. The final decision to commit Studebaker fully to automobile production came in late 1902. On November 12, a new board composed of Fish and his supporters, including Clem Studebaker, Jr., and E. L. Kuhns, resolved to begin production of electric and gasoline automobiles.[27] Production remained limited, but Studebaker finally, after much hesitation, had committed itself to the new industry.[28]

Studebaker continued to produce wagons, even though it stopped producing carriages in 1910. In the next decade the wagon industry experienced increasing consolidation caused by pressure from the automobile industry. From 1900 to 1905 the number of wagon producers declined by 20 percent. The coinciding rise of the automobile industry wreaked havoc in the horse drawn pleasure vehicle trade. Amidst radical cost cutting and wage cuts, the wagon association reported in 1906 that "There is panic today among the carriage manufacturers of the United States."[29] The association declared, "Among the carriage manufacturers can be found the greatest lot of self-loving cowards to

be found in any industry known."[30] The call for order, for the end of "irresponsible" price cutting, went unheeded in an industry threatened with demise.

The Studebaker Corporation proved large enough to ride out the storm within the carriage/wagon industry, while at the same time continuing its transition into the automobile industry. Indeed, in the first decade of the new century, the wagon division continued to make money. Net profits remained steady throughout the decade, even showing a slight increase from 1906 to 1911. The growth of cities allowed Studebaker to enter new markets for municipal service wagons. As Clement, Jr., noted, "there is a constant and large demand for the more important products of the company such as farm wagons, sprinklers, flushers, and dump wagons."[31] At the same time Studebaker expanded its foreign market. A ready market for its products was found in Mexico and Argentina, as well as in Australia and the West Indies.

The company enhanced its net profits on wagons by pursuing a pricing strategy that relied on short-term credit and maximum prices. Sales managers were directed to "stiffen up on deals." The board felt that it was of primary importance to get "large returns from its products rather than to increase the volume of business."[32] Still the constant demand for wagons continued. In 1906 Studebaker, in order to meet this increased demand, decided to enlarge its wood shops and kilns so as to increase production. Nonetheless, the production manager of the wagon division continued to complain that the division lagged in filling orders. This situation led Studebaker to increase its prices further for farm wagons, by 54 percent in 1911.[33] At the same time, Studebaker expanded its branch offices. In San Francisco, for example, the company built an impressive four-story showroom for its wagons in 1907, after its old building had been destroyed by the 1906 earthquake.

The continued market for wagons suggests that Clement Studebaker's commitment to wagons was not totally unfounded, at least in the short run. Still, the emergence of the automobile industry meant a declining role for his family in the business the Studebaker brothers had built. Eventually the Studebakers were to become only honorary officers in the company, and then not even this would be given to them. As the family's role in the corporation declined, other business interests and civic affairs increasingly absorbed the family's time. During these years the Studebakers acquired a variety of other enterprises, including the Mishawaka Woolen Company, the South Bend Watch Company, a utility company, and numerous banks located throughout the state. The family also owned extensive timberland throughout the South and the West.

While the family remained active in civic affairs, the city of South Bend appeared to have lost its charm. One family member complained publicly that the city had forgotten that "determined spirit that characterized the life of the early pilgrims in the advancement of civilization."[34] Nonetheless, during these years, Studebakers could be found hosting charity balls for the Visiting Nurse Association, donating money for the building of a YMCA building in downtown South Bend, and organizing summer music programs for the community.[35] J. M. became a national spokesman for the "good roads" movement and an active member of conservation groups concerned with preserving timberlands.[36] He continued to be active in the Republican party throughout these years.

Although John M. Studebaker, even after his retirement in 1915, continued to take a fastidious interest in the company, he increasingly found himself an outsider to the company that bore his name. As a consequence, he remained ambivalent toward the automobile. As late as 1916, shortly before his death, J. M. seriously warned that unless gasoline prices went down people would return to the reliable horse and wagon. Still, J. M. reluctantly admitted that Studebaker's entrance into the automobile industry had been for the best.

Speaking to the board of directors shortly before his retirement, he noted that companies should seek to diversify because "only those that do can survive." He added that businessmen should never remain satisfied, but always look to the future.[37] In offering this advice, he did not mention that in 1900 he and his brother would have been content to have stayed in the wagon industry. In this respect the Studebaker brothers remained men of caution, while history showed the new professionals, the managers, to be visionaries in the modern world of corporate capitalism.

Studebaker Forms an Alliance with Garford, Then Takes Control

In the first decade of the twentieth century, the automobile industry mushroomed: 270 new firms were formed, adding to the 30 firms established prior to the turn of the century. In 1908 the Association of Licensed Automobile Manufacturers, a trade association formed to protect patent rights and to prevent new entries into the market, reported that of the more than two hundred companies in the nation, only twenty were making a profit.[38] Later estimates showed that over six hundred firms had entered the automobile industry by 1908.[39] In these unsettled conditions, Wall Street naturally shied away from investing in the industry. Indeed, most financial houses saw in the automobile industry ominous signs of volatility.[40]

Underlying these disruptive financial conditions were an array of production problems. Lacking manufacturing facilities and basic tools and machinery of their own, most automobile companies relied on a variety of other manufacturers to produce parts, engines, bodies, rubber goods, and electrical equipment. Thus the chief business of the automobile producer was to design a product, place orders for the necessary parts, and then assemble the major components into a machine bearing the company's name.

In this way, companies avoided heavy capital investment, but as a consequence, they were forced to rely on other companies for technical skill, quality products, and technical innovation. Such a system entailed a great deal of trust for an investor interested in an industry characterized by fierce competition and frequent bankruptcy. Moreover, the diversity of companies and suppliers meant that uniform industrial relations within the industry were impossible.

By 1904 the gasoline engine was beginning to dominate the industry. The Olds Motor Company with its gasoline "Runabout" produced 25 percent to 35 percent of the cars sold in the country. Cadillac with its large gasoline engine held another 12 percent of the market by 1904, and the fledgling Ford Company would acquire 7 percent of the market within the following year. Examining these figures, Fish realized that Studebaker needed to make a full commitment to gasoline. At the same time he predicted that three or four firms would dominate the market.[41] This entailed, as Fish accurately realized, that a high concentration of capital would be placed within a single company, a degree of capital that in the case of the Studebaker company went well beyond current corporate resources.

In January 1904, the Studebaker Corporation introduced its first gasoline car, which operated on a 16 horsepower, two-cylinder engine especially manufactured for Studebaker by the Garford Manufacturing Company. The body for the Studebaker runabout was built of wood, patterned after French automobiles, even though pressed steel was increasingly coming into vogue. Within a year the company was producing two gasoline autos, a two- and a four-cylinder model.

Studebaker continued to manufacture electrics as well—Victorias, Phaetons, and runabouts—each using an easy-to-charge battery developed by Westinghouse. The success of this battery, which provided a charge for 40 miles of traveling distance and could be recharged from any 110-volt direct current socket, kept the Studebaker Company in the business of electrics long after most manufacturers had turned to gasoline.[42] Nevertheless, it was becoming evident to most observers that the future lay in the gasoline engine.

That Fish turned to Garford for his gasoline chassis appeared natu-

ral at the time. The Garford Company had recently been reorganized to take advantage of the quickening pace of the market for gasoline cars. Furthermore, Garford already produced the chassis for Studebaker electrics.

Initially organized as the Federal Manufacturing Company, the firm had been set up as a joint venture by George Pope, the founder of the leading bicycle manufacturer and early pioneer in automobiles, and Arthur Garford, who had made a fortune as a manufacturer of bicycle seats and other parts during the bicycle boom in the nineties. In early 1904, Garford broke with Pope, who he feared wanted to take complete control of the company.[43] As a consequence, Garford acquired the options held by Pope on Federal and recapitalized the corporation under his own name.[44] Less than a month after Garford assumed control of Federal, the board of directors at Studebaker authorized George M. Studebaker to open negotiations with the Cleveland-based company.[45]

Fish had carefully cultivated a close relationship with Arthur Garford. The two men shared much in common. Like Fish, Garford was a liberal Republican. In 1912, he would run for governor of Ohio on the Progressive party ticket. Furthermore, both enjoyed golf, so Fish arranged for frequent outings to Chicago and Cleveland for his friend. For his part, Garford presented Fish with a special set of golf clubs manufactured at his Cleveland plant.[46] What most tied the two men together, however, was neither golf nor politics, but business—the automobile business.

Garford, like Fish, hoped to cash in on the automobile boom. A natural speculator, with investments in an array of enterprises (including a uranium mine in Colorado), Garford saw that the automobile business was about to boom. Thus, when Fish approached him with a proposition to build a chassis for a new gasoline automobile, Garford jumped at the opportunity. Nevertheless, he remained leery of Studebaker's intentions. Indeed, when Fish offered to invest in Garford's new company, he turned his golfing buddy down without hesitation. He had just won a battle with Pope for financial control and did not want a repeat performance with Studebaker. As he told a friend, "I am in control and I can raise more capital if necessary."[47]

At first Garford produced only a 20/24 horsepower engine, which he supplied to two other companies along with Studebaker. Garford saw that the future nonetheless lay in a larger engine. Therefore, in the spring of 1906 he recapitalized the company in order to move his plant to a newly constructed, completely modern, factory in Elyria, Ohio. This time Garford allowed Studebaker to gain an interest in his company.[48] Anxious to expand production, Garford offered 6,500

shares for sale. Of this amount, Studebaker interests purchased 2,500 shares. For their investment, Studebaker gained the right to place three directors on the seven-member board.[49]

Garford welcomed the alliance. He maintained a controlling interest in the company, while at the same time the additional capital gained from the expansion allowed him to move into the rapidly expanding medium-priced touring car market. In reconsidering his position vis-à-vis Studebaker, Garford came to realize that the nature of the automobile industry was "Expand, expand, or die."

Automobile manufacturers had sprung up all over the country. Within the single decade from the turn of the century over 270 firms had been formed. Most failed, but among those that succeeded were Cadillac, formed in 1901 with $300,000; Ford, incorporated in 1903 with $500,000; and Packard, launched in 1903 with $500,000. In the two-year period from 1904 to 1906, twenty-two new concerns were incorporated. The race for domination in the industry was on, and only the well capitalized would survive. Those who entered the industry did it not for prestige or status, but to earn money. And, to earn money in these years meant selling cars in the medium-priced or high end of the market.[50]

The alliance with Studebaker held the promise that Garford could compete successfully in this medium-priced market. In 1906 his Cleveland factories were already making 500 chassis per year in the 30/35 horsepower class. The new Elyria plant offered the opportunity to expand capacity to 1,200 cars per year. Moreover, Studebaker contracted for nearly half of the projected production with the promise that it would be given the entire sales market west of the Alleghenies. Garford believed that his company would become a major force in the medium-priced market. As he told his stockholders at the annual meeting, there were "vigorous" and "strong personalities" at "both Studebaker and Garford, so we should meet our goals."[51]

These "vigorous" personalities soon made themselves felt on the Garford board. Fish, once a deferential golf partner to the older Garford, now emerged as a strong-willed, aggressive corporate counsel intent on protecting Studebaker's interest in the new firm. He insisted that Garford's commitment to produce chassis for Studebaker must be maintained at all costs. For instance, when Garford expressed interest in entering the European market, a natural market for his high-priced car, he discovered, as he later told a friend, that "the Studebaker crowd was in control." Fish simply told Garford in unqualified terms that "all of 1907 production was already sold," so Studebaker will not "let even one car go, even to develop a foreign market."[52] Moreover, within the year he had forced Garford to sever his relations with the Cleveland Motor Car Company and Rainer Company.

Garford found that he could do little to resist Studebaker's demands. Although the board was supposed to be balanced, one of Garford's men on the board was ill throughout much of 1906, and the seventh man, the tiebreaker, had shifted over to what had now become the Studebaker camp. If Garford felt betrayed by the alliance, the arrangement worked well for Studebaker. By contracting with Garford, Studebaker increased sales on its gasoline car from $87,662 in 1905 to $368,848 in 1906.[53]

Even with Studebaker looking over his shoulder, all seemed to go well for Garford—at least at first. He took immense pride in the construction of his new plant in Elyria, Ohio. The city of Elyria had contributed over $6,000 for the purchase of land for the plant. Moreover, Garford hoped that the completion of the plant might alleviate labor problems in Cleveland. He had chosen Elyria because its ready supply of labor was "largely native and is constantly being augmented by the products of public schools and many young men of good character and education coming from surrounding farms. Substantially, no foreign labor is employed in Elyria of the Italian, Polish, or Hungarian type."[54]

Construction on the plant had begun on October 1, 1906. By January the construction was well underway with the power plant, heating, and elevators installed. Misled by this initial progress Garford believed that his company was on its way toward becoming "the greatest producer of high grade automobiles in the United States." He instructed his engineers to begin design on a 40/50 horsepower chassis to meet the "great demand for cars with high horsepower." He also sent his general manager C. E. Hadley and his chief engineer James Heaslet to Europe to investigate truck design.[55] It was at this point, however, that things began to turn sour for Garford.

Shortly after Hadley returned from Europe, he became seriously ill and was forced to take a leave of absence. Although Garford replaced Hadley with his chief engineer, James Heaslet, the loss of an experienced general manager came at the worst possible time. Problems with plant layout proved to be more difficult than expected and led to construction delays. The shafting alone took three months to install. Then a construction accident caused further delays at the Elyria plant, leading Garford to complain that the newspapers had greatly exaggerated the mishap. After all, he said, "only Italian laborers" had been hurt, and damage will not exceed fifteen hundred dollars.[56]

Garford's troubles were far from over, however. Just when the Elyria plant was nearing completion, Garford confronted a massive labor strike by Cleveland machinists who saw the move to Elyria, quite correctly, as a strategy intended to eliminate skilled jobs and to cut wages.

Signs of discord became apparent in early May 1907, when rumors of a machinists' strike began circulating in Cleveland. Fearing trouble, Garford discharged "suspected leaders." His plea to Cleveland's chief-of-police for protection against possible "rioting, disorder, and disturbances," however, fell on deaf ears.[57] When the union men demanded the rehiring of the discharged employees, Garford locked out an additional 350 men, thereby reducing his workforce to 150 men. He immediately began transferring his Cleveland plant to Elyria. By June, a full strike was underway. "An unfortunate occurrence," Garford declared, "yet one which cannot be helped."[58]

Before the strike Garford had hoped to maintain minimal production in Cleveland during the start-up of the Elyria factory. He discovered, however, that labor shortages in Elyria meant that an additional 500 mechanics were needed to bring the plant up to full capacity. He now found himself in a bind. His workers were on strike in Cleveland, and labor shortages in Elyria prevented full operation there. Moreover, "owing to the fact that it was generally known throughout the country's labor market that the company was out of sympathy with organized labor," Garford noted, it was impossible for us "to acquire such necessary help." National advertising, in turn, only brought the company poorly trained workers, and then only a third of these stayed. In August, Garford was forced to settle with the union. The strike had cost an estimated $50,000.[59]

Throughout these difficulties, Studebaker kept its distance from Garford's problems with labor. Their relationship remained only contractual. As a result, Fish continued to project an image of an enlightened employer, even while maintaining a phlegmatic attitude toward industrial relations at Garford. Moreover, it remained in Studebaker's long-run interests for Garford to experience these difficulties. While their relationship was limited to procuring Garford's chassis, Fish was already considering a stronger position in Garford. Fish proved unwilling to play the role of a Peter Studebaker who had intervened in the Pullman strike only a decade earlier.

Instead, Fish directed his attention to the internal operations of Studebaker. That May, Fish undertook to reorganize Studebaker with a clear delineation of authority between manufacturing and sales. The reorganization showed that Studebaker was now completely committed to automobiles. There was to be no turning back, no second guessing. The board now accepted Fish's strategy to expand Studebaker's interest into autos through an aggressive acquisitions policy. To implement this policy, the board designated Fish and George M. Studebaker to pursue further negotiations with Garford concerning the possibility of a merger.[60]

To Fish's dismay, however, Garford rejected his offer out of hand. He frankly told Fish that he did not favor such a merger because Studebaker did not "cut much of a figure in the automobile business." Fish returned to South Bend and prepared for war. He now placed before the Studebaker board a detailed plan to gain a controlling interest of Garford. He also suggested that Garford be allowed to use the Studebaker name on its own cars, thereby further binding Garford closer to their interests.[61] Next, Fish proposed a new sales arrangement with Garford. The current sales arrangement divided New York evenly into two territories. Fish recommended that a new sales agency, headed by Hayden Eames, could handle both Studebaker and Garford products, except in those places where Studebaker had sales branches. Arthur Garford, only two months after rejecting Fish's first merger proposal, now accepted Fish's proposition. His problems at Elyria had tempered his opinion of Studebaker.

By this time, however, Fish's acquisition policy had moved beyond Garford. He also proposed to the board that the corporation keep its eyes open for other acquisitions. In early June, he announced that Studebaker had entered into a sales arrangement with the newly formed Everitt-Metzger-Flanders (EMF) company to handle its sales in the West and the South. Fish nonchalantly told Garford that this new EMF-Studebaker alliance would not conflict with his interests since EMF sought to produce only a low-priced automobile.[62]

Clearly this new arrangement with EMF placed pressure on Garford to reconsider a merger with Studebaker. Studebaker offered capital and a distribution system. Fish made exactly this point when he met with a group of Garford stockholders in Cleveland. On February 13, 1908, nearly eight months after his first offer, Fish announced that Studebaker had gained a majority interest in Garford.[63] Soon after this acquisition, Studebaker announced that its dealers had become the sole distributor of the Garford. This forced all Garford dealers into liquidation, thereby giving rise to a series of lawsuits that Studebaker allowed to languish in the courts.[64] Fish then announced that Hayden Eames, who had worked closely with Studebaker interests on the Garford board, had been made general manager of Studebaker. The final stroke came shortly afterward when Fish wrote to Garford to inform him that the sign above the Elyria plant should read Studebaker-Garford. By 1909 George M. Studebaker had become president of Garford.

In 1908 Studebaker earned over a million dollars on a little over five hundred cars sold, but the market was radically changing. Henry Ford had shown that the future lay in the mass produced, low-priced car. In December 1911, Studebaker representatives attended their last

meeting at Garford. Shortly afterward, they sold their remaining interest in Garford to Willys-Overland. The Studebaker-Garford arrangement, for all of the time it had consumed, produced little. In the end only 2,481 Studebaker-Garfords were built in those seven years from 1904 to 1911. For Studebaker, the arrangement had primarily been a learning experience. One wonders what might have happened if Fish had directed his energies toward joining forces with an Olds, a Durant, or even a Ford. In any case, Fish's involvement with Garford had fully committed the board to the automobile industry, and this kind of corporate victory was not something to be scoffed at given his early troubles with the board.

Fish Joins with EMF, Then Takes Control

The year 1908 marked an important turning point for Studebaker, as well as for the entire industry. That year, over sixty-three thousand American cars would be produced, mostly modeled after the "French" design with its heavy, more complex engine located in the front of the car.[65] The introduction of the French design, however, forced American manufacturers to find ways of lowering costs in producing these more complex cars. By the middle of 1908, Buick, Cadillac, and Ford had succeeded in lowering costs while increasing production. Ford broke all records in the industry by producing 101 machines in one ten-hour period. Within the next ten years the price of cars fell by 72 percent.[66]

Fish saw that the market was changing even as he gained control of Garford. He saw that the future lay in a medium- to low-priced gasoline car—just the kind of car EMF proposed to produce. For its part, Garford had failed to live up to expectations. While production costs were relatively low, the company's capacity to produce cars was limited. For these reasons Garford remained tied to the high-priced field, with a car selling close to $2,000 at its lowest. Garford's attempt to build a 40 horsepower car had led only to "expense and confusion."[67] In July 1908 Fish announced that a cooperative arrangement had been made with EMF to market five hundred of its cars. Fish had left nothing to chance. He had arranged that final payment for each EMF was to be made *after* it had been sold.

The Studebaker-EMF deal brought together two corporations as diverse as any in auto history. The Studebaker Corporation had a long history, a tradition of craftsmanship, and a firm sense of itself as an established corporation. On the other hand, Everitt-Metzger-Flanders had been formed by three entrepreneurs well known in the industry for their flamboyant styles. William (Billy) Metzger and Barney Everitt enjoyed reputations as being the best salesmen in Detroit, while the

third member of the triumvirate, the gregarious Walter Flanders, the man credited with organizing the assembly line at Ford, brought production skills to the partnership.[68]

The tall, aristocratic-looking Metzger had opened the first automobile dealership in America in 1900, and then made a good-sized fortune selling the recently introduced Cadillac in 1902. That same year he became associated with the formation of the Northern Car Company. People said that Metzger could sell anything. He joined forces with Barney Everitt, a squat, jovial, Canadian-born entrepreneur, whose associates in the automobile industry included Ransom Olds, Henry Ford, and Fred J. Fisher (one of the seven brothers from Norwalk, Ohio, who became famous for their automobile bodies). Everitt also made a fortune in the industry, first by building automobile bodies for others, and then in 1904 when he helped form the Wayne Automobile Company with Charles L. Palms, a scion of one of the wealthiest families in Detroit.[69]

Walter E. Flanders cut an even more dashing figure. Later described as the genius who brought Henry Ford's vision of a mass-produced car to reality, Flanders had left his home in Vermont at the age of fifteen to become a machinist, first at Singer Sewing Machine Company and then at a machine manufacturer in Cleveland. Standing over 6'3" and weighing 250 pounds, the black-haired Flanders was a roughneck typical of the period.[70] This burly, 35-year-old Yankee was first introduced to Henry Ford when he called on the young company as a salesman representing three machine manufacturers in the city. Later, on hand to see that the machines he had sold were properly installed, Flanders found that Ford wanted him to become manager of the plant with the understanding that he could continue to sell machinery elsewhere in the industry. Flanders stayed twenty months. When he left he had changed production at Ford. As Charles Sorensen, Ford's lieutenant, later recalled, Flanders had fused the three arts of the motor car business—buying materials, production, and selling.[71] Flanders left Ford with an enhanced reputation.[72]

Many wondered at the time how Barney Everitt and Billy Metzger ever got along with the crude Flanders. As one contemporary observed, "Barney, of course, was no mental giant, but Billy was smart and had the marks of a gentleman. He [Metzger] was cold too and his smile was like that of a Spaniard wiping off a knife. . . ."[73] Whatever the contrasts in personality between the partners, these men shared a vision that the future of the industry lay in the mass-produced car. Flanders had worked at Ford through the production of the Model N. When Flanders left Ford in April 1908, a month after the first announcement of the Model T, he set out to produce his own car for the masses, the EMF 30, designed by William E. Kelly, a long-

time associate from Cleveland. Witnessing the frantic acquisitions of William C. Durant, who formed General Motors in 1908, Flanders predicted that "henceforth the history of this industry will be the story of a conflict between giants."[74]

The three men announced their partnership at a gala at the Café des Beaux Arts in New York in which two hundred guests were served frog legs transported from Detroit. Shortly afterward, the "Big Three," as they were labeled by the newspapers, incorporated their new company with stock valued at one million dollars.[75] Their first move was to acquire the Wayne Auto Company and then merge it with Northern, which gave their new company three existing plants, two in Detroit and one in Port Huron. Flanders quickly completed production of the remaining Wayne Cars, while the EMF 30 was being tooled and built. By the end of 1908 close to 172 EMFs had been built, but unfortunately they employed an inefficient cooling system (a thermo-syphon instead of a water pump), so all 172 units needed to be recalled. Nevertheless, by October 1, 1909, Flanders had turned out a total of 6,074 cars. In less than a year he had gained 12 percent of the market, standing only behind General Motors and Ford.[76]

Flanders's success, however, brought disappointment. He had sought a low-priced car, yet the first day the EMF rolled off the floor, so did Ford's Model T with a price tag of $400 less than Flanders's car. It was apparent that the EMF offered little competition to the Ford. Thus Flanders secured the exclusive rights to a low-priced car designed by A. O. Smith and James Heaslet. Renamed the EMF 20, the car was intended to rival the 20 horsepower Model T.[77] Indeed some in the industry predicted that the EMF company would outproduce Ford in 1910, a prediction obviously off the mark.[78]

Producing cars was one thing, distributing them another. Studebaker, with its national sales organization of 4,000 dealers, offered Flanders and his partners the opportunity to become a national company. Moreover, Studebaker provided EMF with an opportunity to gain, as Flanders told his partners, "financial prestige for their company."[79] Exactly who approached whom first—whether Flanders went to Studebaker or Fish to EMF—remains uncertain, but whatever the case, a symbiotic relationship was quickly established between the two. Studebaker agreed to handle all of the export business, and Hayden Eames was assigned all territories in the South and the West. Billy Metzger was given the Eastern territory. The arrangement fitted Studebaker's needs perfectly. It allied Studebaker with an enterprise that promised to become a dominant force in the industry—all without any direct investment on its part. George Studebaker in all candor observed as much when he told the Studebaker board, "We considered

it more advantageous for us to form an alliance with a group of men
. . . possessing . . . factory facilities, experience, and manufacturing
ability of a rare order, as well as an intimate knowledge of the prob-
lems peculiar to the motor car, than to establish a separate factory of
our own."[80]

The arrangement with EMF, also, fitted perfectly into Fish's strat-
egy of entering the automobile industry through acquisition. By
1908, Fish was clearly in charge of the corporation, although he
worked closely with George M. Studebaker, who frequently repre-
sented the company in negotiations with Garford and EMF. Fish,
however, remained the strategist behind the scenes. He saw in EMF
an opportunity to expand at little cost to Studebaker. Furthermore,
EMF offered Studebaker the possibility of acquiring the production
skills of Walter Flanders, a man who had already proved his worth in
the industry.

And, Flanders again proved his worth. Although EMF was built
around three plants, the center of production remained the former
Wayne Auto plant in Detroit. In this plant the EMF 30 was assembled
and finished, while it also housed the corporate headquarters of the
company. EMF continued to contract outside for tires, wheels, radia-
tors, and magnetos, but most EMF parts were manufactured by the
company. On the shop floor, Flanders had created a stable and enthu-
siastic workforce largely by instituting a bonus system that paid em-
ployees, both production and office workers (including stenographers
and office boys), an eighty cent per car bonus. He also assembled a
coterie of key men around him.[81]

Studebaker salesmen found themselves "simply amazed" at the
popularity of the EMF. Studebaker, despite fifteen major branches lo-
cated throughout the country, could not keep up with the demand for
the EMF.[82] From the outset, the EMF crowd had looked forward to
a "harmonious, but aggressive," relationship with Studebaker. Within
the year the scale decidedly shifted toward the aggressive when Everitt
and Metzger accused Fish of deliberately slowing down sales in order
to force EMF stock down. Then, in the spring of 1909 Everitt and
Metzger turned on Flanders and attempted to oust him from the man-
agement. They specifically accused him of having entered into a secret
alliance with Studebaker to the "detriment of EMF." At the board
meeting, Everitt also suggested that if Studebaker wanted EMF's out-
put they should buy the company now, "outright for cash," instead of
manipulating the stock. He proposed that it would be judicious for
EMF to explore the possibility of setting up its own sales organiza-
tion, especially in the West.[83]

Under pressure from his partners, Flanders informed Fish that
EMF's contract with Studebaker was cancelled. Fish received word of

Flanders's unilateral announcement while on a trip to the Pacific coast. Fish responded as the victim: He informed Flanders that in selling the EMF, Studebaker had taken the "whip end" of the arrangement in that "the more we exploit your car, the more we build up your business and build up your company, and make a strong competitor for us in the future." Then, pointing to the recent formation of General Motors, he asked Flanders to consider another matter: "In view of the recent large combination in the medium priced automobile business, and the increasing competition in that particular line, is it wise to turn down so useful an ally?"[84] The answer seemed obvious. At this point, Fish offered to buy a major interest in EMF. Within the month Fish had bought out both Everitt's and Metzger's shares of the business, but Flanders retained control. Although it was reported in Wall Street circles that Studebaker spent close to a million dollars to purchase this stock, the actual amount tendered was a more modest $362,000.

Fish moved to reorganize EMF. He had proposed to merge the two companies, but Flanders resisted this proposal. Instead, Flanders became president of the company, but Studebaker men were placed in all of the leading administrative positions, sparking obvious resentment of many EMF staffers. At the same time, Fish placed three Studebaker men on the seven-man board of EMF. Studebaker also became the sole distributor of the EMF. In September, Studebaker informed Flanders that sales of the EMF were falling.

Flanders saw the writing on the wall. Fish appeared to be doing exactly what Everitt and Metzger had accused him of doing in the first place—depressing sales in order to lower EMF stock. Flanders exploded. In a letter to the board sent in December 1909, Flanders bitterly denounced Fish for manipulating sales in a lame effort to acquire complete control of EMF. He charged Studebaker with "taking advantage of the tremendous demand for EMF 30 and the Flanders 20" by forcing dealers to accept huge discounts or additional orders for Garfords or Studebaker electrics. Flanders bluntly listed a litany of other complaints, including Studebaker's insistence on setting advertising policy; its public announcements that it owned EMF; and its dominating presence on the EMF board. When the EMF board convened a few weeks later, Flanders insisted, over the protests of Fish, George Studebaker, and Hayden Eames, that EMF had the right to cancel its contract with Studebaker.[85]

In breaking with Studebaker, Flanders showed he was well matched to duel with the adroit Fish. The following months were given to parrying. With an independent sales organization quickly filled by dozens of dealers anxious to cash in on the demand for EMFs, Flanders ensured that any countermove by Fish would be blocked. Flanders, in creating this sales organization, now provided the means for EMF

to become a major and fully integrated automobile manufacturer, no longer dependent on Studebaker outlets. Such a move also raised the value of EMF. If Studebaker wanted EMF (although Flanders continued to deny any intention of selling his company), Fish would have to offer more money.

Foiled at the board meeting, Fish countered by turning to the courts through a petition to have an injunction placed on EMF holdings. Yet even with the small army of lawyers hired by Fish to defend Studebaker's interests, the opening moves went in favor of Flanders. Studebaker's attempt to have a restraining order issued against EMF through the Detroit courts failed. As a result Fish turned to the federal circuit court in Cincinnati where a temporary injunction was issued. Flanders responded by increasing production, while urging his stockholders to remove Fish from the board.[86]

Under pressure, Fish directed his lawyers to begin negotiations with Flanders. In the following weeks a series of meetings were held in which both sides offered to purchase one another's interests in the company. Studebaker lawyers reported that "Flanders is not inclined to settle at all. He would rather fight it out." In response, Fish directed his lawyers to continue the fight and avoid any "appearance of abating their energy in pushing the litigation. . . . "[87]

Finally, Fish turned to J. P. Morgan for help. After all, Morgan had backed the company in that critical year of 1894 when the company had expanded its capital base nearly threefold. As a result, Morgan had acquired one sixth of the voting stock of Studebaker. In subsequent years, Morgan continued to take an interest in the company. Fish invited Morgan to back the EMF deal, which finally broke the logjam. In early March, New York newspapers announced that EMF had been purchased by a Studebaker-Morgan combination. Many Wall Street pundits warned that this was the first step by Morgan to gain control of the entire automobile industry.

At a special meeting convened in the New York offices of J. P. Morgan, Flanders and his associates agreed to a final price for their two-thirds holdings in EMF. The deal made Flanders and his associates millionaires. By hanging tough, Flanders had forced the price of EMF stock to triple. Flanders alone received a million dollars for his interests and a three-year contract—at a salary of $30,000 a year plus 1 percent on all earnings—to manage the newly merged company.[88]

The Bankers Step In and the Family Steps Out

Studebaker paid a stiff price for its acquisition. Before litigation began EMF stock had stood at $10 a share. By the end of the fight it had risen to $37 per share. Moreover, the purchase of the EMF stock

placed Fish in a precarious situation. To finance the consolidation, Fish arranged for $3.5 million in notes to be issued, with Morgan to have first option on these notes.[89] In entering into this arrangement Fish gambled on his close relationship with Morgan, but in so doing he used nearly all of the family assets as collateral. Morgan's cooperation involved other costs as well. Morgan insisted that his own representatives, F. P. Delafeld and F. W. Stevens, be elected to the Studebaker board. To make room for the two Morgan men and Walter Flanders, who also joined the board, family members William R. Innis, C. A. Carlisle, and J. M. Studebaker, Jr., resigned. The Studebaker family now had even less power in the company it had founded nearly sixty years earlier.[90]

Fish counted too much on J. P. Morgan. In late 1910 Morgan informed Fish that he was pulling out and would not exercise his option. The automobile industry had been shaken by the collapse of General Motors. Durant, after failing in an attempt to merge with Ford and REO in 1908, had formed General Motors, but within two years, after a whirlwind series of acquisitions, General Motors was in chaos. General Motors had been built on a quagmire of weak and unprofitable companies. A recession in 1910 threatened to bankrupt it. Only the intervention of Morgan banking interests saved the company. Although Durant was forced out from the active management, many on Wall Street viewed the future of the company as poor.[91] The formation of the overexpanded, underfinanced U.S. Motor Company by Benjamin Briscoe earlier in the year indicated that consolidation was rapidly occurring in the industry, but it did little to assuage the anxieties of Wall Street.

Morgan's withdrawal left Fish in a delicate situation. As Fish later reported, with nearly all of the family assets "either directly or indirectly" tied up with that three and a half million dollars of notes that would shortly come due, the Studebakers had been left in an "acute and dangerous" position.[92] Fish desperately turned to the investment banker Henry Goldman, founder of Goldman Sachs. Fish had worked for Goldman briefly as a lawyer before moving to South Bend. Through Goldman a new consortium was organized with the Lehman brothers to take over the bonded indebtedness of the Studebaker Company. On February 14, 1911, a newly organized Studebaker Corporation was capitalized with $15 million in preferred stock and $30 million in common stock. This reorganization followed within months the reorganization of General Motors.

Banking interests were now to play a key role in shaping Studebaker's destiny. While F. W. Stevens, representing the Morgan interests, stepped down, Henry Goldman and Paul Sachs were elected to

the board. Throughout the remaining part of the decade and into the twenties, Goldman Sachs and the Lehman Brothers received weekly reports from South Bend concerning production quotas, weekly wages, and daily work schedules. Wall Street replied with directives on these matters as well as the salaries and promotions of managers extending down to mid-level supervisors.[93]

The entrance of Goldman Sachs and Lehman into the company changed the fundamental nature of Studebaker. No longer would Studebaker be a family business. New types of managers came to the corporation—financial men, accountants, and efficiency experts. In this way, Fish proved to be a purveyor of a future not envisaged by family members or older production men such as Flanders. Other companies and the industry as a whole found a place for the older type of production men, as evidenced in the careers of Nash and Chrysler. Production men found less of a role at Studebaker—as evidenced in the strained relations that continued to exist between Fish and Flanders even after the merger.

Flanders, now a millionaire, was not the type to remain satisfied with his position as general manager for the newly organized Studebaker Corporation. Ever energetic, he managed to start a separate enterprise, the Flanders Manufacturing Company in Pontiac. Flanders Manufacturing was formed through the consolidation of six independent companies. Capitalized at $2.25 million including $420,000 invested by Clement Studebaker, Jr., the central plant in Pontiac, Michigan, soon began manufacturing motorcycles and electric cars. Flanders continued to press Fish to invest in the company, but Fish absolutely refused.

Increasingly, Flanders devoted himself to his own company. When the president of Flanders Manufacturing resigned, Flanders personally assumed the position. For Fish that was enough. Already disgusted with Flanders's half-hearted commitment to Studebaker, and probably offended by his style, Fish plotted to lessen Flanders's influence within Studebaker. His opportunity came through the reorganization of the company. When Fish submitted the new corporate chart to the board, the position of general manager had been dropped altogether. In its place were two divisional managers for auto and for other vehicles. Flanders resigned a few weeks later.[94]

Flanders rejoined Barney Everitt at a new company he had organized in June 1911. Although the company went into receivership a short time later, Flanders himself was by no means finished. Following this failure, he joined Benjamin Briscoe at U.S. Motors, now on the verge of bankruptcy. He scrapped most of the conglomerate except the Maxwell line, which later formed the backbone of the Chrysler

Corporation. Chrysler's challenge to Studebaker in the 1920s therefore might be seen as the ghost of Flanders finally getting revenge on Frederick Fish.

Having reactivated Maxwell, Flanders retired a wealthy man in 1915. Six years later in 1921 he came out of retirement for his last fling. Joining forces with Everitt and Metzger again, along with World War I flying ace Eddie Rickenbacker, he organized Rickenbacker Manufacturing. The end came two years later in 1923 when at the age of fifty-two, Flanders died in an automobile crash. His fifth wife, a former artist's model, inherited a $1.5 million estate, which over the next decade or two she squandered, finally being forced to take a job as a music teacher on the WPA rolls.[95]

In the years following the departure of Flanders, Studebaker production boomed, as did the rest of the industry. American automobile production rose from 11,000 cars in 1903 to 1.5 million in 1916, an average increase of 45 percent per year. In a two-year period, 1915 and 1916, production totals rose an extraordinary 51 percent and 81 percent respectively. The boom was on and with it came a large-scale reorganization of the industry.

The introduction of the Ford moving assembly line transformed the nature of the market. By 1912 half of the cars manufactured bore the name plates of seven producers—Ford, General Motors, Studebaker, Willys-Overland, Hudson, Reo, and Packard. Among these seven companies, Ford dominated the market with production double that of its nearest rival, Willys-Overland. Ford had created a new market for the low-priced automobile. By 1916 low-priced cars ($600–$800) constituted 51.1 percent of the market, although medium-priced cars ($800–$1,300) continued to hold their share of the market. The growth of the automobile market indicated a general increase in national income for the average American, but it also reflected a calculated shift in consumption patterns by the middle class, who were now willing to divert a large portion of their income toward the purchase of an automobile.[96]

During this period of fantastic growth, Studebaker emerged as one of the major producers in the country. It targeted the medium-priced market with the EMF 30, selling at $1,100, and the Flanders 20, priced at $750. Now, the corporation was bigger than any single individual. With Flanders's departure from Studebaker, a new group of financial men came to work in the corporation. Of course, producing automobiles was how the company made its money, so day-to-day problems involving manufacturing, engineering, and styling stayed in the hands of men like Max Wollering, the general manager of production, and brilliant engineers like Fred Zeder, who established the first complete testing laboratory at Studebaker in 1913.

Production men like Wollering remained important to the corporation, but financial men now gained a dominant position in the corporation. The sprawling domain of Studebaker, with its South Bend plant covering 121 acres and four plants in Detroit, now became a fiefdom of men such as Fish and his young protégé, finance man Albert Russell Erskine, who joined the corporation in this period. Questions of production became increasingly intertwined with questions of finance. Clearly the decision to sell its interest in Garford to Willys-Overland was a financial as much as a production decision. And surely the move to promote men such as Erskine to key positions in the corporation indicated the strength financial interests now had in the company.

Fish had saved Studebaker, but in doing so he had transformed the corporation into a new entity. This new organization was to have no place for the original Studebaker family except in name. Although some family members expressed bitterness about this new relationship, the firm's remaining founder, J. M., showed nothing but thanks to his son-in-law.[97] Shortly before his death in 1917, J. M. wrote Fish, "I have trusted wholly to you and your judgment in looking after the financial interests, not only my large interest but the interest of our families and all stockholders of the Studebaker corporation."[98]

The refinancing of the corporation was not without its costs to the Studebaker family, however. Banking interests were now to play a crucial role within the corporation until its demise in 1963. While J. M. was made chairman of the new corporation, power now passed to Fish, as president, and later to Albert Erskine, selected by Goldman to serve as treasurer of the corporation and as heir apparent to Fish.

The Studebaker name had become only a symbol of a distant past. Those Studebakers who remained on the board primarily served advertising purposes. As Scott Brown, the new corporate counsel at Studebaker, was told, "The names of the family were retained by the corporation for advertising value and for the preservation of good will, if for no other reason."[99]

While continuing to own stock in the new public corporation bearing their name, the Studebaker heirs soon realized they had little role to play in the new corporation. Clement Studebaker, Jr., resigned as vice president in November 1913, and his brother George M. resigned two days later. Perhaps the feelings of the family members were best expressed in 1925 by J. M. Studebaker, Jr. He wrote in a testimonial to Harold Briggs, vice president of sales, who was retiring that year, "You have won our hearts and God knows your have won our money—*both gone forever.*"[100]

Studebaker Prospers and Paternalism Thrives, 1913–1929

Tradition Constructed

At the recommendation of Wall Street financier Henry Goldman, the Studebaker Corporation appointed Albert R. Erskine its president on July 8, 1915.[1] Erskine was to hold this position for the next eighteen years as the corporation established itself as a major automobile producer in the teens and the twenties, a time of prodigious expansion in the industry. During these years, in a conscious public relations effort, Erskine constructed a corporate history that portrayed Studebaker as an enlightened employer concerned with its employees and the community. To accomplish this he authored the first history of the corporation in 1918, dutifully dedicated "To the Memory of My Friend, John Mohler Studebaker."[2] Erskine had known Mr. Studebaker only six years before J. M.'s death in 1917, but he realized that J. M.'s view of himself as a benevolent industrial statesman projected a desirable corporate image.

Goldman saw in Erskine a dynamic leader that Studebaker needed if it was to fulfill its promise of becoming one of the nation's leading producers—if not the largest producer—of automobiles. Erskine promised the corporation much, and for the next eighteen years, he dominated. As *Automobile Topics* observed shortly after Erskine's death, "Erskine was the Studebaker Corporation. Big in physique, dominant in character, proud, independent and ambitious . . . [his] rise in the automobile industry was characteristic of the counting house rather than the shop. . . . [He] lived in the world of facts and figures and he built by enlisting the special talent of others."[3]

In his capacity as president, Erskine articulated a reconstructed Studebaker tradition that replaced nineteenth-century paternalism with scientific managment and corporate welfarism. He translated the Studebaker tradition to fit the needs of the modern era. Corporat-

ism replaced familial benevolence. Yet in the end, market forces subverted the rhetoric of social responsibility. When Erskine finally stepped down from the presidency eighteen years later in 1932—humiliated and forced out by the board—he left the company and its pension programs in bankruptcy. Less than a year later he committed suicide.

The Industry Expands and Finds Stability, 1911–1929

The Erskine years fell into two parts that closely paralleled the growth of the automobile industry in the period from 1911 to 1929. From 1911, the year that Erskine first joined the corporation as treasurer through 1918, the industry underwent a production revolution that transformed corporate management, industrial relations, and the automobile market. Following World War I, the automobile industry entered into a second phase characterized by stability, excess capacity, and an emphasis on automobile design, efficient marketing, and distribution.

In his drive to make Studebaker into a leading automobile manufacturer, Erskine confronted an industry that was undergoing a profound transformation in technology, managerial organization, and industrial relations. The development of new technologies drove the industry toward high-volume operations. As a result the industry sought ever-greater product standardization and streamlined production. Similarly, managerial organization tended to develop hierarchically to ensure more efficient operations in production, distribution, engineering, finances, and industrial relations.

This revolution had begun when Henry Ford developed the necessary production techniques to mass produce his automobile. In so doing, Ford made the automobile accessible to the masses. While others, including Alanson Brush and Ransom Olds, had experimented with low-priced cars for the masses, Ford fulfilled the promise of producing an affordable, durable, and reliable means of transportation for the common man. Within seven years after the introduction of the Model T in 1908, the industry had moved toward large, capital intensive, and highly integrated production. As a consequence, the industry became increasingly concentrated, especially in the 1920s. By the end of the decade there were fewer than twenty-five automakers left, while the seven largest firms accounted for 90 percent of the market. Of these seven firms, Ford and General Motors far outpaced the others in both cars produced and profits earned.

While automobile companies differed radically in terms of managerial structures and industrial relations, the very size of the automobile company challenged American management. Here, American

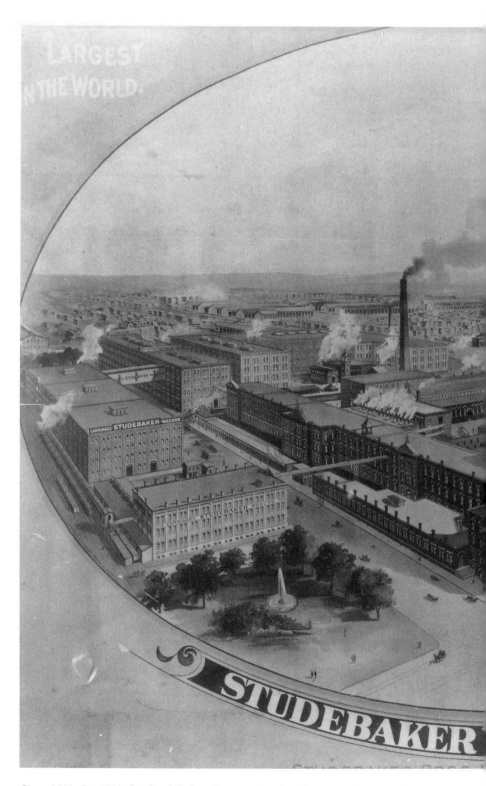

Circa 1900. By 1900 the Studebaker Corporation had become the world's largest wagon manufacturer. The company was just beginning its move into the automobile industry—a decision made reluctantly by the brothers. Archives, Studebaker National Museum, South Bend, Indiana.

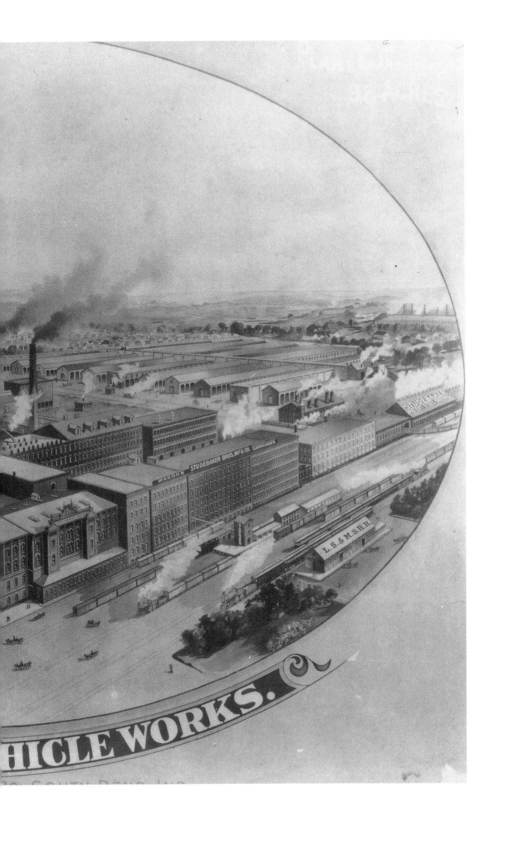

Circa 1910. In 1908, Walter Flanders left the Ford Motor Company to produce his own car for the masses, the EMF 30. Under Frederick Fish, Studebaker acquired the EMF Corporation with the backing of J. P. Morgan. The EMF 30 never seriously challenged Ford's Model T in the low-priced field. Archives, Studebaker National Museum, South Bend, Indiana.

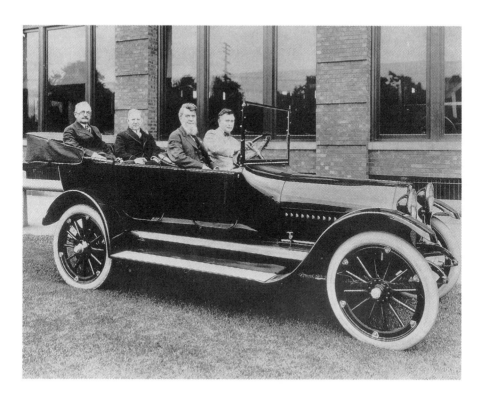

1916. (L. to R.) Frederick Fish, A. R. Erskine, J. M. Studebaker, and J. Heaslet go for a ride in a Studebaker Big 6. Even as late as 1916, J. M. believed that horse-drawn wagons were here to stay. Archives, Studebaker National Museum, South Bend, Indiana.

1929. This advertisement for the Studebaker President Eight captures the glamour of an era that would soon end with the stock market crash. The Studebaker President set scores of racing and durability records when driven by stock car racer Ab Jenkins. Here, however, Studebaker promotes the car as a luxury car. While some luxury cars prospered during the Depression, most notably Cadillac, the Studebaker Eight was not luxurious enough for the upscale buyer and not affordable for the typical middle-class buyer in the 1930s. Archives, Studebaker National Museum, South Bend, Indiana.

1929. A. R. Erskine placed high hopes on the model he named for himself. It did not catch on and was soon phased out of production. In the background is the house he built for himself in South Bend. Archives, Studebaker National Museum, South Bend, Indiana.

1932. Launched in 1932, the Rockne marked another failed attempt to enter the low-priced market. The death of famed Notre Dame football coach Knute Rockne was devastating, but it is doubtful the car would have made it even if he had lived. The Rockne was replaced by the Dictator Model A in 1934. Archives, Studebaker National Museum, South Bend, Indiana.

business once again made a significant contribution to modern industry—the divisional organization.

Developed by Alfred P. Sloan, Jr., the General Motors model allowed each division to manufacture its own product, while operating as its own profit center. This decentralized structure provided flexibility and managerial competition. Centralized control of this structure was maintained through a corporate headquarters that oversaw the financial operations of the entire organization. Sloan's organization allowed General Motors to become the leading automobile producer in the world.

As successful as General Motors was in these years, Sloan's model did not find ready acceptance in the other auto companies. Indeed, only after World War II did Henry Ford's grandson introduce the G.M. structure to Ford. Chrysler, in turn, only developed a multidivisional approach in the 1960s. Organizational diversity also characterized the independents. For example, in the 1920s Studebaker sought to enter multimodel production, but Studebaker management remained centralized. Simply put, managerial organization within the auto industry remained strikingly heterogeneous. Mass industrialization and modern technology did not necessarily dictate uniform managerial structures within the auto industry.

Industrial relations in the automobile industry also showed great variation. While the auto industry remained antiunion throughout this period, Studebaker, with its long history of paternalism, instituted far different labor practices than did either Ford, which remained brutally antiunion, or General Motors, which introduced a range of paternalistic measures designed to prevent unionization in its shops.[4]

The introduction of the Model T on October 1, 1908, marked the beginning of a manufacturing revolution in American business. Within a year sales for the Model T had so outdistanced production that Ford was forced to stop taking orders for a period of nine weeks. Volume sales of the low-priced, sturdy Model T allowed Ford to construct a mammoth new factory at Highland Park, Michigan, in 1910 that ensured a continuous flow of assembly operations. Walter E. Flanders, Ford's production chief from 1907 to 1908, had already developed a moving assembly line that assigned each worker specific tasks instead of having him assemble the entire car. By 1915, only five years after the completion of the Highland Park plant, Ford was nearing sales of half a million a year.

Ford's manufacturing techniques led to a prodigious expansion in the rest of the industry. In 1910 the automobile industry made 157,000 cars, while in 1915 it produced close to 900,000 cars. This tremendous expansion allowed the general lowering of automobile prices. For example, in 1908 the average retail price was about $2,000.

By 1917, the typical car sold for $750. Furthermore, Ford's domination of the lower-priced market—cars under $500—transformed the nature of the automobile market. Ford's Model T, selling for $440 in 1914, claimed 45.4 percent of the entire market, with an annual production of 548,000 units, four times that of its nearest rival, Willys-Overland. Ford sold 96 percent of cars that retailed for $850 or less.

The rapid expansion of the automobile industry in these years created a labor shortage. A tight labor market allowed workers to change jobs frequently. Confronted by continued problems of labor turnover, automobile manufacturers sought to stabilize their workforces by offering high wages and introducing programs designed to instill company loyalty. On January 5, 1914, Henry Ford shook the industry when he announced a $5 per day plan. At the time, unskilled labor often earned only $1 a day. The $5 per day plan led to a sharp decline in employee turnover at Ford.

To further ensure a stable—and loyal—workforce, Ford also established a sociological department to ensure that his workers had a proper home environment. Although critics of the Ford program accused the company of paternalism and meddling in the personal lives of employees, Ford showed the importance of instituting employee programs. (At Studebaker, Erskine sought to emulate the Ford model, albeit in a less iniquitous and officious manner.) Ford's policy of paying high wages allowed his employees to purchase the very cars they built.

The expanding demand for automobiles in this period permitted even medium-priced manufacturers to introduce new production technologies. Above the lower-priced market dominated by Ford stood three other distinct classes of cars: the medium-priced market offered cars between $650 and $1,375, the high-priced market sold cars priced between $1,375 and $2,775, and luxury-priced cars provided the wealthy consumer with automobiles priced over $2,775.[5]

Ford's rivals fought to fill the niches within this medium-priced and luxury-priced market by offering stylish models that came with standard features such as windshield wipers, self-starters, and demountable tire rims. In 1913, the medium-priced market accounted for 30 percent of automobile production. Willys-Overland held 29 percent of this market, Buick and Studebaker about 21 percent each, and Hupmobile and Reo about 7.5 percent each.

In 1916, the Toledo-based Willys introduced a small-engine, light model that sold for $615 fully equipped. By cutting out the market slightly above Ford's inexpensive Model T, Willys rapidly became the largest medium-priced producer. At the same time, the intrepid Will Durant introduced the Chevrolet that offered a stylish $750 model. By 1916 Chevrolet had become the fifth largest producer, having in-

creased its sales from 3,500 in 1912 to over 70,000 in 1916. The industry also saw the spectacular rise of the Dodge Brothers that offered a moderately priced, simple, four-cylinder model.

The success of Willys-Overland, Chevrolet, and Dodge forced other medium-priced producers to lower their prices. This vigorous competition and rapid expansion of the medium-priced market transformed the industry. In 1916, Willys-Overland produced 140,000 automobiles, Buick 124,800, Dodge 71,400, Chevrolet 62,900, and Studebaker 65,400.

Erskine Offers Reconstructed Paternalism in His Drive to Compete

With a ruddy complexion, jutting chin, and autocratic manner, Erskine dominated Studebaker as no other president had or would. He proclaimed "efficiency and economy" as the watchword of the company. His critics claimed that Erskine never left the administration building to go to the shop floor, but Erskine felt that accounting was the key to understanding any business. As he observed in the *Nation's Business*, accounting reduces "all problems and events of the many departments to the common pecuniary unit of measurement."[6]

Although trained as an accountant, Erskine showed he was more than a man beset by figures. He saw himself as the industrialist who could make Studebaker into an equal of Ford and General Motors, and he was willing to do it. Erskine appeared to symbolize the businessman of the New Era, and to many in these early years—to his associates at Studebaker, Goldman on Wall Street, and industry journalists—Erskine ranked among the ablest executives of the day.[7] If Erskine's later image was that of a Durant with the soul of an accountant, his reputation in his heyday was the envy of most.

A loyal Republican, Erskine embodied the ideal of the businessman in the 1920s. He was the poor boy who had made good through hard work. With success he espoused those New Era values of social responsibility, industrial cooperation, and civic responsibility. Erskine translated the Studebaker tradition of familial paternalism into scientific management and corporate welfarism. The modern manager, he told his fellow businessmen, has developed "an ideology and a way of life which are slowly evolving into a new ethical form."[8]

However strained his rhetoric, he continued to espouse the importance of enlightened industrial leadership inherent in the Studebaker tradition. As he frequently repeated in his speeches and interviews, "Men are the most important element in every undertaking. Collectively, we call them the organization." Loyal, well-treated workers, high-quality products, and corporate tradition were terms often

equated by Erskine. Like the Studebaker brothers before him, he urged his fellow executives to show imagination in creating new ways of ensuring better working conditions for both their managers and the workers on the shop floor. Better programs made for better *and more loyal* employees.[9] "Yes sir, I defy anyone to take a Studebaker man away from us, defy anyone! I simply say it cannot be done."[10]

Surely the paternalism expressed in Erskine's rhetoric was consciously self-serving. Enlightened management allowed for a stable workforce, sold cars, and provided continuity within the "Studebaker tradition." Paternalism was common throughout the automobile industry in these years, but "paternalism" itself varied greatly within each company.[11] Thus, while Studebaker looked at the practices of other companies, it developed its own practice of enlightened management. In turn, Studebaker employees actually viewed Studebaker as an exceptional place to work. In short, both employees and managers at Studebaker accepted and acted upon the rhetoric of corporate paternalism.[12]

In his espousal of modern management, Erskine captured the spirit of the age. In doing so he also provided a sense of continuity with Studebaker tradition imparted by the brothers and Frederick Fish in early years. Erskine carefully cultivated this image as a modern executive who still maintained close ties to the Studebaker heritage. In the drama of the 1920s he readily assumed his role as an industrial statesman. He claimed the role of company historian, South Bend booster, and a public-spirited citizen of the nation. As the *South Bend Tribune* observed upon J. M.'s death, "It is a happy circumstance that the long established policy of the institution [Studebaker] has not changed. Mr. Erskine came to South Bend as a stranger, but he was not content to occupy that remote relation long. . . . [He] has in a helpful and practical manner manifested a keen interest in the civic and public enterprise of the place, identifying himself with all of its important activities."[13] Erskine carefully cultivated the image of "South Bend's foremost citizen."[14] Little wonder that rumor had it that Erskine kept Studebaker in South Bend at the wishes of J. M. Studebaker on his deathbed.[15]

Nevertheless, Erskine remained an outsider to South Bend in ways that the Studebaker brothers clearly were not. Born to a well-established but impoverished Southern family in Huntsville, Alabama, Erskine had built a career through making the right sort of friends. He started as an accountant for the American Cotton Company in St. Louis, later moving to become treasurer of the Yale and Towne Corporation and then treasurer of Underwood Typewriter. At Underwood he came to the attention of Henry Goldman, who first suggested to J. M. Studebaker that Erskine be brought to Studebaker as

an understudy to Fish. Thus Erskine came to Studebaker in 1911 as treasurer with the understanding that he would assume the presidency of the corporation upon J. M.'s retirement.

Erskine's presence at Studebaker was felt immediately. Refusing to take a desk, he spent three months investigating every aspect of the company. Then he turned to reorganizing the financial and clerical system. This involved the creation of new office forms that Erskine insisted be used throughout the plant. At the same time he began hiring key personnel in accounting and sales.

His efforts were duly noted by Henry Goldman, who had kept a careful watch on his protégé. "My associates," he wrote to Erskine, "are astounded at the way you have broadened out in every possible direction and how tactfully you are handling the organization." Goldman saw Erskine's "guiding hand" everywhere. Both Fish and J. M., he noted, were quite pleased with "their" choice to head the corporation.[16] In another letter Goldman assured Erskine, "I really have such an admiration for what you have accomplished I am sure that my prophecy made to you a year ago that within five years you would be known as one of the big industrial men of the country will come true. I want this to become true and I want to do all in my power to make you personally benefit."[17]

And for a few brief years Goldman's promise seemed to be realized. The corporation flourished over the next few years. From 1911 to 1924 Studebaker earned $115 million in profits, with the stockholders receiving $49.5 million in dividends. By 1923 Studebaker had reached sixth place in sales and stood behind only Ford and General Motors in total assets.[18] Erskine set the stage for the company's move into the low-priced market with its new car—the Erskine—and shortly afterward into the glamour market with the purchase of Pierce-Arrow in the summer of 1928.

These were prosperous years for Erskine and the Studebaker Corporation. Never a modest man, Erskine displayed his wealth in a manner fitting to the glamour of success. His mansion, built in the early twenties in the newly developed southeast section of town, away from the older wealth of J. M. and Fish, combined English and Southern Colonial architecture in a massive Georgian-styled brick manor.[19] When it was completed he furnished the home with Flemish tapestries, oriental rugs, antique English, Italian and French furniture, Georgian silver and European paintings—much of which was acquired at the auction of the Vanderbilt estate. The bill from this auction alone was $231,622.[20] In this elegant manor Erskine entertained the elite of South Bend and Detroit.[21]

Erskine's charismatic personality and domineering style, along with Goldman's support, won over both J. M. Studebaker and Fish. There

was never a doubt that Erskine should succeed Fish. As J. M. told Erskine, "I hope that you will never regret associating yourself with the Studebaker name," candidly adding, "I also trust that Mr. Goldman will never regret placing his confidence that he did in making his large investment." In praising Erskine, he also sought to ensure that Erskine carry on the Studebaker tradition. He told Erskine, "The good name that the Studebaker brothers built up was done by honesty and . . . endeavoring to give every man a square deal. . . . I don't believe anyone in the world today can say that any one of the five Studebaker brothers ever did a dishonorable act during their lives."[22] He expected no less from Erskine.

The drive toward more efficiency, greater productivity, and higher profits in the automobile industry, however, created an environment not always amenable to the ideology of enlightened management. By 1917 ten companies accounted for 75 percent of all domestic auto production, and by 1923 their share would rise to 97 percent.[23] The adoption of mass production assembly lines allowed for greater output and reduced automobile prices. This benefitted the consumer but made for a fierce battle between producers for market share. The center of this battle focused on the medium-priced car market.[24]

For Studebaker, which had established itself in this market through its Fours and Sixes, thereby earning net profits amounting to $1.7 million by 1913, any attempt to increase its profit margins entailed reducing production costs.[25] This was exactly the task that Erskine set out to accomplish.

When Erskine assumed the presidency of Studebaker in 1915, he took control of a vast domain that included factories located in Detroit, South Bend, and Walkerton, Ontario. He insisted that efficiency be the single criterion to judge the performance of each of these plants. Even before becoming president he had warned the board that "our direct labor costs and overhead . . . have been in excess of what it ought to be."[26] He called for reductions across the board—in man hours, wage costs, inventory, and total labor force, where possible.

Erskine realized, however, that meaningful cost reductions could only come from more efficient production, better plant layout, consolidation of overlapping factory functions, and innovative engineering. This meant spending money, a lot of money. He reported to Fish that "Willys-Overland and Dodge Bros. have both had large increments of capital in the past few years. . . . Our plants are separated, none are thoroughly modern, and we are far excelled in plant facilities by Overland, Buick, and Dodge, our strongest competitors."[27]

He refused to allow Studebaker to be left behind in a rapidly changing industry. He targeted new investment at the Detroit facilities, es-

pecially Plant 3, which produced engines and axles, Plant 5, which produced service parts, and Plant 10, an assembly plant. More importantly, he proposed that a new plant be built in South Bend solely for the manufacturing of bodies. By consolidating body production in South Bend he estimated that a $5.00 savings per body could be made in costs alone. At an annual production rate of 35,000 bodies this meant saving $175,000 a year.[28]

Erskine's most important innovation was the installation of a new assembly line and conveyor system in the South Bend plant. (Only following World War I would Erskine install continuous line production throughout all Studebaker plants.) At the same time, a greater stress was placed on the interchangeability of parts. Plans were adopted to use the same chassis for the four- and six-cylinder models, thereby reducing productive labor per car from 686 hours in 1913 to 365 hours in 1914. This entailed a corresponding cut in total wage costs from $6.7 million to $4.1 million.[29]

In transforming production at Studebaker, Erskine relied heavily on the engineering department, which had been acquired from the EMF organization. Competition in the medium-priced market entailed offering well-designed cars to the cost-conscious consumer. The engineering department was charged with offering attractively designed bodies as well as standardized accessories, including self-starters, windshield wipers, easy-to-change tires, and numerous other features.

Studebaker's engineering laboratory had been set up in 1911 by chief engineer James Heaslet, whose experience in the industry as a production man and an engineer dated to the turn of the century. Under Erskine's direction, this engineering laboratory was enlarged in 1913 to become one of the most modern in the industry. That same year Heaslet was made vice president of production, a post he would retain for the next four years until the outbreak of World War I. The engineering laboratory was left in the hands of Fred M. Zeder, a recent engineering graduate from the University of Michigan. Shortly after coming to Studebaker, he was joined by two other remarkable engineers, Owen R. Skelton, a former Pope-Toledo and Packard engineer, and Carl Breer, formerly with Allis Chalmers. These men—the so-called Three Musketeers—soon gave Studebaker a reputation for innovative engineering.[30]

In the summer of 1913, Erskine moved to transform work at Studebaker through the introduction of a piece-rate system when he instructed Heaslet to conduct a full time-motion study. Erskine specifically wanted Heaslet to establish tables that stated in exact terms the requirements for each department, the number of employees necessary to meet these requirements, the rates to be paid, and the quality

of work performed.[31] The consequences of Heaslet's study soon be-
came apparent. Within two years, Studebaker had cut its labor costs
and its number of total employees. Heaslet estimated, for example,
that the Detroit workforce had been reduced nearly 28 percent in this
two-year period, while labor costs were cut by $2.6 million.[32] Further-
more, he reported, the introduction of piecework had raised produc-
tion as much as 200 percent in certain assembly tasks.

In his efforts to increase production and lower costs, Erskine con-
tinued to maintain that management could avoid "friction and ill feel-
ings" from Studebaker employees. He insisted that his staff exercise
"considerable attention to working conditions in our factories."[33] He
ordered the construction of the Studebaker Club, open to all super-
intendents and foremen, for bowling, billiards, and other recreational
activities. Erskine insisted that equal attention should be given to line
personnel as well when he ordered that the new factory layout include
drinking fountains, washrooms, and lockers. These facilities improved
the morale of the workforce, while also allowing easier supervision of
employees during rest periods. Indeed, a watchman was employed for
the purpose of preventing "unnecessary dallying and thievery."[34]

At the same time he proposed the introduction of an accident
insurance and pension program for employees.[35] Managed through
Equitable Life Insurance, the plan stipulated that Studebaker pay
the initial premium, along with monthly contributions to the em-
ployee fund. The plan offered Studebaker employees one of the best
programs in the industry.[36] In its first year, the company reported that
fifty families had received payments of $500 each for compensation
for deaths.

The corporation also adopted a profit-sharing plan for all executives
down to departmental foremen. Erskine also instituted a policy of re-
warding long-term employment with anniversary checks ranging from
bonuses of 2 percent to 10 percent of salaries for all employees with
more than two years of continuous service.[37]

These liberal employment policies appeared, at least initially, to pay
dividends. Productivity increased and the workforce *seemed* content.
Heaslet reported in 1914 that estimates showed a 25 percent increase
in productivity, while earnings had increased 10 percent.

He attributed this improvement primarily to better machinery and
tools. Moreover, he added that a "general feeling of satisfaction . . .
prevails throughout the factory." He noted that "careful attention is
being given to keeping the building clean, lighted, and well ventilated
and in improving conditions generally." There is a good feeling among
the workers and "we intend that these feelings shall be fostered and
encouraged."[38] Erskine gleefully seconded Heaslet's optimism when

he reported to Fish that "the adoption of the profit sharing plan and the considerate treatment the men are receiving from their superiors are, in my opinion, some of the contributing causes of the happy situation."[39]

The promise of peaceful industrial relations, however, remained elusive.[40] Although mobility and high wages often substituted for unionization in these years, Studebaker continued to experience high labor turnover.[41] Turnover at Plant 3 in Detroit alone averaged over 200 percent annually.

The most dramatic evidence of discontent appeared in late 1913, even as Heaslet spoke. That summer 2,500 Studebaker workers at Plant 3 walked out when a fellow worker was fired without notice for an unexcused absence. The Detroit newspapers reported that many of these workers were toolmakers between seventeen and twenty years of age.[42] Immediately the strikers were joined by Industrial Workers of the World (IWW) organizers John Walsh and John Fisher, who appeared before a picket line of six hundred workers who had remained at the gate to win over the night shift. The IWW had come to Detroit earlier in the summer to organize the auto industry. With the walkout the IWW organizers told the press that this was "the first step in organizing all the industry." Walsh was reported to have told the picket line, "Now that we're out let's strike for the eight hour day. We can get it—we can get Cadillac and Packard, too."[43]

Although thirty police officers were rushed to the Studebaker plant, the police commissioner personally met with the IWW leaders and assured them that they would not be interfered with as long as no disturbances were raised. By the following day, however, most of the men returned to work. The primary issue behind the strike had in fact been a demand for a weekly instead of a semimonthly payday. When Studebaker management agreed to this demand, the strike quickly fizzled.[44] Nonetheless, this incident showed periodic discontent among Studebaker workers, belying the rhetoric of peaceful industrial relations.[45]

Studebaker Joins the War Effort and Erskine Consolidates Postwar Power

America's entrance into World War I brought an outpouring of patriotic sentiment from Studebaker managers and workers alike. While Erskine publicly denounced dissenters such as Robert La Follette, the liberal Senator from Wisconsin who opposed the war, Studebaker workers took to the streets in patriotic demonstrations in support of the war. Managers reported to Erskine that shop employees had filled the plant with American flags.[46] Erskine also arranged for those em-

ployees who enlisted in the armed services to receive up to 50 percent of their salaries while in uniform—an arrangement later rescinded at the request of the federal government.[47]

The war also brought huge profits to Studebaker.[48] With the first outbreak of war in Europe war orders had flowed into Studebaker offices. With an agent posted in London to secure war contracts, business boomed.[49] By 1916 contracts with France and England for wagons and automobiles exceeded five million dollars.[50] With America's entrance into the war, company profits further increased. In less than a year after the outbreak of war Erskine was able to report to the board that the vehicle division had received $8.5 million from the government for gasoline automobiles and trucks, as well as for transport wagons. As a result, net profits on wagons increased 15 percent while automobile profits increased 10 percent in a six-month period.[51]

But profits came with a cost. Before America's entry into the war, Studebaker stood sixth in total cars produced, and although this marked a decline from its position as the third largest producer in 1914, Studebaker had nearly doubled production in those two years. New competition from Willys-Overland and General Motors had pushed Studebaker from the top rankings, but the completion of a new foundry at the South Bend plant and the introduction of a line of trucks in 1913 and buses in 1915 promised a solid future for the corporation.

The war, however, delayed Erskine's plans to put Studebaker into the top three. This was soon evidenced by the rapid decline in automobile production during the war years. Two months before America entered the war Erskine reported that over 71,000 cars had been contracted for by the nearly 4,000 Studebaker dealers throughout the country. Although freight delays tied up deliveries, net sales increased 13 percent during the last quarter before America's entry into the war. That year, however, Studebaker produced only 40,000 cars, and by 1918 production had fallen to 16,000.[52] The rapid decline in production led Erskine to conclude that "Our entry into the war . . . undoubtedly upset business in general."[53] War orders soon renewed profits, but at the war's end Erskine concluded that from "the standpoint of profits, our war business was unattractive with profits on automobiles nearly absent."[54]

Much to Erskine's surprise, the war revived the wagon business. World War I, otherwise so modern in its use of technology, proved to be a war that relied heavily on the horse. With America's entrance into war, the wagon division found itself overwhelmed by domestic and war orders. By the end of 1917, the head of the wagon division reported that domestic production alone was averaging 700 wagons a week. He added that "we are taking advantage of the opportunity

to bring prices up to what they should be to represent a fair profit," which in fact meant a boost in wagon prices 59 percent above what they had been at the start of the year.[55] By the spring of 1917, the division reported that it could no longer keep up with production to meet the demands for army vehicles and the "good trade conditions in the cotton territory of the South." Even the buggy business boomed in ways not anticipated. "The effect of the automobile, the young men going into the army, and the general tendency to use the buggy as a business vehicle instead of pleasure," the manager of the wagon division observed, had put every job into a "profit making class."[56]

Still, Erskine held no illusions concerning the future of the wagon business. With the war's end, he immediately arranged for the sale of the wagon business to the Kentucky Wagon Manufacturing Company in Louisville.[57] Thus ended the business from which the Studebaker Corporation had sprung.

The death of J. M. Studebaker in March 1917, only weeks before America entered the war, had allowed Erskine to cut further links with the Studebaker family. He began by replacing former wagon men with his own managers—men such as Max Wollering, who now became vice president in charge of production. Under Wollering's direction Studebaker would complete factory layout to allow the introduction of continuous manufacturing.

By 1918 Erskine was prepared to confront his only serious rival bearing the Studebaker name, George M. Studebaker. Within the year following J. M.'s death, Erskine, even while proclaiming the continuation of Studebaker tradition, further extended his control in the company by removing George M. Studebaker from the board of trustees.

Erskine's opportunity came when reports reached him that George and his brother were involved with inside trading and selling short on the stock market. Outraged by these reports, he demanded that George resign from the executive and finance committees of the board. Because of "sentiment and courtesy," he wrote, "I have allowed you to be given a salary for which I have been subjected at times to unpleasant criticism." Five days later, George replied in a letter equally bitter in tone that accounts of his selling short were "totally inaccurate." Moreover, claiming that his position as "director comes from the stockholders, not from any appointment from you," he refused to withdraw from the board for fear that the removal of his name might "further weaken public confidence in your administration." He pointedly added, "It appears to be currently believed by the public that the Corporation is now administered from certain Eastern centers of stock speculation, rather [than] with primary consideration for the stockholders." In the end, however, George knew who held the reins of power.

Two days later he submitted his resignation to the board.[58] Erskine had succeeded in purveying a tradition, one now fully disembodied from the family.

Even as the war drew to a close Erskine made two crucial decisions: First, he decided to produce a multiline of cars to challenge his nearest competitor, Willys-Overland, and perhaps Ford and General Motors. Next, he decided to build a completely new, fully modernized plant in South Bend.

After a brief downturn during the recession of 1919 (in which Studebaker fared quite well), the automobile market boomed. From 1921 to 1926 alone, per capita income for workers increased by one third, and the introduction of installment payments allowed them to purchase cars in numbers never previously seen in the history of American industry.[59] Moreover the average price of passenger cars rapidly fell from $762 in 1914 to $692 in 1925. Under these conditions style itself became a singular feature in purchase of the automobile. As Erskine reported, "style has become to us as much a sales factor as a mechanical design."[60] Now most cars were closed, stylish, and increasingly faster.

Ford continued to lead automobile production in these years. Indeed, the downturn in the automobile market in 1920 was in large part due to Ford's flooding the market with Model Ts to permit more Model Ts to be produced at still lower costs. From 1922 to 1923 Ford output rose from 1.3 million cars to 2.1 million cars.[61] Yet the market had changed toward models that offered consumer status and style—such as the new hardtop.

The indefatigable Billy Durant, who had reemerged as a force in the automobile industry, saw this change in consumer tastes, and indeed helped shape the new market, through his Chevrolet. Introduced in 1915, the Chevrolet gave consumers just what they wanted—status at just a slightly higher price than the Model T. The financial downturn of 1920 pushed Durant out of G.M., but under the guidance of Alfred Sloan and former Ford executive William Knudsen, Chevrolet became the car with the greatest sales, surpassing Ford in 1927.[62]

The postwar years saw other crucial changes in the automobile industry as further consolidation took place. The downturn in auto sales created a flurry of mergers as Locomobile was purchased by Durant, Lincoln sold out to Ford, and Crane-Simplex was absorbed by Mercers, who in turn later sold it to Locomobile.[63] Other mergers also occurred when the Auburn Automobile Company, under the able management of thirty-year-old Errett Lobban Cord, gained control of the Duesenberg Motor Company in 1927. Shortly afterward the Hupp Motor Company became the ninth largest company in total assets when it bought the Chandler-Cleveland Motor Corporation.[64]

In these years of industrial consolidation, Erskine's decisions appeared (contrary to his later critics) more than reasonable. Moreover, he tried to frame his expansion program within the Studebaker tradition—as he interpreted it.

Changing conditions in the postwar market forced manufacturers of medium-priced cars such as Studebaker to fight fiercely to maintain a place. Erskine felt that the key to Studebaker's success lay in the construction of a new, fully modern plant complex. This decision had in fact been made as early as 1916, but the war had hindered this expansion. Still, Erskine felt it was "absolutely necessary" to consolidate and expand production. Thus, with the war's end he arranged with Goldman Sachs to issue $15 million in gold bonds to finance the project.

In 1917 Studebaker engineers under the able Fred Zeder undertook the design of three new models—all within the mid-price range—as the basis of the company's new postwar line. The models centered around the Light Four, the Light Six, and the Big Six. To produce these cars Studebaker had invested close to a million dollars in pattern, die, and tool equipment. After undergoing extensive testing, including a 50,000-mile test drive over the most arduous conditions in Canada and upstate New York, the Big Six premiered at the New York Auto Show in early 1918. The Big Six quickly gained a reputation for its performance and durability. It maintained a strong market position throughout the mid-1920s, until it faced competition from the new, high-compression cars, including the Chrysler, which first appeared in 1924. The departure of Zeder, Skelton, and Breer in 1920 to set up a consulting firm, which later became the nucleus of engineering at Chrysler, cost the corporation dearly in terms of keeping up with innovations in the industry. This single decade of the twenties saw the introduction of pressure lubrication, interchangeable bearings, mechanical fuel pumps, unit transmissions, balloon tires, disc wheels, shock absorbers, oil and air filters, and four-wheel drum brakes. Without a strong engineering staff, an automobile company simply could not compete. Zeder's successor, Guy P. Henry, pursued a play-it-safe course. For example, he resisted four-wheel hydraulic brakes, even when this had become standard on most cars.[65] Only the arrival of Barney Roos in 1926 revived Studebaker's engineering department, but in the intervening years Studebaker had been left behind, particularly in the development of a high-compression engine. That Studebaker maintained a market position at all was due to Zeder's design of the Studebaker Six.

Still, in the early twenties these models placed Studebaker in the top ranks of automobile makers in the immediate postwar years. Although 1921 was marked by a severe downturn in the general market,

Studebaker rose to fourth place in production with 65,000 cars, behind Dodge, Buick, and Ford. Unlike most of the industry Studebaker had reduced wartime inventories in the midst of increased production. As a consequence, Studebaker escaped the serious reverses of the other auto companies, such as its major rival Willys-Overland, during the depression of 1920–21. When the market turned up the following year, Studebaker produced over 100,000 cars, and stood only behind Ford, G.M., and Dodge.

By 1925 the new South Bend plant had been completed, with a new foundry, new body shops, and advanced engineering laboratories. These facilities allowed Studebaker to remain one of the few companies to build all of its own bodies, thereby remaining completely independent of outside suppliers for closed body manufacture.

The introduction of the latest machinery and new factory layouts promised to increase productivity as well as lowering production costs through more efficient use of labor. The completed plant included a new machine shop, iron foundry, and forge shop. Railroad lines running into the plant allowed freight cars to be unloaded directly at points of central distribution or fabrication.

Covering 225 acres with buildings occupying seven and a half million square feet of floor space, the plant was estimated in value at $50 million, of which $39 million had been added since November 1918. Annual production capacity was 180,000 cars, requiring 23,000 employees.[66] Erskine reported that foreign markets were strong, especially in the Far East and India, and that further expansion was being planned as the company was undertaking "strenuous efforts to arrange for dealerships in all civilized countries of the world."[67] In 1922 alone sales amounted to $133 million, more than the total of all horse drawn equipment manufactured by the Studebaker Brothers in its previous history.[68]

The board rewarded Erskine for his efforts with a new contract of $60,000 a year plus bonuses up to one million dollars on the first ten million dollars earned in net profits. The contract seemed well deserved.[69]

Erskine's decision to expand capacity and to pursue multimodel production seemed obvious to a man of his ambition. This strategy was in keeping with others in the industry. Why he decided to consolidate production in South Bend and not Detroit (now the center of auto manufacturing in the nation), however, remains another story. He later claimed that Fish and he had promised J. M. on his deathbed that the company would always remain in South Bend. There was more to the decision than sentimentality, however. Erskine maintained that South Bend had "better manufacturing conditions" than Detroit.

By "better manufacturing conditions," he specifically meant more pliable labor.

Simply put, the war exacerbated existing tensions within the Detroit plants. Many workers, production manager Max Wollering observed, continued to hold that "Studebaker was not a good place to work" and looked with suspicion on Studebaker's assurance that their jobs were good. "With such a reputation," he noted, "the best classes of workmen are not attracted to us and this we attribute to the high turnover of labor in 1917."[70] Wollering reported that a turnover rate of over 300 percent in Studebaker's Detroit plant had left an "undercurrent of unrest" among workers.[71]

Virulent labor unrest affected Studebaker as well as the rest of the nation.[72] In the war years, Erskine worried that "the former loyalty of employee to employer is diminishing, cooperation is less than it used to be, and industrial workers are demanding rights not heretofore demanded of nor acknowledged by employers." He observed that some corporations are "fighting these conditions, while others are voluntarily meeting them, and we believe that the latter is the wise one." He emphasized that Studebaker wants "cooperation, loyalty, and contentment."[73]

In late May 1919, just when Erskine felt that Studebaker had avoided labor upheavals, a major walkout occurred in Studebaker's Detroit plant. Estimates of the walkout ranged from company figures of a thousand workers to union estimates of double that number.[74] The strike began when employees at Plant 3 walked out demanding the reinstatement of an assistant foreman, increased wages, and a shorter working day. The strike lasted less than a week before Studebaker employees returned to work without having won their demands.

By that August, Wollering reported that "labor is apparently in a quieter mood and we do not look for any trouble. . . . " The problem encountered in the late spring and early summer had "blown over for the present at least," although wages for both skilled and unskilled workers were increasing. The average weekly wage for production workers had risen from $28.70 in June 1918 to $34.80 by June 1919. Even as labor appeared to be in a "quieter mood," indications were that problems with labor remained.[75]

In consolidating manufacturing in South Bend, Erskine hoped to alleviate these kinds of problems. In constructing the new South Bend plant, Erskine had directed that the "prime consideration" be given to the "safety and welfare of our men."[76] As a result Studebaker tried to tack a delicate course in confronting potentially explosive situations.[77] The downturn in the labor market following the recession of 1921 and the corresponding shift from skilled and semiskilled work

to more unskilled labor did more than anything to defuse labor militancy in the automobile industry for the rest of the decade.

A stable and loyal workforce remained essential to the fulfillment of Erskine's vision for Studebaker. His own background at Towne and Yale showed him that through the use of "corporate welfarism" industry could institute an array of programs to raise worker morale, instill loyalty, and increase productivity.[78] As a result, corporate welfarism under Erskine differed from the paternalism of the family-owned business run by the five Studebaker brothers. The primary difference lay in the introduction of professional managers into personnel relations. A personnel office, the Cooperative Department, staffed by specialists, now assumed the responsibility for setting wage schedules, hiring and firing, maintaining benefit and insurance programs, handling employee relations, and overseeing myriad social clubs and athletic leagues sponsored by the corporation.

Nevertheless, corporate welfarism at Studebaker proved neither fully consistent nor fully enlightened. The primary goal of welfarism was to encourage worker productivity and loyalty, while keeping organized labor out of the shop. The Cooperative Department was designed to curb the arbitrary power of the shop foreman in the hiring and firing process, but foremen continued to intimidate workers on the floor. As a consequence few complaints made it to arbitration in the personnel department. Moreover, competition within the automobile industry dictated holding down wage costs and intensifying work on the floor, even while the virtues of the welfare program were touted.

At the core of the welfare program rested the Cooperative Department headed by Reverend Charles A. Lippincott, a Presbyterian minister, who had distinguished himself in South Bend for his community efforts.[79] Upon resigning his pastorate at the First Presbyterian Church, Lippincott declared, "It is my firm conviction that when men fully understand the motives and plans of the management, they will respond heartily to this invitation to cooperation for mutual benefits."[80]

Under his guidance, an emergency hospital for workers was established, social clubs and athletic teams organized, a marching band and orchestra formed, and new dining facilities built. Furthermore, Lippincott gradually extended his role in setting wage rates, operating hours, and working conditions. Through his efforts, a personnel department was established, which interviewed and approved all prospective employees. In turn, grievance procedures were established so that employees could bring problems with their foremen and other superiors to the department. By 1927, the Cooperative Department held the power to oversee the dismissal of any employee by a shop foreman.

Known affectionately as "the Great White Father" by Studebaker employees, Lippincott spoke out in favor of giving workmen voice in "the direction of their own labor and working conditions."[81] He believed, too, that workers should be able to buy their own homes, and in 1919 the Studebaker Corporation helped organize with the local Chamber of Commerce a housing corporation to finance the construction of houses required to absorb the expected forty to fifty thousand new residents created by the influx of new workers to South Bend. Studebaker also established a low-interest mortgage plan for its workers to buy homes at cost.[82]

Both Erskine and Lippincott attributed a good deal of success to the cooperative plan. Erskine felt that the steady drop in labor turnover was largely due to the benefits offered through the plan. He specifically noted that labor turnover fell from 169 to 62 percent from 1920 to 1921. Erskine boasted that over $800,000 had been paid to over 8,000 employees in anniversary checks; and over 3,000 employees took one-week vacations after two years or more of continuous service in 1920. Fewer workers participated in the stock sharing plan, which remained primarily a management program.[83]

By the mid-1920s Erskine had created an image of enlightened management.[84] Corporate advertising, company publications, and press reports conveyed this view that loyal workers built better cars.[85]

Studebaker's "Golden" Years Dull

The immediate postwar years proved to be the golden years of Studebaker. By 1921 Erskine was able to report that the corporation was enjoying its largest sales in history. With net profits reaching $10.4 million for over 65,000 cars sold, Studebaker found demand outpacing production.[86] Looking toward further expansion, Erskine opened negotiations with William Robert Wilson, president of Maxwell Motor Corporation, concerning a possible merger.

All signs pointed toward successful negotiations. Wilson had formerly worked for Studebaker before becoming president of Maxwell. Moreover, the chief backers of Maxwell, James C. Brady and his brother Nicholas Brady, had instructed Wilson that they supported the merging of the two companies. For his part Erskine also favored the merger. Such a merger not only promised to enlarge Studebaker's capacity, but also offered the opportunity to secure the services of two of the finest automotive engineers in the country, Walter Chrysler and Zeder, who had recently joined the Maxwell team. In the end, however, negotiations fell through when Erskine's offer of $26 million was rejected as too low.

The failure cost Studebaker dearly. Shortly afterward, Walter Chrys-

ler revealed his new high-compression engine car. The appearance of
this car proved vital in prompting bankers to finance the expansion
of Maxwell, which became the Chrysler Corporation.[87]

Further bad news followed. Shortly after negotiations with Max-
well broke off, Arthur Lehman and Henry Goldman resigned their
positions on the board. Perhaps they realized the failure to merge with
Maxwell marked a turning point for Studebaker. While Goldman and
Lehman continued to hold financial positions in the company, it was
clear they were cutting back in their commitment to the company.
Lehman resigned in November 1926 with a note stating that in the
past the Lehman brothers had always held two seats on the board, but
given the current situation today, "the corporation would benefit by
having a more diversified list of directors than is at present the case—
men from other cities and localities than are now represented and from
other walks of life."[88] One month later Henry Goldman resigned.[89]
Although Goldman was replaced by his close associate Waddill Catch-
ings, it was clear that Studebaker's connection with Eastern financial
circles had changed. As a result Erskine began to cultivate relations
with Midwestern financial interests in Detroit, Cleveland, and Pitts-
burgh.

Erskine continued to press on. He had little choice. In 1926 he
appointed two new vice presidents to his team, Paul Hoffman in sales
and Harold S. Vance in manufacturing. A self-made millionaire, having
made his fortune as southern California's leading Studebaker dealer,
the thirty-four-year-old Hoffman soon emerged as a leading figure at
Studebaker.[90] Vance's career was markedly different—that of a me-
chanic made good. He began work at Studebaker in 1910 as a me-
chanic's apprentice, gradually working his way up through the ranks
of production. With the retirement of Wollering, after seventeen years
of service, Vance was the natural choice to replace him.[91]

Hoffman's appointment came following the resignation of H. A.
Biggs, vice president of sales. The expansion of Studebaker had left
many dealers in disarray. Many dealers simply lacked proper account-
ing systems, so as a consequence, the corporate office lacked basic in-
formation concerning sales. Thus one of Hoffman's first tasks upon
moving to South Bend was to establish standardized accounting sys-
tems for dealers. At the same time he created a research department
to provide basic information concerning consumer preferences for
body design, accessories, and future needs.[92]

Although corporate profits remained high, Studebaker's place in
the industry had fallen. In 1923 Studebaker was in fact hot on the
heels of Buick, but in the intervening three years Buick had quickly
outdistanced Erskine's company. Moreover, within two years after its
founding Chrysler had surged past Studebaker in sales.[93]

Pressed by competition Erskine moved to expand Studebaker into the low-priced field with the introduction of a small, durable car designed for both the American and European markets. Surveys had shown that the future of the automobile market lay in people with limited means who wanted inexpensive cars.[94] With this in mind Erskine conceived of the car in 1924 during a two-month tour of Europe. What he sought was a car that offered fuel efficiency and European design. Introduced in Europe in the fall of 1926, the new model, "the Erskine," was heralded by the press. Designed by Raymond H. Dietrick, the founder of the famous design firm of LeBaron, the Erskine was advertised as meeting the "American standards of performance and comfort with European requirements in economy." Nevertheless, the Erskine failed in both markets. Put on sale in 1927 to celebrate the seventy-fifth jubilee of the corporation, the Erskine— the so-called little Aristocrat—found little appeal in the European market, and Americans in 1927 expected more power than the Erskine with its 146-cubic-inch engine could offer. Moreover, priced at $995 the Erskine never really challenged Chevrolet's hold on the market and was further undercut in 1927 by Ford's new Model A, which sold for $525. With sales of only 25,000 annually from 1927 through 1929, the Erskine was finally abandoned in 1930.[95] Thus what began, in Paul Hoffman's words, as "one of the great events in the history of the Studebaker Corporation," ended as a dashed dream—the first of many for Erskine.[96]

While testing the waters for a cheaper car, Erskine also moved to upgrade Studebaker's offerings in the higher-priced range. By 1926 consumers sought style and power. The Studebaker line of Sixes offered style, but in the new age of high-compression engines, a six-cylinder engine was hardly enough to lure those more upscale buyers who were willing to pay more for a car. Thus Erskine proposed to introduce a new eight-cylinder model. To design such a car, however, Erskine realized he needed to rebuild the engineering department that had languished.

By 1926 Erskine had had enough of Guy Henry, especially when his chief engineer vociferously protested Erskine's plans to build an eight-cylinder car. Henry felt the Six was doing well, so why change? It was the wrong question to ask. Erskine simply discharged him and hired an engineer with a strong background in working with Eights, Delmar G. (Barney) Roos.[97]

Roos transformed the engineering department. Self-assured, widely read in the arts, literature, and the social sciences, and strikingly handsome, Roos ran the engineering department as his own personal fiefdom, brooking interference from no single individual—including Erskine, who had been heard to proclaim on more than one occasion,

"engineers are just there to take orders from the sales guys."[98] Still Erskine appreciated the importance of engineers. In 1926 he had transferred the entire department from Detroit to South Bend where new engineering facilities had been built at a cost of nearly half a million dollars.[99] At the same time, Erskine gave the go-ahead for the building of a new proving grounds, one of the most modern in the industry. To staff the new research department, Roos now hired a team of engineers formerly with the Bureau of Standards, including chief engineer William S. James, metallurgist K. M. Wise, carburetor specialist E. C. Newcomb, and former racer Ralph DePalma. With his team in order Roos set out to design Erskine's new straight eight.[100]

When revealed in 1928 the President showed engineering at its best. Although not innovative, the new President proved to be a solid, durable car. The interior was lavish by most standards with an eight-day clock, fuel gauge, and temperature gauge set in a walnut instrument panel surrounded by inlaid silver beading. Selling at a price of $1,985 to $2,485, the car was a good bargain.

The President was complemented by the introduction of two other cars to round out Studebaker's line of Sixes, the Commander Six and the Dictator. Studebaker sought euphonious names for its cars, but the "Dictator" proved to be an embarrassment. In a number of European countries, Studebaker sales offices renamed the car the "Director."[101] The Commander, selling at $1,495, and the Dictator at $1,245, enabled Studebaker to maintain itself in the mid-priced market in the face of fierce competition from Chrysler and Buick. With over 3,800 dealers Studebaker could hold its own.

Thus Erskine entered 1928 riding high. Although the previous year's profits had been reduced by the costly introduction of the President and the failure of the Erskine, Studebaker had solidly placed itself as a leader in the mid-priced market. Erskine's own optimism remained unrestrained.[102]

In 1928, Erskine made one of his most daring moves—the purchase of Pierce-Arrow, the maker of the prestigious luxury car.[103] During World War I Pierce-Arrow had over-expanded, as had many other manufacturers. By 1928 the company was short on capital, and lacking a national distribution system, its prospects looked poor.[104] Moreover, it was evident to the president of Pierce-Arrow, Myron Forbes, that a single model producer could not compete with a General Motors or Chrysler. Thus when he approached Erskine with the possibility of a merger, Erskine immediately jumped at the offer. From Studebaker's point of view Pierce-Arrow, based in Buffalo, New York, offered the opportunity to acquire an eastern plant. The combination of the two companies presented Erskine's company with the potential

of becoming the world's largest producer of eights. Such a merger, he believed, would leave Studebaker "sitting pretty."[105]

By early September 1928, negotiations appeared complete. The arrangement made Erskine chairman, while Forbes assumed the presidency of the company. Erskine insisted, however, that 90 percent of Pierce-Arrow stockholders approve the merger before it was finalized. Only in early August, after Pierce-Arrow reported losses of $274,000 for the quarter, would proxies be received approving the merger. The decision proved to be a wise one. The next year sales increased 78 percent when Pierce-Arrow introduced a new model eight, which substituted pressed steel for the hand-hammered aluminum body of previous models. The year closed showing a $2.5 million profit, a marked improvement from the previous year's loss of more than a million dollars.[106]

Although Studebaker's share of the overall market remained ninth in the industry, far behind its stated goal of competing with General Motors and Ford, Erskine's success was recognized by the board. Not only did the board agree to set aside 40,000 shares of stock for Erskine at $50 a share, it also accepted Erskine's plans to undertake a $7 million advertising campaign, the largest in Studebaker's history.[107]

Most of the campaign focused on newspapers, but Erskine—always a man of the times—produced a feature "talkie" film which included female models in elaborate gowns showing off the Studebaker line. The film concluded with Notre Dame's famous football coach, Knute Rockne, giving a pep talk to his team on the value of teamwork. The *New York Times* described the film as slightly corny, but it captured the essence of Erskine's message: Studebaker cars were glamorous, affordable, and built through teamwork. Studebaker was on the rise.[108] Who could have predicted in 1929 that this dream would soon come to such an abrupt end?

Studebaker Survives the Depression, 1929–1940

Tradition Resurrected

After failing to extend Studebaker into the upper-priced luxury market through acquisition of Pierce-Arrow and into the lower-priced mass market through the introduction of a new model, Erskine came face to face with unparalleled economic depression in the early 1930s. As sales and profits plummeted, Erskine pursued a policy of maintaining stock prices by paying out exorbitant (under the conditions) dividends. Erskine remained steadfast in his conviction that the economic downturn was going to be only a repeat of the short-lived recession of 1921—a period of rapid expansion and profit for Studebaker. On hindsight, he should have accepted Henry Ford's dismissal of history as "bunk." The Great Depression of the 1930s was not a glitch in the market (like the 1921 recession) but an economic collapse that brought disaster to the independent auto manufacturers, already left vulnerable by the rapid consolidation of the industry in the 1920s.

Erskine's policy brought inevitable results: In 1933, the corporation was forced into receivership. Erskine turned over management of the corporation to his close associates Paul Hoffman and Harold Vance. Under their leadership the corporation emerged from bankruptcy in 1935, and with the introduction of the Champion, the company turned a profit in 1938 for the first time in nearly a decade.

Hoffman and Vance sought continuity with the past by projecting an image of the corporation as an employer concerned with its employees. Yet when the Congress of Industrial Organizations (CIO) won a collective bargaining agreement in 1938, industrial relations at Studebaker were transformed. The paternalism of the Studebaker brothers and the corporate welfarism of Erskine had served as an asseveration that organized labor was not welcome at Studebaker. In the 1930s, however, the Hoffman-Vance regime openly welcomed and in-

deed encouraged organized labor within the company. When the first signs of organized labor appeared at Studebaker, Hoffman and Vance provided crucial assistance to the union by sending letters on company stationery inviting workers to join the American Federation of Labor (AFL) union. Later, after the CIO broke with the AFL, Hoffman and Vance continued to enjoy cordial relations with the union.

Enlightened management, as interpreted by Hoffman and Vance, entailed the acceptance of collective bargaining, unemployment insurance, pensions, and limited government regulation. In the process, Hoffman and Vance succeeded in resurrecting the Studebaker tradition, but in doing so the tradition itself was revolutionized and a new history was constructed.

The Automobile Market Crashes, Taking Erskine with It

By the late 1920s, the medium-priced car market was being challenged by the major automobile producers—Ford, Chevrolet, and Chrysler. They produced inexpensive models offering most of the features of more expensive models. In 1928 a prospective automobile buyer was offered a new Model A Ford at $495 (introduced in late 1927), a new six-cylinder Chevrolet for $585, or the recently introduced high-powered Chrysler Plymouth for $655. These prices directly challenged independent producers such as Studebaker, Packard, and Hudson who offered models within the $750 to $1,500 range. Consolidation and vertical integration among the majors allowed for volume production that further undercut the medium-priced market. The introduction of these new models by the majors pressured the independents to enter the low-priced market through volume production. As a result, throughout the late 1920s and early 1930s, various independents sought to enter volume production through consolidation with other companies or by introducing their own low-priced models.[1]

Economic depression in the 1930s brought further chaos to the market, leaving in its wake the corpses of those companies weakened in the 1920s. In this way, economic depression ensured the winnowing of the weak, while strengthening the larger producers. Most affected by the depression was the medium and luxury auto market. The medium-priced market ($750-$1,500) accounted for close to 30 percent of total sales in 1927, but by 1934 it accounted for only 4.1 percent of sales. Similarly the luxury market (over $1,500), which accounted for 5.5 percent of total sales in 1927, fell to 0.8 percent in 1934.[2] As the decade drew to a close, companies such as Graham-Paige, Durant, Reo, Auburn, Hupp, Franklin, Peerless, and Jordan had been relinquished to history.

Automobile sales fluctuated radically throughout the depression for the major automobile producers.[3] Sales, which had peaked in 1929, plummeted dramatically by 1932, rebounded in 1935, and then fell again during the recession of 1937–38. Ford led sales in 1929 with over 1.5 million cars, followed by Chevrolet with over 950,000 cars. In 1932, Ford sales fell to 232,125, behind the leading producer Chevrolet, which sold a dismal 306,716 cars. Ford resumed leadership in 1935 with over 900,000 cars, followed by Chevrolet with over 700,000 cars sold. Three years later in 1938, sales once again dropped off with Chevrolet in first place, but with only 490,447 cars, followed closely by Ford with 410,048 cars sold. In these roller coaster years, competition for dominance in the low-priced market remained fierce.

In the decade of fluctuating sales, Ford and General Motors continued their rivalry for first place that had begun in the late 1920s. Of the Big Three, all of which suffered declines in sales, Ford Motor Company found the going the hardest. A large part of the Ford Company's problem was Henry Ford himself. After having taken control of the corporation by purchasing the remaining shares of the minority stockholders led by the Dodge brothers, he had turned the corporation over to his longtime associate Charles Sorensen and his son, Edsel Ford. At the same time he forced the removal of other top executives, including William Knudsen, who had played an instrumental role in making the corporation the world's leading automobile producer. While Henry Ford publicly expressed complete confidence in the ability of his son Edsel, the older Ford's arbitrary interference in the day-to-day management of the corporation played havoc inside the company. Moreover, Henry Ford's impetuous and irrational style of management blocked Edsel's proposals to institute managerial and organizational reforms that had been implemented at General Motors during these same years.[4]

The ascendancy of Harry Bennett, a close associate of Detroit's underworld and a thug in his own right, further demoralized management and employees alike. While Henry Ford supported his son's move to take over the failing Lincoln Motor Company in 1922, which was transformed into a leading luxury car manufacturer, he refused to restyle his Model T, which was increasingly being challenged by General Motors' Chevrolet. Only in 1927, after General Motors had outdistanced Ford in 1925 in profits and in sales in 1927, would Henry Ford agree to the replacement of his beloved Model T with the introduction of an elegantly styled Model A. Introduced in January 1928, the Model A proved to be an engineering and popular success. In 1929, Ford sold almost two million cars, but competition remained stiff with the introduction of Chevrolet's new six-cylinder car.

When the depression hit in late 1930, production fell throughout

the industry, with Model A sales dropping to 762,056 cars in 1931. In 1932 Ford came out with the first mass-produced, low-priced V-8 engine. The V-8 temporarily put Ford ahead of Chevrolet in sales, but throughout the 1930s Chevrolet and Ford ran neck and neck for first place. Ford management, however, continued to be plagued by rivalries and factional disputes. Authority for operations remained divided and ill-defined.[5] By 1941 the corporation had fallen completely under the control of Harry Bennett, before Henry Ford II, the grandson of the founder, ousted Bennett and took control of the corporation in early 1945.

Meanwhile, General Motors continued to prosper under the leadership of Alfred P. Sloan, Jr. By 1926 General Motors offered models in a variety of classes with its Chevrolet, Pontiac, Oldsmobile, Buick, and Cadillac. The Chevrolet introduced a new model that sold for $525 and offered a full-length frame, oil gauge, temperature indicator, and new transmission.[6]

With the depression, the Chevrolet remained the only class in which General Motors was able to maintain any significant volume. In 1931 General Motors remained in first place in the market with 43 percent share, but sales had declined radically, especially in the other lines. Cadillac sales fell to a low of 3,903 cars in 1933, while Buick sales dropped to about 43,000 sales in 1933 from a peak of over 200,000 sales in 1926. Oldsmobile and Pontiac also reached lows in 1932 and experienced low sales throughout the decade. Given that the difference between the most expensive Chevrolet and the Buick was only about $130 (with Oldsmobile and Pontiac falling in between), this was not surprising.

General Motors countered these declining sales by moving into the production of diesel engines and diesel-powered vehicles for both highways and rail use. Between 1932 and 1936 General Motors quadrupled its automobile sales, and in the process its net profits for consolidated operations increased thirtyfold, from $8.8 million to $283 million.[7] By the time Alfred Sloan retired in 1937, after having brought order to Durant's dream, General Motors had become the world's largest manufacturer. G.M. produced 40 percent of all motor vehicles built in the United States, and over 35 percent of those built in the world.

The most dramatic entrance into the majors came with the Chrysler Corporation, reorganized from the older Maxwell-Briscoe Motor Company in 1925. In 1920, Maxwell-Briscoe was on the edge of bankruptcy when Walter Chrysler was called upon to save the company. He quickly moved to penetrate the low-priced market when he acquired the Dodge Motor Company. His Plymouth, introduced in the summer of 1928, became an instant hit. With the onset of the

depression, Chrysler reduced prices in 1930 and again in 1931, which allowed sales to jump from 30,000 units to 94,000 units. The company spent $9 million retooling to introduce a new six-cylinder Plymouth in 1932. Selling for $494, the Plymouth reached a high of 122,000 cars sold, making Chrysler the only automobile company to sell more cars in 1932 than in the previous year. By 1933 Chrysler had 25.8 percent of the entire new car market. While other companies retrenched, Chrysler pushed ahead with an aggressive capital investment program. As a consequence, the company emerged from these years in good shape, having retired its debt of $60,000,000 in the process. When Walter Chrysler turned over the presidency of the corporation to K. T. Keller in 1935, he had proved that attention to technological improvements as well as to more efficient methods of production could be profitable.[8]

The stock market crash confirmed the trend toward concentration, which entailed a diminishing number of manufacturers and intensified competition for those that survived. This pattern had been established already in the 1920s, but the depression decade accelerated this trend as company after company fell by the wayside. During this decade the market share of the Big Three climbed from 75 percent in 1929 to 90 percent in 1939.[9] In turn many firms went out of business or shifted to other lines of business. Elcar and Jordan failed in Cleveland, while Reo and Marmor-Herrington shifted to truck manufacturing. The most dramatic shift came when the Peerless Motor Car Company closed down its lines for two years before entering beer production with Carling's Black Label.

As the Big Three increased their share of the market the remaining independents struggled over the remaining 10 percent. The precipitous drop in the medium and luxury market left independents scrambling to enter the low-priced, volume production market.[10] In a six-year period from 1927 to 1933, sales in the $750-$1,500 class fell from 29.7 percent of the market to 3.2 percent. Similarly, the luxury car market fell from 5.5 percent in 1927 to 1.2 percent in 1933.

The shattered market in medium- and luxury-priced cars left companies that had prospered in the twenties reeling in the 1930s. Packard, which had outsold its nearest rival Cadillac by a three-to-one margin, found that the luxury market collapsed by 1932. As a result, Packard sales fell from 50,000 in 1928 to 8,000 in 1932, which still accounted for 40 percent of all cars in this price class. Reduced prices stabilized a deteriorating situation, until Packard introduced its new eight-cylinder Model 120, designed to sell for under $1,000. The new car was an immediate success, outdistancing every car in its class except Pontiac and Buick. The following year, in September 1936, Packard brought out a six-cylinder model. While Packard lost its luxury market

to Cadillac, sales reached 109,000 cars in 1937. The strategy of entry into lower-priced cars appeared successful, but Packard had lost much in the way of its name and now it was competing with other volume producers.

Nash Motor Company also sought to compensate for declining sales in the medium-priced market through the production of its low-priced Lafayette in 1934. Sales reached 86,000 cars in 1937, but without increased volume the company was forced to raise its prices into the medium-priced class. In 1937, Nash Motors merged with Kelvinator, a producer of refrigerators.[11] A similar pattern was followed by the Hudson Motor Car Company. The depression caught the company with an excessive investment in plant and weak capital liquidity. In 1933, it sought to enter the low-priced market with the Essex Terraplane, but the volume was not sufficient to make a profit. As a result, the price of the Terraplane was gradually increased into the medium-priced range.

The decline of Willys-Overland, a leading manufacturer in the medium-priced market, shocked the industry. In 1917, Willys-Overland had become the second largest automobile producer in the country. Unfortunately, Willys overexpanded and was caught in an exposed position with the recession of 1921. The company rebounded, however, and in 1928 Willys broke all company records with the production of 324,437 automobiles. The depression brought a steady decline in sales, however, so by 1931 sales had fallen to 61,782. The company was finally reorganized under the leadership of Ward M. Canaday, but in the process its working capital had fallen from $87,000,000 to $15,000,000 during the decade. The company survived during World War II primarily due to military contracts to produce the Jeep.

Other medium-priced producers proved less successful. Durant Motors was liquidated in 1933; Reo stopped passenger car production in 1936; Auburn entered bankruptcy in 1937, joined by Hupp in 1938 and Paige-Graham in 1940.

In early 1929, however, the future still looked good. The medium-priced market showed some signs of erosion, but Erskine was intent upon pursuing an aggressive expansionist strategy. The merger with Pierce-Arrow allowed Studebaker's entry into the profitable luxury market with its promise of marginally higher profits. Still, he anticipated Studebaker's movement into the low-priced market. As Erskine looked at the top ten companies in sales, those in the lower end of the market appeared particularly strong.[12]

While Studebaker stood fourth in the industry in 1921 by producing 65,000 cars, the fourth largest producer in 1928, Hudson-Essex, manufactured nearly four times that number with over 282,000 cars. Put another way, Studebaker had nearly doubled its production in

those seven years between 1921 and 1928, but its place in the industry had fallen to ninth.[13] For Erskine it seemed obvious that Studebaker needed to reenter the low-priced market.

Even the collapse in the stock market in October 1929 did little to dampen Erskine's plans for expansion. Certain that 1930 was going to be a repeat of the 1921 recession, he remained enthusiastic about the company's future. Although sales and profits dropped that quarter, Studebaker dealers in all of the major cities reported that they were quite optimistic about the market and expected increased sales. Indeed, Hoffman reported after a tour of the major cities that dealer morale was high. "Their optimism," he said, "is based quite generally on the decided swing toward 8-cylinder cars, on which they quite generally expect to see Studebaker profit substantially."[14] As a consequence of these reports, and concerned that Studebaker stock remain stable, Erskine paid a $1.25 quarterly dividend on common stock. After all, if his dealers were telling him all was well, then it must be so.

Erskine placed great hopes on the introduction of a new transmission, developed by Studebaker engineers in 1931.[15] More than new technology, however, was needed to turn sales around. In the fourth quarter of 1931 the company experienced the worst sales in its history.[16] The company's net profit fell below one million dollars for the first time since Erskine had assumed the presidency. Erskine ordered the workforce slashed by nearly two thousand employees. Unfortunately, Erskine had ordered the discontinuation of the pension program, so many of these workers were left without benefits.[17]

With declining sales and profits, Erskine turned to the high-volume market. Erskine wrote Fish that the lower-priced field was "where the largest volume business is done, where the number of competitors at present is smallest, and where the volume of Studebaker gains that can be obtained is greatest in the shortest space." He proposed the production of a new car that would not bear the Studebaker name for fear of losing the medium-priced market.[18]

Thus the Rockne was born. Established as a separate division, Rockne had its own dealer organization, engineering department, and production facilities located in the old EMF plant on Piquette Avenue in Detroit.[19] Erskine hoped to capitalize on Notre Dame's legendary football coach, Knute Rockne, who had been under contract with Studebaker as a promotional speaker since 1927. Only twelve days after accepting a vice presidency in sales, Rockne died in a plane crash in Bazaar, Kansas, on March 31, 1931.

The Rockne was a calculated gamble from the start. Knute Rockne's death ensured certain failure. Originally designed for Willys-Overland by two Detroit engineers, Ralph Vail and Roy Cole, "the

Rockne" had been acquired by Erskine when Willys announced it lacked the capital to produce the car. Erskine made a full commitment to the car. He hired the former vice president of sales at Willys-Overland, George Graham, to head the sales division, and he appointed Ralph Vail to head production and Roy Cole to head engineering. Harold Vance was named president of the company.[20]

The first Rockne models appeared on the market in early 1932. Although a bargain at their prices, the Rockne faced immediate challenges even without the depression.[21] It entered the ring with Ford, Chevrolet, and Plymouth, only to get knocked out in the first round. With less than 23,000 Rocknes produced, Erskine ordered production stopped in the first year.[22]

By 1932, Erskine himself admitted to the press that "the prevalent economic and social crisis beclouds the future."[23] So often given to hyperbole, Erskine in this instance understated the situation. In the first quarter alone sales declined 13.5 percent from the previous year. Moreover, Studebaker experienced its first loss in profits in twenty-one years.

Erskine moved to cut the workforce further. By 1931 the workforce had been reduced from 18,000 to 11,000. While the company maintained a preference for keeping married men with dependents, Erskine declared that "all employees who lived outside of South Bend and a number of single persons without dependents" should be "weeded out." Still, even as Erskine undertook radical cuts, he continued to refer to the "Studebaker tradition." He noted that "Studebaker wage earners have been treated in a broad and generous manner for many years, and we shall continue to indulge them in the best possible compensation."[24] At the same time he ordered executive salaries over $5,000 reduced by 20 percent.

Nevertheless, Erskine remained steadfast in his policy of maintaining a high dividend policy. In 1930 he paid a dividend of $7.8 million—seven times the net profit for the year. The following year, he issued $3 million in dividends by drawing from reserve capital funds. The policy was doomed to failure as the depression persisted. By 1932 the corporation's working capital stood at only $3.5 million, with liabilities exceeding assets by $15 million.

Erskine's policy received the full endorsement of the board. Frederick Fish, too, insisted that the depression was similar to the 1921 downturn. Similarly, Arthur Lehman, the fox of Wall Street, agreed that a high dividend should be paid "when it is not unreasonable to expect a revival in business."[25] Only one director (among the fifteen on the board), banker John F. Harris, warned of the consequences of paying dividends without an accumulated surplus. He

bluntly told Erskine that "the courageous and intelligent thing to do" was to skip the dividend. He finally resigned in February 1932 with a warning that "many perplexing questions will arise" concerning the board's dividend policy. He specifically charged Erskine with inside trading.[26] Without offering any evidence for this accusation, Harris remained a voice in the wilderness. Indeed, the only consternation Harris's resignation caused was a fear on Fish's part that it might create "bad publicity."

Nevertheless, Studebaker remained strapped for capital. In a last-ditch effort Erskine proposed a merger with the cash-rich White Motor Company, a major truck manufacturer. Robert Woodruff, a former Coca Cola executive, had taken over White Motor following the death of a founder of the company, Walter White, in 1929. As a fellow southerner and close friend of Erskine's, Woodruff saw the merger as a natural. Erskine saw the advantage of a merger as complementing Studebaker's light trucks with White's heavy trucks. Moreover, he saw White's $22 million reserve as a boon, especially in light of recent losses, high dividends, and the cost of the Pierce-Arrow acquisition.

Erskine proposed the acquisition of White for $26.8 million in Studebaker stock. To cover these costs, Studebaker issued $14 million in notes.[27] Faced with $3 million losses of their own, White directors accepted the proposal. White could provide liquid assets, while Studebaker offered an effective distribution system with approximately 2,100 dealers.[28]

By December 1932, Studebaker had acquired nearly 95 percent of the White Motor Company when a minority of stockholders blocked the merger by using Ohio's tough acquisition laws. As a consequence, minority stockholders sequestered a significant part of White's assets from Studebaker.[29] This left Studebaker in a position of being unable to meet payments on bank loans due March 13, 1933.

In the midst of the White stalemate, the worst happened: the nation's banking system collapsed. The crash left Studebaker without working capital to meet its obligations to its suppliers and bankers.[30] Furthermore, financial arrangements made during the White deal had boxed Erskine in. Six months earlier, Erskine had agreed to the condition that outstanding notes in connection with the White deal would be paid off before any further debt was accrued by Studebaker.

Erskine became frantic in his quest for additional capital. He estimated that a loan of only $20 million would tide the company over. But where to get such a loan? In early March, he personally traveled to New York to implore investment houses to approve a loan. As he later told his board of directors, he met with "every" New York bank seeking credit to carry Studebaker over through October. Finally, after a series of brutal confrontations with bankers, Erskine admitted fail-

ure. The conditions asked by Chase National Bank and Chemical National Bank were simply too harsh. Four days later on March 21, Studebaker was placed in receivership.[31]

The announcement of bankruptcy shook the industry. As the leading trade journal of the industry, *Automobile Topics*, observed, "All this befell with the suddenness of an earthquake."[32] Studebaker's total indebtedness stood at $7.1 million, a rather modest amount. The real problem was cash flow. Net assets—including that elusive accounting category "good will"—were $77.6 million in excess of liabilities. Furthermore, Studebaker common stock stood at a solid $16.22 per share at the time that the receivership was announced. In many respects, the bankruptcy was only technical, but it was, nonetheless, bankruptcy.

The anouncement shocked South Bend. Throughout the city "there was one topic of general interest. . . . On the streets, in hotel lobbies, stores, factories, offices, everywhere people talked of one thing—the Studebaker Corporation."[33] The bitterness of bankruptcy was especially acrid to Erskine when he realized that the federal judge appointed to oversee the receivership was Thomas W. Slick, a longtime enemy of Erskine's.[34] Erskine expected to remain as president, but Slick would have none of it. He appointed Paul Hoffman, Harold Vance, and A. G. Bean, the president of White Motors, as trustees.

In the following months Erskine's problems deepened. In late March it was revealed that he owed $732,000 in back taxes.[35] Forced out of the presidency, deeply in debt, suffering now from both diabetes and a heart condition, Erskine broke. The once gregarious man now fell into a deep depression, cutting himself off from his friends and former associates. On June 30, Erskine surprised his wife by organizing a small dinner party for her family and his adopted son. He appeared to be in good spirits throughout the meal. Shortly before retiring at 10:30 that evening he told his wife that he would skip breakfast the next morning, but would like to have his son meet him at 9:30 A.M. The next morning, Erskine woke early. After scribbling several notes at his desk, he phoned his wife's sister to come to the house. He then phoned Hoffman and spoke to him approximately thirty minutes. He rose from his desk, went into the bathroom, closed the door, wrapped a handgun in a towel, and then fired a single bullet through his heart. Erskine died instantaneously. His son found a note which read, "Russell: I cannot go on any longer. Devotedly, A. R. E."[36]

Paul Hoffman and Harold Vance Revive a History

Paul G. Hoffman and Harold S. Vance, appointed in 1933 by Federal Judge Thomas Slick of District Court 5 to revive the fortunes of

the Studebaker Corporation, present a study in sharp contrasts. Paul Hoffman, the ever-optimistic salesman, a Studebaker dealer-distributor who became a millionaire by the age of 34, gained national prominence as a spokesman for business progressivism in the 1930s and 1940s, a time when relations between government and business were often strained. Harold S. Vance cut a much different figure. A production man *par excellence*, Vance began his career at the age of 15 as an apprentice mechanic at the EMF plant in his hometown of Port Huron, Michigan. From there, over the next two decades, he worked his way up through the ranks of the Studebaker Corporation to become vice president of engineering.[37]

Working in adjacent offices, Hoffman and Vance equally divided the responsibilities of running a corporation whose future appeared uncertain at best. Hoffman headed sales and public relations, while Vance took charge of production. Hoffman and Vance formed a unique working relationship in an industry notorious for its egocentric (and eccentric) personalities.[38] Hoffman and Vance were not close friends; they rarely socialized outside of the office. Still both had risen under the watchful eye of Albert Erskine and had come to share his vision that what distinguished Studebaker from other automobile manufacturers was a unique relationship between management and labor.[39]

To revive the company, Hoffman and Vance called upon a history—constructed by the Studebaker brothers and Albert Erskine—that spoke of management and labor forming a cooperative partnership. Hoffman and Vance now undertook to extend this historical vision to include organized labor. While the Studebaker brothers and Erskine had actively resisted unionization, Hoffman and Vance welcomed unionization at Studebaker by the Auto Workers Union.

During the depression, Hoffman and Vance willingly entered into this new world of formalized contractual relations between labor and management—a world far different from the paternalism of the Studebaker brothers or Albert Erskine. No doubt, this accommodation to organized labor in the 1930s was a matter of economic necessity, but it also reflected a sincere belief held by Hoffman and Vance that management and labor had a mutual interest in the fate of the corporation. Vance and Hoffman remained certain that if they could convince Studebaker employees to sacrifice, the corporation could be saved. As a consequence they sought to boost the morale of their workers by promoting the reciprocity of interests between management and line workers. If Studebaker employees joined them in saving the company, Vance and Hoffman promised that their efforts would be rewarded. As Vance later told union leaders, "You help us get this plant going, and if we do, we won't, as Company people, forget the employees who brought us through the rough times."[40]

While Vance remained the dominant force within the factory, Hoffman was called upon to articulate the Studebaker vision to shareholders and the larger public. He argued that "one of the most dangerous thoughts ever advanced" was that the corporation is the extension of top management. To believe this was "to live in the shadows" of a doomed corporation. "It is the philosophy of the Studebaker management," he believed, "that we are trustees not only of the cash given us by our stockholders, but also the abilities of the men and women who serve the company." Our belief is that "a friendly atmosphere brings forth the best there is in men [and women]. It so happens that friendliness has been the tradition with Studebaker since 1852."[41] In short, cooperation paid real dividends for the corporation. He offered to the corporation the slogan, "Studebaker Is America's Friendliest Factory."[42]

Hoffman succeeded in selling his message to his employees. Paul Hoffman always remained P. G. (while Vance remained "Mr. Vance") to the workers at Studebaker.[43] That Hoffman achieved a harmonious relationship with labor throughout the depression and the war reveals, depending on one's perspective, either the foibles of management or the rich opportunities for cooperation between management and labor within the American industrial system. However one judges the history of the Studebaker Corporation in these years, Paul Hoffman believed that he was pursuing a course of enlightened self-interest. As one of the nation's most articulate spokespersons for business progressivism, he maintained a firm faith that his policies offered a functional approach for managerial relations with labor. His acceptance of collective bargaining, unemployment insurance, pensions, and limited government regulation within the automobile industry set him apart from the majority of other executives in the industry. While Hoffman espoused cooperative relations with labor, he remained a strong advocate of the free enterprise system. Although he felt that free enterprise was in "greater danger from business reactionaries than it is from communists," he remained critical of what he considered excessive New Deal interference in the automobile industry.[44]

Through his public pronouncements and frequent speaking engagements, Hoffman gained a national reputation as a businessman of moderate and enlightened views. Through his association with Maurice "Tex" Moore, Studebaker's corporate counsel and the brother-in-law of Henry Luce, the founder of *Time* and *Fortune* magazines, Paul Hoffman carefully shaped his public image.[45] The depression brought out the worst in many auto executives, especially those of the earlier generation; for Hoffman it brought forth his best.[46]

Whatever their intentions, however, in 1933, Paul Hoffman,

Harold Vance, and the president of White Motors, Ashton Bean, acting as trustees of a company in bankruptcy, faced an unparalleled crisis.[47] The receivership proved to be unique in a number of ways. First, Judge Slick's appointment of Hoffman and Vance, close associates of Erskine's, suggested that the company was fundamentally sound. Moreover, Judge Slick immediately approved the release of funds for Hoffman to undertake an advertising blitz informing the public that Studebaker was still in business. This ensured that Hoffman would be able to keep the dealer organization basically intact.[48] By April the Studebaker assembly line was running again, with about nine hundred workers called back. On April 2, local newspapers reported that over 65,000 people turned out to watch a five-mile parade demonstrating South Bend's support for Studebaker. As one paper said, the "leaden skies and raw bitter wind" did not prevent "the greatest civic outpouring in the history of the city."[49] As April drew to a close the corporation actually showed a profit of $20,000.[50]

The reopening of the South Bend plant, as one observer noted, sent "a wave of fresh optimism over the city and gave general business its biggest boost since the Roosevelt administration started firing its emergency legislation at startled congressmen."[51] With unfilled orders for about a thousand cars, the plant had resumed limited production. Still, the major problem remained a lack of capital. Although the Studebaker plant was valued at an estimated $46.8 million, the company was in dire need of cash. In March 1933 Hoffman reported that cash on hand stood at only $300,000. Hoffman and Vance moved to cut expenses, consolidate manufacturing, and raise additional capital through the sale of Pierce-Arrow. Working with an eastern financial group headed by George F. Rand of Marine Trust, Hoffman sold Pierce-Arrow for one million dollars in cash. Five years later Pierce-Arrow produced its last car.

Even with these efforts, the company remained desperately short of capital. Hoffman now directed all his energy to raising capital in eastern financial circles. At first results were disappointing. Hoffman's cause was helped considerably when an audit conducted in April 1933 by the accounting firm of Sanderson and Porter concluded that Studebaker was "fundamentally sound." With a break-even point of 65,000 cars and capacity to produce 150,000 units, the report maintained that Studebaker could compete in every price field except the lowest.[52] Following the report, Slick released an additional $700,000 for retooling. With the Sanderson-Porter report in hand and the way cleared by the courts, Hoffman traveled to New York to seek the aid of the company's longtime backers on Wall Street, the Lehman Brothers.

Joined by Maurice "Tex" Moore, a partner of the prestigious law firm Cravath and Associates, Hoffman opened negotiations for a

new loan backed by a specially formed banking syndicate headed by Lehman Brothers.[53] Impressed by Hoffman's energy and personality, as well as the Sanderson-Porter audit, this syndicate coordinated the rechartering of Studebaker as a new corporation under Delaware law.[54] The deal put together by the syndicate called for the establishment of a new corporation backed by $6,867,698 of ten-year, 6 percent notes. At the same time 2,138,299 shares of new stock were issued, which absorbed all outstanding preferred stock.

In the process of writing the deal, White truck stock was sold separately. In 1935 the directors of White appointed Robert F. Black as president. With a background in trucking dating back to 1910 when he had gone to work for Mack trucks, Black designed and developed a new truck that put White into the forefront of truck production. On the way, as one wit remarked, "Black took White out of the red."[55]

The Hoffman-Vance team had accomplished what appeared to many to be a miracle. As Frederick Fish, who had come out of retirement to play an active role in the reorganization, noted, "We did not have a cent in cash when the receivers took charge, and we had held our organization together."[56] When Hoffman arranged with Farmers Trust, Marine Midland, Chase National, Commercial National, and Guaranty Trust to have debtor claims dropped by over 20 percent, over $20 million in debt had been removed from the books.[57] Moreover, Studebaker had been able to put close to $6 million into its working cash account. Studebaker remained woefully undercapitalized.

On March 9, 1935, Studebaker was discharged from receivership. Now it was up to Hoffman and Vance to see what they could accomplish. As the *Journal of Commerce* observed, "Reorganization alone will not solve all of Studebaker's problems. The role of the medium priced car maker in today's highly competitive market is not a simple one."[58]

Hoffman Welcomes the Union and Revives the Company

In the bitter years of the depression, when labor and management in the automobile industry often confronted one another in fierce and often violent struggle, Vance and Hoffman proved to be unique in their approach. For this they received loyalty from their employees and praise from organized labor. These were the golden years of industrial relations at Studebaker. Clearly, Hoffman and Vance's vision distinguished Studebaker from other producers.

Hoffman and Vance understood the importance of maintaining a loyal workforce. In 1933, however, they encountered a workforce no longer confident in Studebaker management. The onset of the depression had undermined Erskine's industrial welfare programs. As layoffs

occurred, Studebaker tried to ensure worker loyalty through company relief measures that provided employees with baskets of food, coal, and land allotments on company-owned land in Barrien Springs, an agricultural area in Michigan just fifteen miles north of South Bend.[59] The building of an indoor recreation facility shortly before Christmas in 1933 (complete with basketball, volleyball, and handball courts, a rifle range, and a lounge with billiard tables and table tennis) did little to address the more pressing problems faced by Studebaker employees in the first days of the depression.

Relief measures and sports programs proved to be poor substitutes for better wages and guaranteed employment. For example, as the company was reorganized, workers found that they could be laid off without notice. And, as economic conditions worsened, foremen reasserted their power on the shop floor that had been relinquished to the Cooperative in the 1920s. Foremen now assumed full responsibility for hiring. Each morning displaced workers would gather outside the factory gates hoping to be reemployed even for a day. Some foremen took advantage of the situation by insisting on "kickbacks" once a worker was given a job. Moreover, shop workers were arbitrarily dismissed at any hint of complaining.[60] Although wages had risen following the crash in 1929, workers found the work exhausting. As one worker recalled, "You had to work like a machine only you didn't break down as often."[61] Workers were not allowed to leave the line for a drink or to use the restroom until the noon break or until the close of the workday. Such conditions were ripe for unionization.

The enactment of the National Industrial Recovery Act (NIRA) that recognized the right of workers to organize brought new life to organized labor in the auto industry. Until the NIRA, the history of unionism had been one of dismal failure directly attributable to timidity on the part of organized labor and fierce obstinacy on the part of management.[62] With the NIRA's enactment the American Federation of Labor, which had completely abandoned the auto industry in the 1920s, sent organizers to recruit autoworkers. These organizers often found their greatest successes among the independents, like Nash, Studebaker, and White.

Like other autoworkers, Studebaker employees remained generally unfamiliar with the traditions of unionism. Talk about forming a union first began in the metal finishing department.[63] Here, as one early unionist recalled, workers were "bumping elbows and waiting on each other to get their operations done and talking union pretty much at the same time." Similar talk branched out to larger departments in the factory. Still the going was slow. Workers heard rumors about the union, but often interested workers simply did not know whom to

contact concerning the location and time of meetings.[64] Finally, in June 1933, enough workers had enrolled in the union for the AFL to issue a charter to Studebaker Local 18310.[65]

The first meetings took place in the AFL Hall above the South Shore Railway Station. There, a little over half a dozen men met. From the outset the union confronted problems of leadership. Within the first year the local had gone through six presidents. Organizing proved too tough a job for most. Furthermore, Studebaker workers simply did not have a union tradition. As Lodia Richardson, a former coal miner who was called upon to take the presidency because of his union experience, later recalled, "You've never seen so many dumb people. These people here in South Bend, they were so dumb about unions that it was pitiful." They did not know how to set up and run a union, they did not know parliamentary procedures, and they did not know anything about the economics of the auto industry. In the end, after only a few months, a frustrated Richardson resigned as president.[66]

Richardson's place was taken by Russell J. Merrill. Merrill brought new life to the union. The son of a Methodist minister, Merrill proved to be an excellent speaker and union organizer. A high school graduate, with one year at a local teachers' college, Merrill had begun work at Studebaker in 1924. He completed the task that Richardson and others had begun. By the end of 1933 approximately 1,900 workers had joined the union.

In these turbulent days, Studebaker management played an important role in ensuring the local's survival. From the first talk about a union, Bill Studebaker, a son of Henry Studebaker and cashier of the company, had urged Hoffman to start a company union to head off the UAW, but Hoffman replied, "No. We're not going to start a company union. If the workers want to organize, let them organize."[67] Because of Hoffman's attitude, management earned the respect of the union. Indeed, some union members gave Hoffman a good share of the credit in ensuring the success of the union. As one worker said, "Hoffman was a pretty good fellow, you know. And I think he was on Roosevelt's side, the way he was talking. So when he said get organized, we did get organized."[68]

Both the vice president of production, R. A. Vail, and plant manager, Bert Fowler, were union-minded themselves and insisted that foremen not harass union organizers.[69] Nevertheless, the union experienced overt hostility from floor supervisors and foremen who opposed it. As one foreman told a union organizer, "don't ever let me catch you signing up anybody on company time. I don't care what you do during the noon hour, and I don't care what you do before work, and I don't care what you do after work. But when you're get-

ting paid and that bell rings, don't ever let me catch you talking to somebody about the union, and don't you ever let me catch you signing up anybody."[70]

When problems became too severe, however, the union always found Hoffman's door open. Hoffman made clear to the union his belief that "if the foreman can't get along with working class people, he's no good."[71] Whenever the union got into a real jam, they would get it straightened out with top management.[72]

Still, in late 1934, union membership began to decline. Management's accommodation with the union had not led to a contract or an increase in wages. Without wage gains members fell to only 400 by April 1934. Concerned with the very survival of the union, the organizing committee responded in a peculiar fashion that tells much about the management of Studebaker in these years. One unionist described the events: "The first thing we did was to go to management and explain to them just what the most critical wage problem in the shop amounted to. . . . " Management agreed to inform their employees that wage increases were impossible under the conditions, but this was not the fault of the union. Later that year, however, management met with the union and granted a wage increase of five cents an hour.[73] This so revived the union that by 1935 the plant was nearly a hundred percent union. The informal arrangement between management and the union had drawbacks, though. Management continued to resist signing a formal contract, insisting that arbitration and negotiation were to be handled on a personal, direct contact basis.

The union's favored status under Hoffman gave the Studebaker local a larger role in the national affairs of the UAW than its small numbers might have warranted.[74] Because the Studebaker local was among the first to be given federated status in the AFL, it took on an advanced character in terms of union consciousness.[75] Isolated for the most part from AFL leadership in Detroit, Studebaker unionists remained nearly autonomous in conducting their internal affairs. As one leader declared, "We run our union to suit ourselves."[76]

Indeed, Studebaker's Local 5 quickly aligned itself with the "progressive" faction within the AFL. When the Congress of Industrial Organizations split from the AFL at a national convention in the fall of 1935, Studebaker's Local 5 quickly joined the walkout. The United Auto Workers' (CIO) next convention was appropriately held in South Bend.[77]

There was a certain irony in Local 5's reputation as a militant local. Within their own corporation, Local 5 remained generally moderate toward, and even dependent on, Studebaker management.[78] Indeed, at the 1936 convention UAW leaders urged their members and the

public to "buy Studebaker." The UAW claimed that Studebaker management was the most enlightened in the motor industry.[79]

Employees who had gone through the receivership felt a deep loyalty to Studebaker.[80] This relationship paid added dividends for Hoffman and Vance. In 1935 they secretly arranged with the UAW to exclude Studebaker from a threatened industry-wide strike. Peace with labor did not come cheaply, however. Studebaker wages were the highest in the industry, while output on the line was close to 10 percent lower than the industry-wide average.[81]

While cooperating with labor, Hoffman and Vance sought to instill loyalty within the executive management. The Studebaker team, the local newspaper noted, was aggressive, for the most part young, and composed of "hard-hitting businessmen who are convinced that the Studebaker tradition and the Studebaker products are on their way to greater success. . . . "[82]

In engineering, Hoffman had some of the best engineers in the country, including the abrasive, but brilliant, Barney Roos and William S. James. In the factory Hoffman could count on R. A. Vail, a mechanical engineer who had begun his career with Olds in 1904. The salaries for these men ranged from $8,000 for the lowest vice president in sales to $20,000 for engineers such as Vail and Roos. These salaries contrasted sharply with Hoffman and Vance's salaries of $41,428 each.[83]

Creating a cooperative spirit was only part of Hoffman and Vance's strategy to revive the company. Realizing that production costs needed to be lowered, they closed the forge shop in 1935 after determining that most of the equipment was obsolete. The closing of the forge meant that Studebaker would now rely on outside suppliers for such parts as fenders, clutches, and body stamping.[84] At the same time, entire buildings were abandoned and then demolished to reduce fixed costs. Other expenses were cut by consolidating secretarial and other support staff. By late 1935 Hoffman was able to report that the plant's operating expenses and administrative costs had been substantially reduced.

Realizing that the receivership had inevitably demoralized even the most loyal Studebaker dealers, Hoffman and Vance also sought to bolster dealer morale through a series of meetings held in late 1934, even as negotiations were being conducted with the New York banks for refinancing the corporation. Studebaker arranged for over 2,000 dealers to meet in Chicago for a three-day "strategy planning" session. Following the meeting, Studebaker announced plans for the "new" Studebaker: "New engineering, new styling, new performance, new effortless control—that's the new Studebaker for 1935."[85]

The new Studebaker look entailed introducing a completely new body shell for the President. The President had been redesigned to attract buyers in the moderately priced field. Studebaker also introduced a Land Cruiser modeled in part on Pierce-Arrow's "Silver Arrow," also aimed at the middle-priced market. For the lower end of the market (under $1,000), the company provided the Studebaker Six, Dictator Six, or Special Dictator Six.[86] The following year, Studebaker engineers, under the guidance of Barney Roos, introduced a range of new engineering features that immediately caught the public's attention. Roos's engineers had remarkably incorporated engineering innovations into the Studebaker line, while design and retooling costs were kept to a minimum.[87]

In the summer of 1936 Roos resigned from the company to join the Rootes Group in England, where he quickly emerged as a key designer in their revitalization program.[88] Roos's place was taken by William S. James as chief engineer working under the direction of Roy Cole, vice president of engineering. That same year Hoffman hired French designer Raymond Loewy as a consultant. Studebaker engineering reinvigorated sales, and with it, dealers' morale. By the end of 1936, the company could report sales of 91,999 cars and trucks for the year. This put the company in the black for the first time since 1931. A new spirit of "optimism and enthusiasm" was evident at Studebaker. By 1936 applications for dealerships were up and demand was outrunning supply. In turn export sales were up 8.7 percent from the previous year.

Conditions had so improved that Hoffman and Vance began the construction of a new assembly plant in Los Angeles.[89] In early 1937 the *Wall Street Journal* reported that Studebaker was discussing the possibility of calling in nearly 7 million dollars worth of its 6 percent debentures in order to force their conversion into common stock. In the end, Studebaker decided against this action, but the very discussion indicated that the corporation had turned the corner.[90] One industry journalist reported that "Hoffman looks like a cat who swallowed the canary."[91]

Hoffman's exuberance carried well into 1937. At the directors' meeting in January, Hoffman reported that the cash balance had risen from a little over $5 million to $7.1 million. Still the company was not fully out of the woods. Hoffman noted that much of the plant equipment, particularly in the engine department, was old.[92] To address these problems, Hoffman told the board, $800,000 in new equipment must be ordered immediately for the engine department. Hoffman also warned that it would be impossible to hold 1937 expenses to 1936 levels. Salary raises were in order, and the newly enacted Social Security Act entailed additional wage costs. These new

costs placed the corporation in a dilemma: Increased costs should entail increased prices, but prices could not be increased if the company was to remain competitive. The "only alternative," Hoffman felt, was "to increase volume."[93]

At this point Hoffman and Vance made a bold decision: They gave the go-ahead to develop a new model. Their decision was a clear gamble: On the line was Studebaker's survival.[94] Shortly after reorganization in March 1935 work began on a new car designed to compete in the low-priced field. What emerged in 1939 was the Champion.[95]

As the Champion was being developed, Studebaker confronted declining sales beginning in the second quarter of 1937 that continued into the following fall. A nationwide recession beginning in September 1937 only added to Studebaker's troubles as national auto sales fell nearly in half. As a consequence total net sales for Studebaker declined nearly $20 million from $91 million in 1936 to $70 million in 1937. In these conditions, Studebaker's rivals—Packard, Chrysler, Nash and DeSoto—lowered prices, which further cut into Studebaker's market.

In the midst of this downturn, Hoffman confronted what he described as "our first labor trouble during the eighty-five-year history of Studebaker."[96] The trouble occurred within the context of the Flint sitdown strike against General Motors in late December 1936. For two months the workers at the Chevrolet and Fisher body plants in Flint had held out for union recognition, when they finally brought General Motors, the nation's largest corporation, to the negotiating table. This militant action inspired workers throughout the country, including those at Studebaker who prided themselves on having formed one of the first UAW locals. On May 19, 1937, the Studebaker UAW initiated a walkout that closed the entire plant. Their demand was simple: they wanted a union contract.

Two days after the walkout an agreement between management and labor was formally reached, calling for a collective bargaining agreement. In a closed meeting with the board, Hoffman reported that after "seemingly endless negotiations with union authorities, an agreement had been reached." Hoffman felt that while production had suffered, "in the last analysis it was not all loss in as much as . . . this was probably the finest working agreement with labor in the industry." Hoffman also reported that the union had admitted that the strike had been unauthorized and probably did not enjoy the full support of the entire workforce. Still, Hoffman agreed to a new grievance procedure, a 10 percent night shift premium, time and a half for overtime, and a new seniority system. A unique feature of the agreement was that either party after thirty days' written notice could reopen the contract.[97]

The contract marked an advance in industrial relations at Stude-

baker. Still without a developed industrial relations staff, labor contracts were open to liberal interpretation by the union, especially in matters related to labor standards and workers' rights.

Most notable in this regard was the union's determination of "bumping rights." Prior to 1937 Studebaker allowed a laid-off senior worker to displace *the* employee with the least seniority. Under the new contract this right was to be interpreted by the union as allowing the displacement of *any* worker with less seniority. The issue of "bumping rights" did not become an immediate problem, but in the postwar period, especially in the competitive decade of the 1950s, the issue of bumping rights became a point of continued contention.

New industrial relations had come to Studebaker, but Hoffman and Vance continued to run the company as they had in the past—informally and personally. This allowed the union to define labor standards, job rights, and grievance issues in their own terms. In short, Hoffman and Vance preferred to allow the union to have responsibility on the shop floor. Without countervailing pressure from management, however, and with the growth of factional politics within the union following the war, the union simply could not represent the general interests of the company while protecting its own constituency. Still, Hoffman and Vance had refrained from using union-busting techniques.[98]

Studebaker Becomes a Champion

Clearly by early 1938 Studebaker appeared on the rebound. Studebaker's position in the market rose in 1938 from thirteenth to tenth, even as overall sales in the industry dropped. This success allowed Hoffman to tell reporters that the company was well positioned to take advantage of any upturn in the economy. Such talk was more than wishful thinking on Hoffman's part; he had a major card to play, a trump carefully concealed in the form of the Champion. When introduced in 1939, the car became an instant winner.

The Champion was designed to compete in the low-priced field.[99] Entering the low-priced market at this time was clearly a gamble. The recession in late 1937 had cut heavily into the company's working capital. Speaking to the board of directors in April 1938, Vance warned that with a working capital of only $10.8 million and projected tooling costs for the new model estimated at over $3 million, the company was exposed to a potentially "great embarrassment should unexpected paralysis of sales shut off income." Still, he told the board, "the circumstances of the past six months and prospects for the future impel us to depart from the more prudent course that we would have preferred."[100]

The job of designing this new low-priced car—a car that was both light and economical, but still provided the low-priced car owner with all the power, performance, and style he or she was accustomed to— fell to Roy E. Cole and his band of engineers, who set up shop in the deserted Rockne plant in Detroit. Styling was handled by Raymond Loewy, a Parisian-born designer who had made his reputation first in fashion and then in industrial design. A pioneer, Loewy had gained fame for his designs for Greyhound, Trans World Airways, and the Pennsylvania Railroad.

Joined by Barney Roos's successor, W. S. James, Loewy took three years to design the Champion.[101] Over one million dollars was invested in its engineering. Unveiled in 1938, the Champion was everything it promised. It weighed from 500 to 650 pounds less than any of the Big Three models, while having from 10 percent to 25 percent more fuel economy. Loewy's sleek design highlighted a chromium grille and streamlined body. The interior was roomy, with broadcloth upholstery and a new climate control system.

The car proved to be an immediate hit with the public. Within the first year (1939) over 72,000 Champions were sold. The factory went to a five and a half day week with an additional 1,500 new workers hired, bringing the total to 7,000 employees.[102] By 1940 Hoffman was able to restore managerial salaries that had been cut in 1937, inform-ing the board that "it is important that a high morale be maintained." Equally important, Champion sales increased consumer interest in Studebaker's higher priced Presidents and Commanders.[103] In turn, in-creased production allowed Studebaker to lower its overall costs in manufacturing its new line.

By 1940 Studebaker had moved from tenth in sales to eighth, hav-ing gained 2.4 percent of the market. (Much of this gain came at the expense of Hudson, whose share of the market fell to 1.85 percent.) The depression had forced many out of business, but Studebaker had survived. Studebaker's recovery seemed complete.[104] By the close of 1939, Hoffman could claim that Studebaker was the largest of the independents.

The company's future again looked bright, even though as one Studebaker employee put it, "they had been shook." Vance and Hoff-man had brought order to Studebaker. They had revived the company by calling upon a tradition that spoke of cooperation between man-agement and employees. Tradition, even as it was translated into terms that accepted unionization, collective bargaining, and contracts, had been preserved.[105]

Studebaker Merges with Packard, 1941–1954

Tradition Broken

As World War II drew to a close, Paul Hoffman and Harold Vance looked to the future with confidence. History seemed to be on their side. World War II had replenished the company's coffers, and the postwar automobile market appeared ready to ignite, fueled by a backlog of pent-up consumer demand. Furthermore, while the other automobile companies during the war experienced periodic wildcat strikes that portended ill for the future, the Hoffman-Vance regime had established harmonious industrial relations at Studebaker. This had been accomplished by offering their employees high wages, good benefits, and favorable working conditions. This, they said, was the Studebaker way.

World War II brought prosperity to Studebaker as defense contracts allowed the company to replenish its coffers. The rapid expansion of Studebaker's workforce changed the composition of Local 5. The result, which became fully apparent after the war, was the growth of factionalism within the union. As a consequence, relations between management and the union changed in ways not readily evident during the flush years of the war. Studebaker's strategy of continuing a high-wage policy, while not enforcing production standards, hid many of the problems created by the war.

In short, the strategy paid off—at least initially. Reconversion plans, first laid in late 1943, allowed the corporation to jump in on the postwar boom by introducing the first newly designed model on the market. While labor strikes stymied their Big Three rivals, Studebaker and the other independents increased their market share nearly 50 percent in the immediate postwar years. By 1950, independents accounted for nearly 22 percent of the market, well above the 9 percent held in 1941.[1]

The prosperity during the war years and the immediate postwar period imparted an illusion that all was well at Studebaker. Even as the automobile market had become further concentrated in the 1930s, Hoffman and Vance believed that they could go toe-to-toe with the Big Three by pursuing enlightened industrial relations with organized labor. During the war Hoffman and Vance allowed costs to escalate. A similar situation occurred among the Big Three, but unlike Studebaker, the major producers were willing and able to incur the costs of a major strike in their attempt to get cost back in line. Studebaker's management, however, could ill afford a strike. The logic of management's ideology dictated friendly relations with labor. Moreover, such a strike precluded rapid entry into a boom market. Also, the chronically undercapitalized company simply did not have the resources to sustain a long walkout.

Once having decided to pursue a liberal wage policy and costly production standards created during the war, the company's only recourse, if it were to remain competitive, meant modernization of its plant and production facilities. Concerned with maintaining the value of the company's stock, the directors, acting against Vance's advice, decided against investing the capital necessary to modernize Studebaker's antiquated plant. The mistake proved fatal.

The outbreak of the Korean War in 1950 and the ensuing battle between Ford and General Motors for dominance in the market in 1951 left Studebaker (and the other independents) vulnerable to even minor fluctuations in sales. Confronted with rapidly declining sales and a shrinking share of the market, Studebaker was forced to consider combining forces with Packard. Hudson and Nash had set such an example when they merged in May 1954 to form American Motors. To strengthen their bargaining position Studebaker's management was forced to undertake the once unthinkable: a confrontation with the union over wages and production standards. In 1954 as negotiations opened with Packard, Hoffman and Vance battled labor within Studebaker. In the process, the Studebaker tradition was shattered, even as the Hoffman-Vance regime continued to hold rhetorical claim on it.

Studebaker Enlists in World War II, Only to Battle after the War

Even before America's entry into the war, Hoffman and Vance traveled to Washington to procure government defense contracts. The outbreak of war in Europe had severely damaged export sales. Moreover, rising material costs cut into profits even while sales continued to increase. As a consequence, Hoffman sought to place Studebaker at

"the disposal of the government with a view to fitting into national defense in the most effective manner."[2]

His lobbying efforts soon paid off. In the fall of 1939 Studebaker won its first defense contract to build military trucks for France. Shortly afterward, Vance was selected to serve on the advisory committee to the Council of National Defense, established in the spring of 1940 by Franklin Roosevelt to increase defense production.[3] Vance's appointment brought further opportunities for the corporation. Four years later, William S. Knudsen, chairman of the Council and president of General Motors, approached him to discuss the possibility of Studebaker producing the Wright 2600B engine to be used in the new Flying Fortress bomber. Behind schedule in its production of engines for the army and British programs, Wright was willing to license Studebaker to build 6,500 engines for them.[4]

Although Hoffman had been an outspoken critic of the government's efforts to curtail civilian production, even going as far as to ridicule in a national radio address the proposal that the government could produce 500 planes a day, he leaped at the contract with the Army Air Corps to build the Wright "Cyclone" engine. The contract called for the building of a $50 million plant with 21 acres of floor space to be constructed on Chippewa Avenue on the southside of South Bend. Construction of the plant began in January 1941 and the factory was in full operation by June 1942. In addition to the southside plant, the Defense Plant Corporation agreed to bear the costs of constructing new plants in Fort Wayne and Chicago to be used in engine production.[5]

In June 1941, the same month that Germany attacked the Soviet Union, construction began on the new Chippewa Avenue plant. Studebaker then received a contract to build military trucks for the Red Army. That fall the army assigned a third major contract to Studebaker—the designing of a new amphibious vehicle nicknamed "the Weasel." Hoffman told the board that even though the government had imposed quotas that curtailed civilian auto production by 20 percent, the corporation was in a "reasonably secure position because of defense contracts for trucks and airplane engines."[6] The Japanese attack on Pearl Harbor brought an end to civilian auto production. Production of passenger cars halted at 3:35 P.M. on January 31, 1942.

With the war came increased defense contracts and increased profits for Studebaker. The contractual arrangements with the military ensured profits for the corporation. Studebaker became one of the first corporations to enter into a government defense contract on a "cost plus a fixed fee" basis. This arrangement called for a fixed profit plus final costs of production and had been developed by the military to protect a company from the inflationary costs of materials during war-

time. The consequence of this arrangement for Studebaker was that management paid less attention to production costs. The guarantee of fixed profits, only determined after final production costs, did little to encourage management to watch production standards or manpower.

Moreover, to ensure stable labor relations, the company pursued a policy of accommodation with organized labor. In June 1941 Studebaker announced an eight cent hourly wage increase to its workers. Hoffman stated the wage accord was within "the Studebaker tradition." For its part, labor enthusiastically welcomed the agreement. *Labor News*, the official newspaper of Local 5, reported, "It [the agreement] again adds proof to the wonderful employer-employee relationship deservedly so highly approved of throughout the nation." The paper added, "Studebaker officials and the union prefer the way of peace."[7] By the end of 1941, piece workers were earning 9.8 percent above their base rates, well above the industrial average. More importantly, administration of labor standards, grievance procedures, and contractual rights largely fell to the union acting through its shop stewards.[8]

The composition of the union itself was changing. The rapid influx of new workers into Studebaker transformed the company. By the end of the war, Studebaker employed over 26,000 workers. Recruited from throughout the country, these workers felt little loyalty to the company. Nor did they share the union's tradition of cooperating with management. In turn, management lost touch with its employees. As one union leader later recalled, "They [the management] lost not only their push for quality, they lost their close contacts with people."[9] Furthermore, Studebaker hired on a two-tier system, hourly employees and piece workers. Disparity in wages between the two classifications created tensions. In 1944 Vance succeeded in getting the War Labor Board to agree to increase piece rates to equalize earnings, but the tensions created between the different classes of workers were emblematic of factional problems that were to develop after the war within the local.

Military officials expressed more concern with labor costs than did management. One labor leader remembered that military officials were everywhere. "You had generals comin' in tryin' to tell you how to run the machines—never saw a machine in their life . . . they made life miserable for the company and us." Concerned with work standards, the military proved especially hostile to the union, often encouraging workers not to join the union. Concerned with cost overruns, the Army Air Force finally proposed in mid-1943 that the contract with Studebaker be converted into a fixed-price contract. Vance responded immediately. In a lengthy three-page letter to the Commanding General in charge of procurement, Vance replied that the cost plus fixed

fee contract signed in January 1941 had worked well. The corporation had erected and equipped three new plants and had trained 15,000 workers for the purpose of bringing production of engines to 2,000 per month. He pointed out that the corporation had been willing to take a smaller profit margin under the cost plus a fixed fee contract to protect itself against inflated material and supply costs. The importance of this protection, he continued lest his point be missed, was that the monthly volume of engines was "approximately equal to the company's entire working capital, and even a small percentage of loss on such a volume would constitute a serious hazard to Studebaker's financial resources, even its very existence."[10] Vance's none-too-subtle point was not missed: the Air Force kept the existing arrangement.

Contrary to Vance's intimation, the company was not tottering on the verge of bankruptcy. Net earnings for 1943, including those charged to the government under the cost plus fixed fee contracts, totaled $364,119,211, as compared with $221,420,582 in the preceding year, an increase of 64 percent. Negotiations with the government had led to a mutual understanding that these earnings were not to be taxed as excessive profits. These earnings allowed the corporation to undertake substantial debt retirement, while increasing working capital. In 1943, debentures totaling over a million dollars were converted to 82,312 shares of common stock. Another $2.9 million in debt was redeemed in cash out of working capital. By December 1944 the corporation had increased its working capital to $26.3 million.[11]

Studebaker profited from the war, and in the process gained a reputation as a company that could get the job done. By the war's end, Studebaker had produced over 63,000 aircraft engines used in the Flying Fortresses, and close to 200,000 heavy-duty trucks, many of which were furnished to the Soviet Union. Indeed, "Studebaker" became a slang word for truck in Russian. The company's amphibious assault vehicle, the Weasel, saw action in Italy, the Normandy invasion, the Aleutians, and the South Pacific. War production had amounted to $1.2 billion.[12]

In early 1944 the War Department and Studebaker agreed to a predetermined plan to terminate military contracts. Appointed by Hoffman, Courtney Johnson headed a Studebaker team that negotiated final termination contracts with the military. Only 105 days after V-J Day, Studebaker had terminated all of its defense contracts; *Business Week* proclaimed Studebaker as the "model and pride" of contract termination.[13] Studebaker entered the postwar world exuding confidence.

Oligopoly characterized the automobile industry in the postwar era, even as new entrants such as Kaiser-Frazer, Tucker, and Crosley joined the industry, and independent manufacturers experienced a dramatic

increase in market share in the immediate postwar years. In 1948, for example, independents claimed over 18 percent share of the passenger car market. By 1950, however, the Big Three—General Motors, Ford, and Chrysler—had begun to reassert control over the industry. By 1955, Kaiser, Tucker, and Crosley had withdrawn from the industry, while the Big Three regained 94 percent of the market (General Motors 50 percent, Ford 22 percent, Chrysler 22 percent), leaving the remaining 6 percent to independents and imports.[14]

Competition occurred largely on the basis of economies of scale, which left the independents at a great disadvantage. Innovation became incremental at best, and the decision by the independents to abandon the small car market placed them in head-to-head competition with the major producers—ground they simply could not compete on for any length of time. Escalating labor costs, set by the United Auto Workers Union in its "industry-wide bargaining" agreement with General Motors in 1946, further hurt the independents, who had higher break-even points than the Big Three.[15]

General Motors emerged from World War II as the dominant force in the industry. In early 1941, Charles Erwin "Engine Charlie" Wilson replaced William Knudsen as president of General Motors. Under his leadership, General Motors made over 673 million dollars in after-tax profits, even while increasing productive capacity 50 percent. By the war's end, General Motors was set for a huge take-off. From 1946 through 1967, General Motors averaged a higher rate of return on its total assets—14.67 percent—than any other automobile producer. At the same time General Motors increased its share of the market from 40 percent in 1931 to nearly 50 percent in the 1950s. G.M., however, consciously stayed below 50 percent of the market to avoid an antitrust suit that could have resulted in the company's breakup.

As a consequence of this massive wealth, General Motors found it easier to accommodate organized labor in the postwar period. In the winter of 1945–46, the United Automobile Workers, led by Walter Reuther, entered into a bitter 113-day strike against General Motors. In prestrike negotiations Reuther demanded a 30 percent wage increase and a pledge from G.M. to hold the line on car prices. Reuther counted on G.M.'s eagerness to enter the postwar sellers' car market, but he failed to consider that G.M.'s intransigence would be reinforced by a wartime excess profits tax that in effect compensated for any loss of revenues that would come from a strike. This miscalculation led to a three-month strike that concluded with the union getting only an 18 ½ cent hourly raise. The direct cost of the strike to industry and labor was more than $1 billion. Furthermore, an ascending spiral of inflation ensued, as prices and profits roared upward.[16]

Meanwhile, Ford Motor Company embarked on one of the most

dramatic comebacks in corporate history under Henry Ford's grandson, Henry Ford II. Following the death of Edsel Ford in 1943, the eighty-year-old Henry Ford resumed the presidency of the company. Already a victim of two strokes, he fired his longtime associate Charles Sorensen and allowed Harry Bennett unprecedented power within the company. Corruption ran unchecked under Bennett, and only the appointment of Henry Ford II as vice president in late 1943 saved the company from further decline. In this family-owned firm, Henry II joined forces with his grandmother, Mrs. Henry Ford, and his mother, Mrs. Edsel Ford, to force Bennett from power in September 1945. Henry Ford II found a company losing $9 million a year. Understanding that dramatic action was needed, he lured Ernest R. Breech, president of Bendix Aviation Corporation, to Ford. Breech in turn hired a group of ten former air force officers, known as the "Whiz Kids," to overhaul the company's internal operations. By 1950 Ford had regained second place in the industry.[17]

Meanwhile, Chrysler's management remained steady under K. T. Keller, who had become president of the company in 1935. By 1940, when Keller became chief executive officer of the company following Walter Chrysler's death, one out of every four cars sold in the United States was a Chrysler. During the war Chrysler became a major tank producer. In the postwar years, Chrysler continued to excel in engineering, but its styling continued to lag under Keller's dictum of building roomy interiors to allow passengers to wear hats. Boxy and unattractive, Chrysler vehicles failed to excite the public in an era of sleek, stylish cars. When Keller stepped down in the fall of 1950, the company remained financially healthy, but increasingly vulnerable in a capital-intensive, fiercely competitive industry.[18]

The nature of the postwar industry was best captured in the inability of new companies to enter the industry. The most dramatic failure came when a former Studebaker salesman and small Detroit manufacturer, Preston Tucker, attempted to build a medium-priced, rear engine, high horsepower "Tucker." Although he received initial backing from the Reconstruction Finance Corporation and was able to raise approximately $7.2 million in franchises, he ran afoul of the Securities and Exchange Commission and left the industry.[19]

The most serious challenge to the Big Three came with the formation of Kaiser-Frazer in the summer of 1945.[20] The company became a success story overnight. Underlying its initial success, however, lay serious problems. With working capital estimated at only $6 million, the corporation continued to confront financial problems, but internal problems proved to be even more serious. The marriage between Kaiser and Frazer proved to be incompatible. Kaiser remained primarily a salesman; Frazer, the production man. And their staffs brought to

the company styles and outlooks that were not easily blended. The Kaiser men, "Orange-Juicers" as the Frazer men called them, brought with them a "go-ahead" spirit they had learned in the construction and shipbuilding industry. When Frazer called for retrenchment in 1949, following a bad sales year in 1948, Henry Kaiser replied, "The Kaisers never retrench." It marked the breaking point for Frazer, who resigned shortly afterward.[21] In 1954 the company left the domestic passenger car business, turning to the production of the Jeep in the United States and the "Peron" in Argentina.

The failure of Kaiser-Frazer revealed the problems of any independent challenging the Big Three. The postwar automobile market continued to be characterized by increased concentration by the Big Three, but for a brief period of time from 1946 through 1950, independent producers such as Studebaker prospered.[22] A set of circumstances, including rapid reconversion by the independents, a boom in auto sales, and a series of militant labor strikes that particularly affected the Big Three, allowed the independents to increase their share of the market to over 20 percent, double their prewar market share.[23]

As a consequence, production boomed. Annual production and profit figures in the period from 1946 through 1950 reached all-time highs for the independents. Hudson's annual production hit a high of 155,000; Nash's reached 190,000; Packard's 105,200; and Studebaker's annual production ranged between 70,000 and 268,000.[24] Supplier strikes and material shortages affected the independents as well, but they quickly accommodated organized labor. Moreover, independents showed they were far from complacent concerning their position in the industry. Although independents were later accused by their critics of not investing enough in production facilities, Studebaker alone increased its net value (property, plant, and equipment worth) 252.7 percent compared to General Motors' 207.7 percent and Ford's 252.4 percent. Only Chrysler increased its worth more by investing 363.0 percent.[25] Moreover, independents introduced automatic and overdrive transmissions prior to 1953, and Studebaker, following Ford's lead, installed an automatic line for machining engine blocks in 1950.

Studebaker Enters the Postwar Era

As Studebaker prepared to enter the postwar era, Hoffman told the press, "We'll have a chance to make our dreams come true."[26] Hoffman and Vance had prepared for an aggressive postwar program that called for the company to be the first to enter the market with completely redesigned postwar models. Both Hoffman and Vance felt that

the demand for automobiles in the postwar period should reach an "all-time high." In June 1944 the War Production Board gave its approval for retooling for limited passenger car production. At the same time, Hoffman and Vance announced the promotion of Ralph A. Vail as vice president of production, thereby freeing Vance from production duties. Although the summer saw 2,700 workers laid off with the final cancellation of the Weasel and truck contracts, Studebaker was geared up by the fall of 1945 to begin production of the Champion, based on the 1939 model.[27]

A smooth conversion to peacetime production meant nothing without an adequate sales system. Thus K. B. Elliott, vice president of sales, continued to press for additional funds to maintain his division. The sales budget had been cut by nearly one third, but Elliott warned the corporation that the "factory-dealer-owner relationship cannot be allowed to break down." Within the first year of the war 15 percent of the dealers had gone out of business.[28] As a consequence, Elliott initiated a series of conferences among dealers to maintain service facilities for Studebaker car owners. Even with these efforts, by 1944 only 70 percent of Studebaker dealerships were still in business. In early 1943, Hoffman made a crucial decision that fundamentally changed the distribution system. Intent upon increasing profit margins for his dealers, Hoffman decided to discontinue selling through distributors and begin selling directly to dealers. This policy proposed to provide greater discounts, while providing the home office with direct contact with the dealers. Most dealers welcomed this change, but later critics charged that distributors had served to unify sales, while boosting the morale of dealers.[29]

During the war, Studebaker continued to rely on Raymond Loewy to direct design work. Loewy selected Virgil Exner to head the South Bend studio. Under Exner a select group of designers came together, including Gordon Buehrig, well known for his design of the Cord and Auburn Speedster; Robert Bourke, who later designed the 1953 Studebaker; Holdon Koto, who left Studebaker at the end of the war to work for Ford; and John Reinhart, who later designed the Lincoln Continental Mark II in 1956. In early 1944 Exner, a man of immense ego, broke with Loewy, also known for his egotism. Exner was quickly hired by Roy E. Cole, head of Studebaker engineering, and was set up in his own separate design studio in the basement of his house, working parallel to Loewy's studio. In effect, Studebaker in these years had two rival design groups.[30]

In the spring of 1946 Studebaker revealed the "first genuine postwar" car, the 1947 Champion. Although Studebaker advertising credited Raymond Loewy with having designed the Champion, the man responsible for the car was Exner. Cole's gamble with Exner paid off.[31]

The 1947 Champion was striking in its design. Low-riding, with contoured lines that suggested speed, the Champion ushered in a new era in automobile design. Whether the public really accepted the new design remains debatable; nonetheless, in the sellers' market that characterized these years, Studebaker could not keep up with consumer demand. Net sales amounted to over $141 million. Hoffman looked forward to 1947 as "the year of fortune." Profits soared over the next three years. By 1950 Studebaker held over 4 percent of the market. Payroll increased to 23,000, with a second shift added in 1949.

Optimism ran high at Studebaker. "I don't see," Hoffman wrote Vance, "what can stop us from becoming the fourth biggest company in the field."[32] In these flush times, great expectations often gave way to illusion. Testifying before a congressional committee in late 1948 Vance declared that Studebaker had found a profitable niche within a highly concentrated industry. Even if Studebaker's business fell by more than 50 percent, he told the congressmen, Studebaker would continue to operate profitably.[33] Vance felt that Studebaker over the next few years could expect to gain 6 percent of the market. As Paul G. Hoffman's biographer later declared, "What now stands out most striking about Studebaker's postwar record is the disparity between contemporary and subsequent assessments."[34]

Vance realized that if the corporation was to maintain its place in the industry it needed to increase its capacity by approximately 100,000 cars, to 450,000 units. As a consequence, Studebaker's assembling capacity was increased. In early 1946, Studebaker converted its aviation plant to a truck assembling plant. The following year the corporation purchased the Empire Steel Corporation for $7.4 million. That same year Studebaker arranged with the Canadian government to purchase an aviation plant in Hamilton, Ontario. This plant, costing $3.5 million, offered Studebaker one of the most modern factories in Canada. In late 1947 the Canadian government had placed an embargo on imported cars, so Studebaker now had ready access to its largest foreign market. Seeking to reduce assembly and transportation costs for its eastern market, Studebaker purchased an assembly plant in New Brunswick, New Jersey, for $8.8 million in 1951. The corporation expected to save $75 per car, including freight and other costs.

The company's purchases, however impressive, failed to address a central problem for the corporation—modernization of its South Bend facilities. While the acquisitions program had expanded assembling facilities, Vance realized all too well that its production facilities were antiquated. Yet he confronted a dilemma: Modernization meant lower dividends and lower dividends threatened the value of Studebaker stock. Vance took his problem to a special meeting of the board of directors held in late 1949.[35] Vance opened the meeting by noting

that over the next three years the corporation needed to spend $60 million for major retooling changes. The industry was moving toward the V-8 engine and if Studebaker was to remain competitive, it needed to market the Champion with a high-performance engine. Vance concluded that the corporation had expended over $59 million in gross capital expenditures since the war, and because of this, there had been "a great improvement in Studebaker's position in the automobile industry." Still further expansion meant that the corporation should increase its working capital by $21 million to $70 million, Vance proposed that the corporation issue a 50-cent dividend for the quarter. Vance's advice went unheeded. The board unanimously approved a $1.25 dividend payment for the quarter.

A year later Vance again raised the issue with the board. Vance told his directors that the corporation had greatly improved its competitive and financial position. Nevertheless, Studebaker's sales of $473 million were only 22.7 percent of Chrysler's, while Studebaker's working capital of $56 million was well short of Chrysler's $149 million. Moreover, both Chrysler and General Motors were free of debt at the end of 1949, whereas Studebaker had an outstanding debt of $9.5 million. Vance warned that the final quarter looked "dim." Once again he urged the board to limit dividends. And once again, the board ignored Vance's advice and voted to pay out $1.25—the same as in 1949.[36] The board's decision not to modernize the South Bend plant was to have lasting—and fatal—consequences.

Meanwhile, other problems loomed within management and labor. By 1949 significant changes had begun to occur within the corporation's management team, beginning with Paul Hoffman's decision to head the European Recovery Administration in 1948. Although Hoffman offered to resign from the corporation, the board of directors insisted that he be granted a leave of absence.[37] In his place, Vance now became both chairman of the board and president.

When Hoffman returned to Studebaker five years later, he found a much changed corporate management. In the intervening years, key executives at Studebaker, many of whom had risen to positions of prominence in the corporation during the depression, had retired. During the 1930s Studebaker had been able to keep high quality executives who in other circumstances would have been attracted to better, growing companies. When these executives left after the war, they were often replaced by lesser lights, since in the postwar boom years, more talented people were attracted to Ford and G.M. Among those who left Studebaker were R. A. Vail, vice president of production; J. W. Hines, master mechanic; and Roy Cole, vice president of engineering. Studebaker promoted from within to replace these men, making Stanwood W. Sparrow head of engineering.

There is little doubt that these losses in engineering and production were particularly serious. Without Cole's political finesse in the engineering department, fierce battles erupted in the design department.[38] In turn, Vail was replaced by P. O. Peterson, a man whose history in the automobile business dated back to 1916 when he went to work at Buick (he joined Studebaker three years later). For all of his experience, however, Peterson failed to win the respect of workers on the line. As one union leader later put it, "Nobody ever took Mr. Vail's place. He was very, very intelligent and a very humane man, and a guy who knew his stuff like very few people ever did."[39]

Aside from the problem of modernizing production facilities, Vance also confronted a dilemma with labor. In pursuing enlightened management policies, considered necessary during the depression and war years, Vance had allowed labor costs to rise and production standards to fall. To have confronted these issues in the postwar period would have hindered Studebaker's rapid entry into the postwar auto boom and betrayed company tradition. Nonetheless, this unwillingness to confront labor costs and declining work standards hamstrung the company's ability to compete with the Big Three over the long haul. At the same time, Studebaker management acquiesced to labor on the implementation of work rules and production standards. This relationship occurred at a time when the union itself was becoming increasingly politicized by the changing composition of Studebaker's workforce.

Indeed, Vance often seemed more preoccupied with maintaining labor stability than he was with production costs.[40] He ignored problems related to deterioration of the incentive pay plan, overmanning, extensive bumping, and idle time allowances. These problems might have been addressed with proper administration of the union contract, but Studebaker management under the Hoffman-Vance regime refused to delegate labor problems to their industrial relations department. In turn, shop foremen and other supervisory personnel were not instructed as to the specifics of the union contract or points of interpretation. The availability of Hoffman and Vance to meet with union representatives contributed to the sense of cooperation at Studebaker, but it often short-circuited the small industrial relations staff and plant supervisors.[41] *Time* magazine quoted Vance as saying, "Committees call for compromise and compromise is not a solution. I solve the company's problems with men directly responsible for them. If anyone is at fault, I am to blame. . . . " *Time* observed that Vance seldom wrote a memo, but instead did most of his business by phone. Any worker, the article continued, can dial Vance at 496 on the company phone and hear at the other end, "Yes sir, Mr. Vance speaking."

Vance and Hoffman took pride in their workforce, often pointing

out that nearly one third of their workers were father-son/daughter teams and that the average length of service at the company was ten years.[42] For this reason the corporation felt their workers deserved high wages—the highest in the industry. In a letter to Studebaker employees in September 1947, Vance and Hoffman reported that Studebaker continued to be the only company still working under the piece rate system. Under this system, Studebaker paid the same base rate as Detroit, plus a premium for production. The piece rate system was designed to allow Studebaker workers to earn approximately 10 percent more than Detroit workers through premiums. In some departments, however, premiums were considerably higher, up to 50 percent over base rates alone.[43] Hoffman and Vance recognized that overmanning, a result of World War II labor practices, remained the major obstacle to efficient operations at Studebaker. They felt, however, that Studebaker could continue to pay above the Detroit wage scale through increased productivity. This meant reducing the workforce gradually by not replacing employees who left through normal turnover.[44]

This assumed cooperation with the union. The union for its part saw its role as protecting its membership. This meant negotiating the best contracts possible, resisting speedups, and protecting jobs. The union recognized that wages, labor standards, and employee rights were matters for negotiation. The problem was that management often did not understand its logical role in this give and take process. George Hupp, president of Local 5 from 1946 to 1947, recalled during his negotiations with management that "the Union expected resistance and did not get it." At certain points during the 1946 negotiations, "I wanted to reach across and grab them by the throat and tell them what they should answer." Our "entire bargaining committee, the stewards, felt that the company was too lenient."[45]

Union leaders, as elected officials, sought to serve their own constituents. And in this way they operated within a political world of their own. By 1946 union politics within Local 5 had changed with the expansion of the workforce during the war. The changed composition of the workforce was evidenced in the hiring of black and women workers. Before the war blacks were found exclusively in the foundry, accounting for about 10 percent of the workforce. During the war the union began to integrate blacks into other parts of the factory.[46]

Following the war the UAW continued to push for integration. In 1945 the first blacks were assigned to the assembly line. When a group of white workers protested, the union insisted that it was union policy that "people be given opportunities to make it on their own." The company's policy of recruiting blacks in the South, during and im-

mediately after the war, further increased the number of blacks in the company. By the 1950s blacks served as shop stewards and union officers.[47]

While some white workers complained about working with blacks, the union experienced little difficulty in integrating blacks into the workforce. This cannot be said about women. Women had long worked at Studebaker in the packing and sewing departments. During the war, however, about 2,500 women joined Studebaker to work in other departments. These women were put on a separate seniority list. Following the war, they demanded a single seniority list. The issue divided the union, finally leading the international to rule in favor of the women. The creation of a single seniority list had unexpected consequences. When the company began cutting back its workforce in 1953, women were bumped. In the end only about 600 women remained in the plant, many relegated to the sewing room. Indeed, at least one union officer said he supported what he described as "equal rights" because he saw that it meant that women could be bumped by men in "women's jobs."[48]

The debate over women offered only one example of growing tensions within the union. Many of the workers who had remained at Studebaker during the war resented veterans who returned to claim their seniority built up while they were in the service. The union was forced to call special meetings to address this issue. Other tensions arose between skilled workers and production men over bumping rights. Craft workers opposed production men being able to bump them, even though trade workers willingly exercised their bumping privileges against production men when necessary. Disparities in pay and rights between shifts often created further internal problems within the unions. The outcome of these tensions was factionalism.

Factionalism within Local 5 revolved around rival leaders who sought to earn support by organizing specific constituencies that had emerged with the changing composition of the union. These factions remained ill defined during the late 1930s, but periodic wildcat strikes during the war suggested internal tensions within Local 5. Internal tensions were only exacerbated by factional warfare on the national level. The ostensible division concerned the issue of Communists in the union, but as scholars later noted, the real struggle was political. George Addes, the head of the left faction, was himself a practicing Catholic, who tended to distrust the small Communist party grouping within the UAW; and Walter Reuther was a socialist who had worked in the Soviet Union in the early thirties.[49] The ascendancy of Reuther as head of the union in 1946 following the 113-day strike at General Motors brought the factions into open and final warfare in 1946.

National union politics inevitably spilled into Local 5. Estimates

placed Communist support at only two or three members, but this did not stop Reuther supporters within Local 5 from denouncing their rivals, headed by William Ogden, as Communists. The Reuther faction knew full well that Ogden was not a Communist, but as one put it, "you know this is politics."[50] The pro-Reuther slate won the election in 1947, but factionalism continued to be a force in union politics. This factionalism set the stage for heated confrontations with management once the immediate postwar automobile boom had spent itself.

The Korean War Stalemates Studebaker, Forcing Hoffman to Surrender

The outbreak of the Korean War in June 1950 hindered planned expansion efforts within the automobile industry, even as consumers continued to buy cars, and defense contracts fattened corporate treasuries. By the end of the year, President Truman imposed price and production controls on the industry. These restrictions affected Big Three producers by hampering their expansion plans. Ford delayed expanding V-8 engine production and automatic transmission capabilities. Still, consumers purchased 5 million new units in 1951 and 4.2 million units in 1952. More devastating was the postwar recession that followed in 1953.[51]

As the country embarked on a military expansion program, shortages occurred in steel, rubber, and nickel. As a consequence, automobile manufacturing was inevitably affected. Studebaker was forced to announce a 20 percent reduction in production due to these material shortages. From the outset of the war, Studebaker management saw the military program as an opportunity to cushion any potential decline in sales. "When our combined military production program reaches maturity," the annual report of 1951 declared, "it will compensate for any reduction in automobile volume which is foreseeable at this time."[52]

In June 1950 Studebaker received its first post–World War II contract for military trucks. At the same time, it converted its New Jersey plant for the production of jet engines. While military contracts provided the corporation with the cash it needed in the midst of a declining auto market, defense work also meant that the corporation once again delayed modernizing its automobile plant. Vance expressed specific concern about the effect the military buildup was having on civilian production, but defense contracts offered an easy way to bolster company income.[53]

The year 1950 marked the high mark in Studebaker's years of prosperity. The corporation continued to hold over 4 percent of the market, although this required increased sales of 268,229 cars—the high-

est sales in the company's history. The last quarter of 1950 showed the first signs of a soft market, however. The following year sales fell to 205,000 as Loewy's facelift of the 1950 car "The New Look"—the well-known aero-nose design—did little to capture the public's imagination. When one Studebaker executive first saw Loewy's bullet nose he disparagingly commented, "Boy, if they ever come out with a silly thing like that, we go bankrupt."[54] His words proved prophetic.

In 1951, the company had entered into dangerous waters. Although a V-8 model was introduced in 1951, the company's share of the market fell to 3.8 percent.[55] Even a government exemption from the wartime price freeze could not halt declining profits. From 1950 to 1951 profits fell nearly in half. In the spring of 1951, the company began laying off its night shift.[56] The year 1952 did little to improve the situation.

The year 1953 began well enough. Indeed, Vance's picture appeared on the February 2 cover of *Time*, which touted his leadership in launching the innovative 1953 Studebaker models. *Time* reported that Vance had turned down an offer to replace Charles Wilson as chief of the Office of Defense Mobilization, a key defense post within the new Eisenhower administration. Vance felt he was needed at Studebaker.[57]

The introduction of a new medium-priced Commander line and a low-priced Champion boded well for Studebaker's future. The corporation spent over $27 million in retooling for the model changes. The Commander dropped the aero-nose design for a sleek, low-built European look. The model took the industry by storm. *Road and Track* reported that "all hell broke loose" in the innermost councils of General Motors with the public unveiling of the new Studebaker.[58]

The successful launching of the Champion and Commander coupes promised a good year for the corporation. Vance told the press that the new Studebaker line would give "the company the best competitive position of its automotive history." The *Wall Street Journal* agreed: "The Studebaker Corporation is probably the best situated of any automobile company outside the Big Three," it reported, only to add, "but at best its long range outlook is speculative."[59]

All agreed that the Studebaker Commander was a masterpiece to behold. Designed by Loewy's chief South Bend designer, Robert Bourke, the new coupes were low with smooth aerodynamic lines. Two problems marred these cars, however—delayed production at the outset of the selling season and then poor quality workmanship once the cars entered production. While the new Studebaker design met with enthusiastic praise from the automotive press, poor workmanship soon tarnished the car's reception. As one Studebaker owner complained, "The 1953 models are the most crudely constructed and fitted

automobiles Studebaker has ever made."[60] That the cars were over-priced relative to the competition did little to help the situation.

Vance's production goal of 350,000 cars quickly turned sour with the outbreak of a ten-week strike at Borg-Warner, a major parts supplier, in the early spring of 1953. The strike forced Studebaker to curtail production of lower-priced cars with regular transmissions for higher-priced sedans with automatic transmissions. Vance estimated that the strike alone cost the company 20,000 cars in sales and had left many dealers completely demoralized. By the time production resumed, the automobile market had entered a sales slump aggravated by credit tightening by the Federal Reserve Board. In September, the corporation announced the layoff of over 6,000 workers, a third of its work force.[61]

Further bad news followed when the Defense Department announced that it was cancelling the jet engine contract now that the Korean conflict had ended.[62] Vance reported that every action was being taken to obtain additional defense contracts, although Secretary of Defense Charles Wilson announced that the government had instituted a policy of restricting defense producers through what he described as a "narrow based" procurement policy.

When Paul Hoffman returned to Studebaker as chairman of the board in March 1953, he found a corporation in serious decline. Studebaker stock had dropped from $11.70 per share in 1949 to $6.05 in 1952. In 1953 income per share fell to $1.13.[63] Studebaker appeared to be in free fall. By 1954 Studebaker's share of the market was only 2.4 percent and falling.

Vance and Hoffman's problems had just begun. With the overall decline in retail sales, Ford and General Motors entered a fierce price-cutting war that left Chrysler and the independents struggling to maintain their ever-shrinking portion of the market. While the independents had taken advantage of the conditions that prevailed in the early postwar years, the majors had prepared for a comeback that came in full force in 1953. General Motors targeted $108 million for production expansion; Ford committed $201 million.

Ford's comeback under Henry Ford II and Ernest R. Breech was little short of spectacular. Under Breech's direction Ford was reorganized along G.M. divisional lines. Moreover, Breech spent over $1.2 billion on new facilities. By 1949 reductions in cost had doubled Ford's profits to $180 million. Realizing that 80 percent of the market lay in the lower-priced field, Breech moved to directly challenge G.M.'s Chevy line with a low-priced V-8 model in 1953. The year opened with Breech announcing what he called the "Ford Blitz." Under pressure from Ford, G.M. entered what industry observers described as a "slugfest" with its old rival.[64]

The price war caught the independents at a time when they were already on the ropes. They defended themselves as best they could. Vance denounced Ford for starting the price war. "If this fight continues to the point where it looks like two or three companies, I think public opinion will force the government to do something about it." Packard's new president James J. Nance joined in by declaring that his company was now "taking off the gloves" in their fight for defense contracts.[65] Such bravado among the chorus of lilliputians did little to intimidate the giants, G.M. and Ford.

Behind the scenes, Hoffman and Vance understood all too well the harrowing implications of the auto war. Hoffman candidly informed his board that "so long as this situation continues Studebaker dealers are not in a position to compete pricewise." The result of the battle, he observed, had forced auto dealers to resort to price cutting, over-trading, and other unsound practices that had the effect of demoralizing the entire retail market. In the last year, he reported the company had lost 10 percent of its dealers. Still, he declared, "If you look over the history of the world, progress is made in what people think of as bad times, that is, when people really get down to the job. These are tough times. . . . "[66]

As the fourth quarter of 1953 drew to a close, the independents found themselves in complete disarray. Market share for the independents had fallen from 14.2 percent of the market in 1952 to 9.4 percent by the end of 1953. The path downward was marked in red. Nash's after-tax profit in the last quarter was under $1 million. Packard had a $4 million loss. Studebaker's last-half before-tax profit in 1953 was only $600,000. Hudson found itself losing $18 million before tax credits for the whole of 1953.[67] The way out of the morass seemed clear—consolidation through merger.

The flurry of merger activity over the next two years began when Kaiser, which had not shown a profit since 1948, joined with Willys-Overland in April 1953. (In 1954, the newly merged Kaiser-Willys withdrew fully from domestic passenger vehicle production, while continuing to produce the Jeep.) A year later, Hudson and Nash formed the American Motors Corporation. This consolidation forced Studebaker to look at a possible merger with Packard.[68] As one auto analyst observed, "the independents obviously cannot live on five percent of the market."[69]

Talk of mergers had been in the air since 1946, but only the chaos of the market in 1953 had given impetus to such discussion. A major proponent of merger among independents was the brilliant George Mason, the head of Nash-Kelvinator, who had initiated discussions at various times with Hudson, Packard, and Studebaker. Indeed, Mason had entered new talks with James J. Nance, the president of Packard,

concerning the possible merging of Nash, Packard, and Studebaker. Earlier, Mason had played an essential role in luring Nance away from Hotpoint to assume the presidency of Packard in 1952 with the expectation that this was to be the first step in putting the four companies together into a single form able to compete with the majors. Nevertheless, in their talks Nance and Mason were at loggerheads (a clash of egos, many said) when Mason died in October 1954.[70]

Packard was experiencing its own problems, having lost $5.2 million in the first half of 1954. Still, Packard's losses paled in comparison to Studebaker's loss of $19 million during the same period. This left Packard in a relatively stronger position. As negotiations opened in the summer of 1954, Packard insisted that Studebaker reduce its labor costs. Hoffman, as chief negotiator for Studebaker, accepted Packard's demand. As a consequence, Hoffman and Vance embarked on a course that was to reverse decades of cordial relations with organized labor. Their faith in tradition no longer seemed tenable.

Publicly Hoffman continued to promote the principle that the Studebaker workforce made the difference. He made this a central theme of the annual stockholders' meeting held in early 1954. In a question and answer period with the stockholders, Hoffman went on at length espousing the theme of quality workmanship within a smaller company. Even with all the talk of automation, he said, "the quality of your product is the attitude of your worker in the plant." It has been proven "time and again," that "machinery is important but the attitude of the worker is most important. The smaller company can establish a closer and more friendly relationship with its working force and we are counting on it."[71]

Even as Hoffman spoke, however, he sought to bring labor costs in line. At the board meeting, Harold Vance had traced the problem of high production costs directly to the decision made at the end of the war to make concessions to labor in order to gain rapid entry into the market. The board agreed that the piece rate premium was too high and the company had an excess of manpower. Minutes of the meeting noted that Vance felt that he had convinced "union leaders that it would be better for the union and its members in the long run to eliminate excessive manpower and reduce the piece work prices so that the remaining employees would be provided greater job security."[72]

The new tune being sung by Hoffman and Vance behind closed doors must have struck many at the meeting as odd after two decades of hearing the praises of the Studebaker workforce. Early in the year, P. O. Peterson, vice president in charge of production, had left the corporation to join G.M. because Vance had tried to convince him that a "showdown" with labor was dangerous from the corporation's point of view.[73] Nonetheless, the complete disruption of the auto mar-

ket by the summer of 1953 left the corporation with little choice but to reduce production costs through manpower cuts and wage cuts.

The first step in the program was the hiring of Anna Rosenberg, an industrial relations expert and former Assistant Secretary of Defense, to conduct a full study of industrial relations at Studebaker. In a series of lengthy reports issued through late 1953 and into 1954 Rosenberg estimated that workers' wages at Studebaker were averaging nearly 20 percent higher than at its major competitors. She also noted that plantwide bumping was excessive, costing the corporation over $700,000 in the first four months of 1954 alone. Moreover she frankly told Vance and Hoffman that the corporation had neglected industrial relations, management development, and supervisory communications. She proposed an extensive program in each of these areas to establish "a climate wherein the union and supervisory personnel will understand and appreciate the various measures necessary to effect improvements in economy, efficiency and quality."[74]

The union, contrary to the tone of Rosenberg's reports, shared many of the management's concerns. Throughout early 1954, the executive committee of Local 5 openly discussed the "havoc" the Ford-G.M. war was having on the smaller auto manufacturers, including Studebaker. Moreover, Walter Reuther had instructed the leadership of Local 5 that piece rates, production standards, and manpower allotments at Studebaker needed to be brought into line with the rest of the industry.[75] Local 5 leadership was also aware that Studebaker cars were overpriced and not competitive with G.M. and Ford cars.

With this in mind, the executive committee of the union agreed to reopen contract negotiations, provided that management was also willing to reduce excess supervisory personnel. Negotiations between the union and management took place over three months in what Hoffman later described as the fiercest bargaining ever conducted in the company's history. At issue were piece rates, manpower requirements, and work standards. In agreeing to new standards, however, the union faced a major problem—opposition from the rank and file.[76]

Piece rates had continued to be a sore point throughout the postwar period. In 1949 a wildcat strike had occurred in support of 49 employees who were dismissed in the seat division for refusing to follow new work standards set by management. At issue was the production rate for new leatherette seats the company had introduced that year. The production team under P. O. Peterson felt that the rate for leatherette seats should be that for cloth seats. He pointed out that Studebaker workers built one to two seats per hour, while the industrial average was three to four seats an hour. Finally when 49 workers refused to follow the standard, Peterson dismissed the entire group. With the dismissal of the workers, the entire seat department went

out, closing down the body and final assembly line, idling 16,000 workers. Although leatherette seats accounted for only 7 percent of seat production, the union leadership started the machinery for a formal strike.

With the threat of a strike, Vance stepped in and agreed to establish a committee of four union and four company officials to establish cloth-leather seat piece rates. In taking this position, Vance had refused to back up his managers. In explaining his position, Vance declared, "Unfortunately the company's position was not good. . . . Beyond this the situation did not warrant the discharge of 50 men. They should have been disciplined otherwise—by two weeks or thirty days lay off." He went on to tell Hoffman that "I have told our boys in the plant that they must not resort to discharge except in the most extreme cases. Our labor situation is going to be touchy throughout this month and until the union elections are over. Meanwhile electioneering is going on at a great rate and all the different factions are looking for an issue."[77]

The following year saw periodic walkouts and wildcat strikes that local leadership seemed unable to control.[78] This set the stage for negotiations that opened during the summer of 1954 in a general atmosphere that Anna Rosenberg described as "desperate." That summer the company was forced to lay off another 1,700 workers.

Hoffman and Vance agreed that the company must be willing to accept the risk of a major strike—a strike that might do irreparable damage to Studebaker sales and dealers. Therefore, it was decided that the company should open its books to the union, while keeping Reuther informed as to the status of the negotiations and the possibility of a strike.[79]

The union for its part maintained a tough bargaining stance. In the end, however, the situation dictated compromise for both parties. Concerned with the survival of the company, and under pressure from the international office, Local 5 officers agreed to restructure piece rates and bumping rights.[80] The principal victory for management was the reduction of wages by 18 percent. Still the victory had not gone entirely to management. The union had demanded and won a continuation of 40 minutes of personal time a day; bumping rights had been modified only slightly; vacation pay was increased for employees with 15 years or more of service; and the corporation agreed to pay shift premiums of 6 to 8 percent (compared to industry patterns of 5 to 7.5 percent). Management agreed to these concessions with the union's assurance that "Studebaker's employees by enthusiastic teamwork would overcome this handicap." For its part, the Local 5 union leaders felt that the company had been honest during the negotiations. Local president Louis Horvath was quoted in the local paper, "they

opened their books to us, something no other corporation in the country has ever done, and we saw they needed our cooperation. We wanted to do everything we could for the company, and at the same time give our members the best possible arrangement."[81]

Yet when the leadership of the union brought the new contract before the rank and file in one of the largest union meetings held in the city, they encountered overt hostility. Over 3,200 union members gathered at John Adams High School to hear Louis Horvath defend the new contract. Immediately, William Ogden, a longtime rival to Horvath, attacked the contract for imposing reduced shift differentials, lower holiday pay for less senior workers, and tighter disciplinary clauses. He maintained that Studebaker management had outbluffed and hoodwinked Horvath and his negotiating team. Ogden's message won over the rank and file, who openly booed union representatives when they defended the contract. The final vote showed the depth of opposition to the contract when it was defeated by a 3 to 1 margin. The defeat stunned union leadership.[82]

Studebaker management responded immediately. Hoffman sent a sixty-day notice informing the local of its intention to terminate the contract. Hoffman also launched a public relations campaign through the newspapers and radio stating management's position. A full-page ad appeared in newspapers explaining why Studebaker felt compelled to terminate the labor agreement. The advertisement pointed out that Studebaker was paying 18 percent more to its employees than were its competitors, while work standards remained 20 percent below that of its rivals. Furthermore the company maintained that bumping had cost the company $789,000 in the first quarter of 1954 and that personal time allowed by Studebaker was twice that of Detroit.[83]

The campaign worked. Within five days after the defeat of the contract, petitions began circulating in the union calling for a reconvening of the meeting. A week after the first meeting, the union membership gathered once again. This time by an 8 to 1 vote the labor agreement was ratified. Hoffman greeted the agreement as a "triumph for responsible labor leadership" and a symbol of "the unique spirit of cooperation that has been in many ways Studebaker's greatest asset," but the victory cost Horvath and his fellow officers dearly among the rank and file.[84]

Having won a pro-management contract, Hoffman entered merger negotiations certain that he had lived up to his end of the bargain. Working through a group of New York and Chicago bankers including Lehman Brothers, Kuhn Loeb, and Glore-Forgan, the managements of Studebaker and Packard reached an agreement to merge the two companies.[85]

The marriage of the two companies was largely an act of faith.

Both managements had accepted financial estimates of each at their word. To ensure that the marriage worked, it was agreed to make James Nance the president and chief executive officer of the new corporation. Nance's performance in stopping Packard's downward slide had impressed the financial market and the auto industry alike. The new arrangement called for Hoffman to become chairman of the board and Vance to chair the executive committee of the board.

Hoffman had accomplished his mission. In the two years since he returned to Studebaker he had renegotiated a new contract with labor and had successfully merged his company with Packard. The merger gave Studebaker a fighting chance to stay in the auto business. Still there were those who saw the merger as weak and highly speculative, as suggested by the low price of Studebaker-Packard stock, $13 per share, on Wall Street.[86] As one old observer of the auto industry wrote a friend, "Now Hoffman is stuffed shirting once more around Studebaker. His recent settlement with the CIO may be one way of prolonging things but I greatly doubt if it will save Studebaker."[87]

The decade of illusions had ended. No longer would Studebaker dream of becoming a major auto producer. Claims were no longer made concerning the value of independence. Such claims rested on the rhetoric of an earlier age that proclaimed the Studebaker tradition of quality craftsmanship and enlightened management. The course of the next years increasingly imparted a hollow ring to such rhetoric, suggesting more promise than reality.

SIX

Studebaker Attempts to Reverse Course, 1954–1957

Tradition Rejected

On September 26, 1954, over 57,000 men and women filled Notre Dame stadium for a rally organized to introduce the new president of the newly merged corporation, James J. Nance, to Studebaker employees and their families. After hearing the Secretary of the Air Force Harold E. Talbot, Notre Dame University president Father Theodore Hesburgh, Harold Vance, and Bob Hope and his troupe of entertainers, Studebaker employees welcomed Nance. While known for his matter-of-fact style, Nance soon brought the crowd to its feet. "If we carry on the tradition of Studebaker, if we work together, cooperate and fight the good fight to achieve our common goal, we have every reason to be confident. . . . I sincerely believe that today can mark the beginning of a great new chapter in the history of Studebaker."[1] The language—both in its tone and its expressed sentiment—echoed a Studebaker tradition of communal interest, shared fate, and management-worker cooperation.

Privately, he found little to respect in a tradition that he thought had led to the debacle that had forced Studebaker to merge with Packard. Suspicious of what he perceived as Studebaker's lax attitude toward labor, aware of the still high labor costs at the company, and having gained a national reputation for making Hotpoint a national appliance manufacturer, Nance sought to replace the Studebaker tradition with a regime that brought labor costs and labor standards under control through tough contractual negotiations with the union.

His strident stand against the union surprised and quickly disheartened Studebaker managers and employees alike. Resentful of Nance's attitude, suspicious of his executive team, lacking confidence in his proposed strategy, Studebaker executives resisted change. In the end, the Studebaker tradition, imbued with a hundred years of experience

and promulgated as a corporate vision by the previous management, inhibited any natural bonding of two corporations whose "cultures" were so different.

In different market conditions Nance might have enjoyed the luxury of undergoing a gradual integration of the two managements. Market conditions within the automobile industry in 1954 and 1955, however, brought financial disaster to the newly merged corporation. Nance discovered that while market structure might dictate strategy, managerial organization could not simply be imposed from above, especially if there was resistance from below. This lesson proved fatal. After sixteen hectic months marked by acrimonious labor relations and huge financial losses, Nance was forced to step down and allow aircraft engine manufacturer Curtiss-Wright to take over the management of the corporation. Nance discovered that while history could not be easily overturned, it also could no longer be restored.

Auto Giants Tower over the Lilliputians (and Nance)

The merger activity of 1953 and 1954 that brought about the formation of American Motors (AMC) and Studebaker-Packard (S-P) had saved the independents, but the end result was little more than lilliputians standing on one anothers' shoulders bravely proclaiming they were now ready to do battle with the Big Three. Throughout the negotiations with Studebaker, Nance had faced one inescapable, discordant fact—General Motors held close to half of the market; Ford another third; and Chrysler a little more than 10 percent. This left the remaining share—about 5 percent, more or less—to AMC and Studebaker. This allowed little room for error, particularly in targeting models and styles for the market. Moreover, Chevrolet alone offered eighty-eight different models and Ford thirty-six, while Studebaker-Packard jointly offered sixteen.[2]

Following the G.M.-Ford price war in 1953, competition in the industry remained mostly over style, although some technological advances were seen with the introduction of automatic transmissions. Throughout the 1950s, the Big Three seemed willing to compete to see who could manufacture the largest automobile. Low-priced Chevrolets, Fords, and Plymouths became larger and larger. As they did, they cut into the medium-priced market.

The luxurious cars of the mid-fifties reflected the opulence of the American consumer in these years. Following a brief recession after the Korean War, the economy boomed. Auto sales continued to rise, peaking in 1955 when expanding income and looser credit allowed for record purchases. Yet while auto sales hit all-time highs for the Big Three, these gains came at the expense of the independents. In 1955

American Motors sold only 137,000 units (1.9 percent of the market) and Studebaker-Packard sold 148,000 units (2.1 percent of the market). Some of their problems came from their inability to offer the consumer a range of models. Indeed, when seven new models were introduced that year, only one came from an independent—Studebaker's Starliner series. Big cars, produced by big companies, seemed to be what the public wanted.[3]

Only George Romney, who became head of American Motors after the death of George Mason in October 1954, was willing to undertake a contrary strategy against what he called the "dinosaur in the driveway." In 1950, the Nash Company had introduced the first generation of modern compacts, the six-cylinder Rambler with a 100-inch wheel base that sold for $1,800. In 1954, American Motors extended its line with a "standard sized" six-passenger, four-door Nash that had interior room comparable to that of the Big Three, but was a foot and a half shorter.[4]

While the Rambler finally came into its own during the recession of 1957–58, most manufacturers, including Studebaker, were hesitant to enter the small-car market. Because of fixed investments in plant and machinery, as well as the astronomical costs of retooling to build a new model, manufacturers found that there was only about a $500 difference in production costs from a compact to a standard-sized car.

In the fall of 1954, Nance remained cautiously optimistic about Studebaker-Packard's future. With the backing of the corporate board and New York investors, Nance felt that Studebaker-Packard could go toe-to-toe with the Big Three. This entailed making the newly merged company into a multiline producer with models that extended from the low end of the market through the luxury end of the market. Multimodel production promised increased volume, lower production costs, and better adaptability to a volatile market. Nance believed that multimodel production would restore Studebaker's position in the industry, and even Hoffman told Nance that the new, consolidated corporation had "a real opportunity to win a strong fourth position in the industry and in time, to compete for third position."[5]

Details of the merger had been formulated by a group of New York–Chicago financial interests including Lehman Brothers; Kuhn, Loeb and Company; Glore, Forgan and Company; Metropolitan Life Insurance Company; Chase National Bank; and National City Bank.[6] These interests had formulated what was called "the bankers' plan" (a term later dropped in the annual report of that year), which provided the necessary capitalization for the consolidated corporation. The willingness of these New York financiers to support the merger was based on the sole expectation that a combined Studebaker-Packard Corporation had the potential to compete with the Big Three across model

lines. One memorandum, "Benefits of a Merger," circulated in the spring of 1954 among Lehman Brothers; Kuhn, Loeb and Company; and Glore, Forgan and Company, spoke of a possible combined industry share reaching as high as 14 percent of the auto market for Studebaker-Packard. Metropolitan Life Insurance offered a $25 million credit line with the expectation that the new corporation would lose money in 1955 and again in 1956, but by 1957 the company would be in the black.[7]

This optimism concerning Studebaker-Packard's future came in part from the great hope the New York–Chicago investors placed in James J. Nance. He was just the kind of tough executive who could turn a company around. As one news reporter observed, "He does not want to run a company by the rule book, but he is a tough character."[8] This perception of Nance as "tough" was shared by most who knew him.

Fifty-three years old when he came to Studebaker, Nance had made his reputation as the man who had built Hotpoint into one of the great appliance companies in America. A product of the Midwest, he had been educated at Ohio Wesleyan and Ohio State University before he joined National Cash Register in 1923, the training ground for many leading executives during these years.[9] Four years later he moved to General Motors to join the newly formed Frigidaire division. Here he became known as "Mr. Frigidaire," but he remained nonetheless discontented in the backwaters of this G.M. division.

His big break came when he assumed the presidency of Hotpoint, General Electric's languishing appliance manufacturing affiliate. Within five years, Nance had taken Hotpoint from tenth place to third place within the industry. This success enhanced his image as an executive who knew how to get things done, an executive who understood the integral part of sales, finance, and production.[10]

He brought this reputation with him to Packard in 1952. Once the most esteemed producer of luxury cars in America, Packard had fallen behind Cadillac in the 1930s, a setback from which the company never fully recovered. Although sales had boomed in the immediate postwar years, success proved short-lived when Packard introduced its 1949 models that quickly gained dubious notoriety as "a bathtub turned upside down."[11]

Nance immediately shook up the older Packard management by replacing executives with his own team members, many of whom came out of the appliance trade. (Within two years he had lowered the average age of his executive staff from 59 years to 46 years.) He set his engineers to work on a new V-8 engine. Faced with old and obsolete factories, he transferred the manufacturing of engines, axles, transmissions, and chassis components to a modern, one-million-square-foot

plant just outside of Detroit. He built a new plant in Utica, Michigan, for the manufacture of automatic transmissions. By mid-1953 luxury car sales were running well ahead of the average of the previous five years.[12] For all of his efforts, Packard failed to recoup its share of the market, which had fallen from 1.9 percent in 1952 to 1 percent in 1953. Studebaker's share, in turn, had fallen from 3.15 percent to 1.48 percent.[13]

Nance felt two steps needed to be taken to turn Studebaker-Packard around: control labor costs at Studebaker and expand model selection. The first part of this strategy implied a conscious rejection of the "soft" labor practices followed under the Hoffman-Vance regime. The second part of the strategy, multimodel production, followed from a careful estimate of the current auto market and a breakdown of production costs.

Best estimates showed that the high-priced market in automobiles only represented a total of 3.54 percent of all sales, while the upper medium- and medium-priced market accounted for 7.13 percent and 10.07 percent respectively. Nance hoped to make approximately 50 percent of total S-P sales in the medium-priced market ($2,000–$2,500), but to do this the consolidated corporation needed to produce more models. As it was, Buick offered eighteen models in this price range, Olds thirteen, and Mercury thirteen, while Packard offered only five.

With this in mind, Nance told his first consolidated stockholders' meeting that the first need that had to be met was "the development of a full line of cars in every major price class. . . . "[14] The merger of Studebaker and Packard, which combined their resources into what then appeared to be a viable entity capable of greater penetration of the market (at least above the 3 percent held by the two companies together), appeared to dictate a multimodel strategy. Packard was to uphold the luxury line, while Studebaker continued to produce in the medium- and lower-priced line. Sales reports in 1953 showed that Packard was being hurt in small towns in the lower-priced field. The merger with Studebaker was designed to address this problem, while helping Studebaker in the higher-priced field.[15]

Such a strategy made sense in terms of the current lines of the two corporations, manufacturing costs, and moreover, in maintaining dealerships. Beginning in mid-1953 both Packard and Studebaker experienced sharp declines in dealerships throughout the country, many of which went over to Ford or General Motors. The multimodel strategy offered by Nance brought new excitement to those dealers who had remained with Packard and Studebaker.

In pursuing multimodel production, Nance consciously rejected American Motors' strategy of specializing in a small car such as the

Rambler. Since the 1930s various attempts had been made by the independents to develop a small, low-priced car—the Terraplane (Hudson), the Lafayette (Nash), and the Rockne (Studebaker), but in each case sales had been too low to meet the minimum conditions for economies of large-scale production.[16] To gamble with the production of a specialized car simply did not make sense to either Nance or Hoffman in 1954.

At the annual meeting of the stockholders in 1954 a stockholder had raised the question of producing a small car. Hoffman replied, "that is something you have had, with the Crosley and Kaiser, as you have had with other cars. There is no evidence that the American public will buy the light, cheap car in volume. The light, cheap car in America competes with the secondhand cars and there is every evidence that it has been tried time and again—every evidence is that competition of the light, cheap car loses out."[17]

Hoffman and Nance were nonetheless aware of the advantages of European-style cars that limited annual style changes. Once again, however, they were caught in a bind. Nance felt that there was much to be said for "freezing" a style, but in a highly competitive industry, the "motor car maker gives the buyer what he wants. Witness the current scramble for horsepower supremacy."[18] In 1954, European cars, such as Volkswagen, held a little over 1 percent of the market. Little did anyone foresee the big gains for the smaller, European-type cars that would come during the recession of 1957–58. As a consequence, even in late 1955, Wall Street felt that the prospects for Studebaker-Packard were better than for American Motors.[19]

In pursuing his multimodel producer strategy, Nance foresaw the possibility of combining the newly formed Studebaker-Packard Corporation with the recently organized American Motors Corporation. Discussion of such a merger had been in the air for quite some time. Indeed, in the summer of 1954, *Business Week* reported that Nance had initially been brought to Packard in order to "fatten up" the company as a mate to Nash, but Nance could never see "eye to eye" with the equally egotistical president of Nash, George Mason.[20] Nonetheless, Nance and his staff believed that a merger of the two recently consolidated companies was essential for the survival of the independents.

This belief took on great poignancy because many on Nance's staff felt that the merger with Studebaker had been a mistake. The speculative nature of the merger, they observed, was indicated by the low market price of the consolidated stock, $12 a share. W. R. Grant, Nance's right-hand man, urged his boss to open discussions with George Mason concerning a merger of the two companies. The possibility of such a merger, he wrote, might "go a long way toward re-

moving the very serious clouds now surrounding the current transaction [the Studebaker-Packard consolidation]. . . . This would then appear as a broader plan than merely a consolidation of two companies. It would also serve notice on South Bend labor that they are only one factor in a broader picture."[21]

Acting on this advice, Nance began meeting with Mason. Nance later reported that they were on the verge of closing the deal just a week before Mason's death on October 8, 1954. They had decided on January 1 as the target date to conclude the merger.[22] Mason's successor George Romney, however, showed less enthusiasm for such a merger. His strategy to produce a small, specialized car did not fit in with an AMC-Studebaker-Packard consortium. Still, he did not immediately reject Nance's early advances. When asked at a press conference about the possibility of a merger with Studebaker-Packard, he simply replied that "I have not ruled them out." Then when pursued on the issue, he added, "The banking groups had been studying this business of merger for several years even before the Nash-Hudson merger. Of course that was a factor in the Studebaker-Packard merger, as I understand it."[23]

Throughout late 1954 and 1955, Nance and his staff continued to cooperate with AMC, either through subassembly agreements or exchange of engines, but each effort failed because of hesitancy on AMC's part. The final attempt came in 1955 when AMC chief engineer Meade Moore agreed to swap Studebaker's V-8 engine for an American Motors Six to be used in the Champion. The deal seemed to be all set. Studebaker went so far as to cancel a tooling order for production of a six-cylinder engine—when George Romney nixed the deal. Romney informed Nance that AMC was going to need all of the six-cylinder engines it could produce given the expected Rambler sales volume in 1957. Romney's expectations for a boom in Rambler sales were realized, but this ended all talk of merging the two companies.[24]

Nance Battles Middle Management and Labor

Nance insisted that if the multiline, multiplant strategy were to succeed, Studebaker-Packard Corporation needed to be reorganized along the lines of General Motors, a model that relied heavily on general managers for project planning and operation, while a strong staff and committee structure at the top imparted centralized control and overall direction to the divisions. Divisions were to be organized along functional lines, including production, finances, sales, operations, and engineering.[25] Imposing this new organization implied radical reduction of corporate staff for both companies. For example, Nance directed each department head in purchasing and product planning to

provide "a confidential note listing the 'surplus' personnel that he has, especially at the supervisory and upper salary levels, together with an estimate of when he expected to relieve the payroll of this burden."[26] By late 1955, Nance was pleased to report that corporate staff had been reduced by 851 executives. Interestingly, the heaviest cuts occurred among the Packard staff, 616 persons, compared to a reduction of 235 persons at Studebaker.[27]

This reorganization of corporate management created inevitable tensions between Packard and Studebaker personnel. The situation was only exacerbated by Nance's distrust of Studebaker tradition and management. Nance's hopes of a merger with AMC paralleled, as he told his closest associates, his disappointment with the merger with Studebaker. Nance and his Packard staff felt that Studebaker had deliberately misled them about the financial position of their company and its production costs.

During the prenegotiations, both sides had offered estimates as to production costs and break-even points. As W. R. Grant, the key negotiator for Packard, told Nance, "the whole philosophy of the merger was that each of the parties was to accept the book figures of the other without examination." Within a month following the merger, however, Grant reported that Studebaker had deliberately underestimated its break-even point by over one hundred thousand cars.[28] If the lower projected break-even point had been achieved, Studebaker would have been in the black. Instead, Studebaker experienced heavy losses throughout 1954, aggravated by a downturn in the retail market. In July, Grant warned Nance that the Studebaker division was looking at an annual loss of $38.2 million (and possibly more), $6 million more than initially projected during the merger negotiations.[29]

Thus from the outset of the merger Nance and key Packard staff expressed a mistrust toward Studebaker personnel. Nance candidly told one executive he sent to South Bend that "You have a staff you are inheriting in South Bend that doesn't know what work is."[30] Nance felt it important, however, that the new consolidated corporation present an image of a "united" corporation, even though the two companies had "quite divergent" philosophies as to "basic company objectives and policies." Privately, he admitted, "Frankly, I am at my wit's end as to how to handle this problem of determining what our corporate 'character' should be and how to get everybody connected with the Company together in their thinking."[31]

Neither side seemed to respect the other. Packard men tended to see Studebaker men as old, unimaginative, and soft—yet condescending; while Studebaker men saw Packard executives as young, arrogant, lacking a sense of tradition—and likewise, condescending.

Indeed, Packard personnel expressed open disdain for Studebaker

personnel. As one Packard man bluntly told H. E. Churchill, the head of the Studebaker division: "your division has only a few young men on its payroll with any significant degree of potential." Another Packard manager wrote Nance that his division was experiencing an "emotional disturbance" in trying to integrate Studebaker personnel into service zones. "The problem is further aggravated," he wrote, "by the South Bend attitude toward Packard. They are not yet aware of the importance of the Packard products to the corporate cause especially during 1955."[32] Nance's promotion of Packard managers or personnel brought in from the outside—often from Ford—only aggravated the situation.[33]

Nance tried various ways to overcome tensions between the two staffs. He continually spoke of "teamwork" and "corporate image." At one point in early 1955, he gave a party for twenty-five of his top executives and their wives to "break some ice" and "iron out tensions."[34] In the end, these attempts failed. By the summer of 1955, Nance confronted open resentment from key Studebaker personnel. Nance's handling of the labor situation that summer only worsened the situation.

Nance came to Studebaker intent on lowering labor costs. He had carefully monitored AMC's willingness to take on labor in their plants. In the summer of 1954, while the negotiations between Studebaker and Packard proceeded, George Romney had moved to address the labor problem at the AMC's main plant in Kenosha, Wisconsin.[35] Negotiations lasted over a year, but in the end management won its contract. Following the contract, Romney continued to press the union for further concessions. This led to a bitter strike in January 1956, but Romney won the contract he wanted. By 1960, AMC was earning a $48.2 million profit. The following year, AMC offered a precedent-breaking contract that called for profit-sharing for labor.[36] Romney had gambled on a specialized car market, the Rambler. Behind this gamble, however, lay a willingness to crack labor's strength in the company.

Nance closely watched AMC's campaign to control labor costs, especially in light of his own problems with labor.[37] Feeling that the labor situation at Studebaker was "extremely sensitive and explosive," Nance began replacing Studebaker personnel with his own men in the industrial relations division. This further increased bitterness on the part of Studebaker personnel.[38]

At the same time, the head of production at Studebaker stepped down under pressure from Nance. His replacement, Clarence Smith, resigned shortly afterward under "constant, unwanted and stupid interference." Soon there followed what one executive described as "indiscriminate dismissals of key Studebaker personnel of proven capa-

bilities, not involved in duplication, and without any attempt at evaluation." These men were replaced with Packard men with "new, and fancy job titles." The new management, it seemed, was "obsessed with the notion of imitating the Big Two organizationally."[39]

By early 1955, Nance was set to undertake a full assault on labor at Studebaker. Intent upon lowering labor costs, Nance launched what he called "Operation 55," a program designed to eliminate excess employees, raise production standards, and address the "bumping problem." Operation 55 began with the replacement of the head of industrial relations, Walter Grundeck, a Studebaker employee of over twenty years, with a Packard man, Peter Barno. Another Packard man, R. P. Powers, was made vice president of operations and given the assignment of heading negotiations with the union. He was to be assisted by the new vice president for corporate industrial relations, C. D. Scribner.

These changes were duly noted by the union. Local 5's newspaper *Studebaker Weekly News* reported under a headline, "New Company Discards Old Traditions," that what now existed was a "brand new company with new policies, new philosophies and a different approach" that resembled Ford and G.M. The union ominously noted that it "recognized that a change has occurred and we must prepare ourselves to deal with things as they are now."[40]

Nance did not ease tension when he sought to weaken the power of shop stewards while strengthening the position of foremen. To ensure cooperation with his supervisors on the floor, he held a dinner with 500 of his foremen to let them know, "You, from now on, are members of the management team."[41] At the same time Nance initiated a series of time studies conducted department by department.

The confrontation with labor began in early January 1955. The company began to tighten work rules and raise job standards. This provoked an embattled Local 5 to undertake a series of slowdowns and work stoppages. On January 20, the union voted to strike until management reconsidered its work standards, which were "beyond normal human capacity." The strike closed the plant for 36 days. Finally, after nearly 160 hours of negotiation, a formal contract was signed.[42]

Problems with labor were far from settled, however. Over the course of the following months wildcat walkouts broke out throughout the plant. A common feeling prevailed among workers that these wildcats should be "laid at the steps of management," especially given Nance's hard-line position and continued layoffs. At the same time, the union developed a particular dislike for Nance's industrial relations staff. As one local leader later recalled, the union felt that "Barno

and Powers were incompetent," but Scribner, the vice president of industrial relations, was "anti-human more than anti-union."[43]

Paul Hoffman, as chairman of the board, also felt uneasy about Nance's aggressive attitude toward labor. Until this time Hoffman had stayed on the sidelines to give Nance more rein in running the corporation. Writing to Nance on January 20, Hoffman urged him to "put forth a real effort to foster and strengthen good relations between management, its workers, its dealers, and the general public." He told Nance that "there is an area, and one that is very important, in determining quality in which we can excel—and by a very large margin—and that is in the attitudes of workers." He reminded Nance that "Studebaker-Packard by the very reason of the fact that it is a smaller company and because of its traditions has a better opportunity to promote a constructive attitude on the part of its workers than have the bigger companies."[44] Hoffman spoke of an older tradition to a man who had already rejected that tradition as detrimental to the interests of the company. A more serious confrontation with labor was already in the works.

By March, line workers were in full revolt against Nance's attempt to impose tighter work standards. C. D. Scribner reported that resistance on the final production line was "clear and adamant."[45] Flare-ups along the line spread to other parts of the plant. A wave of wildcat strikes throughout the spring showed that both management and union leadership had lost control of the situation.

By the time union elections came in July 1955, Horvath did not seek reelection. Instead, the Horvath faction put up Lester Fox. He was soundly defeated by William Ogden and his "militant" faction by a vote of 5,404 to 3,813.[46] The defeat of the Horvath faction meant that the international union now exerted little control over the local.

Nance informed his directors that when the current contract expired in July he would seek "comprehensive" renegotiations with the union concerning "all phases of control including bumping and transfer rights."[47] He accused the union of "violating the agreements" reached over work standards. He warned that a strike would cost the company $5 million a month and would "shut off the supply of cars to dealers at a time when they need them most," but he was willing to take a strike if necessary. "Although a strike was not wanted," he declared, "it would be better to liquidate the assets of the Company than to have them liquidated through impossible production costs."[48] He told his staff to prepare for such a strike. "The one happy family" attitude prevalent at Studebaker needed to be replaced.[49]

The March agreement expired in August, and this brought on another series of confrontations. As negotiations opened, Nance an-

nounced an indefinite layoff of 1,700 hourly employees, 17 percent of the workforce. The Ogden leadership, having pledged itself not to grant any concessions to management, recommended to the rank and file that the expired contract be maintained on a day-to-day basis. The rank and file rejected the extension, even though Ogden urged a more moderate course of action. In a belligerent mood, the rank and file voted instead to walk out. Immediately the International UAW declared the strike a wildcat and ordered the local back to work.

Ray Berndt, a former president of Local 5, was sent by the International Office in Detroit to restore order. At a mass meeting of the union, Berndt told Local 5 members that while the international believed that the company was out to break the union, negotiations could not proceed until the workers returned to the plant. C. D. Scribner, who attended the mass meeting as an observer, described the meeting as "anarchy." It is clear, he wrote, that "the Union had absolutely no control over its membership, and that the minority was ruling the majority." He told Nance that one member of the union negotiating committee confidentially informed him that "the Union was having difficulty controlling the mob."[50]

Only the extraordinary efforts of the international and local officers brought an end to the walkout. Seven days after they had walked out, the workers returned to the plant, with the promise that negotiations would resume on September 13.[51]

Negotiations extended over the next four months with neither side willing to compromise. At the crux lay the issue of the company's demand to end bumping rights, transfer rights, and a forty-minute break time. As Nance astutely noted, "The company sought to take back more than the Union had gained in its entire history." Issues involving bumping and transfer rights were not easily relinquished. On these issues "both parties appeared poles apart."[52]

Negotiations dragged on through September, forcing Walter Reuther to step in and take over the negotiations himself.[53] Joined by his staff of Matthews, Berndt, and Douglas Fraser, Reuther entered into round-the-clock negotiations from December 16 to December 20. Out of these prolonged meetings a final contract was reached as the new year approached.[54]

Ratifying the contract was to be a different matter. The mass meeting of the local to discuss the contract proved to be "really rough." Under pressure from the rank and file, five of the twelve local members of the negotiating committee denounced the contract publicly. Television spots and local advertisements were used by the company to convince employees that the contract was in their interest. "Recognizing that the organized opposition would get out their vote, our problem was to get the balance of membership to vote," Nance later told

his board. A special appeal was made to the wives. "It's an old axiom that wives don't like strikes. . . . It worked and saved our bacon." He also noted that the international, aware of local opposition, had arranged to have a secret vote by machine. Otherwise, Nance declared, we would have lost a voice vote. Finally, after the votes were counted, the contract was ratified. As Nance put it, "We just squeaked by with a 53 percent approval."[55]

The victory had been costly from all sides. Over the course of the year there had been 85 wildcat stoppages and a complete plant shutdown that lasted for 36 days. Any trust between the employees and management had been completely broken. Many workers now felt that Nance had "raped" Studebaker. A feeling prevailed that now it was every man for himself.[56]

And what had been gained? The new contract offered an increase of 21 cents per hour. Rest, relief, and cleaning time was reduced from 40 minutes to 24 minutes. The ratio of stewards to workers was reduced from 1:50 to 1:75, with a 15-hour limit on time allowed on company pay for adjusting grievances and meeting with management. Workers gained slight increases in pension and insurance contributions, but in the process plant-wide seniority and bumping was eliminated. Now, transfers and bumping were not to be across skill or occupational rating lines. The union agreed to the principle that "the Company is entitled to a fair day's work for a fair day's pay."[57]

Nance Battles the Market and Loses

A simple fact was enough to dissuade Nance of any illusion of victory: in 1955 the company lost another $29 million. Reports beginning in April 1955 showed impending disaster. For the first time in the postwar period, sales of Nash and Hudson exceeded total Studebaker and Packard deliveries. The continued decline of S-P sales indicated that even the most conservative sales projections were not going to be met. A slumping buyers' market only aggravated the situation. Ford and Chevrolet had produced a record 7.8 million cars. By the end of December 1955, however, dealers reported 650,000 unsold cars still in stock. Even with curtailed production and inventory cleanups, dealers' stocks still rose to hit a new record of 900,000 unsold cars. Left with their own huge uncleared inventory, Studebaker-Packard dealerships began to crumble. By September Studebaker alone had lost 260 dealers. In these circumstances, Nance gave the go-ahead to sell the Packard's forge and foundry facilities at Detroit, as well as the New Brunswick assembly plant, erected in 1950 to meet defense orders.[58]

Still there were some signs of hope. The company had sold 30,000

more units than the previous year, and the Studebaker Commander V-8 had sold well in the consumers' rush for V-8 engines. (In turn, the Champion, which won the Mobilgas Economy Run, for the first time fell below its rival, the Commander.) Moreover, as Nance pointedly told his directors, the losses were within a million of the forecast given to the banks at the outset of the year. The labor problem had been addressed, and management between Studebaker and Packard was now unified. The corporation's greatest problem was that its cars continued to be priced higher than the Big Three products, without much to differentiate them in terms of performance or style.[59]

In this situation, Nance realized the importance of a new model for the company's future. There was a hitch, however: Nance estimated that the costs of a new model would range between $25 and $30 million. This required additional capital, and Nance became increasingly desperate to acquire additional funds for model development.[60] Having financed the merger the previous year, financial interests were unwilling to extend further credit to the corporation. Nance had little choice but to go ahead with a face-lift of the 1956 Studebaker instead of introducing a new model. Thus instead of spending an estimated $25-$30 million on product development, Nance allocated $8 million for style changes.

Nance felt that time was of the essence in developing that right line of models to lure consumers to Studebaker-Packard. Surveys showed that "the lack of a clear-cut corporate image can be traced directly to our line of products."[61] Nance placed great hopes in Studebaker's engineering staff, the one division in the company that he seemed to hold in high regard. Yet he was facing the threat of losses in the engineering staffs both at Studebaker and Packard. Typical among those he was to lose was John DeLorean, who was described as "the most fertile mind in advance engineering." With salaries ranging between $10,000 and $15,000 a year—$5,000 to 10,000 less than the Big Three—Studebaker lost DeLorean and other key engineers.[62] By late 1955 the vice president of engineering at Packard reported that his division was 10 percent below necessary personnel. Furthermore, the forty engineers employed by the corporation worked in extremely poor facilities. The state of Studebaker-Packard's engineering department was best indicated by the fact that Ford employed 13,000 engineers in its divisions.[63]

The lack of funds and personnel proved particularly detrimental in product development. When Nance complained to the head of engineering that the instrument panels on the prototype 1956 model Studebakers did not look "important enough," he was informed by one engineer that "It was decided that we could not afford a new in-

strument panel. . . . We could have done more but it would have meant excessive tool costs and a high price penalty."[64] The same story occurred time and again for other product ideas, including fuel injection, aluminum drum brakes, disc brakes, and rack-and-pinion steering.

Planning for the 1956 models revealed other differences between Nance and the engineering division. For example, Nance felt that Loewy had "misled" Studebaker with his "European" styling. This attitude brought Nance into open conflict with Loewy. Loewy's contract was expensive, running to over a million dollars a year, the highest in the industry. Nance considered breaking the contract with Loewy in 1955, even with the threat of a lawsuit (Nance's lawyer had told him "an imprudent contract furnishes no legal reason for breaking it"), but in the end, Nance cut the contract to only "research and development" styling. This meant that Loewy was assigned to attend European car shows. Operation of the Loewy studio in South Bend was abandoned, thereby ending a history that dated back to 1937. Before he left, Loewy developed the 1956 Hawk series, one of the most glamorous cars designed in these years.[65]

Sales for the 1956 model year proved to be even worse than the previous year. The face-lift for the 1956 models had been completed in an extraordinary seven weeks, but in the end the company had little to show. The closest Studebaker came to introducing a new model was the Loewy restyled Starlight, which was introduced as the Hawk. A four-door station wagon was also introduced to enhance the Studebaker-Packard lineup, which included the Champion 6, the Commander V-8, the Packard President V-8, and the high-powered Golden Hawk. The lineup impressed few in the auto industry. *Consumer Reports* listed Packard-Studebaker cars as the worst buys in their class, even though an impressive 20,000 Hawks were sold.

Within the first quarter it was clear that the company was facing a debacle. At first Nance ordered production increased to cut unit costs, even though this was a cash drain. In February, however, Nance ordered the Detroit Packard plant to shut down for a month, and then reduced production by 40 percent.[66] By the year's end, production had reached only 82,000 units. With sales of $303 million, the corporation lost three times more money than it had ever lost in its history. In turn, the corporation's net worth fell to a little more than $15 million.[67] By the second quarter of 1956 Nance had borrowed over $29.7 million against his $45 million credit line.

Nance realized that the end was near. The gamble to save the two companies through merger had failed. The strategy to save the company through a multimodel competition with the Big Three simply had not worked. Attempts to build Studebaker and Packard cars with

interchangeable parts had been shown to be "not practical for the competitive market."[68] Instead, Studebaker-Packard found itself competing with AMC, whose profits increased with its successful Rambler.

Without additional capital, any attempt to save the company by expanding into the small-car market became impossible. Throughout this period Nance continued to probe the possibility of gaining a foothold in the small-car market. In early 1955 he directed Courtney Johnson to meet with the representative of Kaiser-Willys Corporation concerning a possible joint venture with Kaiser in producing the Jeep. At this point Kaiser had sold all of its automobile machinery and equipment to Argentina for the production of the "Peron." Discussions of a possible joint venture, however, came to nought.[69] Shortly afterward, Nance discussed the possibility of selling or leasing a plant to Volkswagen of Germany, Pegaso of Italy, or Scania Vabis of Sweden. These negotiations also failed to produce anything concrete.[70] Desperately, Nance explored the possibility of representing Renault in the United States. Renault had just developed its new Dauphine, which was expected to rival the German VW and the French Simca. A number of meetings were held between the two companies, but given Studebaker's current problems, Nance decided that it was best to hold off any decision until 1957 or 1958.[71]

Matters continued to worsen. Earlier Nance had learned that the Department of Defense had canceled its $420 million jet engine contract. From the outset of his presidency Nance had placed great hopes in defense contracts. Throughout the first half of the decade, General Motors had received the greatest share of defense business (over 55 percent of total contracts), but Nance continued to hope that his company could emerge as a prime defense contractor.

The Defense Department's adoption of "narrow base" production—the funneling of contracts to larger "price-competitive" companies—clearly favored General Motors and other large defense contractors. Nance responded to the cancellation by rallying support from Indiana politicians, only to be informed by a Defense representative that "the preservation of smaller companies" was a "sociological question."[72] Nance described the cancellation as a "severe blow."[73]

By the spring of 1956 the Eisenhower administration itself was concerned about the possible liquidation of Studebaker-Packard. The crisis came to a head in April 1956. The possible bankruptcy of Studebaker-Packard threatened to have both political and economic consequences for the Eisenhower administration. Having announced his intention to seek a second term only two months earlier, Eisenhower realized that the liquidation of the 75th largest corporation in America was a political issue made for the Democrats. "It is manifestly to the interest of the big companies, as well as to the economy as a

whole," he wrote, "to keep Packard-Studebaker operating." He went on to observe that "For more than a year I have been working on this particular matter, especially urging the Defense Department to give this firm some defense contracts in the items in which it has already established a fine production record."[74]

Eisenhower, always the fiscal conservative, had no intention, however, of reversing Charlie Wilson's decision to reallocate defense contracts. Therefore, Eisenhower did not call for the renewal of the jet engine contract, but instead approved an order for some five thousand trucks. Eisenhower also directed Wilson to talk with representatives of the Big Three as to the possibility of bailing out Studebaker-Packard in some way.

The immediate background for the crisis had been set in January when Nance had been informed by a consortium of insurance companies that they were unwilling to extend an additional $50 million to the company to strengthen its dealer organization and to retool for the new 1957 models. It was clear to Nance and his board that without additional funds the corporation could not continue operations through 1956. Nance told his board that even if the company forwent tooling for a new model, the company lacked sufficient cash to maintain day-to-day operations for the duration of the year.[75]

The board responded immediately.[76] Compensation for the entire board and the chairman was suspended, while at the same time a special finance committee was organized to raise additional money. Beginning in early March meetings were held with a number of corporations to discuss the possibility of financial loans or outright merger. Over the course of the next month board members discussed different possibilities with representatives of Chrysler, American Motors, Ford, International Harvester, Textron, Pullman Company, and Curtiss-Wright. Ford expressed some interest in acquiring the Utica plant, and Roy Hurley, president of Curtiss-Wright, seemed somewhat attracted to Studebaker-Packard because of possible tax credits.[77]

Negotiations with General Motors concerning a possible loan to Studebaker-Packard proved particularly interesting. Robert Hinshaw, a New York corporate attorney and son-in-law to Secretary of State John Foster Dulles, entered into direct negotiations with General Motors concerning a possible loan. He felt that "our proposal, in addition, will set a far-reaching precedent for solving business problems without resort to or dependence upon governmental authority, direction, or assistance. In so doing, even if the complexion of the Administration or the Congress should change and the federal government should veer once more to the left, our proposal will automatically lessen and reduce the risk to the business community of new and more crippling anti-monopoly legislation or harsher anti-monopoly law enforce-

ment." In the end, General Motors decided that such a loan would only further open the corporation to charges of monopoly.[78]

By early April conditions had so worsened that consultants advised the board that Studebaker-Packard should consider liquidation. In an impassioned speech Nance persuaded the board to continue its search for a financial benefactor.[79] Nance personally undertook a program to cut his executive staff and to consolidate the sales force of Studebaker-Packard.

In late April, Secretary of Defense Charlie Wilson intervened. Flying to Detroit he spent the day in discussions with Nance. At the meeting Wilson and Nance agreed to pursue further discussions with Roy Hurley of Curtiss-Wright. Six days later on April 27 Nance and J. Russell Forgan, head of the finance committee and senior partner of the New York and Chicago investment firm of Glore, Forgan & Company, traveled to Washington to meet with Roy Hurley. Attending the meeting were Secretary of the Treasury George Humphrey, Secretary of Defense Charles Wilson, and other key representatives of the Eisenhower administration. At this meeting Hurley raised the possibility of arranging a deal with Daimler-Benz, manufacturers of the prestigious Mercedes-Benz, to grant Studebaker-Packard sole distribution rights to their cars in the United States. Daimler-Benz had close connections with Curtiss-Wright and had expressed dissatisfaction with their current American dealer. Moreover, Hurley insisted that he needed a guarantee of "extensive defense" contracts before he could commit himself to any merger.

Over the course of the next two months negotiations continued with Curtiss-Wright and Textron. Meanwhile, Nance was forced to initiate severe cuts at Studebaker-Packard. Along with reducing personnel, he closed the Connor Plant in Detroit and the Los Angeles assembly plant.[80] In June, Nance ordered the closing of the South Bend Studebaker plant, but this order was rescinded shortly afterward because of its possible effect on negotiations with Curtiss-Wright.[81]

Meanwhile, Secretary Wilson proposed that Studebaker-Packard organize a new subsidiary corporation to handle defense contracts. He was unwilling to make a pledge of defense contracts to Studebaker-Packard in its current condition, but he might consider offering contracts to a subsidiary. Other problems arose as well. A $15 million loan offered by the New York Federal Reserve Bank was, as Nance put it, "too onerous for acceptance."[82] The Treasury Department ruled that Studebaker-Packard tax credits valued at $56 million would be of little use to Curtiss-Wright.[83] Finally, when all appeared to be doomed, Hurley proposed a deal to save Studebaker.

The deal was tough by any standards. Curtiss-Wright agreed to of-

fer "managerial assistance" to Studebaker-Packard. In turn, Curtiss-Wright received an option to buy five million shares of unissued Studebaker-Packard stock at $5 per share. A new subsidiary was created, the Utica-Bend Corporation, to handle defense work at the Utica and South Bend Chippewa Avenue plants. Curtiss-Wright also acquired the Aerophysics Development Corporation for $17 million. For its part, Studebaker received $25 million for leasing these plants, as well as an additional $10 million for inventories. In addition, Studebaker also received another $10 million from Daimler-Benz to take over distribution of its auto. At the same time Studebaker-Packard received new financing from twenty banks and three insurance companies.[84]

The Curtiss-Wright deal was made under the most extreme conditions. Threatened with bankruptcy, Nance and the directors acted as speedily as possible. There was one drawback to the deal: it was illegal. The corporation had turned over its defense plants and contracts, created a new subsidiary, and entered into a management relationship with another company without having gained stockholder approval. The directors had been informed by their own legal counsel that such a move was probably illegal. The alternative was bankruptcy, however.[85]

The battle had been won, not the war. In December 1956 Nance's resignation became final. Harold Churchill, former Studebaker engineer and division head of Studebaker, now replaced Nance. The resignation of Nance brought the resignation of twelve officers of the company, including Paul Hoffman, Harold Vance, Ray Powers (industrial relations), William Graves (engineering), Walter Grant (finance), Elliot Richards (treasurer), A. Stanley Thompson (chief engineer at Packard), C. D. Scribner (industrial relations) and William A. Keller (sales). As a group they fared well, except for Walter Grant, who took a position at New York Central. As for Nance, he was given a severance payment of $268,000 to be paid into a trust. Shortly afterward he accepted a vice presidency at Ford.[86]

Nance's reign of sixteen months had proved to be one of the most controversial in the company's history, matched only by Albert Erskine's. There was no doubt that Nance had accomplished much in a short space of time.[87] A broad product line in keeping with current consumer taste had been developed in a year and a half. The 1956 face-lift had been accomplished in an extraordinary seven weeks. Moreover, Nance had removed, although not with a good deal of delicacy, fat within the corporate executive staff. And he had addressed the problems of labor costs and work standards, albeit at a terrible and demoralizing price. In doing so he had won the support of his board

and his financial backers. Indeed, his actions had enhanced his reputation in business circles, as evidenced in his move to Ford following the Curtiss-Wright deal.

Nance found his share of detractors, then and now. For instance, Edward Mendler, who had played a key role in negotiating the consolidation, articulated the sentiment of many who judged Nance a failure. In a long, detailed letter sent to Paul Hoffman in late 1956, Mendler leveled his criticism of Nance's administration.[88] "If charts, graphs, forecast committees, heavy staff organizations and meetings," he wrote, "were the only techniques and requirements of success, Studebaker and Packard should have been declaring record dividends." But, "Never, in my long business experience, have I witnessed a managerial propensity for selecting key personnel so lacking in basic business and simple economic literacy. This obviously could only result in an organization riddled with incompetents and neophytes."

Still, the problems of Nance ran deeper than his selection of personnel alone. "The new management seemed obsessed with the notion of imitating the Big Two organizationally. Now, there is nothing wrong with that—it's a noble pursuit, if you have the volume to require it and justify it expense wise." The fact was, however, that Studebaker simply did not have the volume necessary to have this sort of organization. The 1955 Packard, he noted, was "full of bad quality parts," including faulty axles and "unbelievably bad" body construction. These problems he attributed primarily to poor management. "The operating climate had deteriorated drastically as a result, and only as a result, of new management policies and practices." In this situation, other problems became acute, particularly the labor problem. Nance's handling of the labor situation, he implied, was the final straw that broke the camel's back.

Mendler's criticisms were astute and to the point. Nance's attempt to model Studebaker-Packard after the Big Two, structurally and strategically, disrupted the internal operation of his corporation and failed to earn a greater share of the market. This criticism suggested, however, that another alternative was possible. Mendler assumed that Nance should have left well enough alone. Packard and Studebaker should have continued operation as separate organizations pursuing their own market strategies, while attempting to integrate common activities where possible. Such an alternative simply ignored the fact that Packard and Studebaker had merged because both corporations had failed independently. There is no reason to assume—and experience discounts the idea—that consolidation without divisional integration would have succeeded where Nance failed.

On the other hand, a strategy that called for Studebaker-Packard to have gambled solely on a small, specialized car market presented its

own difficulties. Studebaker-Packard was simply too large to gamble with a single model car. Moreover, management still would have faced a labor problem. In the case of American Motors, single model production forced layoffs and the imposition of tighter work standards. Romney proved no more enlightened than Nance in confronting organized labor; both men willingly accepted bitter strikes to establish management's right to manage, except that in the case of Studebaker-Packard, both management and the employees lost.

Nance faced a no-win situation dictated by market conditions and tradition. The ongoing battle between General Motors and Ford, continued even in the midst of a severe downturn in consumer demand, left little room for Nance to maneuver. The Eisenhower administration did little to help matters, especially when the Federal Reserve tightened money and the Defense Department cut defense contracts. More importantly, Nance confronted the intransigence of tradition when he tried to impose his will on Studebaker. A tradition of professed enlightened management, cooperative industrial relations, and militant trade unionism simply could not be dismissed by a new style of management. Bitterness and conflict became the inevitable result of this disregard for corporate tradition.

If emulation of the Big Three failed to bring success, what else was there? The board of trustees asked themselves this very question in 1957. The answer came shortly: the compact car market and diversification. Both proved to have their drawbacks, leading one Studebaker executive to conclude, "It didn't seem to make any difference who was president. Every time they came to a fork in the road they always took the wrong turn."[89]

Studebaker Halts U.S. Production, 1957–1963

Tradition Abandoned

Tradition haunted corporate leadership at Studebaker before it closed its doors in 1963.

The last six years of the corporation's history were ones of desperate struggle to remain in automobile production, even as the board pursued a deliberate strategy of diversifying corporate holdings through the acquisition of other companies. In this situation, tradition became both a symbol of failure and a thread of hope. Any sign of employee discontent was taken by the board as further evidence that the corporation still suffered from labor problems. Many on the board believed that the days of automobile production for Studebaker were numbered. Labor had helped kill the company. Management's task was to save the stockholders from disaster by diversifying corporate assets into new opportunities for growth.

Tradition took on deeper meaning than antilabor sentiment, however. Those who hoped that Studebaker could find the right car to produce—a car that would revive the company's fortunes—found in tradition a company that had always pulled through. Studebaker was to be seen as a company that had willingly accepted the challenge to advance. History became associated with style and design. History became a means to bolster optimism. The introduction in 1962 of the Avanti, designed by Raymond Loewy, captured this spirit. A year later Studebaker abandoned automobile production in South Bend, thereby ending a 100-year history.

Americans (and Studebaker) Think Small, Briefly

The early 1950s, with the failure of Hudson's Jet, Kaiser's Henry J, and Willys's Aero, had given little sign of the great potential for the

For the
Sixth Time
in America's history

1940s. This World War II advertisement drew upon Studebaker's tradition of serving the nation by producing military vehicles. World War II brought profits to Studebaker through the production of Wright "Cyclone" airplane engines and military trucks, but the war gave Studebaker a false sense of security whose tenuousness soon became evident in the postwar years. Archives, Studebaker National Museum, South Bend, Indiana.

1950. The Studebaker Champion. Introduced in 1945, the Champion was Studebaker's first postwar automobile. The "bullet-nose" Champion, designed by Raymond Loewy, became one of Studebaker's best-known automobiles—for better or worse. Enthusiasts called it ahead of its day; critics felt that the "bullet-nose" showed how out of touch Studebaker was with Detroit. Archives, Studebaker National Museum, South Bend, Indiana.

1952. This photograph was widely used in Studebaker advertising to convey to the public the tradition of craftsmanship at the company. In the picture above, a grandfather, two sons, and two grandsons are grouped around a Studebaker "Commander." Within a few years Studebaker management would consider itself as having a "labor problem." Archives, Studebaker National Museum, South Bend, Indiana.

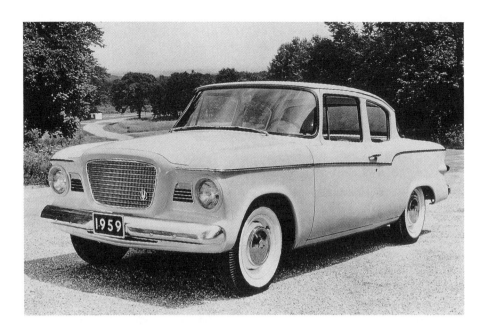

1959. Studebaker's introduction of the Lark brought the company profits as the compact car market boomed after American Motors brought out its Rambler. The Big Three soon entered with their own lines of compact cars. By the 1960s, however, American consumers were buying "muscle" high-powered cars. Archives, Studebaker National Museum, South Bend, Indiana.

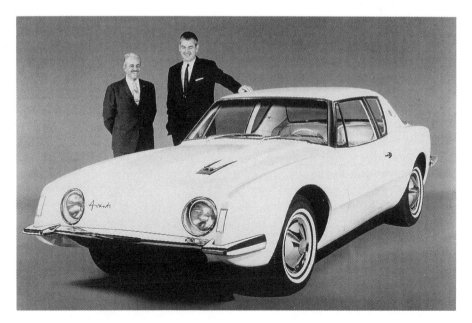

1962. (R. to L.) Raymond Loewy and Sherwood Egbert. The introduction of the Avanti with its unique streamlined, all plastic body came too late to save the company. Avantis are still produced today in Ohio for a select group of devotees. Archives, Studebaker National Museum, South Bend, Indiana.

1979. The Studebaker factory still stands today, having changed little from this 1979 photograph. Too expensive to be torn down, the plant reminds the city of South Bend of a "golden age" when the town prospered. Archives, Studebaker National Museum, South Bend, Indiana.

small compact car. Even Romney's Rambler lost money in its first year. By 1955, however, Rambler sales were 80,000, and the following year sales would reach 186,000, putting American Motors in the black. More important, however, was the sudden arrival of the Volkswagen "Beetle."

Developed before World War II for Hitler as "the people's car," the Volkswagen was put into production only after the war by a newly formed corporation jointly owned by the German federal government and the state of Lower Saxony. Headed by Heinz Nordhoff, Volkswagen targeted the American market by building a strong service organization. As early as 1955, Volkswagen already accounted for half of all sales of import cars, although this meant only 28,000 cars altogether. By 1960, however, Volkswagen sales had reached 160,000.[1] Fueled by VW sales, compact cars' share rose to over 10 percent of the market.

The rapid growth of the compact market finally convinced the Big Three to enter the market in 1960 with the Ford Falcon, the Dodge Dart, and the Plymouth Valiant—all scaled-down conventional cars. The only innovative design came with Chervolet's Corvair, which had an air-cooled, rear-mounted engine.[2] Still, Big Three compacts—along with a shift of consumers back to larger cars as the economy began to revive—gutted the compact car market. By 1962, the compact market appeared dead.

The disappointment of the compact market captured the fate of Studebaker in its last years. Illusion of a turnaround, the expectation of a breakthrough, anticipation of a better future always ended in dashed hopes and bitter defeat. The better day never came.

Still, the rescue by Curtiss-Wright instilled a moment of hope at Studebaker, especially when Roy T. Hurley, CEO of Curtiss-Wright, selected former Studebaker engineer Harold Churchill to run the daily operations of the company.

Harold E. Churchill presented a sharp contrast to Nance. An engineer and a production man, the fifty-six-year-old Churchill gave every appearance of being a relaxed, patient man, only betrayed by his chain smoking. Handsome and square-jawed, Churchill was a Studebaker man *par excellence*. Confident and self-assured, he had been an engineer at Studebaker for thirty years before Hurley selected him to head the revitalization program. Hurley provided the cost analysis, production and finance men, while he allowed Churchill to coordinate corporate strategy and industrial design.

Financial interests in New York and Chicago felt, as one banker noted, an enormous confidence in "the combined managerial ability of Studebaker and Curtiss-Wright."[3] In turn, Churchill found banks playing an even greater role within the corporation. During the ne-

gotiations, banking interests insisted on establishing a select steering committee composed of representatives from First National City Bank of New York, First National City Bank of Chicago, and Chase Manhattan Bank that would meet periodically with Churchill and Curtiss-Wright. This committee accepted Churchill's strategy that removed Studebaker from direct competition with the Big Three.

The signing of a formal agreement with Daimler-Benz, which gave Studebaker the exclusive right to import and sell Mercedes-Benz in the United States, offered further encouragement to the banks. A survey of Studebaker dealers in early 1957 showed that 60 percent of them were already selling foreign automobiles. Therefore, many bankers felt that "Studebaker had turned an important corner" with the Mercedes deal.[4]

Churchill also reversed Nance's administrative structure by replacing it with a small, flexible management. "I've always had a personal fetish against things that are complicated and big," he declared, and this sentiment was carried into his views of management and car design.[5] Working closely with A. J. Porta, a "crackerjack financial man," he restructured management at Studebaker. He began by lopping off former Packard personnel within the organization. Over the course of the next two years Churchill replaced twelve of the leading executives under Nance with his own men.[6] For those who remained he increased executive salaries and stock options to ensure a loyal executive staff. At the same time he cut back on outside consultants who he felt only caused "confusion and hurt morale."

Churchill also sought to revive employee morale on the production line. To do so he revived the rhetoric of the older Studebaker tradition, so easily dismissed in the Nance years. Churchill told the citizens of South Bend, "We pride ourselves on the spirit of good fellowship that prevails, on our teamwork, and our ability to 'live and let live' in the American way. . . . As a member of the Studebaker-Packard family each employee is a part of a closely knit industrial community."[7] Even while he spoke these words, however, his new administrative team oversaw the final phaseout of production facilities in Detroit.[8]

He instituted weekly meetings between managers and foremen to ensure that those on the line were kept informed of the specifics of production and labor costs and the union contract. He began a night school for supervisors to develop their managerial skills.[9] Often seen strolling throughout the plant, he was described by *Business Week* as an executive willing to get his hands dirty, who does things an "auto president used to do years ago before lawyers, accountants, and salesmen took over the executive suites."[10]

Throughout 1957 and 1958 Studebaker management continued to

confront problems with Local 5 over the perennial problem of work standards and layoffs. Churchill moved to address these problems by direct negotiations with union leaders and through changes in the Industrial Relations Department. In July 1957 Churchill replaced P. S. Barno as head of Industrial Relations with Clifford M. MacMillan. This move was primarily designed to bring a new management team into the contract negotiations with the union that opened that month.

Churchill's efforts to stabilize industrial relations at Studebaker were aided when the union elected T. Forrest Hanna to the presidency of Local 5.[11] MacMillan welcomed the election. He told Churchill that Hanna is a "pretty decent citizen" and will not "condone a wildcat limiting production sort of strategy." MacMillan was further encouraged because the militants under Ogden had lost strength throughout the plant.[12]

As new labor negotiations opened in July 1957, MacMillan proposed to peg pay increases to company profits, thereby exempting wage increases from cost of living standards.[13] This proposal caused a brief union walkout, but unlike during the previous Nance regime, a serious confrontation with labor was avoided. Following a two-day walkout, negotiators returned to the table to hammer out a final contract. The contract called for the union to receive a 2.5 cent per hour increase when sales reached 60,000 and a full 5 cent per hour increase upon attainment of 90,000 cars. Negotiations over pension benefits were to be withheld until the following year.[14]

Negotiations with labor in 1958 were conducted in the midst of a general downturn in sales within the automobile industry. In the first nine months of the year sales declined to $92 million, with a loss of $22.5 million.

Even with the loss, Churchill remained cautiously optimistic concerning the future of Studebaker. He recognized that the growth of population, national income, and multiple car ownership among families indicated a strong general need for a small economy car. He felt that such a car might also find a market among working women who needed a second car for transportation. As he remarked to one associate, "One of the basic things that occurred in the automobile industry is the importance of the feminine influence."[15]

Still, he realized that the introduction of a small model Studebaker was an immense gamble for the corporation. To manufacture a new car entailed huge retooling costs. "The yoke of the independent," he told his staff, "lies in tooling costs."[16] The move to a small car meant betting the company's future.

Churchill envisioned a new model car that would turn the company around in much the same way the Champion had in the 1930s. He

had helped E. J. Hartig design the Champion; now he undertook the design of a new compact car, the Lark.

In undertaking this project, Churchill consciously redirected, as he put it, "our product philosophy away from head on competition with the Big Three."[17] The first sign that Churchill was moving in this direction was the introduction of the Scotsman in 1957. Designed by Duncan McRae as the economy slipped toward recession in May 1957, the Scotsman was a scaled-down Champion without any accessories. Priced at $1,776, two hundred dollars less than the cheapest Chevrolet, the standard Scotsman came with only vacuum windshield wipers, manual transmission, turn signals, and a simple heater-defroster unit. Factory options included overdrive, an oil bath air cleaner, and electric windshield wipers. Within a year the Scotsman became Studebaker's largest seller, contributing 17 percent to total sales.[18]

Under the new financing established during the Curtiss-Wright negotiations, Churchill found the capital necessary to launch the development of a new model. That final quarter Studebaker premiered its Lark. Designed by chief engineer Eugene Hartig and stylist Duncan McRae, the Lark proved to be the car that Studebaker management had long sought. Although advertised as a full six-passenger car on the inside, the Lark gave the appearance of a compact on the outside. Retailed at $1,997, the Lark offered Studebaker a brand-new look. Faster than the Scotsman, the Lark recorded good gas mileage at the annual Mobil Gas Economy Run. Sales of the Lark in the last quarter of 1958 put Studebaker in the black for the first time since 1953. Studebaker sales, not counting the popular Hawks, rose from 45,070 in 1957 to 131,075 in 1958. Within the year Studebaker gained a 2.1 percent share of the market. The results were little short of remarkable. Sales rose from $180.7 million to $387.4 million; following a $13.4 million loss, Studebaker brought in $28.5 million in profits. The number of employees also rose from 8,175 in 1958 to 11,307.[19]

The soaring sales of the Lark brought an ecstasy to the city of South Bend and the factory. Soon signs began appearing throughout town reading, "South Bend Goes Up with the Lark." Civic pride and company spirit were back.[20]

The turnaround in Studebaker sales did not translate into a new commitment to automobile production by the board of directors. Indeed, increased sales encouraged the directors to pursue their strategy of diversification. Studebaker's profits were seen as an opportunity to make the corporation appear more attractive to potential subsidiary companies. Until the success of the Lark, Studebaker-Packard had found stock exchanges with other companies hard to sell. Now, with profits growing, the board moved aggressively to diversify the holdings of the corporation.

Studebaker Diversifies

In April 1958, after two years of management, Curtiss-Wright decided not to exercise its $5 million share option.[21] Following Curtiss-Wright's withdrawal, the corporation refinanced its debt, reducing it to $16.5 million, while maintaining a huge tax loss carry forward credit estimated at $120 million built up over the course of five years. In refinancing the corporation an implicit understanding was reached with the sponsoring financial institutions—twenty major banks—that Studebaker should begin to diversify its corporate interests, "despite any success in automotive operations."[22] In short, both Curtiss-Wright and the bankers understood that Studebaker no longer had much of a future in the automobile business.

In pursuing this strategy of diversification, several new directors were added to the board, including Edward H. Litchfield, former dean of Cornell Business School and current chancellor of the University of Pittsburgh.[23] Churchill remained chief operating officer of the company. Without a chairman of the board, the executive committee served as the directorate of the company, a situation bound to create problems.

Board members remained divided on their commitment to remaining in the automobile industry. The board agreed to the general strategy of diversification, but many felt that Studebaker's days as an automobile producer were numbered. By the end of 1958 the corporation held $35 million, and looked forward to having $57 million in cash by the end of 1959. With the tax credit to expire at the end of 1959, Studebaker could now afford to undertake a longer-term diversification program.

The board assigned the recently appointed board member Abraham M. Sonnabend, chair of Botany Mills, to head the acquisitions campaign. In a January 1959 meeting, Sonnabend outlined the basic principles for acquiring new companies. The corporation, he stated, should look for companies making at least $5 million in pretax earnings. Companies that relied on merchandising or distributive know-how should be avoided. The board also agreed not to pay more than two times the book value of assets for a company. Some companies should "complement" the auto business, but the main goal was to diversify. Among the types of companies to be considered were a railway car manufacturer, a street and industrial sweeper manufacturer, a plastics company, and a therapeutic chair manufacturer.[24] It was evident from the ensuing discussion that some board members already envisioned a corporate future without the automobile division.

The common opinion was that the Studebaker plant, with its mul-

tistory buildings, some dating back to the 1800s and the rest constructed in the early 1920s, was not equipped for modern high-speed assembly operations. Moreover, Studebaker's reputation as having a "labor problem," developed in the Nance years, continued to haunt the company, even though Churchill had formed good working relations with labor. As one executive investigating Studebaker for a possible merger noted, "[Studebaker] management is working under considerable hardships resulting from a soft labor attitude at Studebaker-Packard for the past thirty years." "In fact," the executive incredulously noted, "it was a matter of pride with former management [Hoffman-Vance] that Studebaker-Packard had never suffered a strike."[25]

In choosing A. M. "Sonny" Sonnabend to head the acquisitions program, the board selected one of Boston's toughest businessmen. Like Nance, Sonnabend was egotistical and strong-willed; yet one basic difference separated them: Nance was a corporate man, a team player. Sonnabend was a money man who sought to go his own way. A combat navy pilot during World War II, Sonnabend first made his reputation in hotels. As chairman of Botany Mills, a money loser until Sonnabend assumed command, he had evolved what soon became known as "the Botany formula" for putting the company into the black.[26] The formula called for complex financial maneuvering that allowed for the use of pretax profits of the acquired company to pay for the purchase.[27] In this way the company literally paid for its own acquisition, usually within eight years. (Corporate raiders would pursue similar strategies in the 1980s.) But here lay the hitch. The success of the Lark meant that the value of Studebaker stock had increased, while tax credits had decreased. Acquisitions would have to come through current holdings.

Sonnabend's strategy seemed sound. Yet his presence on the board created its own problems. His aggressive personality offended many board members. Sonnabend's willingness to criticize fellow members openly by calling into question their business acumen created hard feelings.

Initially, the board tolerated Sonnabend, but many felt that he aspired to become the new chairman of the corporation. Nonetheless, he proved relentless in his search for companies to acquire. In 1959 he brought to the board eight possible acquisitions, including Revlon, Oliver, and Winn Dixie Stores. In the end Studebaker acquired only three of these companies, Gravley Tractors, CTL Plastics, and Gering Plastics, all moderately sized manufacturing firms. Larger companies, as one Oliver executive said, simply felt that "Studebaker stock is not worth the paper it is written on."

As Sonnabend pursued his acquisitions policy, critics on the board

became openly hostile to his handling of the program. Frank Man-
heim, a senior partner at Lehman Brothers, soon emerged as Sonna-
bend's leading critic. He privately wrote another board member that
the corporation should make one or two major acquisitions "a la Tex-
tron," rather than pursuing Sonnabend's strategy of a series of small
ones. He added, "It is imperative that Studebaker-Packard move vig-
orously into acquisitions. Time has been in the company's favor thus
far; it is running against it now." He warned that outside earnings
remained poor, but the company had $25 to $35 million in excess
cash.[28]

What most irked Manheim was Sonnabend's insatiable ego. In a
series of letters to other board members he continued to report on
Sonnabend's "egotism." "If he [Sonnabend] possibly can, he will take
full advantage of any publicity opportunity to be the great savior of
Studebaker-Packard.[29] Irritation turned into aggravation, then open
hostility. Finally, an angry Manheim wrote Sonnabend directly, "I was
amazed to read today in the *Boston Herald* of how Boston's A. M.
Sonnabend turned the Wall Street bankers' apparent loss of $38 mil-
lion in S-P into a tidy profit. Actually," Manheim continued, "of
course you will remember, you had virtually nothing to do with the
refinancing program. You were not called in to 'salvage' the company.
Moreover, you give little credit to other directors, our counsel, and
our management with your distortion of the facts and the complete
misrepresentation of what has transpired."[30]

Tensions, long suppressed in board meetings, came into the open
in the summer of 1959 when Sonnabend proposed the acquisition of
Niagara Therapeutic Chair Company. Niagara, with pretax earnings
of $1 million per year, had agreed to a price of $8 million. Warned
of Sonnabend's proposal the previous night, Churchill immediately
raised an objection to entering the therapeutic chair business. Sonna-
bend replied that Studebaker should acquire any respectable company
that would bring in more business. Churchill answered that the suc-
cess of the Lark meant that Studebaker should stick to its policy of
moderate diversification. Sonnabend countered that the Big Three's
impending entrance into the small-car field would pose a serious
"threat to the corporation's survival." Any downturn in the auto busi-
ness meant that Studebaker would be forced to close down its auto-
mobile operations. The Niagara deal was left undecided and eventually
fell through, but divisions within the board remained.[31]

Further, manifestations of these divisions came the following
month. They began when Sonnabend raised objections to a proposal
by Daimler-Benz to purchase preferred stock in Studebaker. "Ger-
mans," he said, were "undesirable stockholders who might get control
of the corporation." He added that he opposed any large share of for-

eign stockholders, but especially the Germans. Churchill once again took issue with Sonnabend, pointing out that Daimler had provided new business to the corporation as well as technological assistance. Sonnabend moved that the financial agreement reached the previous month allowing Daimler-Benz to purchase stock be terminated. In a divided vote, the board barely defeated the motion.[32]

Sonnabend's actions convinced many on the board, as one director observed, that Sonnabend's acquisition activities were designed by a long-term goal of gaining control of Studebaker. Rumors of Sonnabend's braggadocio began to spread among board members. One rumor reported that Sonnabend at a Brandeis graduation party had told a crowd that he had taken over the Studebaker board and that "changes were coming." He claimed that he had acquired $1.5 million worth of shares of Studebaker, and he hoped in the near future to replace its "stodgy" managers with some creative minds.[33] Clearly lines were being drawn.

This was hardly the board of old, either Fish's or Hoffman's, where differences were subsumed in genteel expression. That summer, Harold Vance, the man who had struggled so adamantly to keep Studebaker in autos, died.[34]

The entry of the Big Three into the compact business did little to bolster confidence that Studebaker would remain in autos. In 1959 Studebaker turned a $28 million profit, but in the first six months of 1960, under competition from the Big Three, the company earned only $3.3 million, down $12 million from the previous year's earnings. The entry of Ford's Falcon and Comet, G.M.'s Corvair, and Chrysler's Valiant and Dart cut heavily into compact and import sales. Mid-spring of 1960 showed Studebaker still controlling over 11 percent of the compact market, but its total share of the industry was only 2.05 percent.

The Big Three had aggressively targeted Studebaker dealers with offers to set up "dual dealerships." Chrysler had been particularly aggressive, leading one Studebaker spokesman to call Chrysler's policy a "flagrant" violation of antitrust law. One survey showed that approximately 30 percent of all Studebaker dealers (accounting for 20 percent of all retail sales) were dualed with one or more of the Big Three. Yet Studebaker officials recognized that the problem was more than dual dealerships. As the head of sales at Studebaker noted, Volkswagen had 350 dealers and was selling 150,000 cars; Studebaker had 2,000 dealers and could not sell 100,000 cars. Declining Studebaker sales were soon reflected in the deterioration of Studebaker stock. In fall 1959 Studebaker stock had risen to $29 a share; that summer of 1960 it stood at $13 per share. Perhaps the situation was best summarized by

the Studebaker dealer who told *Newsweek*, "this industry is no place for a fellow with a weak heart."[35]

With declining automobile sales and falling stock prices, the board saw that radical action was needed. Operating without a chairman since Paul Hoffman had left the corporation in 1956, the board now agreed that it should initiate a search for a new chair and a chief operating officer. At the same time, the board moved to eliminate the acquisitions committee under Sonnabend and replace it with an "acquisitions staff," under a new vice president directly responsible to the CEO. To serve in this position, the board brought in a former executive vice president of Revlon, W. D. Newhort. This move targeted Sonnabend, and he knew it. He told the press that he did not feel the changes would result in "more realistic, more imaginative, or sounder acquisitions."[36]

With factionalism in the open, Sonnabend made little effort to hide his feelings at board meetings. "We are not wasting money, we are wasting time," he told the board. "This company can be successful both in auto lines and in diversification." He boldly declared that with the right management Studebaker could be earning $10 to 15 million in annual profits in the next few months. Instead, the board had made it a point to downgrade him by removing him as chairman of the acquisitions committee.

Sonnabend's speech was too pointed for the board to ignore. One board member heatedly replied (speaking of Sonnabend in the third person), that if he could bring in $10 to $15 million in "good, solid companies, let him do it." Sonnabend was not about to back down. "I see nothing but failure and doom for this company unless I am given the chairmanship."

At this point Edward Litchfield, who as a former dean of a business school was used to controlling egotistical personalities, stepped in to ease the situation. He observed—on an upbeat note—that the future for 1961 and 1962 looked good. The company had survived "the bump of new competition in compacts," and the automobile plant now had good management. In the meantime, he proposed that a "caretaker government" under an acting chair and chief operating officer be established to manage the corporation. Sonnabend acquiesced to Litchfield's proposal, but with great reluctance. "I will vote for it," he said. "I am a member of the team, a minor league team playing in the majors—in the cellar where it belongs." Then he added, "Studebaker is doomed. We are temporizing, when we need the best brains to survive."[37] He meant his, of course, but such was not to be. He nonetheless continued his quest for control of Studebaker.

In September 1960, the board invited Clarence Francis, former

chairman of General Foods, to become acting chairman and chief operating officer of the company.[38] The seventy-one-year-old Francis had been a director since 1958. In assuming the chairmanship of the board and the position of CEO, Francis replaced Churchill as the formal head of the company. Churchill, for his part, agreed to take a staff position within the corporation, although it was understood that he would have little involvement in the daily operations of the company.[39]

The selection of Francis as chairman was intended as a clear signal to Wall Street that Studebaker sought to accelerate its acquisitions program. Although the board remained committed at this point to keeping Studebaker in the automobile business, a growing faction continued to question the future of this line of business.[40]

As 1960 drew to a close, Studebaker's market share had fallen to 1.3 percent.[41] The head of sales reported that within the last half year over 205 Studebaker dealers had gone out of business. Francis openly spoke of liquidation. Even Sonnabend agreed that "we will have to liquidate if the present management stays." The board voted to speed up the search for a new CEO.[42]

Egbert Advances, but Studebaker Collapses

The search for a new CEO reopened old wounds. Once again Sonnabend insisted he was the right man for the job. When the board met that December, however, the search committee recommended Sherwood Egbert, a forty-year-old executive vice president with McCulloch Corporation. Trained as an engineer, he had spent most of his business career at McCulloch. Although he had little experience in acquisitions, or with stockholders and banks, he was well known for being an aggressive, young "operator."

The board's recommendation was the final straw for Sonnabend. "I continue to believe," he declared, "that even now my program could save the company and that the present policies of the board will lead only to ultimate ruin of the entire enterprise."[43] Both Churchill and Porta went on record favoring Sonnabend. Churchill told the board, "I seriously question whether Egbert is the solution." Nevertheless, the final vote was eight for Egbert, four for Sonnabend. Porta immediately announced his resignation from the corporation effective on completion of the transition. As a director was sent to phone Egbert of the news, Sonnabend, who had been waiting outside for the final decision, now reentered the room. He did not bother to sit down. Having minced no words in the past, he was not disposed to do so now. "You have doomed the company. . . . The decision is ridiculous. This board should disband and get out—it is worthless."[44] He, too, submitted his resignation.

Sherwood Egbert stepped into a troubled corporation. A young, egotistical executive on the rise, he confidently felt he was the right man for the job. A former Marine Corps officer, he brooked little dissent in his staff. He quickly replaced comptroller, treasurer, and general sales manager.

He came to Studebaker with little sense of Studebaker tradition or loyalty toward the automobile division. Nonetheless, he moved quickly to correct midyear losses. He announced a new advertising campaign designed to sell Studebakers. He increased television advertising by sponsoring the popular "Mr. Ed" television series, a sitcom featuring a "talking horse." Meanwhile, he instructed engineers to add tachometers and compasses to all models in order to appeal to the teenage market. He also became actively involved in municipal efforts for neighborhood redevelopment around the Studebaker plant as a way of enhancing the Studebaker image in the community and as a "concerned employer." He told the local press that "I feel very strongly that success is through people, not machines. . . . "[45] Egbert, the man brought to Studebaker to engineer its diversification out of the automobile industry, continued to echo the sentiments of an older tradition.

While Egbert concurred with the overall strategy of diversification, even if it entailed the possibility of abandoning the automobile industry, he gave every appearance of remaining committed to automobile production. Within a month of assuming the presidency he announced that Raymond Loewy had been retained to work on face-lifts for the 1962 and 1963 models. Shortly afterward, he informed the board that he planned to introduce an entirely new model for 1964 even if the estimated tooling cost was $35 to $40 million.

At first, Egbert found luck on his side. The spring of 1961 brought increased sales. Sales skyrocketed in March to over 33 percent above the previous month. The 1961 Lark and Hawk had shown an impressive 19.5 percent increase in the last quarter. This had been accomplished even though the number of dealers had hit an all-time low.[46] Predictions were that Studebaker would finish the year with only a $10 million loss, while still maintaining a $25 million cash reserve. Moreover, Daimler-Benz announced that it had agreed to provide Studebaker with all the cars it could sell. In June Egbert announced that Studebaker now expected a profit of $4 million at the end of the year. He had accomplished what seemed to be the impossible: he had pushed Studebaker into the black.[47]

At this point, just when all looked well, things began to turn sour again. In July 1961, Egbert informed the board that he had just undergone surgery for cancer. Sonnabend, who had been waiting in the wings, saw his opportunity to seize control of the corporation. Work-

ing with D. Ray Hall, a board member, Sonnabend made his bid for power. Hall called for the replacement of Egbert. At this point, Churchill stepped into the fray. Although he had vociferously opposed Egbert at the time of his appointment, he now rose to his defense by telling the board, "Egbert has done a hell of a job in South Bend. It is time for this board to sacrifice personal ambitions and whole heartedly support what Egbert and his people are doing. . . . We should get behind Egbert and help him do what I know he can."[48] The board agreed and affirmed a vote of confidence. When Egbert returned to work, he discovered that his problems were far from over. Labor wanted a new contract.

Egbert typified the modern business executive of the 1960s. Success within a single corporation was not an end in itself, but a promise of things to come—the promise of better offers from larger companies. His commitment was to the conglomerate, not to its separate divisions; his devotion was to his career, and its success depended less on the enterprise or its workers as such, than on increased earnings. In this world, image was as important as the "bottom line," although the two shared a peculiar relationship.

Egbert's image in business circles as a young tycoon worked against him with Studebaker employees. They tended to see Egbert as a brash hotshot who cared more about Wall Street than the company. Egbert's manner did little to win the hearts and souls of his employees. In a televised address aired in late September he projected an image as a young, cocky businessman who simply wanted to put the screws to them. When he announced he wanted to divert cost-of-living wage increases to the pension fund, he only confirmed this impression.[49] Thus, while Churchill had pacified labor, Egbert discovered himself once again embroiled in the "labor problem" at Studebaker.

The final break with the union came on January 1, 1962. Studebaker workers, now numbering less than 6,500, undertook what proved to be the longest strike in Studebaker's history. Lasting 38 days, the strike drew national attention and once again revived the view that Studebaker was a corporation with uncontrollable labor problems. Egbert and his staff had exacerbated tensions with the union through their "Operation Containment," which called for maintaining the company's position in autos through the control of labor costs. The workers had heard this song before, especially under the Nance regime, but now they would have none of it. In turn, Egbert was not prone to compromise. The last quarter's profits in 1961 showed the company making $8.5 million, most of it from the auto division. As a result the company had ended the year $2.5 million in the black.[50]

From the outset of the strike, Egbert showed he meant business.

After local police chief Orson Harmon refused to send in his men to protect the plant, Egbert brought in his own security force. *Business Week* called the strike "the longest and most painful" in Studebaker's history. Tempers flared on both sides. At one point the picket line forcibly stopped Egbert's car and demanded that he show a pass in order to leave the South Bend plant. Later, the workers claimed that Egbert had climbed from his car and challenged a worker to a fistfight. Although the charge was never proved, Egbert claimed that the story "grew like a fish story from a minnow to a whale." Whether true or not, it revealed the animosity between Egbert and his employees.[51]

The UAW leadership had made clear from the outset that it was willing to give management a favorable settlement to help overcome serious losses in early 1961. *Business Week* conjectured that Egbert had carefully calculated how long the strike could be tolerated and then moved to end a contract that fell below industrywide standards. Indeed, throughout the strike the board of trustees had taken a militant position. Three weeks into the strike the trustees had urged Egbert to hold fast in negotiations. As one trustee told the board, if "the strike needs another one or three weeks, then we should take it. Stockholders will benefit in the long run." Francis, as chairman, concurred, saying "there is a principle involved." Litchfield added, "Now that the strike is pinching, people know we're serious."[52]

The board voted to prolong the strike until mid-February to drive home its point. In the end, the union capitulated. Cleanup time was reduced five minutes; corporate contributions to pensions remained thirty cents below those at General Motors; and a wage increase was held to four cents per hour the first year, and six cents the following two years. Egbert had proved his point. As he told the stockholders later that year, "It was high time that this corporation stood up to its management responsibilities and met them head-on. And this is what we did. Some of the labor items in our labor contract were not only bad, they were shameful. These have been corrected . . . and the contract we have now is certainly a far improvement over what we had before."[53] The board of directors, involved in dismantling the automobile company through diversification, took comfort in Egbert's assurances that labor had been brought under control.

Meanwhile, Egbert continued to pursue his mandate to expand the corporation's holdings through diversification. In one three-month period, Egbert arranged for the purchase of Chemical Compound (the makers of STP engine additive), Schaefer (a manufacturer of commercial refrigerators), and Andy Granatelli's Paxon Products. In November 1962, the corporation's acquisition program climaxed with the purchase of Trans-International Airlines and Franklin Manufacturing Company, a household freezer manufacturer. Trans-International

proved to be a lost cause from the outset, while Franklin placed an additional drain on Studebaker's financial resources. To cover the $41 million price tag (Studebaker's largest acquisition in its history), Egbert borrowed another $25 million from six banks. As a result this cut into potential borrowing for the new 1964 models.

In late 1962 Egbert confidently told the board that the acquired divisions were returning 14 percent on investments. Moreover, the corporation won two government contracts worth $53.6 million for trucks. With common stock hovering between $6 and $10, many saw the corporation as "virtually a new company."[54]

Others knew better, however. For all of these early gains, Studebaker confronted major obstacles in maintaining its modest position in the auto industry. At least 25 percent of the country remained unrepresented by Studebaker dealers; the plant remained antiquated; and rumors continued to persist that Studebaker was planning to leave the automobile business. Such rumors, Egbert told one interviewer, hurt auto sales and company stock. "It's like a rat gnawing at your heels."[55] As a result, auto sales remained slack. Egbert felt that if Studebaker was to remain in the auto industry it needed to double its share of the market from 1.5 percent to 3 percent. He felt that the key to Studebaker success was its "performance image." What Studebaker needed, he concluded, was a high-performance car aimed at an upscale market. He personally assumed the task of working with Loewy to design such a car—a car that promised to shake the industry.

When Egbert began work on a new model car, it was unclear to many whether he was fully committed to remaining within the automobile industry. The very expense of closing the automobile plant was itself prohibitive. Most estimates placed the cost at $82 million, which included buying back obligations from dealers. This meant that the corporation would be left short $22 million, including $16.5 million in notes owed to the bank.[56] Still the board was prepared to bail out of automobile production if it became necessary. Egbert had been brought to Studebaker with the tacit understanding that the trustees and financial investors did not want the corporation to remain dependent on autos.

As a consequence, Egbert's commitment to autos in 1961 was at best a calculated investment decision. Yet over the course of the next months in early 1961, during the early stages of design, Egbert underwent a transformation concerning the corporation and its future in automobiles. Suddenly he got the automobile bug. He became obsessed with building a new car. Perhaps it was his large ego, or simply that he realized that the cancer in his body was spreading; but whatever the case, Egbert became obsessed with building a new Studebaker car.

In the process, he became an automobile man. He described this conversion at the annual meeting of stockholders in 1962. Too ill to stand, only a shell of the former Marine who had come to Studebaker the year before, he told a hushed convention that the doctors at the South Bend Clinic had "a hey day in my abdomen the last month and they have been hacking their way around." He still had not fully recovered from the operation, he said, but he felt invigorated by the new car he had helped create.

In nearly a whisper he told the convention how he had developed the car. "The performance image was really bugging me," he said. "I bought $6.00 worth of magazines on foreign sports cars and American sports cars . . . sketched out what I thought would be the kind of car that the American public wants. . . . that would bring Studebaker an image like it never had in a hundred and ten years." He took the sketches to Raymond Loewy, had him put them into clay, and put into production his new concept—the Avanti.[57] After his address, the stage curtain behind Egbert swung open to reveal the new Avanti. Witnessing Egbert's enthusiasm, Francis remarked, "I judge that Sherwood likes that car." Overhearing the remark, Egbert replied, "My whole heart is in that car, boy."[58]

The Avanti was indeed a marvel. Designed for the prestige end of the market, the all-fiberglass-body Avanti was styled so it would not undergo change for a four- to five-year period.[59] The Avanti promised once again to make Studebaker a leader in design. Intent to ensure that Studebaker was no longer just "another me-too company," Egbert ordered the Avanti to be put into production as quickly as possible.

Egbert invested heavily in the Avanti—his reputation and his health. The Avanti promised a new future for the company. Egbert felt that there is "a new esprit de corps or certainly a new aggressive spirit" within the auto division. Although the division had lost $8.8 million in the first six months of 1961, sales in the last quarter rose 20 percent above what they had been in the previous quarter. With the Avanti about to go on the market, he expected that the company would be in the black within the next three years. It promised to do for Studebaker what the T-Bird had done for Ford.[60]

Still ill, Egbert pushed the production of the Avanti forward. Introduced in the spring of 1962, the Avanti soon encountered immense production problems. The manufacturing of an all-plastic body meant that over 104 parts needed to be glued together. The problem was that sometimes the parts just did not fit. As one Studebaker executive said, "You can pry a sheet metal all over the place, but you can't move a piece of plastic reinforced with glass. It has to fit exactly." Moreover, plastic had a tendency to shrink 2 to 3 percent as it settled. As a consequence, the first fifty Avantis produced had their rear win-

dows pop out once they were driven at high speeds. The head of production reported that the production of the Avanti was "organized chaos."

Mechanically, the Avantis were excellent, but no two bodies seemed to be exactly alike.[61] Its introduction caused tremendous excitement in the trade, but delayed production hurt sales. Egbert had promised to deliver 1,000 units a month, but in 1962 he delivered only 1,300 cars in all.

Then, Studebaker's other models began to slip further. Egbert had launched the new models right on schedule, under budget through the use of a new computer system. For the first time in twenty-five years, a pilot line had been set up and produced 150 cars to ensure that body fixtures were perfect. Following this it took only five weeks to reach full production (60 cars per hour). The new models, other than the Avanti, were generally conventional looking and no longer "offbeat." The front end generally had a "General Motors look" with a narrow grille running across the entire width of the car, a deliberate change from the traditional Studebaker "pouting mouth."[62]

In June, Egbert was back in the hospital, having undergone surgery in Boston, Massachusetts. His secretary told board members that he would enjoy receiving cards and personal notes, adding, "I am sure that it goes without saying that these should be in a light vein and contain no reference to business."[63] No wonder—the auto division was operating at a loss of nearing two million a month. The board raised concerns about launching a 1964 model.

Still recovering from his second major surgery in a year, Egbert proposed the release of a new Avanti II, targeted for February 1964. This new line, including a sports car and two- and four-door sedans, would replace the Lark by 1966. Egbert felt that Studebaker could produce 112,000 cars in 1963. Others on the board had their doubts. Egbert had begun to lose his credibility. His fight with cancer had taken its toll on this once tall, dark-haired, "model American" executive.

His faltering acquisitions program, in turn, did little to enhance Egbert's image among the board. His final loss of credibility with the board came when he had approved the acquisition of Domowatt, an Italian appliance manufacturer, only to discover Domowatt was nearly bankrupt.[64] By January 1963, the board was actively discussing the closing of the auto division.

Egbert struggled desperately to save the division through bank loans to finance the new Avanti II, only to be told by the banks that such money would only be advanced if Studebaker was willing to use its acquired divisions as collateral. Egbert understood that this condi-

tion was too high to accept. He was forced to order a reduced production run of a face-lifted Lark. Avanti II was dead.

In June 1963 Clarence Francis stepped down as chairman of the board, replaced by Randolph Guthrie. Clearly the board was moving in the direction of leaving auto manufacturing. The remaining hope was the 1964 model. Egbert's faith that the 1964 face-lift might do what the 1959 face-lift had accomplished was quickly dashed. By late October, it was evident that this ploy had failed. Production was cut to 35 cars an hour. Egbert continued to press the board to remain in the auto business, but within the month it was announced that he was to undergo further surgery. He was now placed on an indefinite leave, with his position being assumed by Byers Burlingame, the man who had closed Packard operations four years earlier.

Worried about the possibility of lawsuits from dealers, Guthrie and his staff sought ways of maintaining a minimal presence in the auto business. Churchill was now assigned the task of arranging with a European manufacturer the possibility of selling their cars under the Studebaker name. Finally, when Churchill's attempts proved futile, it was decided that Studebaker would move operations to Hamilton, Canada. All lines were dropped except the Lark.

The board tried to keep its closure plans secret. Worried about plant sabotage, as well as stock prices, the board had expected to announce the closing in late December. Such news, however, could not be kept secret.

On December 9, an investigative reporter for the *South Bend Tribune* announced that he had discovered plans to stop production in the city. The news stunned the city. Many Studebaker workers did not believe it. A harried board convened a press conference to undertake damage control. Yes, they said, the plant was closing, but production would continue in Canada. The end had come.

When the last Studebaker, a red Lark Daytona, rolled off the line shortly afterward, a single worker was given the task of closing the gates for the final time. "I went up to the second floor and walked along the empty assembly line," he recalled. "Everything was still in place, and I thought, 'we could start production tomorrow.' I couldn't believe there would never be a tomorrow."[65]

Epilogue

Tradition as Contested Terrain

Production of Studebaker cars continued on a limited basis in Canada until 1967. Even this late, Gordon Grundy, the head of operations in Hamilton, Ontario, entertained hope that Studebaker might succeed in Canada. Breakeven for the Canadian operation was only 7,000 units per year, and the plant had a capacity of producing 30,000 units. Furthermore, General Motors offered to furnish engines for the Lark at only $130 more than the price for which South Bend had supplied engines. This allowed the Canadian plant to raise production to 14,000 units per year. At the same time Grundy sought to arrange for Studebaker to serve as a representative for either Toyota or Volkswagen. His efforts went for nought. In February 1967 the board informed him that they were closing the Hamilton plant.

The move to Canada had allowed the corporation to appear as though it were staying in the automobile business, but in reality the closing of the South Bend plant meant the end of Studebaker, the 114-year-old vehicle producer. The move to Canada had been designed by the board for the sole purpose of protecting the corporation's assets from lawsuits by dealers, estimated at a potential loss of $40 million. Studebaker, the automobile manufacturer, died with a whimper in 1967, hardly noticed by the press.

In the next decade, Studebaker lived on in name through its diversified holdings. Diversification continued through the acquisition of Big Four Industries in 1966 and Wagner Electric Corporation in 1967. In late November 1967, Studebaker merged with the Worthington Corporation to form a new corporation, Studebaker-Worthington. Studebaker-Worthington came to its final fate in the fall of 1979 when the corporation was absorbed by McGraw-Edison. Studebaker survived therefore in name only, having found an afterlife through its capital, a ghost of its former self.

Studebaker's presence in South Bend remained long after the death of the corporation. The day following the December 9 announcement that Studebaker would cease operations, the *South Bend Tribune* observed that the news had been received by the city as "like having an

old and venerable friend die."[1] The history of Studebaker Corporation and the city were so closely intertwined that it was hard to separate the two. Shortly afterward, at an emergency public meeting called by the city council to discuss the closing, an irate civic leader rose and told the sullen gathering that "this is not Studebaker, Indiana, this is South Bend, Indiana."[2]

Such talk seemed like bravado at the time, but South Bend quickly recovered economically during the boom years of the late 1960s brought about by the Vietnam War. Shortly after the closing of Studebaker, S. T. Skrentay, an executive at Studebaker, had written a private memo to C. T. Gallagher, head of industrial relations, summarizing the mood of the employees. He wrote, "No one was prepared for this kind of shock. The possibility that the South Bend operation could collapse was a chunk of reality that was never allowed to creep into the individual employee's mind; it never figured in his planning. If a mood permeates the work force—it is the mood of despair and disillusionment." He added that "Studebaker was really a member of the family—a capricious and wayward member—but a member nonetheless. These people are thankful for what Studebaker has provided—and if you can't say anything nice about the dead then say nothing."[3]

Stunned by the closing, Studebaker employees soon became the focus of national efforts to aid the city. Immediately upon the closing of the corporation, the Johnson administration targeted federal funds to aid displaced workers in finding new jobs. Through the Manpower Development and Training Act, over 2,500 unemployed workers were retrained. The Department of Labor and the National Council of Aging funded Project ABLE (Ability Based on Long Experience) to help Studebaker workers over the age of 50. Project Able provided job development, training, and placement for those older workers who initially felt abandoned by the closing of Studebaker. At the same time the Area Redevelopment Administration provided funds to attract new businesses to the area, while the Agriculture Department liberalized eligibility for the distribution of surplus food. While unemployment rose to over 9 percent in early 1964, by September of 1966 the unemployment rate had been reduced to 2.3 percent, below the state and national average. Indeed, total employment stood at 104,000, an increase of more than 10,000 from 1961. *Business Week* reported that South Bend's major problem was a labor shortage.[4] Economically the city shifted its economy to education, medical services, retail trade, government services, and diversified manufacturing.

Studebaker employees also drew national attention when it was discovered that most of the 6,000 workers who were still on the job when Studebaker closed were left without pensions. Although most of the workers had at least ten years of service at the company, under

the pension formula proposed by the company only those with twenty years or more of service were eligible for pensions of $80 to $90 per month. The closing of Studebaker allowed the management to discontinue the pension plan and deny benefits to those with less than twenty years of service. Moreover, it was revealed that the company had redirected its pension funds toward new acquisitions. Largely as a result of this tragedy Congress enacted the Employee Retirement Income Security Act of 1975, which required companies to establish minimum standards for pensions and to purchase federal insurance to protect pensions.[5]

These efforts, supported by the Indiana Democratic delegation of Senators Vance Hartke and Birch Bayh, and local Congressman John Brademas, held the city together during these critical years. In doing so, a new myth was created—that of the Midwestern community coming together to help those in need. As Lester Fox, the former unionist who was to head Project Able, declared, "When this crisis occurred, the community took the position that these were friends and neighbors and good citizens, who through no fault of their own, had lost their jobs. This community will rally to help friend and neighbor when the situation calls for it."[6]

Thus South Bend survived the demise of Studebaker, but the city continued to be haunted by the apparitions of the failed corporation. The legacy of Studebaker remained in the abandoned buildings that spanned the older industrial center of the city. Too expensive to tear down, and too antiquated to be converted to new industry, the abandoned Studebaker plant lay empty and decaying, a symbol of the once proud industrial city and the Midwestern "rustbelt."

The death of Studebaker elicited sentiments of guilt, accusation, and nostalgia, as well as scholarly analysis. Economists found in the automobile industry a poignant case study in how size worked against independents such as Studebaker.[7] Monopolistic domination of the automobile industry came under close scrutiny by Robert F. Lanzillotti, who found Big Three control of the automobile industry critical to understanding the collapse of independent automobile manufacturers. Similarly, Lawrence J. White in his study of the automobile industry published in 1971 maintained that the automobile industry was "a classic case of a tight oligopoly, displaying many of the textbook symptoms and problems of oligopolies." White found that the "large size of investment needed to operate a successful car manufacturing concern" undermined the viability of independent automobile manufacturers.

The most devastating analysis came from labor economist Robert M. Macdonald shortly before Studebaker closed its South Bend plant in 1963.[8] Macdonald observed that automobile independents, already

weakened by a significant size disadvantage, further hurt themselves by accepting poor wage contracts. He pointed to Studebaker as having the highest wages in the industry and the most "inferior production standards, higher shift differentials, more liberal relief allowances and the like." He blamed management for not addressing these problems and instead "scapegoating" labor for these problems. Nevertheless, he quickly added, "excess in labor practices alone were a formidable barrier to effective competition, quite capable of imperiling the company's economic well being."[9]

In making his case, Macdonald observed that hourly earnings at Studebaker were 18 percent higher than at its major competitors, work standards in some departments were 20 percent below the levels maintained in competitors' plants, and plantwide bumping costs totaled nearly $789,000 in 1954 alone. He blamed management and labor alike for allowing this situation to get out of hand.

Economists such as Macdonald focused their analysis on "external" factors—such as capital resources, firm size, distribution systems, and consumer demand—as key to understanding the demise of independent automobile manufacturers in the postwar period. Yet economists often missed a singular feature intrinsic to understanding the history of Studebaker and other independents: Even if domination of the Big Three was inevitable, some independents survived longer than did others.

Put another way, Studebaker had survived in a world of fierce competition for over sixty years. Given the eventual failure of most firms in the marketplace, this was an accomplishment in itself, particularly in the automobile industry where death was more common than life. The history of the automobile industry remained for most a silent record of aborted attempts to give birth to new enterprises. For those that entered the world, few reached maturity. That Studebaker made the successful transition into the automobile industry, survived during turbulent years when the industry took shape, recovered from bankruptcy in the depression, and remained one of the last independents to continue production in the postwar period, should be seen positively.

Any comprehension of individual firms lies ultimately in understanding the management of the company. Obviously, some managements perform better than do others. While firm size is important, managers actively make choices as to what technologies to use, what products to produce, and how best to encourage their employees to work harder while remaining loyal to the firm. These choices set the parameters of how long a company survives in a hostile and unpredictable world. Fate is determined by individual managers making critical choices.

At each stage in Studebaker's history, management made crucial decisions concerning the future of the company. First, management led by corporate counsel Frederick Fish decided to enter the automobile business on an experimental basis. This decision came only after a long struggle between Fish and the company's founders, John and Clement Studebaker. In the end, Studebaker's decision to enter automobile production was based on an optimistic appraisal that huge profits could be earned in the automobile business. Nevertheless, there remained good reasons, also based on "rational" expectations, to remain in wagon manufacturing. Indeed, Studebaker's wagon manufacturing division continued to be profitable well after the company had committed itself fully to the automobile. Fish's estimation of the future of the automobile proved correct, while the Studebaker brothers clearly underestimated the automobile's potential.

Still, if the Studebaker brothers had failed to appreciate the automobile industry, those who took over the company, following its successful transition into automobiles, appreciated the value of Studebaker's history. Under Albert Erskine, the company instituted a corporate welfare system that drew symbolically on the brothers' self-promotion and reputation as enlightened employers. This use of tradition held clear economic benefits for the company, even if it was not understood fully by economists who examined Studebaker's demise fifty years later.

The success of Studebaker's automobile business in the 1920s confirmed that a correct decision had been made, but the rise of General Motors in these same years forced management to make another crucial choice concerning the best means of meeting the challenge of the majors. The question posed was simply whether Studebaker should remain in the medium-priced market or challenge the majors on their own grounds by producing a multiline of models from low-priced, high volume selling cars to a high-priced, select market of luxury cars that yielded high marginal profits. Under the company's energetic president, Albert Erskine, the corporation undertook to expand its line of cars in both markets. The strategy failed. Declining profits, the failure of the Rockne to catch on with the public, and Erskine's insistence (supported by Wall Street) on paying dividends after the stock market crash of 1929, finally forced Studebaker into receivership in 1934.

The revival of Studebaker in the late 1930s illustrates another aspect of the story overlooked in a narrow economic interpretation of the automobile industry—management's tenacity in keeping the company afloat in these years, even though economic conditions suggested failure. Also in these years, Paul Hoffman and Harold Vance confronted one of the important challenges of modern business in

the twentieth century—its relations with newly organized labor. Hoffman, acting upon what he perceived as the Studebaker tradition, sought to stabilize relations with the United Auto Workers Local 5. This choice involved early recognition of the union at a time when organized labor was not well established. At the same time, Hoffman and Vance instituted a policy that offered Studebaker employees high wages and high benefits in return for loyalty to the company. With the outbreak of the war, the industry and the company cost-plus defense contracts masked the harmful economic effects of these policies.

The postwar period brought the final challenge for the company. By 1954, faced with a declining share of the market, Studebaker concluded a merger with Packard. This consolidation forced Studebaker to address questions concerning its relations with the union, as well as market strategies. In the process, corporate tradition of a company that cooperated with labor was rejected. James Nance believed Studebaker's benevolence had failed. Production costs were too high in relation to those at the majors, wildcat strikes were too prevalent, and shop floor control had been relinquished to an irresponsible union. This perception led the company to reverse a hundred-year tradition and to take a tough, confrontational stand toward labor.

Declining market share also placed Studebaker in a position of re-evaluating its business and market strategy. Once again the corporate leadership was led to address the question of whether the company should try, as it had briefly in the 1920s, to compete toe-to-toe with the majors or to "gamble" with a specialized car, as American Motors was doing with its Rambler. Company officials decided initially to go with a multimodel approach. When this failed, they turned to a specialized market. In the end, both approaches were unsuccessful. Meanwhile, the corporation decided on a third approach—diversification. By 1963, Studebaker was out of automobile production, having reinvested its corporate assets in myriad other, more lucrative enterprises.

Whatever success Studebaker had enjoyed as an automobile manufacturer was quickly subsumed by its demise. The failure of Studebaker dominated discussion of the Studebaker tradition. While early scholars pointed to oligopoly and high wage costs, a new generation of scholars in the 1980s sought to recast the story of Studebaker. Sympathetic to labor, these younger scholars reinterpreted the Studebaker tradition in terms of betrayal and managerial incompetence. The first efforts at revision came with Michael Beatty, Patrick Furlong, and Loren Pennington, who issued a concise history of the corporation, *Studebaker: Less Than They Promised* (1984). Their study became the basis of a poignant public television documentary under the same title that traced the devastating effects of the shutdown on the personal

lives of families that had worked for Studebaker. Even Paul Hoffman's sympathetic biographer picked up on this theme of incompetent management when he quoted Paul Hoffman as saying that Nance's administration had been "disastrous."[10]

The sharpest criticism of management appeared in 1989 in Stephen Amberg's "Triumph of Industrial Orthodoxy: The Collapse of Studebaker-Packard Corporation."[11] Amberg accused Nance of making a strategic mistake by trying to impose a General Motors model on Studebaker. Amberg maintained that Studebaker would have been better off producing a single, specialized model instead of engaging in multimodel production. He pointed to the success of the Champion in the late 1930s to bolster his case. In pursuing a more "specialized" strategy, Amberg argued, Nance could have avoided disaster in the marketplace and acrimonious industrial relations.

Amberg's reconstruction of the historical record failed to mention that the Champion was developed as a volume model for the lower end of the medium-priced market. Contrary to Amberg's assertion, the Champion was not targeted for a "specialized" market, and indeed the development of the Champion explicitly rejected a single-model policy aimed solely at the small-car market. Furthermore, in 1954, any attempt to have closed Packard's luxury line would have led to thousands of layoffs. At the time, neither the board of directors nor the union would have allowed Nance to pursue such a strategy.

Studebaker was simply too large to have "gambled" with a single model car, especially a low-priced smaller model that the American public expressed little interest in buying in 1955. Given Studebaker's high labor costs and its relative lack of capital, this strategy did not appear viable at the time. German and Japanese manufacturers entered this market in the 1960s and 1970s, but they were backed by huge government loans and direct subsidies. Furthermore, the small-car market always remained vulnerable to competition from the Big Three. In the end, Studebaker management turned to the specialized car market in 1962 with the introduction of the Avanti—aimed at the luxury market—but this came only after the company had embarked on its policy of diversification and, moreover, after it had laid off thousands of employees. Production in a specialized "niche" market necessitated a small workforce.

Yet scars remained. Studebaker tradition now became a source of bitter feelings. Interviewing Studebaker employees twenty-five years after the closing, historian John Bodnar observed that "memories acknowledged a sense of both individual survival and community devastation in the aftermath of the plant closing. The 'others' who suffered were symbolic representations of the devastation that all of them

had felt. The reality of some making transitions to other jobs softened the impact over time but did not eliminate the need to convey devastation somehow."[12]

Bodnar argued that the interviews illustrated "a selected memory at work." Studebaker employees recalled the prewar period as "relatively stable and orderly," when "tension and conflict were acknowledged but subjugated." In the postwar era, he maintains, the "dominant narrative stressed disorder and tension." He maintains that the differences in this narrative are attributable to the "breakdown of institutional hegemony imposed by the Studebaker Corporation." The consciousness of workers in the prewar period, he concludes, revealed "a world that was actually repressive and tightly controlled by the company and the union, but that repression was submerged in memory because it had been suppressed in the past. . . . " In turn, the dominant memories of the 1950s, of conflict and strikes, reveal that the repression and control of the prewar era were replaced by debate and uncertainty.

Because Bodnar does not explore fully the historical context in which these memories were shaped, he overlooks the possibility that the memories of these Studebaker employees were generally accurate. While memory surely can play tricks on us all, Bodnar refuses to consider the possibility that relations between management and the workforce were perceived as better because they were in fact better than what followed in the post–World War II era. In order to bring Studebaker out of bankruptcy, Hoffman and Vance called upon a tradition, as they construed it, that fostered harmonious labor relations and encouraged worker productivity. Acting upon a tradition that they felt would foster economic recovery, Hoffman and Vance welcomed unionization and its extension on the shop floor. Harmonious relations prevailed not just because they were perceived to have prevailed, nor because Hoffman and Vance had imposed "corporate hegemony" on the minds of their employees, but because "objective conditions" were conducive for management-employee cooperation. In turn, when this tradition was rejected in the postwar period because management thought the union and employees needed to be brought into line, labor relations deteriorated quickly. It was not a matter of "false consciousness" that the postwar period was one of turmoil, discord, and disillusionment.

A droll account of disillusionment in the Studebaker tradition is found in Robin Hemley's novel, *The Last Studebaker* (1992).[13] Hemley's story focuses on the disastrous consequences of the plant's closing for Lois Kulwicki, a middle-aged mother of two daughters. Lois's father lost his job at Studebaker when the plant closed years before in

South Bend. For Lois, the Studebaker tradition had misled her father into thinking the world was safe because he was protected by the company to which he had given his life. As Lois's father tells her many years later after having abandoned his family, "Hell, Studebaker shut down without any warning. If you asked me, that started the whole thing. Sort of set a precedent. Just think, if they hadn't folded, we'd still be a family." Lois reconciles herself with the past by systematically destroying a vintage Studebaker. The demolition of the car symbolizes the devastation wrought by the Studebaker tradition on her family. In the end, by liberating herself from that tradition, she finds freedom.

While the novelist finds escape from tradition as a means of self-realization, the people living in South Bend today have sought also to reinterpret their past. The reminder of Studebaker's traumatic closing in 1963 stands frozen in time in the sprawling complex of abandoned brick factories and offices found in downtown South Bend. The construction of a new minor league baseball stadium, a convention center, public library, and numerous other buildings reflects the spirit of a medium-sized midwestern city seeking to overcome its decline as an industrial city. Still, the "Studebaker Corridor" stands idle and crumbling. The buildings serve as a symbol of failure.

The city has sought to capitalize on its past by promoting tourism. The University of Notre Dame draws thousands of visitors each year to South Bend. Although Notre Dame has forgotten its close historic association with Studebaker, the city of South Bend has promoted the Studebaker name to attract tourists.[14] The old Studebaker mansion, Tippecanoe, has been turned into an upscale restaurant, largely for outside visitors. A Studebaker Museum is now housed in a building that was once the largest Studebaker dealership. Here, visitors can experience the Studebaker legacy as embodied in its preserved wagons and automobiles. The museum also holds the extensive corporate archives, but there is less interest in this aspect of the corporation's history. Instead, visitors are introduced to the history of the corporation through displays and a visual presentation that deliberately downplays the union tradition at Studebaker. As one museum trustee declared, "The union killed Studebaker; we are not going to let it kill South Bend's future." As a consequence, the Studebaker tradition has been translated into boosterism.

Others, too, have reinterpreted Studebaker's past to fit their own needs. Car aficionados have organized the Studebaker Driver Club, a national organization nearly 18,000 strong who gather at each of various meets across the country to show their restored cars and to swap Studebaker stories and car parts. For these collectors, the *Smithsonian* magazine noted, each Studebaker car carries "the genes of the old

green wagon from which it was descended."[15] Ironically, these collec-
tors of "the Studie"—a car produced by a company that would fail—
harken to the tradition of the company's founders. The Studebaker
has become a symbol of craftsmanship of a bygone era. In this way,
the Studebaker tradition has become nostalgia.

Notes

Preface

1. Gregory Von Dare, "Review of Joe Sherman, *In the Rings of Saturn* (Oxford University Press, 1993)," *Motor Trends* (January 1994), 22.

Introduction

1. See, for example, Richard R. Nelson and Sidney G. Winter, *An Evolutionary Theory of Economic Change* (Cambridge, 1982). A neo-Darwinian perspective is articulated in Howard Aldrich, *Organizations and Environments* (New York, 1979). An excellent critique of this view is found in Mary Zey-Farrell, "Criticism of the Dominant Perspective on Organizations," *Sociological Quarterly* 12 (Spring 1981), 181–205.

2. The beginning point for any study of managerial choice and corporate ideology is Reinhard Bendix, *Work and Authority in Industry: Ideologies of Management in the Course of Industrialization* (New York, 1956); and Charles Dellheim, "The Creation of a Company Culture: Danbury's, 1861–1931," *American Historical Review* (February 1987), 13–44. Corporate image is explored in Richard S. Tedlow, *Keeping the Corporate Image: Public Relations and Business, 1900–1950* (Greenwich, 1979); and Gareth Morgan, *Images of Organization* (Beverly Hills, 1986).

3. Paul R. Lawrence and Davis Dyer, *Renewing American Industry* (New York, 1983), 33.

4. William J. Abernathy and Kim B. Clark, *Industrial Renaissance: Producing a Competitive Future for America* (New York, 1983).

5. The relationship between structure and strategy is developed by Alfred D. Chandler, Jr., *The Structure of American Industry* (New York, 1971), 256–301; *Strategy and Structure: Chapters in the History of the American Industrial Enterprise* (Cambridge, 1962); and *The Visible Hand: The Managerial Revolution in American Business* (Cambridge, 1977). David Hounshell offers an excellent study of the development of production technologies in *From the American System to Mass Production, 1800–1932* (Baltimore, 1984), 189–215. "Flexible specialization" is the central focus of Michael J. Piore and Charles Sabel, *The Second Industrial Divide* (New York, 1984). Piore has explored alternative organization models in myriad other articles, including "American Labor and the Industrial Crisis," *Challenge* (March/April 1982), 5–11.

6. Indeed, this study has been deeply influenced by the "new institutionalism" and an "organization school" of history that emerged in the late 1960s and early 1970s. Influenced by business history and contemporary American sociology, this kind of history focuses on institutional structure and process. The premise of this approach was that people managed and were managed

through rational systems of control and communication. This approach, however, places less emphasis on the importance of individuals and specific motives than I believe is warranted by the historical record. See John Higham, Leonard Kreiger, and Felix Gilbert, *History: The Development of Historical Studies in the United States* (Princeton, New Jersey, 1965), 230–31; Louis Galambos, "The Emerging Organization Synthesis in Modern American History," *Business History Review* 44 (Autumn 1970), 279–90; Galambos, "Technology, Political Economy, and Professionalization: Central Themes of the Organization Synthesis," *Business History Review* 57 (Winter 1983), 471–93; and Robert D. Cuff, "American Historians and the 'Organizational Factor,' " *Canadian Review of American Studies* 4 (Spring 1973), 19–31. For a masterful essay on the emergence of the organizational school and Alfred Chandler's work, see Thomas K. McCraw's introduction to *The Essential Alfred Chandler: Essays toward a Historical Theory of Big Business* (Boston, 1988), 1–21.

7. See Kenneth R. Andrews, *The Concept of Corporate Strategy* (Homewood, 1971); Edmund Learned, Kenneth R. Andrews, C. Roland Christensen, and William D. Guth, *Business Policy: Test and Cases* (Homewood, 1965); and Oliver Williamson, *The Economic Institutions of Capitalism: Firms, Markets, Relational Contracting* (New York, 1985). Important articles concerning Chandler's approach include Richard Caves, "Industrial Organization, Corporate Strategy and Structure," *Journal of Economic Literature* 18 (March 1980), 64–92; and Oliver Williamson, "Emergence of the Visible Hand," in Alfred D. Chandler, Jr., and Herman Daems, eds., *Managerial Hierarchies: Comparative Perspective on the Rise of the Modern Industrial Enterprise* (Cambridge, 1980), 182–202.

8. Alfred D. Chandler, Jr., *Strategy and Structure: Chapters in the History of the Industrial Enterprise* (Cambridge, 1962), especially 1–17. Chandler's thesis can also be found, along with the other studies cited, in a number of important articles, including "The Beginnings of 'Big Business' in American Industry," *Business History Review* 33 (Spring 1959), 1–31; Chandler, "Development, Diversification and Decentralization," in Ralph E. Freeman, ed., *Postwar Economic Trends in the United States* (New York, 1960); Chandler and Fritz Redlich, "Recent Developments in American Business Administration and Their Conceptualization," *Business History Review* 33 (Spring 1961), 1–27; "The Railroads: Pioneers in Modern Corporate Management," *Business History Review* 39 (Spring 1965), 16–40; and Chandler, "The Structure of American Industry in the Twentieth Century: A Historical Overview," *Business History Review* 43 (Autumn 1969), 255–98. A complete collection of Chandler's essays is found in *The Essential Alfred Chandler: Essays toward a Historical Theory of Big Business*, Thomas K. McCraw, ed. (Boston, 1988). McCraw's introduction provides a highly useful discussion of the development of Chandler's thinking.

9. See Hal Bridges, "The Robber Baron Concept in American History," *Business History Review*, 32 (Spring 1958), 1–13; and John Tipple, "The Anatomy of Prejudice: The Origins of the Robber Baron Legend," *Business History Review* 33 (Winter 1959), 510–23. The portrayal of American businessmen as robber barons found early expression in Charles Francis Adams, Jr., *Railroads: The Origin and Problems* (New York, 1893), 128–29; Henry Demarest Lloyd, *Wealth against Commonwealth* (New York, 1894); and Matthew Josephson, *The Robber Barons: The Great American Capitalists, 1861–1901* (New York, 1934). The "robber baron" thesis came under attack from Allan Nevins in *The Emergence of Modern America 1865–1878* (New York,

1927) and his review of Josephson's *The Robber Barons* in *The Saturday Review of Literature* 10 (March 3, 1934), 522. His critique of the robber baron thesis was developed more fully in his *John D. Rockefeller: The Heroic Age of America* (New York, 1940) and *Study in Power: John D. Rockefeller* (New York, 1953). The constructive work of business leaders in this period was emphasized in Edward Chase Kirkland, *Men, Cities and Transportation: A Study in New England History 1820–1900*, 2 vols. (Cambridge, Mass., 1948); Thomas C. Cochran, *Railroad Leaders 1845–1890: The Business Mind in Action* (Cambridge, 1953); Fritz Redlich, *History of American Business Leaders: A Series of Studies*, volume I, *Theory, Iron and Steel, Iron Ore Mining* (Ann Arbor, 1940), volume II, *The Molding of American Banking: Men and Ideas, Pt. I, 1781–1840* (New York, 1947), *Part II, 1840–1910* (New York, 1951); and Ralph W. Hidy and Muriel E. Hidy, *Pioneering in Big Business, 1882–1911* (New York, 1955). Historian Chester M. Destler defended the robber baron thesis in "Wealth against Commonwealth, 1894 and 1944," *American Historical Review* 50 (October 1944), 49–69.

10. See William H. Lazonick, "Industrial Organization and Technological Change: The Decline of the British Cotton Industry," *Business History Review* 57 (Summer 1983), 195–236; Bernard Elbaum and Lazonick, eds., *The Decline of the British Economy* (New York, 1986); and Lazonick, "Theory and History in Marxian Economics." In Alexander J. Field, ed., *The Future of Economic History* (Boston, 1987), 255–312.

11. See Michael J. Piore, "American Labor and the Industrial Crisis," *Challenge* (March/April 1982), 5–11; David Friedman, "Beyond the Age of Ford: The Strategic Basis of the Japanese Success in Automobiles," in John Zysman and Laura Tyson, eds., *American Industry in International Competition: Government Policies and Corporate Strategies* (Ithaca, 1983); and Peter Katzenstein, *Small States in the World Market: Industrial Policy in Europe* (Ithaca, 1985).

12. Gerald Berk, *Alternative Tracks: The Constitution of American Industrial Order, 1865–1917* (Baltimore, 1994); and Stephen Amberg, *The Union Inspiration in American Politics: The Autoworkers and the Making of a Liberal Industrial Order* (Philadelphia, 1994).

13. Alfred D. Chandler, *Strategy and Structure*; Chandler and Stephen Salisbury, *Pierre S. DuPont and the Making of the Modern Corporation* (New York, 1971); and more recently, Paul R. Lawrence and Davis Dyer, *Renewing American Industry* (New York, 1983). Sloan recounts his story in *Adventures of a White Collar Man* (New York, 1941) and *My Years with General Motors* (Garden City, 1964).

14. Michael Mortiz and Barrett Seaman, *Going for Broke: The Chrysler Story* (Garden City, 1981); and Robert B. Reich and John D. Donahue, *New Deals: The Chrysler Revival and the American System* (New York, 1985).

15. Labor in the early automobile industry is discussed by Joyce Shaw Peterson, *American Automobile Workers, 1900–1933* (Albany, 1987). For a Marxist account of these early years see David Gartman, *Auto Slavery* (New Brunswick, 1986). The best account of the CIO drive to organize the automobile industry remains Sidney Fine, *Sit-Down: The General Motors Strike of 1936–1937* (Ann Arbor, 1969). The role of the state in aiding industry unionism is discussed in Jonathan Zeitlin's provocative essay, "Shop Floor Bargaining and the State: A Contradictory Relationship," in Steven Tolliday and Jonathan Zeitlin, *Shop Floor Bargaining and the State: Historical and Comparative Perspectives* (Cambridge, 1985). Zeitlin does not specifically focus on

the American automobile industry, but the relationship between government policies and the growth of industrial unionism within the automobile industry remains an important, though unexplored, topic.

16. William J. Abernathy, Kim B. Clark, and Alan M. Kantrow, *Industrial Renaissance: Producing a Competitive Future for America* (New York, 1983), 89–90.

17. Melvin Dubofsky, *American Labor Since the New Deal* (Chicago, 1971); Nelson Lichtenstein, "Conflict over Workers' Control: The Automobile Industry in World War II," in Michael H. Frisch and Daniel J. Walkowitz, eds., *Working Class America: Essays on Labor, Community, and American Society* (Urbana, 1983); and Lichtenstein, "From Corporatism to Collective Bargaining: Organized Labor and the Eclipse of Social Democracy in the Postwar Era," in Steve Fraser and Gary Gerstle, *The Rise and Fall of the New Deal Order, 1930–1980* (Princeton, 1989), 122–52.

18. Thomas A. Kochan, Harry C. Katz, and Robert B. McKersie, *The Transformation of American Industrial Relations* (New York, 1984), 41; and Daniel J. B. Mitchell, *Unions, Wages, and Inflation* (Washington, D.C., 1980).

19. Robert M. Macdonald, *Collective Bargaining in the Automobile Industry: A Study of Wage Structure and Competitive Relations* (New Haven, 1963), 368.

20. Albert Russel Erskine, *History of the Studebaker Corporation* (South Bend, Indiana, 1924). Originally written in 1918, this book was revised and expanded under the same title in 1924. In the second edition, Erskine brought the history of Studebaker up through the post–WW I years and spent considerable time on employee programs instituted by his administration.

21. Kathleen Ann Smallzried and Dorothy James Roberts, *More Than You Promise: A Business at Work in Society* (New York, 1942); Stephen Longstreet, *A Century on Wheels: The Story of Studebaker* (New York, 1952). Quotation is found in Longstreet, *A Century on Wheels*, 120.

22. Longstreet, *A Century on Wheels*, 120–21.

23. Frederick H. Harbison and Robert Dubin, *Patterns of Union-Management Relations*, (Chicago, 1947), 202.

24. Robert M. Macdonald, *Collective Bargaining in the Automobile Industry* (New Haven, 1963).

1. The Birth of a Corporation, 1852–1905

1. Johann Beissel and the Ephrata Community still remain to be explored by scholars. The most recent discussion of the commune, placing the society in a countercultural tradition, can be found in E. G. Alderfer, *The Ephrata Commune: An Early American Counterculture* (Pittsburgh, 1985). Older histories offer insights, although they can be misleading. For example, see Julius Friedrich Sachse's detailed *The German Sectarians of Pennsylvania, 1742–1800: A Critical and Legendary History of the Ephrata Cloister and the Dunkers* (Philadelphia, 1899; reprinted, 1971); James E. Ernst's unreliable *Ephrata: A History* (Allentown, Pennsylvania, 1963); Walter C. Klein's skewed *Johann Conrad Beissel, Mystic and Martinet, 1690–1768* (Philadelphia, 1942); John E. Jacoby's biased *Two Mystic Communities in America* (Paris, 1931); Martin Grove Brumbaugh, *A History of the German Baptist Brethren in Europe and America* (Mount Morris, Illinois, 1910; reprinted, 1971), 438–

70; S. G. Zerfass, *Souvenir Book of the Ephrata Cloister* (New York, 1921; reprinted, 1975). A contemporary record of the society is found in Peter C. Erb, *Johann Conrad Beissel and the Ephrata Community, Mystical and Historical Texts* (Lewiston, New York, 1985). A general perspective on the German Baptists can be found in *Seventh Day Baptists in Europe and America*, volumes I and II (Plainfield, New Jersey, reprinted 1980).

An excellent perspective of Palatine Germans is found in A. G. Roeber, *Palatines, Liberty, and Property: German Lutherans in Colonial British America* (Baltimore, 1993). A fascinating study of another utopian experiment in industry is described by Anthony Wallace, *Rockdale: The Growth of an American Village in the Early Industrial Revolution* (New York, 1978).

2. "Golden Wedding Anniversary," October 20, 1870, Box 1, Clement Studebaker Papers, Northern Indiana Historical Society, hereafter CSP.

3. Quoted in Walter Carlock, Alvin Faust, and Irene Miller, *The Studebaker Family in America, 1737–1976* (Tipp City, Ohio, 1976), 72, 76–78. Also see *Ashland (Ohio) Times*, October 13, 1897, Clipping Book 1896–1900, Studebaker Corporation Papers, Studebaker National Museum, South Bend, Indiana, hereafter SP.

Other biographical information on the Studebaker family can be found in "Clement Studebaker" and "John Studebaker," and "Peter Studebaker," George Irving Reed, ed., *Encyclopedia of Biography of Indiana* (Chicago, 1895), 192–97; and "Clem Studebaker" and "J. M. Studebaker" in *South Bend and the Men Who Have Made It, Historical, Descriptive, and Biographical,* compiled by Anderson and Cooley (South Bend, 1901).

4. Andrew Anderson, "Tribute to Clem Studebaker," n.d., Box I, CSP.

5. Quoted in Chapman and Company, *History of St. Joseph County* (Chicago, 1880), 872.

6. Chapman and Co., *History of St. Joseph County*, 451. Also see Timothy Howard, *A History of St. Joseph County* (Chicago, 1907), 2 v.; John B. Stoll, ed., *St. Joseph County*, Volume III, in Logan Esarey, *History of Indiana* (Dayton, Ohio, 1923).

7. Note on inside of Minute Book I, 1862–1874, SP.

8. Ibid., 86.

9. *Logansport Daily Reporter*, June 19, 1891, Clipping Book 6, SP. Also, Anderson and Cooley, *South Bend and the Men Who Have Made It*, 1.

10. A lien of $700.00 had been placed on the firm by the courts. Andrew Anderson to J. M. Studebaker, December 21, 1912, Box 1, CSP.

11. The brothers did not leave a historic account of their break with their parents' religion. It is interesting to note, however, that in 1900 the corporation agreed to donate money toward the rebuilding of the German Dunkard Church in South Bend. Minutes, Board of Directors Meeting, May 15, 1900, Minute Book II, SP.

Historians have not fully explored specific case studies of profiteering during the Civil War. An interesting example of a war profiteer is found in William B. Edwards, *The Story of Colt's Revolver: The Biography of Col. Samuel Colt* (Harrisburg, 1953).

12. Victor S. Clark, *History of Manufacturers in the United States*, II (New York, 1929), 485. In 1874, at its third annual meeting, the association's treasurer reported that only sixty-five members had paid their dues and complained of the "selfishness of a large number of important firms" that refused to join the association. Studebaker Brothers, however, was a founding member of the

association. By 1880 membership had grown to over 200, including the larger firms. Carriage Builders National Association, *Third Annual Meeting* (October 21, 1874), 65.

13. Information on the early production technology of the carriage industry can be found in Andrew Ure, "Wheel Carriages," *Dictionary of Arts, Manufacturers, and Mines* (New York, 1856), 937–44. Victor S. Clark offers a brief discussion of the vehicle industry in *History of Manufacturers in the United States*, 485. Also, American Iron and Steel Association, *Bulletin* 16 (October 26, 1887), 26; and 17 (May 23, 1883), 137.

14. The rapid expansion of the wagon industry in the United States began after 1830. In 1830 there were approximately 2,000 carriage builders, employing 14,000 workers, while forty years later in 1870 their number had increased to approximately 12,000 carriage builders, employing 37,000 workers who annually produced an estimated 100,000 carriages. Carriage Builders National Association, *Eighth Annual Meeting* (1880–81).

15. New York maintained the largest number of firms with 667 carriage manufacturers reported in the census of 1880, while Ohio reported only 325 firms, and Indiana 195 firms. The size of these firms varied greatly. The total value of production for New York carriage and wagon manufacturers stood at $8,888,479 while Ohio's total production was estimated at $10,043,404. By the mid-eighties, members of the Carriage Builders National Association, now dominated by the larger firms, produced 1,250,000 carriages annually. United States Bureau of Census, *Abstract of the Tenth Census of the United States* (1880) (Washington, D.C., 1880), 26.

16. In 1900 Ohio stood first in the production of family and pleasure carriages (23.6 percent of total number). Indiana stood third in 1900 and second in 1905, producing 2.63 percent of total vehicles produced in the nation. Of wagons, Indiana ranked first in 1900 and 1905, producing 15.5 percent of the total in 1905. Bureau of Census, "Carriages and Wagons," *Bulletins* (89–91) (Washington, D.C., 1905).

17. Carriage Builders National Association, *Seventh Annual Report* (1879–1880), 42–43.

18. For a brief discussion of this type of suspension, see Ure, "Wheel Carriages," *Dictionary of Arts, Manufacturers, and Mines*, 943–44.

19. Similarly, a clear division of labor was also established at another family-run firm, the Harper Brothers Publishing Company. See Eugene Exman, *The Brothers Harper: A Unique Publishing Partnership* (New York, 1965).

20. H. V. K. Kimble to C. A. Carlisle, n.d., "File for YMCA Building," SP.

21. In 1868, Clem Studebaker organized the South Bend Fuel and Gas Company. The firm was later sold to a larger Chicago utility in 1905. "Gas Company Sold," *South Bend Tribune*, November 3, 1905, Clipping Book 50, SP.

22. H. V. K. Kimble to C. A. Carlisle, n.d., "File for YMCA Building," SP.

23. E. M. Brannick to C. A. Carlisle, December 21, 1906, "File for YMCA Building," SP.

24. *South Bend Sunday News*, December 18, 1887, Clipping Book 65, SP.

25. *The Brethren Encyclopedia* II (Philadelphia, 1983), 1230–31.

26. Studebaker Brothers, April 14, 1869, Minute Book 1, 1862–94, SP. Minutes, Studebaker Brothers, September 1, 1871, Minute Book 1, SP. It is worth noting that the minutes for the Studebaker firm remained sparse. In-

deed, the first minute book of the corporation covered the years 1862–1894. Minutes often included social engagements as well as business transactions. See also Higgins, Beldon & Company, *Historical Atlas of St. Joseph County, Indiana* (Chicago, 1875), 28; and DeWitt Clinton Goodrich, *An Illustrated History of the State of Indiana* (Indianapolis, 1875).

27. Production figures for wagons reveal the extraordinary growth of Studebaker in the postwar years: 1868, 3,955; 1869, 5,115; 1870, 6,404; 1871, 6,835; 1872, 6,950; 1873, 10,280; 1874, 11,050; 1875, 15,000; 1876, 16,250; 1877, 17,500; 1878, 18,000; and 1879, 20,000. Company records do not reveal precise figures. These figures are taken from Chapman and Co., *History of St. Joseph County*, 874. Also see D. C. Goodrich, *An Illustrated History of the State of Indiana* (Indianapolis, 1875), 122–23; and Longstreet, *A Century on Wheels*, 48.

28. Albert Peak to C. A. Carlisle, November 27, 1906, "File for YMCA Building," SP.

29. Smallzried and Roberts, *More Than You Promise*, 68.

30. Chapman and Co., *History of St. Joseph County*, 874.

31. By 1880 over a thousand workers were employed to produce a full line of wagons and carriages including broughams, runabouts, tandems, victorias, and heavy wagons of various types.

The fire protection system is described in Albert W. Peak to C. A. Carlisle, November 27, 1906, "Correspondence for YMCA Building," SP. Also, Smallzried and Roberts, *More Than You Promise*, 61–65; and a fine master's thesis, John Joseph Delaney, "The Beginnings of Industrial South Bend" (University of Notre Dame, 1951), 19.

32. An interesting side note on Studebaker's relations with the Central Pacific Railroad over freight rates is found in Loren E. Pennington, "Collis P. Huntington and Peter Studebaker: The Making of a Railroad Rebate," *Southern California Quarterly* 52 (March 1971), 41–53.

33. Smallzried and Roberts, *More Than You Promise*, 53, 55. Also, on production at Studebaker, see David A. Hounshell's fine study, *From the American System to Mass Production*, 189–215. Hounshell mistakenly maintains, however, that Studebaker used antiquated hubmaking equipment. He induces this from a photograph, but for contrary evidence see Clipping, "Electric Welding," *Western Electrician* (April 9, 1892), Clipping Book 6, SP. For a discussion of Studebaker wagon technology see also Otto Klausmeyer interviewed by John Bodnar, May 16, 1984, Oral History Project, Indiana University, Bloomington, Indiana.

34. The plant held twenty boilers, sixteen stationary engines, sixteen dynamos, one thousand pulleys, seven miles of belting, three hundred woodworking machines, two hundred eighty-eight ironworking machines, twenty-five steam pumps, two hundred sixty arc lamps, and two hundred incandescent lamps. Smallzried and Roberts, *More Than You Promise*, 120.

35. *Motor Vehicle Review*, "A Plant Equal to Any Demand" (September 5, 1899), 30–34. Also see Hounshell, *From the American System to Mass Production*, 145–50.

36. In the following decade, Studebaker's reputation for high-quality products allowed the company to open offices in Montgomery, Alabama; Harrisburg, Virginia; Tacoma, Washington; Louisville, Kentucky; Pine Bluff, Arkansas; Chambers, South Dakota; and Portland, Oregon. By 1893 the company reported a 10 percent dividend, plus an additional $50,000 capital surplus.

"Trade News," *The Hub* III, September 6, 1893, 19. Also, Board of Directors Meeting, August 22, 1879; October 15, 1884; September 19, 1885; January 4, 1886; March 21, 1891; and December 14, 1893; Minute Book 1, SP.

37. "Resolution of the Death of Jacob Studebaker," Board of Directors Meeting, January 2, 1888, Minute Book 1, SP.

38. Clement Studebaker, "Early Days of the Carriage Association," *Twenty-Fifth Annual Report of the Carriage Builders National Association* (Philadelphia, 1896). In fact, the wagon manufacturers showed more interest in the tariff issue, although competition from prison labor also drew their attention. Prison labor was used to build wagons and road carts in Jackson, Michigan; Leavenworth, Kansas; Michigan City, Indiana; and Jefferson City, Missouri. As a consequence complaints against the use of prisoners in manufacturing wagons was heard frequently at associational meetings and in the trade press. See *Varnish* I, September 15, 1888, 71; and *Varnish* I, December 15, 1888, 15.

39. *Farm Implement News*, September 28, 1905, Clipping Book 50, SP.

40. *South Bend Morning Post*, August 14, 1891, Clipping Book 6, SP.

41. *Portland Oregonian*, February 25, 1892, Clipping Book 6, SP.

42. Clifton J. Phillips, *Indiana in Transition: The Emergence of an Industrial Commonwealth, 1880–1920* (Indianapolis, 1968), 12. *South Bend Morning Post*, August 14, 1891, Clipping Book 6, SP.

43. Albert Beveridge to John C. Shaffer, December 17, 1898, Albert Beveridge Papers, Library of Congress.

44. *Chicago Herald*, July 3, 1894, Clipping Book 6, SP.

45. Peter Studebaker said that Debs was like "a great many theorists and some lawmakers who do not understand the practical laws of trade." *New York Times*, August 6, 1894. Debs' quotation is from the *Ashland (Ohio) Times*, July 19, 1894, in Clipping Book 6, SP.

46. Carlos A. Schwantes, *Coxey's Army: An American Odyssey* (Lincoln, 1985).

47. *Los Angles Times*, March 20, 1894; and *Seattle Post*, June 2, 1894; Clipping Book 6, SP.

48. *Blacksmith and Wheelwright*, December 1901, Clipping Book 2; *South Bend Times*, November 18, 1899; and *South Bend Tribune*, June 14, 1900, Clipping Book 1896–1900, SP. On Fish's role in the NCF, see National Civic Federation, *Education, Conciliation and Industrial Peace* (New York, 1905), 25 and 46. On the general history of the NCF, see James Weinstein, *The Corporate Ideal in the Liberal State, 1900–1918* (Boston, 1963); Marguerite Green, *The National Civic Federation and the American Labor Movement, 1900–1925* (Washington, D.C., 1956).

49. "Trade News," *The Hub* II, January 1871, 125.

50. Board of Directors Meeting, January 1, 1877, Minute Book 1, SP.

51. E. M. Brannick to C. A. Carlisle (circa 1906), "File for YMCA Building," SP.

52. *Carriage Journal* (n.d.), Clipping Book 6, SP.

53. Board of Directors Meeting, March 13, 1919, Secretary Files 1911, SP.

54. Important works on the North American worker in the late nineteenth century include Daniel T. Rodgers, *The Work Ethic in Industrial America, 1850–1920* (Chicago, 1978); Bryan D. Palmer, *A Culture in Conflict:*

Skilled Workers and Industrial Capitalism in Hamilton, Ontario, 1860–1914 (Montreal, 1979); Richard Edwards, *Contested Terrain: The Transformation of the Workplace in the Twentieth Century* (New York, 1979); John T. Cumbler, *The Working Class Community in Industrial America: Leisure and Struggle in Two Industrial Cities, 1880–1930* (Westport, 1979); Leon Fink, *Workingmen's Democracy: The Knights of Labor and American Politics* (Urbana, 1983); Michael Frisch, *Town into City: Springfield, Massachusetts and the Meaning of Community, 1840–1880* (Cambridge, 1972); Herbert Gutman, *Work, Culture and Society in Industrializing America, 1815–1919* (New York, 1977). For an insightful, albeit brief, comparison of paternalism in the nineteenth century and the progressive era, see David Montgomery, *The Fall of the House of Labor: The Workplace, the State, and American Labor Activism, 1865–1925* (New York, 1987), 238.

55. It is important to note that paternalism in the nineteenth century was most frequently practiced in companies that enjoyed patent monopolies or unusual market power. When these firms later encountered less favorable conditions, policies necessarily changed.

56. This incident was reported in *The Alarm*, II (October 3, 1885), 4. Paul Averich mentions the incident in *The Haymarket Tragedy* (Princeton, 1985). Averich incorrectly cites the incident as occurring February 4, 1886. This strike is also discussed briefly in Charles Craypo, "The Deindustrialization of a Factory Town: Plant Closings and Phasedowns in South Bend, Indiana, 1954–1983," in D. Kennedy, ed., *Labor and Reindustrialization: Workers and Corporate Change* (Monograph in Labor Studies Department, Pennsylvania State University, 1984), 61.

57. "Trade News," *The Hub* II, August 17, 1892, 116; "Trade News," *The Hub* II, August 24, 1892, 11.

58. *The Carriage Journal*, March 1893; *Chicago Tribune*, March 2, 1893; *The Washington Post*, March 10, 1893; *Chicago Herald*, March 3, 1893, Clipping Book 6, SP.

59. *Chicago Times*, March 15, 1893, Clipping Book 6, SP.

60. Advertisement, *American Federationist*, November 1, 1894, Clipping Book 6, SP.

61. Details of the strike are found in L. P. McCormack and B. Frank Schmid, *The Second Biennial Report of the Indiana Labor Commission for the Years 1899–1900* (Indianapolis, 1901), 83–88. Studebaker quotation, 83. Also, "Men Quit Their Work," *South Bend Tribune*, December 4, 1899, Clipping Book 1896–1900, SP.

62. "Studebaker Row," n. d., Clipping Book 65, SP.

63. For instance, those who got their start at Studebaker included Charles H. Frazier, the owner of the local sporting goods store; Adolph Mohr, a wine importer; Ralph Huss, a druggist; and Otto H. Collmer, the owner of a bicycle shop. See Anderson and Cooley, *South Bend and the Men Who Have Made It*, 92, 102, 291, 298, 318, and 319.

64. *South Bend Tribune*, September 5, 1899, Clipping Book 1896–1900, SP.

65. *Chicago Chronicle*, April 4, 1907, Clipping Book 20, SP.

66. H. V. K. Kimble to C. A. Carlisle, n.d., "YMCA File," SP; and *South Bend Times*, December 13, 1894, Clipping Book 6, SP.

67. *South Bend Tribune*, December 16, 1893, Clipping Book 6, SP.

68. *South Bend Tribune*, December 21, 1893, Clipping Book 6, SP.

69. *South Bend Tribune*, September 18, 1891, Clipping Book 6, SP.

70. *Michigan Tradesman*, April 5, 1905, Clipping Book 50; and *Agricultural Advertising*, December 1907, Clipping Book 20, SP. Also, "C. A. Carlisle, Financial Leader Dies," *South Bend Tribune*, September 2, 1938, Clipping Book 85, SP.

71. *South Bend Daily Tribune*, November 12, 1896, Clipping Book 1896–1900, SP.

72. *South Bend Tribune*, May 12, 1899, Clipping Book 1896–1900, SP.

73. *Daily Tribune*, June 9, 1896, Clipping Book 6, SP.

74. *South Bend Tribune*, September 14, 1895, Clipping Book 6, SP.

75. The progress of the plan is reported in Minute Book 2, SP.

76. For an extensive discussion of the effects of the depression on the wagon industry see Carriage Builders Association, *Twenty-First Annual Report of the Carriage Builders Association* (Philadelphia, 1893).

77. Board of Directors Meeting, May 2, 1893, Minute Book 1, SP.

78. "Trade News," *The Hub* III, September 6, 1893, 19. For dividend policy see Board of Directors Meetings, February 9, 1894, and March 12, 1894, Minute Book 1, SP.

79. "Remarks by Clement Studebaker," *Twenty-First Annual Report of the Carriage Builders Association* (Philadelphia, 1893).

80. *South Bend Tribune*, October 15, 1896, Clipping Book 1896–1900, SP.

81. Carriage Builders Association, *Carriage Builders Association Reports*, XXII (Philadelphia, 1894), 32.

82. Mark A. Hanna to Clem Studebaker (Confidential), June 31, 1896, SP.

83. The author owes Professor Philip Vandermeer, a leading authority on Midwestern politics, a note of deep appreciation for his help in explaining Indiana politics in these years. *South Bend Tribune*, October 15, 1896, Clipping Book 1896–1900, SP.

84. Board of Directors Meeting, August 26, 1896, Minute Book 2, SP. Also, Annual Stockholders Meeting, *Studebaker Centennial Report*, April 4, 1952, in Supporting Documents, Box 16, SP.

85. Board of Directors Meeting, February 8, 1899, and May 15, 1899, Minute Book II, SP.

86. Board of Directors Meeting, August 10, 1899, Minute Book II, SP. Also, *New Carlisle Gazette*, March 29, 1898, Clipping Book 1896–1900, SP.

87. *The Implement Dealer*, March 15, 1902, Clipping Book 41, SP.

2. Studebaker Enters the Automobile Age, 1897–1913

1. Joseph A. Schumpeter, *Business Cycles: A Theoretical, Historical and Statistical Analysis of the Capitalist Process* (New York, 1939), 95.

2. For this reason Fish has been generally overlooked by automobile historians, but insiders at the time understood Fish's importance to the company. The accounting firm of Marwick, Mitchell & Company, assigned to investigate Studebaker as an investment opportunity in 1910 on behalf of J. P. Morgan, reported that Fish was the "dominant force" on the board, the man responsible for making the basic decisions within the corporation. Fish was the architect of Studebaker's corporate strategy. See Marwick, Mitchell, *The American Vehicle Company* (1910), SP. Also see J. M. Studebaker to Frederick Fish, September 20, 1915, in "Affidavit by F. Fish, Exhibit 22," in miscella-

neous folder "Affidavit Submitted in Regard to Gift of 2500 Shares from J. M. Studebaker to Fish in 1915," SP.

3. "Affidavit Submitted in Regard to Gift . . . " in SP.

4. "Former Studebaker President Passes Away in Home," *South Bend Tribune*, August 14, 1936, Clipping Book 85, SP.

5. "Speech," *New Jersey Senate Journal* (Trenton, New Jersey, 1886).

6. Irving S. Kull, ed., *New Jersey: A History* (New York, 1930), 943–74; Joseph F. Mahoney, "The Impact of Industrialization on the New Jersey Legislature 1870–1900: Some Preliminary Views," *New Jersey Since 1860: New Findings and Interpretations* (Trenton, 1972), 60–75; "Frederick Samuel Fish," Obit. *New York Times*, August 14, 1936, 17; *South Bend Tribune*, May 4, 1891, Clipping Book 6, SP.

7. Studebaker Minute Book 14, April 22, 1903, SP.

8. The American Manufacturers of Automobiles reported that of the fifty-one concerns manufacturing automobiles in 1901, only twenty-one, or less than half, survived until 1908. American Manufacturers of Automobiles, "The American Automobile Industry, 1901 to 1908" (n.d.), Henry B. Joy Papers, Bentley History Library, University of Michigan. Also, see R. F. Thomas, "The Automobile Industry and Its Tycoon," *Explorations in Entrepreneurial History* 6 (Winter 1969), 147; Ralph C. Epstein, *The Automobile Industry* (Chicago, 1926), 188; Robert Paul Thomas, *An Analysis of the Pattern of Growth of the Automobile Industry: 1895–1929* (New York, 1977), 5.

9. See Hounshell, *From the American System to Mass Production*, 189–215. Also, Morris Woodhull, "Address," *Carriage Builders Association Reports* 24 (Philadelphia, 1897), 18.

10. Studebaker Corporation, Minute Book 2, May 20, 1898, SP.

11. U.S. Bureau of the Census, *Bulletins* #81–90, "Carriages and Wagons" (Washington, D.C., 1905).

12. *Carriage Monthly* (February 1899), Clipping Book 1896–1900, SP.

13. Morris Woodhull, "The Progress of the Motor Vehicle." In *Twenty-Seventh Annual Report of the Carriage Builders Association* (Philadelphia, 1899), 39–41.

14. Turner Manufacturing Company to Charles Neilson, March 15, 1896, Bureau of Fourth Department Assistant, *Postmaster General Division of Motor Service*, Correspondence, 1894–1897, Record Group 28, National Archives, Washington, D.C., hereafter PG/MSC. The role of the postal service in the development of the automobile remains unexplored but is a fascinating story of how the federal government played a key part in this technological revolution. A number of articles at the time recount the government's involvement, including "Motor Vehicles of the Postal Service," *Motor Review* I (October 3, 1901), 4; Perry S. Heath, "Automobile Postal Service," *The Automobile Magazine* I (February 1900), 445–54; and "The Latest Postal Reform," *The Automobile Magazine* I (January 1900), 435.

In late 1896, Fish wrote to Neilson that an electric wagon designed by Strong was nearing completion. Fish assured Neilson that he was confident that Strong's designs would "produce at least make possible by production exactly what you want. . . . " He added that this design would "come nearer to satisfying you than anything we have yet seen." Frederick S. Fish to Charles Neilson, September 8, 1896, PG/MSC.

15. George Strong is identified in the correspondence in the Postmaster General's Office and in Fish's correspondence as mechanical/electrical engineer working in the Bronx and later in Newark, New Jersey. His only pub-

lished piece was "Feed-Water Heater and Pacifier," *Journal of the Franklin Institute* 114 (1882), 321.

16. Studebaker Corporation, Minute Book 1, November 23, 1896, SP.

17. Studebaker Corporation, Minute Book 1, May 12, 1897, SP.

18. Herman F. Cunz to Henry Cave, January 5, 1950, in Henry Cave Papers, Detroit Public Library (hereafter HCP). Also, O. J. Sullivan to H. R. Seldon, December 16, 1949, HCP; and Studebaker Corporation, Minute Book 1, September 21, 1899, SP.

19. The electric car is discussed by John B. Rae, *The American Automobile Industry* (Boston, 1984), 14–15.

20. *Export Carriage Monthly* I (June 1899), 147.

21. Cited in James J. Flink, *America Adopts the Automobile, 1895–1910* (Cambridge, 1970), 21. Also, Rudolph E. Anderson, *The Story of the American Automobile* (Washington, D.C., 1950), 67.

22. *Farm Implement* (June 29, 1899); and *Cycle Age* (June 12, 1899), Clipping Book 14, in SP.

23. Studebaker Corporation, Minute Book 1, February 14, 1900, SP.

24. Studebaker Corporation, Minute Book 1, May 30, 1900, SP.

25. *The Spokesman* (November 1905), Clipping Book 50; and *South Bend Tribune* (March 31, 1902), Clipping Book 41, SP.

26. "No Studebaker-Westinghouse Combination," *Motor Review* (February 20, 1902), 1.

27. Studebaker Corporation, Minute Book 1, November 12, 1902, SP.

28. For an interesting perspective concerning Studebaker's entrance into the automobile industry, see Donald Finlay Davis, "Studebaker Stumbles into Detroit," *Detroit in Perspective* 4 (1979), 16–35; and Davis, "The Social Determinants of Success in the American Automotive Industry Before 1929," *Social Science Information: Colloquium on the Global Automobile Industry* (1982), (Beverly Hills, 1982), 67–93.

29. Carriage Builders National Association, *Reports* 35 (October 26, 1906 to October 10, 1907), 63.

30. Ibid., 64.

31. Clement Studebaker, Jr., "Memorandum," April 1, 1912, Secretary Files, SP.

32. Studebaker Corporation, August 8, 1900, Minute Book 2, SP.

33. Studebaker Corporation, November 24, 1906, Minute Book 2, SP; and Studebaker Corporation, August 8, 1900, Minute Book 1, SP.

34. *Implement Age*, June 9, 1908, Clipping Book 20, SP. Studebaker Corporation, November 7, 1911, Secretary Files (1911), SP.

35. *South Bend Tribune*, November 12, 1907; *South Bend Times*, November 1, 1907; and *South Bend Tribune*, October 30, 1907, Clipping Book 20, SP.

36. *Washington Post*, December 20, 1907; *Evening Post*, June 7, 1901; and *South Bend Times*, May 25, 1908, Clipping Book 20, SP.

37. Studebaker Corporation, November 7, 1911, Secretary Files (1911), SP.

38. Association of Licensed Automobile Manufacturers, "A Brief in Behalf of the American Automobile Industry submitted to the Committee on Ways and Means," December 31, 1908, in Henry P. Joy Papers, University of Michigan.

39. L. H. Seltzer, *A Financial History of the American Automobile Industry* (Boston, 1928), 25.

40. "The Auto and the Bond Market," *Bankers Magazine* 81 (October 1910), 50; L. H. Seltzer, *Financial History*, 30.

41. See EMF Record Book, April 1909, SP.

42. For models see "Studebaker File," National Automotive Historical Collection in Detroit Public Library, Detroit, Michigan.

43. Arthur Garford to Hart O. Berj, November 6, 1904, Box 7, Arthur Garford Papers, Ohio Historical Society, Columbus, Ohio (hereafter GP).

44. "Garford Gets Federal," May 18, 1905, source unknown, Box 7, GP.

45. Board of Directors Meeting, Minute Book, February 2, 1904; November 23, 1906; and May 4, 1905, SP.

46. Frederick Fish to Arthur Garford, November 21, 1903; Frederick Fish to Arthur Garford, December 20, 1903, Box 6, GP.

47. Arthur Garford to I. Gifford Ladd, May 10, 1905, Box 7, GP.

48. Garford Manufacturing Company, *Annual Report* (1906), SP. Also, Arthur Garford to R. P. Peak, April 30, 1906, Box 6, GP.

49. Studebaker Board of Directors Meeting, February 19, 1906, Minute Book, February 2, 1904–November 23, 1906, SP. Also, Garford Manufacturing Company, March 13, 1906, Garford Minute Book, SP.

50. Donald F. Davis stresses the social character of the early industry with the marketing decision to sell in the medium-priced and high-priced markets. This tie between the social backgrounds of most producers and production decisions appears tenuous without a more careful economic consideration of the nature of the early automobile market. See Donald Finlay Davis, *Conspicuous Production: Automobile and Elites in Detroit, 1899–1933* (Philadelphia, 1988).

51. Garford Automobile Corporation, *Annual Report* (1907), Garford Minute Book, November 25, 1907, SP.

52. Arthur Garford to Hart O. Berj, October 8, 1906, in Box 8, GP.

53. Marwick, Mitchell & Company, *American Vehicle Company Report* (1910), SP.

54. Arthur Garford to C. F. Lajanke, April 8, 1904, Box 7, GP.

55. Board of Directors Meeting, November 12, 1906, Garford Minute Book (1905–1911), SP.

56. Arthur Garford to James G. Heaslet, August 23, 1906, Box 8, GP. The plant accident is discussed in Telegram, September 7, 1906, Box 8, GP.

57. Arthur Garford to Fred Kohlar, May 29, 1907, Box 9, GP.

58. Arthur Garford to J. Gullinger, June 10, 1907, Box 8, GP.

59. Arthur Garford to George Dambmann, August 13, 1907, Box 9, GP. Also, Garford Motor Company, *President's Report*, November 25, 1907, Garford Minute Book, SP.

60. Board of Directors Meeting, April 27, 1907, and May 1, 1907, Minute Book, SP.

61. Board of Directors Meeting, June 7, 1907, Minute Book, SP.

62. Arthur Garford to F. W. Colso, August 18, 1907, Box 9, GP.

63. Studebaker paid $600,000 for 3,625 shares. These negotiations are traced in the minutes of the corporation. See Board of Directors Meetings, January 3, 1908; February 6, 1908; February 12, 1908; and February 13, 1908, Minute Book, SP.

64. For relations with these dealers see Garford Board of Directors Meeting, January 20, 1908; October 6, 1908; and October 26, 1908, Garford Motor Company Minute Book, SP.

65. The best history of the automobile industry in these years remains

Flink, *America Adopts the Automobile*. See also Thomas, *An Analysis of the Pattern of Growth of the Automobile Industry*, especially 61, 90–91.

66. Thomas, ibid., 93–94. Also, see Hounshell, *From the American System to Mass Production*.

67. Garford Board of Directors Meeting, November 3, 1908, in Garford Motor Company Minute Book, SP.

68. EMF company, "EMF CO," Advertising brochure, EMF Folder, National Automotive Historical Collection, Detroit Public Library.

69. Beverly Rae Kimes, "E & M & F . . . & Leroy," *Automobile Quarterly* XVII: 4, 340–60; and George S. May, *A Most Unique Machine* (New York, 1975), 119, 252, and 305.

70. His brother Ralph, it might be noted, was much different. He later became the U.S. Senator from Vermont.

71. Charles Sorensen, *My Forty Years with Ford* (New York, 1956), 88–93.

72. Stories circulated of how Flanders worked twelve to fifteen hours a day, and then spent half the night drinking, only to be at work the next morning as "fresh as a daisy in one of his Vermont hay fields." As one fellow worker described him, he was "a terrible boozer, and one of the hardest workers I've ever seen in the automobile business." Otto Klausmeyer, Interview with John Bodnar, May 11, 1984, Oral History Project, Indiana University, Bloomington, Indiana. Also see Sorensen, *My Forty Years With Ford*, 93.

73. Lincoln R. Scaife to H. S. Maynard, May 7, 1951, H. S. Maynard Papers, Detroit Public Library.

74. Kimes, "E & M & F . . . & Leroy," 343. Kimes provides no citation for her sources, but in a letter to the EMF board Flanders spoke of the industry being dominated by "two or three powerful syndicates." See Walter E. Flanders to Board of Directors, April 29, 1909, EMF Board of Directors Meeting, EMF Minute Book, April 1910, SP.

75. Kimes, "E & M & F . . . & Leroy," 344–45.

76. EMF Board of Directors Meeting, October 12, 1909, SP.

77. EMF Board of Directors, July 13, 1909, SP.

78. "Detroit's Supremacy in Automobiles," *Foundry*, June 1910, Clipping Book 5, SP.

79. Walter Flanders to EMF Board of Directors, July 28, 1909, Board of Directors Meeting, July 29, 1909, SP.

80. Quoted in Maurice D. Hendry, "One Can Do A Lot of Remembering in South Bend," *Automobile Quarterly* X, 3 (Third Quarter 1972), 229.

81. Max Wollering, a roundabout machinist, served as production manager, while Thomas Walburn managed the production of the Flanders 30. By late 1909 Flanders reported that production projections had been surpassed. As *Motor World* explained, "EMF factories are going full blast and its production is piling up." Kimes, "E & M & F . . . & Leroy," 351.

82. Branches were located in New York, Pittsburgh, Louisville, Indianapolis, Minneapolis, Boise, Boston, Cleveland, Chicago, Dallas, Denver, Portland, Columbus, Milwaukee, Kansas City, Salt Lake City, and San Francisco. Board of Directors Meeting, April 9, 1910, Minute Book 5, SP.

83. B. F. Everitt to Board of Directors, Board of Directors Meeting, March 4, 1909, Minute Book 1908–October 12, 1909, SP.

84. Frederick Fish to Walter Flanders, April 8, 1909, Board of Directors Meeting, April 29, 1909, SP.

85. EMF Board of Directors Meeting, December 31, 1909, EMF Minute

Book 2, SP; and "Studebaker Out to Form Giant Combine," source unknown, October 5, 1910, Clipping Book 54, SP.

86. Otto Kirchner to Frederick Fish, January 3, 1910, in Otto Kirchner Papers, Detroit Public Library, Detroit, Michigan.

87. The negotiations are traced in a series of letters, including Scott Brown to Frederick Fish, January 13, 1910; Frederick Fish to Otto Kirchner, January 19, 1910; and Otto Kirchner to Frederick Fish, January 21, 1910, Otto Kirchner Papers.

88. Kimes, "E & M & F . . . & Leroy," 351. See also "Morgan and Company Buy Auto Plant," *New York Times*, March 10, 1910, 14; Memorandum, Frederick Fish to Board of Directors, April 7, 1911, Secretary Files (1911); and Walter Flanders to Frederick Fish, April 24, 1911, Board of Directors Meeting, May 2, 1911, Minute Book 5, SP.

89. "Affidavit Submitted in Regard to Gift of 2500 Shares of Studebaker Corporate Stock," SP.

90. Board of Directors Meeting, May 23, 1910, Minute Book, October 10, 1906–October 19, 1911, SP.

91. John B. Rae, *American Automobile Manufacturers: The First Forty Years* (Philadelphia, 1959), 86–89; Flink, *America Adopts the Automobile*, 313; John B. Rae, *The American Automobile: A Brief History* (Chicago, 1965), 43.

92. "Affidavit Submitted in Regard to a Gift of 2500 Shares of Studebaker Stock," SP.

93. For example, see Phillip Lehman to Frederick Fish, July 21, 1911, Secretary Files (1911), SP.

94. Memorandum "402," June 12, 1911, and Memorandum "351," March 27, 1911, Executive Correspondence File, Box 4, SP.

95. *Detroit Free Press*, April 22, 1951, Flanders File, National Automotive Historical Collection, Detroit Public Library.

96. Thomas, *An Analysis of the Pattern of Growth of the Auto Industry*.

97. Fish remained respectful of his father-in-law. The two men—the wagon maker and the corporate lawyer, one a production man and the other a finance man, one from the rural Midwest and the other from the urban East, separated by a generation—enjoyed one another's company. When Billy Sunday, the great revivalist, came to South Bend, both J. M. and Fish stepped forward together to renew their commitment to Christ. Fish and his wife frequently joined her parents on holidays, motor trips, and visits to Europe and California.

98. J. M. Studebaker to Frederick Fish, October 30, 1915, in "Affidavit . . ." 124, SP.

99. J. Newton Gunn to Scott Brown, October 18, 1911. Supporting Files (1911), SP.

100. J. M. Studebaker, Jr., "Testimonial Book to Harold A. Briggs," May 23, 1925, SP.

By the time Frederick Fish died in 1936, most of the Studebaker family had lost its fortune. The most telling sign came in 1952 when Ada Studebaker, the daughter-in-law of Clem, and the wife of George M. Studebaker, wrote Studebaker asking for financial assistance. She began by noting that "I perfectly realize that you represent a corporation which is different from a family group or company." During the crash of 1929 she and her family had lost everything. Now living on $60 a month and in need of a cataract operation,

she turned to the Studebaker Corporation "to make an exception." The board of trustees, many of whom had never met a Studebaker, agreed to pay Ada Studebaker $200 a month pension because, as one trustee put it, "many might feel that a Studebaker in trouble should be helped by the Corporation."

3. Studebaker Prospers and Paternalism Thrives, 1913–1929

1. Board of Directors Meeting, July 8, 1915, Support Documents Box 1; Frederick Fish to Henry Goldman, April 30, 1915, in Minutes, Board of Directors Meeting, May 4, 1915, Support Documents Box 1, SP.

2. Albert Russel Erskine, *History of the Studebaker Corporation* (South Bend, 1924).

3. "Erskine's Death Ends Bold Career," *Automobile Topics*, July 8, 1933; "Studebaker Head Ends Life by Shot," *New York Times*, July 2, 1933, 12.

4. Stephen Meyer III, *The Five Dollar Day: Labor Management and Social Control in the Ford Motor Company, 1908–1921* (Albany, 1981); Allan Nevins and Frank E. Hill, *Ford: The Times, the Man, the Company* (New York, 1954); Allan Nevins and Frank E. Hill, *Ford: Expansion and Challenge, 1915–1932* (New York, 1957); and Rae, *The American Automobile Industry*, 38.

5. The development of the automobile market is discussed by Robert Paul Thomas, *An Analysis of the Pattern of Growth of the Automobile Industry, 1895–1929* (New York, 1977), 89–181, especially 143–70.

6. Erskine continued to stress the importance of "efficiency and economy," especially in his first years at Studebaker. As he told Fish, "*Economy and Efficiency* are the present watchwords of our organization." In the 1920s he tended to emphasize the importance of men within the corporation. In this way Erskine, always the man of his times, articulated the rhetoric found in business circles of the time. See Letter, A. R. Erskine to Frederick Fish, April 2, 1916, Supporting Materials, Box 10, in SP; and Clipping, "Studebaker Efficiency," *Boston Post*, August 13, 1916, Clipping Book 70, SP. For a critical view of Erskine see Interview, Otto Klausmeyer, conducted by John Bodnar, May 11, 1988, in Indiana University Oral History Project, Bloomington, Indiana. See also A. R. Erskine, "What Makes a Successful Executive?" *Nation's Business*, November 1929, in Clipping Book 60, in SP.

7. "What Makes a Successful Executive?" *Nation's Business*, November 1929, Clipping Book 60, SP.

8. "What Makes a Successful Executive?" *Nation's Business*. Also, "A. R. Erskine's Death Ends a Bold Career," *Automobile Topics*, July 8, 1933, Clipping Book 84, SP.

9. Erskine's views of loyal workers and labor turnover are found in a number of articles he published in the 1920s. See A. R. Erskine, "What Has Kept Our Volume Climbing," *System* 42, October 1922, 395–98; and Erskine, "Surely One of the Necessities of Good Management," *System* 50, December 1926, 730–32. For Erskine's views of labor in general see Erskine, *History of the Studebaker Corporation*, 102–130.

10. "Erskine of Studebaker," *Motor*, June 1923, Clipping Book 69, SP.

11. For example, in 1918 Sloan introduced a compensation package for General Motors, but this measure was designed to reinforce short-term interests of the company. Moreover, for all of Sloan's rhetoric concerning the welfare of his employees, the corporation still employed Pinkerton detectives to intimidate pro-union workers. Studebaker, in turn, developed a wide array of

paternalistic practices and programs, designed primarily not to prevent unionism—which presented little threat after the recession of 1921—but to ensure a loyal and hardworking labor force.

12. Perceptions developed in the Erskine years held important implications for later years. As a consequence, Studebaker accepted unionism in the early 1930s, while General Motors only accepted industrial unionism after a bitter strike in 1937. Ford, for its part, remained vehemently antiunion well after the outbreak of World War II. Diversity in labor relations was also seen at Chrysler. Also of interest is Sanford M. Jacoby, *Employing Bureaucracy: Managers, Unions, and the Transformation of Work in American Industry, 1900–1945* (New York, 1985), 120.

13. *South Bend Tribune*, January 1919, Clipping Book 8, SP.

14. He became a board member of the local YMCA, a director of Epworth Hospital, a member of the city planning commission, a trustee of the University of Notre Dame, a leading force in the National Automobile Chamber of Commerce, a director on the Federal Reserve Bank of Chicago, and an official in the Interstate Harbor Commission of Indiana and Illinois. Charles A. Lippincott, "Introduction," in Erskine, *History of the Studebaker Corporation*, xxv.

15. *Detroit Motor*, October 1929, Clipping Book 65, SP.

16. Henry Goldman to A. R. Erskine, May 9, 1914; Henry Goldman to A. R. Erskine, September 5, 1914; and Henry Goldman to A. R. Erskine, March 9, 1914, Erskine Correspondence File, in Conrad Family Papers, University of Virginia, hereafter CFP.

17. Shortly afterward, Goldman arranged for a personal loan of $30,000 for Erskine and offered his palatial summer home to Erskine for his honeymoon. Henry Goldman to A. R. Erskine, June 26, 1914; and J. M. Studebaker to A. R. Erskine, September 12, 1914, CFP.

18. Harold Katz, *The Decline of Competition in the Automobile Industry, 1920–1940* (New York, 1977), 182–83.

19. "Elegant Erskine Manor Again Receives Callers," *South Bend Tribune*, May 6, 1984.

20. Edward J. Murnane to A. R. Erskine, March 7, 1926, Correspondence File, CFP.

21. While an outgoing man, Erskine maintained his closest ties to his family and a small circle of friends. He arranged for his niece to move to South Bend in order to provide her not quite successful husband a job managing Erskine's real estate company, Twickingham Estates. Weekends were often spent with his immediate family and key Studebaker executives in organized shopping trips to Chicago and New York, elegant dinner parties at home, or outings to the newly developed "Erskine" golf course.

Insight into Erskine's private life can be gained through his niece's diary; see Diaries, 1928–29, Janet Conrad File, CFP.

22. J. M. Studebaker to A. R. Erskine, September 4, 1914; and J. M. Studebaker to A. R. Erskine, September 12, 1914, Correspondence File, CFP.

23. Seltzer, *Financial History*, 325; and Katz, *The Decline of Competition*, 29.

24. Katz, *The Decline of Competition*, 31.

25. Board of Directors Meeting, April 7, 1914, SP.

26. Memorandum, A. R. Erskine to the Board of Directors, 9 (n.d.) Supporting Materials (1913), SP.

27. A. R. Erskine to Frederick Fish, April 2, 1916, Supporting Materials (1916), SP.

28. A. R. Erskine, December 29, 1913, Supporting Materials (1913); and Board of Directors Meeting, April 7, 1914, SP. Also, see Max Wollering, "Reminiscences," Henry Ford Archives, Dearborn, Michigan.

29. Board of Directors Meeting, April 4, 1914, SP; also see Memorandum, "Report of Vice-President in Charge of Engineering," April 6, 1915, Supporting Documents (1915), SP.

30. Hendry, "One Can Do A Lot of Remembering in South Bend," 231–35.

31. Memorandum, A. R. Erskine to James Heaslet, August 4, 1913, Supporting Materials (1913) in SP. There is a rich secondary literature on "scientific management" in this period. A subtle account of scientific management is offered by Daniel Nelson, *Frederick W. Taylor and the Rise of Scientific Management* (Madison, 1980). Also useful is Daniel Nelson, *Managers and Workers: Origins of the New Factory System in the United States, 1880–1920* (Madison, 1975). On the development of early management see Leland H. Jenks, "Early Phases of the Management Movement," *Administrative Science Quarterly* 5 (December 1960), 421–47.

32. "Report of Vice President in Charge of Manufacturing," James H. Heaslet to Frederick Fish, August 4, 1914, Supporting Materials (August 4, 1914 to April 6, 1915), SP.

33. Board of Directors Meeting, August 27, 1915, SP.

34. The installation of drinking fountains and washroom facilities marked a significant improvement over the common drinking pail and common washtub still used in most factories in 1913. Memorandum, Max Wollering to A. R. Erskine, August 4,1913, Minute Book I, SP. Also, Clipping, "The Dodge Idea" (unknown source, July 1911), Clipping Book 63, SP. For a description of factory life in these years see Walter P. Chrysler, *Life of an American Workman* (New York, 1937).

35. While management did not conduct a full survey of industrial accidents within the plant, newspapers of the day indicate a high rate of serious accidents throughout this period, including electrocutions, crushed limbs from defective elevators, and amputated hands and legs from unsafe machinery. "Touches Live Wire," *South Bend Tribune*, May 26, 1905; "Caught by Falling Chimney," *South Bend Tribune*, June 6, 1905; "Life Crushed Out," *South Bend Tribune*, June 18, 1905; "Asks for Damages," *South Bend Tribune*, July 29, 1905; "Brings Suit for Damages," *South Bend Tribune*, December 3, 1905; "Sibeneak May Die," *South Bend Tribune*, December 18, 1905; "Man Accidently Breaks Leg," *South Bend Times*, February 2, 1906; "Sues for Loss of Hand," *South Bend Tribune*, August 8, 1906; and "Misses the Elevator," *South Bend Tribune*, August 22, 1906.

36. Erskine was quick to point out that the premiums in Detroit were especially high because a state compensation law made employee insurance mandatory, while the absence of such a law in Indiana allowed greater competition between the insurance companies. Board of Directors Meeting, February 4, 1913, SP.

37. Pamphlet, Studebaker Corporation, *Studebaker Profit Sharing Announced* (1913); also Minutes, Board of Directors Meeting, January 9, 1917, SP.

38. A comparison between 1913 and 1914 revealed the following:

Automobile Division

	1913	1914
Employees	7,617	5,913
Wages	$3.6 million	$2.3 million
Wages Per Car	$221.96	$126.12
Total Man Hours Per Car	73.3	38.9

Memorandum, James G. Heaslet to Frederick Fish, August 4, 1914, Supporting Documents (1914), SP.

39. A. R. Erskine, "Report of First Vice President," August 4, 1914, Supporting Materials, SP.

40. Although the automobile industry was not unique in its drive to increase productivity through the introduction of advanced machinery, the introduction of the moving assembly line reshaped factory work into smaller and smaller tasks, routinized by careful study of work methods, automated technology, and plant layout. At the same time, early social patterns that existed between skilled mechanics and craftsmen who composed the workforce in the early industry led to ongoing conflicts with management as the workforce was segmented into skilled and unskilled labor.

The transformation of work in the auto industry is discussed in Hounshell, *From the American System to Mass Production*; Meyer, *The Five Dollar Day*; Joyce Shaw Peterson, *American Automobile Workers, 1900–1933* (Albany, 1987); and David Gartman, *Auto Slavery: The Labor Process in the American Automobile Industry, 1897–1950* (New Brunswick, 1986). For the transformation of work and its effect on labor in this period see Daniel Nelson, *Managers and Workers: Origins of the New Factory System in the United States, 1880–1920* (Madison, 1975).

41. Detroit attracted early automobile producers in part because of its reputation as an antiunion town, earned in the 1880s when city businessmen had broken the back of organized labor. This reputation was further enhanced with the formation of the well-organized and effective Employers Association of Detroit in 1902. Still it was not until the decade of the twenties, following the postwar recession, that labor appeared tamed (albeit briefly) in the auto industry.

42. *Detroit News*, June 18, 1913, Clipping Book 64, SP.

43. *Detroit News*, June 17, 1913, Clipping Book 64, SP.

44. For accounts of the strike see "Studebaker Auto Workers Strike," *Detroit Free Press*, June 18, 1913; and "1,000 Employees of Studebaker Strike," *Detroit Free Press*, June 17, 1913; Clipping Book 64, SP. For IWW's involvement in auto and in this strike see Melvyn Dubofsky, *We Shall Be All: The Industrial Workers of the World* (Chicago, 1969), 287.

45. Gartman, *Auto Slavery*, 162.

46. *Automobile*, October 25, 1917, Clipping Book 70, SP. Board of Directors Meeting, April 27, 1917, SP.

47. Board of Directors Meeting, February 6, 1917, SP.

48. The first signs that money was to be made in war came in 1916 when the Department of War hurriedly placed a rush order for twenty-five water wagons to accompany General Pershing's expedition to Mexico in pursuit of

Pancho Villa, who had crossed the American border to raid American settlers in New Mexico. Studebaker met the order by ingeniously converting its commercial street sprinklers into water wagons. Newspapers across the country proudly showed Studebaker employees sitting atop the fully hitched wagons ready to drive the teams to the Mexican border.

Still it should be noted that not all automobile executives were as happy with the Villa expedition as was Studebaker. Henry P. Joy, owner of Packard, later wrote Arthur H. Vandenberg, the senator from Michigan, that the government "commandeered my truck production to use on a silly and futile expedition into Mexico to chase a flea. . . . " Joy's feelings, expressed in a letter in 1935, might have expressed his current fears of government expropriation. Henry P. Joy to Arthur H. Vandenberg, April 18, 1935, Joy Papers, in Bentley Library, University of Michigan.

49. Board of Directors Meeting, November 21, 1914, SP.

50. Memorandum, Albert Erskine to Board, November 3, 1915, Secretary Files, Supporting Documents, SP.

Even as the orders poured in, Studebaker refused to subscribe to the Anglo-French war bond drive in the fall of 1915. Initially, Erskine had pledged one million dollars of the five billion dollar loan, but Fish wired him to withdraw. Always his own man, Erskine wired back that he did not favor withdrawing, only to receive a one-line answer from Fish, "I dislike to oppose Mr. Goldman's views." No more needed to be said. Goldman opposed the loan because he feared that it might embroil the United States in the war. Telegrams, Frederick Fish to A. Erskine, October 1, 1915; Frederick Fish to Goldman, October 1, 1915; A. R. Erskine to Frederick S. Fish, October 3, 1915; Frederick S. Fish to A. R. Erskine, October 4, 1914; and A. H. Hepburn to Goldman, October 5, 1915, SP.

51. Board of Directors Meeting, December 28, 1917, SP.

52. Automobile Quarterly, *The American Car Since 1775* (New York, 1971), 125, 139.

53. Memorandum, A. R. Erskine to Executive Committee, June 28, 1917, Supporting Materials, SP.

54. Board of Directors Meeting, April 1, 1919, SP.

55. Memorandum, A. B. Thielens to Mr. Erskine, December 27, 1917, Supporting Materials, SP.

56. Memorandum, A. B. Thielens to Mr. Erskine, May 7, 1918, Supporting Material, SP.

57. Kentucky Wagon continued to produce wagons for a predominately Southern market until the early 1940s. Total sales of wagons from 1868 to 1920 amounted to approximately $150 million.

58. The historical record does not reveal any record of inside trading, which is not surprising, given how difficult this activity is to prove without collaborating evidence. A. R. Erskine to Col. George M. Studebaker, April 29, 1918; George M. Studebaker to A. R. Erskine, May 4, 1918; and George M. Studebaker to Board of Directors, May 6, 1918, Supporting Files, Box 2 (1918), SP.

59. Seltzer, *Financial History*, 46–47.

60. Memorandum, Erskine to Fish, April 2, 1918, Supporting Materials (1918), SP.

61. Thomas, *Pattern of Growth of the Automobile Industry*, 212–31.

62. See Arthur J. Kuhn, *GM Passes Ford, 1918–1938: Designing the General Motors Performance Control System* (University Park, 1986); Bernard A.

Weisberger, *The Dream Maker: William C. Durant, Founder of General Motors* (Boston, 1979); and the useful Alfred D. Chandler, Jr., *Giant Enterprise: Ford, General Motors, and the Automobile Industry* (New York, 1964).

63. Brooks T. Brierley, *There Is No Mistaking a Pierce Arrow* (Coconut Grove, Florida, 1986), 21; and Rae, *American Automobile Manufacturers*, 131–33.

64. Seltzer, *Financial History*, 56–60.

65. William A. Cannon and Fred K. Fox, *Studebaker: The Complete Story* (Blue Ridge Summit, Penn., 1981), 69–72, 94–95.

66. Hendry, "One Can Do A Lot of Remembering," 236.

67. Memorandum, A. R. Erskine to Board, February 4, 1919, Supporting Materials (1919), SP.

68. Cannon and Fox, *Studebaker: The Complete Story*, 45.

69. Memorandum, A. R. Erskine to Frederick Fish, March 28, 1919, Supporting Materials (1919), SP.

70. The most apparent solution to labor shortages, he concluded, lies in "the increased use of female help and we are developing this proposition as fast as possible." Shortly afterward, women were hired to fill positions in the inspection department and the stores department, but throughout the war, labor continued to adopt what Wollering described as an "independent attitude." Memorandum, Max Wollering "Report for the Directors Meeting," November 7, 1917, in Supporting Files (1917); and Memorandum, Max Wollering to A. R. Erskine, July 6, 1917 in Supporting Files (1917), SP.

71. See Montgomery, *The Fall of the House of Labor*, 411–65.

72. With the approach of May Day, 1919, Wollering warned that May 1st was usually a day of trouble, although "we hope to be able to handle anything which may turn up." When May Day passed without trouble, Studebaker management felt its enlightened labor policies in Detroit were paying off. Max Wollering to A. R. Erskine, April 1, 1920, Miscellaneous File 256, SP.

73. A. R. Erskine to Frederick Fish, March 28, 1919, Supporting Materials, SP.

74. *Detroit Free Press*, May 27, 1919, Clipping Book 70, SP. For the month prior to the strike Wollering had seen many signs of labor discontent. Reports of strikes among Studebaker suppliers had alarmed Wollering, who told Fish that he was going over all the wage rates "to forestall difficulties." He felt that wages should be adjusted to remain "just and reasonable" and that the company should continue to be "alive to the seriousness of the matter and to the importance of handling it carefully." Nevertheless, he quickly added that the company should maintain an open shop. Memorandum, Max Wollering to Frederick Fish, May 5, 1919, Miscellaneous File 257, SP.

75. *Detroit News Tribune*, June 4, 1919, Clipping Book 70, SP.

76. As one company spokesman bragged, "we have introduced the best features of modern sanitation, of ventilation, of lighting and heating, and we have achieved, I believe, . . . our purpose of providing ideal working conditions." For a detailed description of facilities see the special issue of Studebaker's in-house publication, *Another Step Forward* (January 30, 1919).

Ironically, labor difficulties with construction workers delayed completion of the South Bend plant by sixty days. In the end, Studebaker broke its contract with the James Stewart Construction Company and brought in a new construction team. The issue was primarily one of the union's demand for a closed shop. As Wollering told Erskine, the construction workers were "thoroughly organized and controlled by a vicious ring whose insistence on the

closed shop was such as to seriously delay the work of several sub-contractors as well as our own." Studebaker had trouble with these men "ever since ground breaking." Memorandum, H. S. Vance to A. R. Erskine, March 28, 1920, Misc. File 256; and Memorandum, Max Wollering to A. R. Erskine, April 1, 1920, Misc. File 256, SP.

77. For instance, the move to South Bend along with the normal seasonal downturn in production forced management to cut the workforce in half in the fall of 1920. "In reducing our force," Wollering told Erskine, "we have endeavored as far as possible to keep on all of the older employees, letting go the new men, the unmarried, etc." Memorandum, Max Wollering to A. R. Erskine, October 28, 1920, Misc. File 256, SP.

78. "Corporate welfarism" became a rage in American business following the First World War, especially after the labor upheavals of 1919. Businessmen imparted an array of meanings to the term, however. As the Bureau of Labor Statistics observed in its 1919 report, *Welfare Work for Employees in Industrial Establishments in the United States*, welfare measures in the automobile industry ranged from joint administration of production work by employees and employed (described by the Bureau as "mutualism") to the installation of better drinking fountains in the plant. At Studebaker, welfarism meant the introduction of anniversary checks, pension and insurance plans, paid vacations, athletic and social clubs, and the latest in modern facilities, including a modern health clinic, cafeteria, and clubhouse. The range of Studebaker's programs, although atypical in industry in general, was not exceptional. For instance, National Cash Register Company in Dayton, Ohio had developed a similar program. For an excellent discussion of corporate welfarism at National Cash Register see Judith Sealander, *Grand Plans: Business Progressivism and Social Change in Ohio's Miami Valley, 1890–1929* (Lexington, 1988).

79. After studying at Princeton's Theological Seminary and the McCormick School of Theology in Chicago, Lippincott brought a social commitment to his work in South Bend. He helped found a chapter of the American Red Cross, chaired the Board of Directors of Epworth Hospital, and actively participated in the YMCA.

80. "Lippincott Resigns His Pastorate," *South Bend News-Times*, July 28, 1919, Local History File (Studebaker), in South Bend Public Library.

81. Later interviews with employees who worked at Studebaker in these years indicate that Lippincott was well respected by the men. J. D. Hill, Oral History Collection, U.A.W. Local 5 Papers, Walter Reuther Library, Wayne State University, hereafter Local 5 Papers.

82. It is worth noting that Lippincott did not turn his department into an investigative bureau along the lines of Ford's Sociological Department. Indeed, little attention was given in the department's monthly publication, *The Co-operator*, to offering personal advice to workers or their families. Most attention was focused on sporting and social events, news of retirements, vacations, and social gatherings.

83. This decline in turnover reflected a general decline in turnover throughout the auto industry in the 1920s, although Studebaker enjoyed a lower rate on average. Erskine, *History of the Studebaker Corporation*, 103–35.

Studebaker's efforts were applauded within the industry. For example, the *Wall Street Journal* felt that the welfare plan should be given "full credit" for Studebaker painters and trimmers not joining a strike that had handicapped production in Detroit, even though they were members of the same union. *Wall Street Journal*, March 25, 1920, Clipping Book 70, SP.

Furthermore, when Studebaker cut back its work force during the down-

turn in 1921, Wollering reported that "we have endeavored to keep at least the nucleus of our organization together. . . . " Fewer days per week were worked, and when piece rates were cut 15 percent, Wollering took pride in telling Erskine that this was "accepted by men in a good spirit." Wollering added that while some workers had been laid off, the company made it a point to keep married men with families, and this had gained further appreciation from the employees. Memorandum, Max Wollering to Frederick S. Fish, January 29, 1921, Misc. File 256, Supporting Documents, SP. Also see J. D. Hill, Oral History Collection, Local 5 Papers.

84. Although labor relations at Studebaker remained relatively stable, Studebaker workers struck briefly in 1924, and throughout the period there were numerous walkouts. Nevertheless, the image of Studebaker as an enlightened employer continued to be held by management and labor even as late as the 1950s. John Bodnar, "Power and Memory in Oral History: Workers and Managers at Studebaker," *Journal of American History* 74:4 (March 1989), 1201–21.

85. As Lippincott explained in the first issue of *The Co-operator*, "Every product that goes out from Studebaker is the work of the Studebaker family. The men who planned and directed the operation which turn out the product should, and do, feel proud of the fact that the stamp of their work is upon it; but they have no more claim to honor which may come than have the thousands of others who contributed toward the actual making of the product. You are a member of the organization which puts out Studebaker products, and so am I." Charles A. Lippincott, "Cooperator," *The Co-operator* I:7, August 1920, 38.

86. Annual Stockholders Report, April 2, 1922; Board of Directors Meeting, January 31, 1923, SP.

87. Board of Directors Meeting, November 27, 1923, SP. For a contemporary description of the negotiations see "Maxwell Merger Off: Wilson Quits as Head," *New York Times*, November 29, 1923, 7. Also see Rae, *American Automobile Manufacturers*, 143–45; and Eugene W. Lewis, *Motor Memories: A Saga of Whirling Gears* (Detroit, 1947), 150.

88. Arthur Lehman to A. R. Erskine, November 12, 1926, Supporting Materials, SP.

89. He candidly wrote Erskine, "From the time of its incorporation I gave this company more thought than I did any other corporation with which I was connected. That time was coincidental with the development of the automobile industry and called forth problems which had to be met with intense care and caution. . . . I shall always be grateful for being kept in touch with one of my children." Letter, Henry Goldman to A. G. Rumpf, December 28, 1926, Supporting Materials, SP.

90. Two interesting studies of the automobile and Southern California during the Hoffman years are Scott L. Bottles, *Los Angeles and the Automobile: The Making of the Modern City* (Berkeley, 1987), and Ashleigh Brilliant, *The Great Car Craze: How Southern California Collided with the Automobile in the 1920s* (Santa Barbara, 1989).

91. Vance's appointment came in March 1926. Memorandum, March 23, 1926, Supporting Materials, SP.

92. Paul G. Hoffman to A. R. Erskine, March 23, 1925; Paul G. Hoffman to A. R. Erskine, March 30, 1926; Box 150, in Hoffman Papers, Harry Truman Library, Independence, Missouri. Also, Board of Directors meeting, April 7, 1925, SP.

93. In the early fall of 1924 Studebaker revealed its new, improved Big

Six engine with increased compression, full pressure lubrication, and new transmission. The Big Six held its own for a while, but in the end the high-compression engine won out. This left its hold on the middle-priced range vulnerable to domination by Chrysler, Buick, and others. Studebaker's failure to keep up with technical innovation in these years is well described in Cannon and Fox, *Studebaker: The Complete Story*, 69.

94. Leonard P. Ayres, *The Automobile Industry and Its Future* (Boston, 1921), 31.

95. The history of the Erskine is recounted in "The Erskine Revealed," *New York Times*, January 9, 1927, 6; and "Advertisement," *New York Times*, January 9, 1927, 13. Also, Board of Directors Meeting, July 31, 1926; October 30, 1926; and April 5, 1927, SP. Secondary accounts of the Erskine are found in Hendry, "One Can Do A Lot of Remembering," 236; Beverly Rae Kimes, "The Big Presidents: Studebaker in the Classic Era," *Automobile Quarterly* 94 (First Quarter 1980), 84–85; and Cannon and Fox, *Studebaker: The Complete Story*, 103–105.

96. Memorandum, Paul Hoffman to Board of Directors, October 30, 1926, Supporting Materials, SP.

97. Kimes, "The Big Presidents," 82–103.

98. Quoted in Hendry, "One Can Do A Lot of Remembering," 236.

99. Memorandum, April 6, 1926, Supporting Materials; and Minutes, Board of Directors Meeting, April 5, 1927, SP.

100. Kimes, "The Big Presidents," 82–104, especially 84–85.

101. Cannon and Fox, *Studebaker: The Complete Story*, 138–50.

102. He enthusiastically told the press "the United States is entering upon the greatest period of business development in its history . . . the home market is the biggest and richest in the world due to high wages, and Studebaker will be a leader in telling this rich audience about its improved product." Quoted in Kimes, "The Big Presidents," 94.

103. In 1928, Erskine, who had emerged as a major figure in American industry, openly supported Herbert Hoover in his campaign for the presidency. As a native of the South, Erskine's endorsement of Hoover was used by the Republicans in their campaign. Shortly after the election he wrote to Hoover congratulating him on carrying the South for the Republican party. He added that one could not blame the South for having remained Democratic because of their "memories of maltreatment and humiliation by the Republicans during reconstruction." Still, whether Republican or Democratic, "Southerners will always maintain the South as a white man's country. . . . " He added that "the negro problem is the greatest peril which confronts America today. It daily grows worse. Our great cities are being crowded with hordes of negroes demanding equality in boisterous and insulting terms wherever you meet them." Later, Hoover invited Erskine to the White House to dine with him. A. R. Erskine to Herbert Hoover, November 9, 1928, Box 4, Conrad Family Papers.

104. The recession of 1921 had forced Pierce-Arrow to consider merging with George Nash's Lafayette Motor Company of Indianapolis, but an upturn in sales the following year ended merger talks. "Studebaker-Pierce Arrow Merger is Outlined," *New York Times*, June 24, 1928, 9.

105. This prospect of a merger took on particular importance given that Studebaker was being outdistanced by its closest competitors, Chrysler, Buick, and Nash, each of whom had initiated what Erskine called "vicious" clean-up campaigns in the spring of 1928. Minutes, Board of Directors Meeting, April 30, 1928, SP. For further discussion of this merger, see Minutes, Board of Directors, June 26, 1928, SP; and Kimes, "The Big Presidents," 89–90.

106. The terms of the deal left Studebaker with a substantial interest in the reorganized Pierce-Arrow company. For an investment of $2 million, Studebaker received all of the Class B stock issued. The plan was not a merger as such, but the allied interests of the two companies, with total assets approximating $200 million, placed them fourth in the industry. "Pierce-Arrow Votes to Join Studebaker," *New York Times*, August 8, 1929, 7; "Studebaker Outlines Reorganization Plans," *New York Times*, September 2, 1928, 8; Minutes, Board of Directors Meeting, October 31, 1929, SP. Brooks T. Brierley, *There Is No Mistaking a Pierce Arrow* (Coconut Grove, Fla., 1986), 24.

107. The record of these stock transactions is found in Minutes, Executive Committee Meeting, June 21, 1927, Supporting Papers (1929), SP. The advertising campaign was announced in "Studebaker to spend $7,000,000 in Advertising," *New York Times*, March 18, 1929, 53.

108. "Movietone Portrays Studebaker in Action," *New York Times*, January 6, 1929, II, 2, and XI, 18.

4. Studebaker Survives the Depression, 1929–1940

1. At the same time, the automobile market by the late 1920s was saturated. A clear sign of this was evidenced in the rise in used car sales. Even before the collapse of the automobile market in the depression years, used car sales in 1927 exceeded those of new cars for the first time in automobile history. *Detroit News Tribune*, June 4, 1919, in Clipping Book 70, SP.

2. The shift to lower-priced automobiles can be seen in the following table:

Percentage of Total Sales by Price Group				
Year	*Under $500*	*$500–750*	*$750–1,500*	*Over $1,500*
1926	41.4	29.1	24.8	4.7
1927	33.7	31.1	29.7	5.5
1928	42.3	30.4	22.9	4.4
1929	53.9	27.5	15.4	3.2
1930	60.3	23.4	13.3	3.0
1931	65.2	20.3	11.9	2.6
1932	70.0	22.0	9.4	1.6
1933	80.9	14.6	3.2	1.2
1934	64.7	30.4	4.1	0.8

Cited in Katz, *The Decline of Competition*, 62. Katz's figures for 1932 appear to be slightly inaccurate.

3. Automobile production 1928 to 1940.

1928		1930	
Chevrolet	1,749,998	Ford	1,155,162
Ford	633,594	Chevrolet	683,419
W.O./Whippet	315,000	Buick	119,265
Hudson/Essex	282,203	Hudson/Essex	113,898
Pontiac/Oakland	244,584	Pontiac/Oakland	86,225
Buick	221,758	W.O./Whippet	69,000
Chrysler	160,670	Dodge	68,158
Nash	138,137	Plymouth	67,658
Studebaker/Ersk.	128,258	Chrysler	60,199
Durant lines	115,243	Nash	54,605
Oldsmobile/Vikg.	86,235	Studebaker	51,640
Graham/Paige	73,195	Oldsmobile	49,886
Dodge	67,327	DeSoto	34,889
Hupmobile	65,857	Graham/Paige	33,560
Plymouth	52,427	Packard	28,177
Packard	50,054	Cadillac/LaSalle	2,559
Cadillac-LaSalle	41,172	Hupmobile	22,183
DeSoto	33,345	Durant	20,900

1932		1934	
Chevrolet	306,716	Chevrolet	620,726
Ford	232,125	Ford	563,921
Plymouth	121,468	Plymouth	351,113
Hudson/Essex	57,550	Dodge	108,687
Pontiac	46,594	Hudson-Terraplane	85,835
Stude./Rockne	44,235	Oldsmobile	80,911
Buick	41,522	Pontiac	79,803
Dodge	30,216	Buick	78,757
DeSoto	27,441	Studebaker	46,103
Willys-Overland	26,710	Chrysler	36,929
Chrysler	25,291	Nash-LaFayette	28,664
Oldsmobile	21,933	DeSoto	15,825
Nash	17,696	Cadillac-LaSalle	11,468
Hupmobile	10,076	Hupmobile	9,420
Cadillac/LaSalle	9,153	Willys-Overland	7,916
Packard	8,018	Packard	6,071

1936		1938	
Chevrolet	975,238	Chevrolet	490,447
Ford	791,812	Ford	410,048
Plymouth	527,177	Plymouth	297,572
Dodge	274,904	Buick	173,905
Oldsmobile	187,638	Dodge	106,370
Buick	179,533	Pontiac	95,128
Pontiac	178,496	Oldsmobile	93,705
Hudson-Terraplane	123,266	Hudson	51,078
Studebaker	85,026	Packard	50,260
Packard	80,699	Studebaker	46,207
Chrysler	71,295	Chrysler	41,496
Nash-Lafayette	53,038	DeSoto	32,688
DeSoto	52,789	Nash-LaFayette	32,017
Cadillac-LaSalle	28,479	Cadillac-LaSalle	27,613
Willys-Overland	18,824	Willys-Overland	16,173

1940	
Chevrolet	895,743
Ford	599,175
Plymouth	509,735
Buick	310,995
Pontiac	249,303
Oldsmobile	215,028
Dodge	225,595
Studebaker	117,091
Chrysler	115,824
DeSoto	83,805
Mercury	82,770
Hudson	79,979
Packard	66,906
Nash	63,617
Cadillac-LaSalle	40,245
Willys-Overland	26,698

Cited in *The American Car since 1775* by the editors of *Automobile Quarterly* (New York, 1971), 140–41.

4. The history of the Ford Motor Company during these years can be found in Nevins and Hill, *Ford: Decline and Rebirth, 1933–1962*, and *Ford: Expansion and Challenge, 1915–1933*; Robert Lacey, *Ford, the Men and the Machine* (Boston, 1986); Peter Collier and David Horowitz, *The Fords: An American Epic* (New York, 1987); David L. Lewis, *The Public Image of Henry Ford* (Detroit, 1976). Also see George S. May, "Edsel Bryant Ford," and John B. Rae, "Henry Ford II," in George S. May, ed., *The Encyclopedia of American Business History and Biography: The Automobile Industry, 1920–1980* (New York, 1989), 138–44 and 145–58.

5. Katz, *The Decline of Competition*, 121–41.

6. The history of General Motors in these years is discussed in Kuhn, *GM Passes Ford*; Weisberger, *The Dream Maker*; and Chandler, *Giant Enterprise*. For a contemporary account, see "General Motors," *Fortune*, December 1939, 148.

7. Sidney Fine, *Sit-Down: The General Motors Strike of 1936–1937* (Ann Arbor, Michigan, 1969), 21.

8. Katz, *The Decline of Competition*, 156–66. Also see Walter P. Chrysler, *Life of an American Workman* (New York, 1950); and Chrysler Corporation, *The Story of an American Company* (Detroit, 1955).

9. Rae, *American Automobile Manufacturers*, 191–206; and Katz, *The Decline of Competition*, 119–243. The following discussion of the industry relies heavily on these two sources. Also see Robert F. Lanzillotti, "The Automobile Industry," in Walter Adams, ed., *The Structure of American Industry*, fourth edition (New York, 1971), 256–301.

10. The drop in the medium-priced car market is revealed in the sharp decline in sales throughout the decade. See Katz, *The Decline of Competition*, 62.

11. Harold G. Vatter, "The Closure of Entry in the American Automobile Industry," *Oxford Economic Papers*, October 1952, 222. Also, Katz, *The Decline of Competition*, 167–75.

12. Moreover, a comparison of the market in 1921 and the current market showed Studebaker's steady decline in these years:

1921		*1929*	
Company	*Sales*	*Company*	*Sales*
1. Ford	903,814	Chevrolet	888,050
2. Buick	82,930	Ford	633,594
3. Dodge	81,000	W.O./Whippet	315,000
4. Studebaker	65,023	Hudson-Essex	282,203
5. Chevrolet	61,717	Pontiac-Oakland	244,584
6. Willys-Overland	48,016	Buick	221,758
7. Hudson-Essex	27,143	Chrysler	160,670
8. Nash	20,850	Nash	138,137
9. Oldsmobile	18,978	Studebaker	128,258
10. Maxwell	16,000	Durant Lines	115,243

The American Car Since 1775, 138–43.

13. These figures are drawn from James J. Bradley and Richard M. Langworth, "Calendar Year Production: 1896-Date," in *The American Car Since 1775*, 138–43. Erskine would have access to annual production and sales figures through automobile trade association reports.

14. Board of Directors Meeting, October 31, 1929, SP; Memorandum, Paul G. Hoffman to A. R. Erskine, October 30, 1929, Supporting Materials (1929), SP. Optimistic reports continued to come in from dealers throughout 1930. See Board of Directors Meeting, January 31, 1930, SP.

15. Studebaker placed high hopes on its new "free wheeling" overdrive transmission, first produced for the President and then extended to Dictator and Commander models. Within a year of its introduction nearly half the cars manufactured in America went over to free wheeling. The enthusiasm for free wheeling was conveyed in a letter written to Lewis Garred of the Hudson Motor Company by one financier who wrote, "Free Wheeling is the coming development that will be adopted by practically all cars within the next one or two years." The question is whether "infringement can be avoided by some slight mechanical change." Carsten Tiedeman to Lewis Garred, Box 20, in Roy Chapin Papers, Bentley Library.

Although it proved to be a short-lived phenomenon, the concept later appeared in automatic overdrive. More noteworthy but given less publicity at the time was the development of a high-capacity, coated steel ball bearing introduced in all Studebaker crankshafts in 1931. This bearing allowed for the development of highly durable, high-speed engines.

16. Studebaker Corporation, Annual Stockholders Report, April 38, 1931, SP.

17. Studebaker Corporation, *Annual Report*, December 31, 1930, Supporting Materials, Box 6; and "Cuts in Salary are Announced," *South Bend News*, April 14, 1932, Clipping Book 81, SP.

18. A. R. Erskine to Frederick Fish, October 5, 1931, SP.

19. Board of Directors Meeting, October 27, 1931, SP.

20. "Rockne Motor Corporation," Press Release, December 1, 1931, Clipping Book 77. Also, Stockholders' Meeting, March 7, 1932, SP.

21. The Rockne 65 and Rockne 75 sold at a modest $585 and $800 respectively. Both models were equipped with free-wheeling transmissions, automatic starting systems, steel core steering wheels, adjustable steering columns, aviation type instrument panels, adjustable front seats, and automatic windshield wipers. The 65 had a 189.8 cubic inch engine and the 75 had a 205 cubic inch engine. See Cannon and Fox, *Studebaker: The Complete Story*, 152.

22. The Rockne engine lived on in the Dictator Six and later in the Commander and Land Cruiser line from 1947 through 1950. The Studebaker truck continued to use the Rockne design until 1961.

23. Board of Directors Meeting, January 26, 1932, SP.

24. Memorandum, A. R. Erskine, "Confidential Memorandum" (n. d. 1931), in Erskine File, South Bend Tribune Archives, South Bend, Indiana.

25. Frederick Fish to A. R. Erskine, January 21, 1931, Secretary Files, Box 4; and Arthur Lehman to Paul Hoffman, January 21, 1931, Secretary Files, Box 5, SP.

26. John A. Harris to Board of Directors, January 30, 1931, Secretary Files, Box 5; John A. Harris to A. R. Erskine, February 16, 1931, Secretary Files, Box 5; and Frederick Fish to A. R. Erskine, March 28, 1931, Secretary Files, Box 5, SP.

27. Erskine's plan called for the creation of a new corporation, United Truck, because under state laws an Ohio chartered corporation such as White Motor could not consolidate with another corporation existing under the laws of another state. White's early history is discussed in Rae, *American Automobile Manufacturers*, 185–86, 196.

The merger plan is detailed in Board of Directors Meeting, March 1, 1933, Secretary Files, Box 6; and Special Executive Committee Meeting, November 17, 1932, Secretary Files, SP. Also, the merger is discussed in "White to Studebaker," *Time*, September 26, 1932, 15.

28. Nevertheless, Studebaker was experiencing some deterioration in its distribution system. Still, Studebaker had developed an effective distribution system of direct factory control of dealers. A comparison with other automobile manufacturers reveals Studebaker's strength.

	Number of Passenger Car Representatives Per Company			
Company	*1926*	*1929*	*1933*	*1935*
Chrysler	6,667	7,464	7,642	11,487
Ford	9,376	8,598	7,480	7,948
G.M.	6,488	19,324	15,475	16,799
Hudson	3,842	3,488	1,842	3,023
Nash	2,196	2,123	1,201	1,400
Packard	750	776	540	843
Studebaker	2,850	4,751	1,733	1,832

From Katz, *The Decline of Competition*, 186, 190, and 365. Also, see Federal Trade Commission, *Report of the Federal Trade Commission on Distribution Methods and Costs*, Pt. IV, (Washington, D.C., 1944), 91–118.

29. Board of Directors Meeting, March 2, 1933; Board of Directors Meeting, October 25, 1932; and Board of Directors Meeting, November 17, 1932; SP. Announcement of the minority stockholders' action is found in *South Bend News-Times*, February 24, 1933, Clipping Book 81, SP.

30. Estimates place debts at $2 million owed to suppliers, $4.5 million owed to banks, and $15 million owed to note holders. Board of Directors Meeting, March 3, 1933; and Memorandum, "Financial Condition," March 15, 1933, Secretary Files, Box 6, SP.

31. The story of these negotiations is recounted in Board of Directors Meeting, March 15, 1933. Also, Memorandum, March 25, 1933, Secretary Files, Box 6; and Special Meeting of Directors, March 15, 1933, SP.

32. "Loss of $8,279,805 for Studebaker," *New York Times*, March 23, 1933, 29:3; and "Studebaker Resumes Under Receivership," *Automobile Topics*, March 25, 1933, Clipping Book 84, SP.

33. Trustee to Be Named Soon," *South Bend Tribune*, November 27, 1933, Studebaker File, in South Bend Tribune Archives.

34. The occasion for entering receivership came when the Edward Iron Works filed a friendly petition with the court for a claim of $6,229 against Studebaker for supplies issued to the corporation. The federal court was

headed by Judge Thomas Slick, whose appointment to the bench Erskine had openly opposed in 1925. Erskine charged Slick with having sold $430,000 of preferred stock in the International Rubber Manufacturing Company on the representation that Studebaker was a partner in the firm. Erskine described the deal as "one of the rottenest things I ever saw," adding that he was sorry that South Bend had not put up a more "worthy candidate." Telegram, A. R. Erskine to Rudolph H. Horst, January 30, 1925, Erskine File, in South Bend Tribune Archives.

35. In the early twenties Erskine had been allowed to purchase stock at $25 a share preferred and $10 a share common, but he placed the stock in his wife's name under the assumption that his gains would not be taxable. This lucrative arrangement—with preferred rising to over $70 a share and common climbing to the $50s by 1927—had been offered to Erskine to keep him at Studebaker after he had been approached by International Harvester to take on the duties of the CEO. See *South Bend Tribune*, March 30, 31, and April 13, 1932; *South Bend News-Times*, May 24 and May 25, 1932, Clipping Book 81, SP.

36. Erskine left a life insurance policy of $900,000 to pay his debts. An ensuing battle over his estate between his wife and her family left the estate at $40,000 before his wife died five years later. See "Rose from a $65 a Month Job to Headship in Automobile Industry," *South Bend Tribune*, July 2, 1933, in South Bend Tribune Archives. Also, "Mrs. Erskine Leaves $40,000," in *South Bend Tribune*, November 1, 1938, Clipping Book 85, SP; and Kimes, "The Big Presidents," 100.

37. Throughout his career, Vance, always the production man, remained concerned with costs and improved efficiency. Such men are rarely happy. As one contemporary of his noted, "Poor old Harold Vance always looks though he was down wind of a ripe one." L. R. Scafe to Maynard, June 13, 1954, H. S. Maynard Papers, Box I, Burton Collection, Detroit Public Library.

38. Credit for Studebaker's subsequent recovery fell mostly to Paul Hoffman, the figure most closely associated with Studebaker in these years. In turn, when Studebaker's fortunes later turned downward following World War II, blame fell on Harold Vance, whom critics charged with having been too soft with organized labor. This account of Studebaker's fortunes was facilitated by Hoffman's leaving the corporation in 1947 to work in the Truman administration. To separate the Hoffman-Vance regime into disparate roles nonetheless misconstrues the shared vision that Hoffman and Vance held for the corporation in a new age brought about by depression and subsequent war.

39. Erskine promoted both Vance and Hoffman to vice presidencies in the corporation in 1925. While Hoffman remained close to Erskine socially, with their families often getting together for dinner parties, trips to Chicago, and weekends on Lake Michigan, Erskine saw both Hoffman and Vance as his heir designates. Both remained lieutenants in his campaign to achieve Studebaker's rightful place among the Big Three. No wonder that Slick's appointment of Hoffman and Vance as receivers of the company in 1933 was considered "friendly."

40. George C. Hupp interviewed by Loren Pennington, May 19, 1972, Walter Reuther Library, Wayne State University, Detroit, Michigan, U.A.W. Local 5 Papers, hereafter Local 5 Papers.

41. "Studebaker Builders Like Their Product," *South Bend Tribune*, September 15, 1938, Clipping Book 85, SP.

42. "Reeves Speaks at Studebaker Birthday," *South Bend Tribune*, Febru-ary 15, 1937, Clipping Book 85, SP; Alan Raucher, *Paul G. Hoffman: Archi-tect of Foreign Aid* (Lexington, Kentucky, 1985), 14.

43. Interview, T. Forrest Hanna by Loren E. Pennington, June 17, 1971, Local 5 Papers.

44. "Boom in Auto," *South Bend Tribune*, September 14, 1939, Clipping Book 85, SP.

A lifelong Republican, active in Los Angeles politics before moving to South Bend, Hoffman publicly supported the party's presidential nominees throughout this period. He joined other Republican businessmen in denounc-ing the "gradual but overwhelming drift from business to political leadership on business matters." If this should continue, he warned, "bureaucratic con-trol of business is inevitable." Free enterprise should be kept free, he said, quickly adding that government nonetheless had an obligation to prevent "unfairness" in industry's treatment of its workers. For this reason, Hoffman defended the Federal Trade Commission against its business critics. He de-scribed the FTC as "public friend No. 1 of free enterprise," which had only become the target of a "minority group" in the business community. If this group was concerned about government involvement in their affairs, he said, then they should correct their own ills to avoid government involvement in the marketplace. "Hoffman Asks Business to Head Upturn," *South Bend Trib-une*, February 16, 1938, Clipping Book 84, SP.

45. This image served Hoffman well. As a result of his public persona Hoffman's career extended beyond Studebaker. In 1943 he became the first chairman of the Committee for Economic Development, formed by a group of liberal businessmen during the war to promote better business-government cooperation on economic issues of the day. Following World War II Hoffman rose to become chairman of the European Recovery Program, the so-called Marshall Plan, followed by a brief tenure as president of the Ford Foundation before becoming a member of the United States delegation to the United Nations and later a top ranking official at the UN. Hoffman's public career is traced by Raucher, *Paul G. Hoffman*.

46. Although certain auto industrialists such as Alfred Sloan, head of General Motors, urged increased trade with the Soviet Union at the begin-ning of the depression to stimulate domestic automobile production, most in the industry remained fearful of both domestic and international commu-nism. Alfred Sloan to Roy D. Chapin, August 16, 1932, Roy Chapin Papers, Bentley Library, University of Michigan, Ann Arbor, Michigan.

Many auto industrialists believed that Roosevelt and his New Deal con-sciously encouraged radicalism among workers. Henry Ford's antilabor and anti-Semitic views, and his use of Harry Bennett and his thugs to maintain an open shop, are well known. Ford remains the eccentric, but more typical of anti–New Deal thought was Roy D. Chapin, former Secretary of Com-merce under Hoover and leading spokesman for the auto industry, who pub-licly warned that the only labor difficulties in the automobile industry were "almost entirely communist in origin." Chapin spoke out against the National Recovery Act for recognizing the right of labor to collective bargaining and its minimum wage standard. Chapin was not alone in his opposition to labor or to the New Deal. Roy Chapin to Pyke Johnson, June 1, 1933, Roy Chapin Papers, Bentley Library, University of Michigan, Ann Arbor, Michigan.

Others expressed even stronger views. Henry P. Joy, a founder of Packard,

actively contributed to right-wing groups such as the American Liberty League, the Sentinels of the Republic, and the American Vigilant Intelligence Federation. He told his friends in the auto industry that both the Federal Council of Churches and the Catholic Church stood on a platform of socialism and communism. Henry P. Joy to William Stayton, November 21, 1934; Henry Joy to Robert J. Bulkley, May 10, 1935; Henry Joy to James T. McMillan, April 15, 1935; William H. Stayton to Henry B. Joy, May 2, 1935, Henry B. Joy Papers, Bentley Library, University of Michigan, Ann Arbor, Michigan.

47. Ashton Bean fit the Hoffman-Vance team well. Brusque in speech to the point of being overly frank, he proved to be an able negotiator with the Wall Street bankers. He died on July 19, 1935.

48. Katz, *The Decline of Competition*, 186. Also, Phillip H. Smith, "Auto Independents Stage a Comeback," *Commerce and Finance* XXIV, July 3, 1935, 553.

49. "65,000 Roar at South Bend Big Parade," *South Bend Tribune*, April 2, 1933, Clipping Book 69, SP.

50. Hendry, "One Can Do A Lot of Remembering," 245.

51. "Hoffman, Vance, Bean Confer on Details of Receivership," *South Bend News-Times*, March 20, 1933, Clipping Book 84, SP.

52. Raucher, *Paul G. Hoffman*, 22–23. Sanderson and Porter Report, Board of Directors Meeting, May 14, 1938, SP.

53. Others involved in the syndicate included the Field Glore and Company, Hayden Stone and Company, and Goldman Sachs.

54. The ability to gain new funds had been made possible by a recent congressional bankruptcy bill that allowed companies in receivership to borrow fresh capital. Hoffman had lobbied heavily for the passage of this bill, which marked a major turning point in bankruptcy law. Studebaker was the first company to be reorganized under so-called Section 77B of the new bankruptcy law; once again, this time ironically, Studebaker recorded another "first" in the auto industry.

55. Rae, *American Automobile Manufacturers*, 198.

56. "Share Total Is Increased to $4,125,000," in *South Bend Tribune*, April 25, 1933, Clipping Book 69, SP.

57. Board of Directors Meeting, May 24, 1935, Support Documents, Box 6, SP.

58. "Studebaker Corporation," *Journal of Commerce*, November 30, 1934, Clipping Book 85, SP.

59. Such relief measures often had hidden costs that were later resented by Studebaker employees. Food baskets were deducted from wages once an employee returned to the job. Moreover, the coal that was distributed was of such obviously poor quality—sometimes barely usable—the workers called it "Indiana Pocahontas." Whatever the intentions of the company, its relief measures were perceived by the workers as "Indian giving": whatever the company gave, it took back in double. Raymond Berndt interviewed by Janet Weaver, April 1, 1980; and Walter Norwicki interviewed by Janet Weaver, March 2, 1979, in Indiana University South Bend Oral History Project (hereafter IUSB), Studebaker National Museum, South Bend, Indiana.

60. Russell Merrill interviewed by Janet Weaver, November 28, 1978, IUSB.

61. George Hupp interviewed by Janet Weaver, December 4, 1978, IUSB.

62. In 1910 the Carriage and Wagon Workers' Union (CWWU) had been rechartered by the American Federation of Labor to include automobile workers under its jurisdiction, but when other craft unions protested, the charter was withdrawn. Refusing to comply with the order (by this time there was little future in organizing carriage workers), the CWWU left the AFL to form the United Automobile, Aircraft and Vehicle Workers of America. Mostly composed of skilled workers, the union enjoyed some success until it was defeated in a strike against Fisher Body in Detroit in 1921. As membership began to dwindle, the union fell under the control of Communist Party organizers, who took the union into the radical Trade Union Unity League in 1929. In these years the American Federation of Labor completely abandoned any attempts to organize the auto industry. Sidney Fine, *The Automobile Under the Blue Eagle: Labor, Management, and the Automobile Manufacturing Code* (Ann Arbor, 1963), 193, 408.

63. George Hupp, an early member of the Studebaker UAW local, recalled that the principal reason for unionizing was the work load and the lack of a seniority system, which enabled foremen to fire workers arbitrarily. George Hupp interviewed by Janet Weaver, December 4, 1978, IUSB. Also, George Hupp interviewed by Loren Pennington, May 19, 1972, Local 5 Papers.

64. One worker recounted his early experiences with the union this way: "We'd heard about meeting but we did not know who was meeting. We didn't know who to contact. We had no phones. We had no transportation. I walked to work. I had no car, no telephone. There was no way to get hold of anybody and you just got inside the gate at seven o'clock in the morning and you got out at three thirty. . . . And the only people you saw were those that worked with you, and went through the gate with you." Raymond Berndt interviewed by Janet Weaver, April 1, 1980, IUSB.

65. The early history of the Studebaker UAW is traced by J. D. Hill, *A Brief History of the Labor Movement of Studebaker* (South Bend, Indiana, 1953); and later in his *U.A.W.'s Frontier* (South Bend, Indiana, 1971).

66. Richardson had been a driving force in the union from the beginning. Richardson had gone to work in the coal mines at the age of fifteen in Herrin, Illinois. Here he had become a member of one of the most militant locals in the United Mine Workers Union. He first joined Studebaker in 1925 when a strike had shut down the Herrin mine. He worked briefly for Studebaker before returning to the mines. When another strike occurred in 1927, he returned to South Bend for good, bringing with him a hard learned tradition of militant unionism. As president of the local, Richardson devoted most of his time organizing, but he found it tough going among workers who knew little about unions. Lodia Richardson interviewed by Janet Weaver, September 5, 1979, IUSB.

67. Lodia Richardson interviewed by Janet Weaver, IUSB. Also, William Ogden interviewed by Loren Pennington, May 15, 1972, Local 5 Papers; and James D. "Red" Hill interviewed by Loren Pennington, May 12, 1972, Local 5 Papers.

68. George Hupp interviewed by Janet Weaver, IUSB.

69. Russell Merrill interviewed by Sonja Coldren, April 9, 1979, IUSB.

70. George Hupp interviewed by Janet Weaver, IUSB.

71. Hoffman is quoted by Walter Norwicki in an interview by Janet Weaver, March 2, 1979, IUSB.

72. Typical was one organizer who told Merrill that a foreman was has-

sling a new member of the union. " 'Russ, I got problems . . . I want to go down and see Hoffman about this guy. . . . That superintendent down there is pretty rough!' So he went with me. We went over and talked to Hoffman on Lafayette Street there. He said, 'Well, I'll take care of him.' By God, he did. . . . " Hoffman transferred the superintendent to a new job in which the union organizer would be over him. In the end, the foreman quit. "Studebaker was like that. They didn't fire him outright, they offered him another job." Walter Norwicki interviewed by Janet Weaver, IUSB.

73. Hill, *A Brief History of the Labor Movement*, 12.

74. The following discussion of the formation of the UAW on a national level draws from Fine, *Sit-Down*, 63–89.

75. Studebaker union leaders corresponded frequently with the locals at Nash and White concerning how best to deal with management and also the internal politics of the autoworkers union. Interestingly, corporate records reveal no discussion among automobile executives on preventing unionization of their plants. Studebaker's leadership in the formation of an independent United Auto Workers Union is traced in Jack Skeels, "The Background of UAW Factionalism," *Labor History* II (Spring 1961): 158–82, especially 160–67.

76. The AFL, under the leadership of William Green, continued to recognize the jurisdictional rights of the craft unions, even though most of the craft unions expressed little willingness to launch an organizational drive in the automobile industry. Nonetheless, Green and the leadership regarded federated unions as recruiting devices for craft unions. Because of this timidity, the total of paid-up membership in the UAW as late as 1935 was only 22,687 members, less that 6 percent of all wage earners in the industry. Moreover, the strength of this membership came from locals outside of Detroit, those such as Nash, White, and Studebaker. Here local leaders increasingly grew resentful of the cautious strategy being pursued by the AFL, and its appointed representative to the UAW, Francis Dillon, in organizing the industry. Carl Felder interviewed by Janet Weaver, November 16, 1978, IUSB.

77. At this convention more than half the members were represented by five locals: Studebaker, Toledo, White Motor, Kenosha Nash, and Seaman Body. Militants from these locals ousted Francis Dillon as president, and elected Homer Martin, a former Baptist minister, in his place. The South Bend leadership under Russell Merrill and Lodia Richardson backed Martin over the Communist faction candidate Wyndham Mortimer. The South Bend delegates also approved a resolution calling for a nationwide organizing drive. For Local 5's role in the 1936 convention see interviews with Lodia Richardson, Russell Merrill, and George Hupp in IUSB. Also, United Auto Workers Union, *Proceedings of the Second Convention of the International Union, United Automobile Workers of America* (Detroit, 1936).

78. This letter cannot be found in the records of the company but is recounted in an interview of George Hupp conducted by Janet Weaver, December 14, 1978, IUSB.

79. United Auto Workers Union, *Proceedings of the Second Convention of the International Union, United Automobile Workers of America* (Detroit, 1936), 257. "Stude and CIO Exchange Compliments on Birthday," *Journal of Commerce*, February 18, 1952, Local 5 Papers.

80. James D. "Red" Hill interviewed by Loren Pennington, May 12, 1972, Local 5 Papers.

81. Even while Hoffman and Vance granted a new role to organized labor in the company, they refused to accept a closed union shop. Moreover, the informal relations established with the union in the early 1930s meant that a formal contract establishing grievance procedures and collective bargaining rights had still not been signed as late as 1937. Grievances were handled on a routine verbal basis with problems being forwarded to Paul Hoffman for review. Hoffman felt that if the union had a problem they could bring it to him and the matter could be ironed out in one-on-one meetings. See Raucher, *Paul G. Hoffman*, 26.

82. This team included two vice presidents of domestic sale, G. D. Keller, a Studebaker employee since 1914, and C. K. Whittaker, who had followed Hoffman from Los Angeles and worked his way up to become a vice president of sales in New York. For international sales, Hoffman held on to R. A. Hutchinson, vice president of European sales, and Arvid L. Frank, president of Studebaker Export Corporation. "Frank Named Studebaker's Foreign Head," *South Bend Tribune*, June 25, 1935, Clipping Book 85, SP.

83. "Executives in 1935," Support Documents (1935), Box 6, SP.

84. Confidential Letter, Paul Hoffman to Department Heads and Supervisors, June 28, 1935, Paul Hoffman Papers, Box 15, Truman Library.

85. "New Studebaker Model Ready," *Chicago American*, December 8, 1934, Clipping Book 84, SP.

86. The Dictator name had first been used in 1927 for a line of medium-priced cars, but by the mid-'30s the name drew increasing complaints from a public who associated the car with Adolf Hitler. Finally, the company was forced to drop the name entirely and replace it with a new name, the Commander. Fox and Cannon, *Studebaker: The Complete Story*, 134–38.

87. In 1935 Studebaker and Packard were the only independents to offer vacuum power brakes, an automatic choke, Hancock rotary door latches, variable ratio steering, and an all-steel body as standard features on their cars. Roos had also designed a "planar" front suspension system that provided independent front suspension to the Studebaker, the only company next to Packard that could claim this for their cars. Planar suspension, however, proved to be Roos's last great contribution to Studebaker.

88. Hendry, "One Can Do A Lot of Remembering," 247; Asa Hall and Richard Langworth, *Studebaker Century* (Contoocook, New Hampshire, 1983), 67; and Fox and Cannon, *Studebaker: The Complete Story*, 117. For Roos's resignation letter, see Delmar Roos to Paul Hoffman, July 31, 1936, Board of Directors Meeting, August 28, 1936, Supporting Documents, Box 7, SP.

89. Board of Directors Meetings, June 28, 1935, and Board of Directors Meeting, July 26, 1935, SP.

90. "Studebaker May Call in $7,000,000 of Debentures," *Wall Street Journal*, March 29, 1937; and "Bonds Help Up By Studebaker," *South Bend Tribune*, August 7, 1937, in Clipping Book 85, SP.

91. "Sparks," Unlabeled Clipping, June 6, 1936, Clipping Book 85, SP.

92. Board of Directors Meeting, January 22, 1937, Supporting Documents, Box 7, SP.

93. Board of Directors Meeting, February 26, 1937, Supporting Documents, Box 7, SP.

94. For denials that Studebaker was aiming at the low-priced market, see "Orders in October May Reach 8,500 Hoffman Reveals," *South Bend Tribune*, October 20, 1933, in Clipping Book 84, SP.

95. This decision to enter the low-priced field appeared courageous given the earlier failures of the Erskine and the Rockne. As one of the designers later noted, "this previous history tended to create doubt as to whether a new entry in the low priced field could or would be successful." Quoted in Memorandum, "Studebaker's Proposed Plan for 1943 Advertising," January 22, 1943, Supporting Documents, Box 10, SP.

96. Board of Directors Meeting, May 28, 1937, Unofficial Minutes, Supporting Documents, SP.

97. Board of Directors Meeting, May 28, 1937, Unofficial Minutes, Supporting Documents, Box 7, SP; Hill, *A Brief History of the Labor Movement*, 32, 36, 78–80; Macdonald, *Collective Bargaining*, 365–66.

98. When Rev. Hugh O'Donnell, a Catholic priest at the University of Notre Dame, sent Vance an anticommunist pamphlet, Vance replied, "the threat which hangs over us constantly does not arise from the fact that practically all of our seven thousand factory employees are organized, but rather from the fact that there are three or four hundred of those seven thousand employees who are such extremists that even their own organizations have great difficulty in keeping them in hand." Harold S. Vance to Hugh O'Donnell, CSC, May 13, 1937, John Cavanaugh Papers, University of Notre Dame Archives. Also, Hill, *A Brief History of the Labor Movement*, 18–19.

99. Annual Stockholders Report (1938), Supporting Documents, Box 8, SP.

100. Board of Directors Meeting, April 26, 1938, SP.

101. Raymond Loewy is discussed in Paul Jodard, *Raymond Loewy* (New York, 1992), especially 61–139. See also Edson Armi, *The Art of American Car Design: The Profession and Personalities* (University Park, 1988), 79–82; Jerry Flint, ed., *The Dream Machine: The Golden Age of American Automobiles* (New York, 1976), 12; "Raymond Loewy, 1893–1986," *Industrial Design Magazine* (Special Issue November/December 1986); Raymond Loewy, *Never Leave Well Enough Alone* (New York, 1951); and Raymond Loewy, "Modern Living: Up from the Egg," *Time*, October 31, 1949, 71.

On the engineering of the Champion, see Cannon and Fox, *Studebaker: The Complete Story*, 156–76; Hall and Langworth, *The Studebaker Century*, 64–109; Hendry, "One Can Do A Lot of Remembering," 228–58; "Studebaker Champion Challenges Big Three," *South Bend Tribune*, March 27, 1939, Clipping Book 85, SP.

102. "Low Priced Studebaker Model," *South Bend Tribune*, March 5, 1938; and "Dealers Shown New Champion," *South Bend Tribune*, March 7, 1938, Clipping Book 85, SP.

103. Board of Directors Meeting, April 25, 1939, Supporting Documents Box 8, SP.

104. "Small Independent Auto Producers Profit Results Cut by Rise of G.M. and Chrysler," *Wall Street Journal*, August 9, 1939, Box 151, Paul Hoffman Papers.

105. James D. Hill interviewed by Loren Pennington, Local 5 Papers.

5. Studebaker Merges with Packard, 1941–1954

1. Charles E. Edwards, *Dynamics of the United States Automobile Industry* (Columbia, South Carolina, 1965), 13; and Automobile Manufacturing Association, *Automobile Facts and Figures* (Detroit, 1958).

2. For example, the company experienced a lower net profit in 1940,

in spite of a 4.7 percent increase in sales, because of rising material costs. Annual Report to Stockholders 1940, March 7, 1941, Supporting Documents, Box 9, SP.

3. Raucher, *Paul G. Hoffman*, 31.

4. Board of Directors Meeting, June 26, 1940, Supporting Documents, Box 8; Special Board of Directors Meeting, October 31, 1940, SP. Michael Beatty, Patrick Furlong, and Loren Pennington, *Studebaker: Less Than They Promised* (South Bend, 1984), 21.

5. Annual Report to the Stockholders 1940, March 7, 1941, Supporting Documents Box 9, SP.

6. The government allotted a quota of 92,000 units to Studebaker, which can be compared to General Motors' quota of 361,815; Chrysler's 188,849; Ford's 151,845; Hudson's 25,871; Nash's 21,972; Packard's 23,056; Willys' 7,768; and Crosley's 333, in "Studebaker Agrees to Cut Auto Output," *South Bend Tribune*, Clipping Book 85, SP. Board of Directors Meeting, March 28, 1941, Supporting Documents Box 9, SP.

7. "The Voice of Labor," *The Labor News*, June 6, 1941, in Paul Hoffman Papers, Box 152, Truman Library; and "Union Hourly Wages Go Up," *South Bend Tribune*, June 3, 1941, Clipping Book 85, SP.

8. Macdonald, *Collective Bargaining*, 260. Also, Steve Jefferys, *Management and Managed: Fifty Years of Crisis at Chrysler* (Cambridge, 1986), especially 91–103.

9. James D. "Red" Hill interviewed by Loren Pennington, Local 5 Papers.

10. In mid-1943, military officials tried to insist that employees in the test cell department should not be required to join the union. Finally Vance was forced to call a late Friday afternoon meeting between a union representative and a high-ranking military officer. The meeting soon turned into a shouting match. The officer finally stormed out when the union representative told him, "Why don't you run your damned Army and let me run the union and we'll both get along." After the meeting, Vance was reported to have told the union representative, "I wish I could have told him that, but I'm not in a position to do that, because he's trying to tell me how to run this machine shop." That following Monday the classified workers were enrolled in the union. Board of Directors Meeting, May 28, 1943, Supporting Documents, Box 10, SP.

11. At the outset of the war the corporation decided to follow a conservative dividend policy with the intention of further enhancing the corporation's accumulation of capital. Only in the first quarter of 1943 would the corporation issue its first wartime dividends, having foregone them in 1941 and 1942. And this first dividend amounted to only 25 cents per share. At the same time, advertising costs were minimal throughout the war.

Of course, the beneficiaries of this policy were those Studebaker employees who received higher salaries and wages through a liberal incentive program. Executives received annual bonuses of 10 percent throughout the war. For instance, in 1943 twenty-seven top executives, including Hoffman and Vance, received $273,454 in incentive pay. Base salaries for executives ranged from $25,000 to $75,000, standard in the industry. Annual Stockholders Report (1943), Supporting Documents, Box 10, SP.

12. "Studebaker Has Major Role in Sending Axis to Defeat," *South Bend Tribune*, September 21, 1945, Clipping Book 85, SP. Also, Beatty, Furlong, and Pennington, *Studebaker: Less Than They Promised*, 21.

13. "Studebaker: Model Termination," *Business Week*, December 29, 1945, 66–71; Raucher, *Hoffman*, 34.

14. The postwar automobile industry is discussed by Lawrence J. White, *The Automobile Industry Since 1945* (Cambridge, Mass., 1971); James J. Flink, *The Automobile Age* (Cambridge, Mass., 1988), 277–92; and Rae, *The American Automobile Industry*, 143–59.

15. James J. Flink offers a succinct description of the oligopolistic nature of the automobile industry and postwar labor conditions in his *The Automobile Age*, 276–81.

16. The strike is discussed in John Barnard, *Walter Reuther and the Rise of the Auto Workers* (Boston, 1983), 101–17; Nelson Lichtenstein, *The Most Dangerous Man in Detroit: Walter Reuther and the Fate of American Labor* (New York, 1995), 113; and Victor G. Reuther, *The Brothers Reuther and the Story of the UAW* (Boston, 1976).

17. The transformation of Ford is discussed by Peter Collier and David Horowitz, *The Fords: An American Epic*; Lacey, *Ford: The Men and the Machine*; and Nevins and Hill, *Ford: Decline and Rebirth, 1933–1962*. For the "Whiz Kids" see John A. Byrne, *The Whiz Kids: Ten Founding Fathers of American Business and How They Changed the World* (New York, 1993), and David Lowell Hay, "Bomber Businessmen: The Army Air Force and the Rise of Statistical Control, 1940–1945," (Ph.D. diss., Univ. of Notre Dame, 1994).

18. The Chrysler story is told in Richard M. Langworth and Jan P. Norbye, *The Complete History of Chrysler Corporation, 1924–1985* (New York, 1985); Michael Moritz and Barrett Seaman, *Going for Broke: The Chrysler Story* (Garden City, New Jersey, 1981); and Richard P. Scharchburg, "Kaufman Thuma Keller," in George S. May, editor, *The Automobile Industry, 1920–1980* (New York, 1989).

19. For a highly favorable account of Tucker see Charles T. Pearson, *The Indomitable Tin Goose: The True Story of Preston Tucker and His Car* (New York, 1960).

20. The new company brought together two of the nation's leading industrialists, Joseph Washington Frazer and Henry J. Kaiser. This upstart gained immediate entry into the industry when the government agreed to lease the Willow Run plant outside of Detroit to Henry Kaiser and Joe Frazer. Seven months after moving into the Willow Run plant, Kaiser-Frazer had turned out their first car. By 1947 the company had turned a profit of $19 million, having gained 4 percent of the market.

Frazer had earned his stripes in the auto industry, having helped develop General Motors Acceptance Corporation, the DeSoto for Chrysler, and the Jeep for Willys-Overland. Kaiser, a California industrialist, had developed a national reputation in construction and shipbuilding. By 1947 these two industrialists had taken their car to eighth place in the industry.

Richard M. Langworth, *The Last Onslaught on Detroit* (Princeton, N.J., 1975).

21. Langworth, *The Last Onslaught on Detroit*, 106–109.

22. For an overview of the postwar automobile industry, see Robert F. Lanzillotti, "The Automobile Industry," in Walter Adams, ed., *The Structure of American Industry*, fourth edition (New York, 1971), 256–301.

23. While independents quickly reconverted their plants to peacetime production, the major manufacturers confronted a series of strikes. Following the strike in the winter of 1945–46, General Motors plants were not fully operational until May 1946. Other strikes followed: Ford experienced a major strike in 1949, and Chrysler confronted a 100-day strike in 1950.

24. Insight into the state of independent manufacturers can be found in a quick glance into their balance sheets of 1948.

Balance Sheet Figures, Five Independents, 1948				
Make	Unit Sales	Sale Revenues	Total Assets	Pretax Profits
Kaiser-Frazer	166,361	$341.6	124.9	20.3
Studebaker	143,120	$383.6	129.2	33.8
Hudson	109,497	$274.7	108.4	22.0
Nash	104,156	$302.9	153.6	36.4
Packard	77,853	$232.0	107.2	23.6

Moody's Manual of Investments, 1952, quoted in White, *The Automobile Industry Since 1945,* 69. Also see Edwards, *Dynamics,* 105–107.

25. Nash increased the value of its net property 286.0 percent; Hudson, 209.5 percent; and Packard, 164.3 percent—an average increase for the leading independents of 228.5 percent, while the Big Three showed an average increase of 234.8 percent. See Edwards, *Dynamics,* 120.

26. "Hoffman Sees Great Future for Company," *South Bend Tribune,* June 7, 1944, Clipping Book 85, SP.

27. "Weasel Work at Studebaker is Terminated," *South Bend Tribune,* August 16, 1945; "Jobless Jam Security Pay Office in City," *South Bend Tribune,* August 9, 1945; and "Goal Will be Met at Cost of $16,000,000," *South Bend Tribune,* September 21, 1945, Clipping Book 85, SP.

28. Board of Directors Meeting, April 28, 1942; and July 24, 1942, Supporting Documents, Box 9, SP. Also, Memorandum, "Studebaker Proposed Plan for 1943 Advertising," January 22, 1943, Supporting Documents, Box 10, SP.

29. Board of Directors Meeting, March 24, 1944, Supporting Documents, Box 10; and "Studebaker Plans Change for Its Sales," August 14, 1944, Clipping Book 85, SP. Also, Richard M. Langworth, *Studebaker: The Postwar Years* (Osceola, Wisconsin, 1979), 16.

30. This unusual development is discussed by Cannon and Fox, *Studebaker: The Complete Story,* 201–202. Also see Robert E. Bourke, "The Starlight and the Starliner: Some Recollections by a Designer," *Automobile Quarterly* X (Third Quarter 1972), 266–74.

31. The story of the Loewy-Exner rivalry is told by Bourke, "The Starlight and the Starliner," 274–76; and Hendry, "One Can Do A Lot of Remembering," 249–52.

32. Paul G. Hoffman to Harold S. Vance, July 20, 1948, Box 150, Hoffman Papers, quoted in Raucher, *Hoffman,* 37.

33. U.S. Congress, Joint Committee on the Economic Report, Subcommittee on Profits, *Corporate Profits* (Washington, D.C., 1948), 246–60, quoted in Raucher, *Hoffman,* 40.

34. Raucher, *Hoffman*, 40.

35. John W. Cornwell to Harold S. Vance, November 11, 1949, Special Board of Directors Meeting, November 22, 1949, Supporting Documents, Box 133, SP.

36. Board of Directors Meeting, November 29, 1950, Supporting Documents, Box 14; and Special Stockholders Meeting, October 10, 1950, Supporting Documents, Box 14, SP.

37. Board of Directors Meeting, March 27, 1942, Supporting Documents, Box 9, SP.

38. For example, Duncan McRae, the chief designer of the 1957 Lark, Studebaker's first compact, left the corporation in 1952 after his clay model for a compact car was destroyed by a rival within the department. "Seven Studebaker Officials Retire," *South Bend Tribune*, June 29, 1947, Clipping Book 86, SP. Also, Langworth, *Studebaker: The Postwar Years*, 40; Langworth, *The Last Onslaught on Detroit*, 140.

39. James D. Hill interviewed by Loren Pennington, May 12, 1972, Local 5 Papers.

40. Macdonald, *Collective Bargaining*, 364.

41. This point was later made by Anna M. Rosenberg, an industrial relations expert, who was brought to Studebaker in 1953–54 to study the labor problem at the corporation. She observed that management neglected to keep its foremen informed about union matters and instead relied on the union to enforce shop discipline. Rosenberg, it should be noted, was a well-known liberal Democrat and the later wife of Paul Hoffman following the death of his first wife. Also, this same point forms the core of Robert M. Macdonald's study of industrial relations in the automobile industry. See Macdonald, *Collective Bargaining*, 361–65.

42. Harbison and Dubin, *Patterns of Union-Management Relations*, 105. Also, see Annual Stockholders Report (1947), April 27, 1948, Supporting Documents, Box 13, SP.

43. H. S. Vance and Paul G. Hoffman to All Studebaker Employees, September 8, 1947, in Macdonald, *Collective Bargaining*, 234–35.

44. Board of Directors Meeting, May 23, 1947, Supporting Documents, Box 12, SP.

45. George Hupp interviewed by Loren Pennington, May 19, 1972, Local 5 Papers.

46. About fifty to seventy blacks had sought to work in the aviation plant, but none were assigned to the assembly line. Instead, they were given jobs in the washing stations located throughout the plant where parts were degreased and washed with varsol, a low-grade kerosene. White workers often came down with dermatitis, so blacks ended up with these jobs. Sterling D. Spero and Abram L. Harris, *The Black Worker: The Negro and the Labor Movement* (New York, 1931), 152–57; and Sanford M. Jacoby, *Employing Bureaucracy*, 171.

47. George Hupp interviewed by Janet Weaver, December 4, 1978; Steve Yandl interviewed by Janet Weaver, June 8, 1979; Raymond Berndt interviewed by Janet Weaver, April 1, 1980; and Lester Fox interviewed by Janet Weaver, March 5, 1979, IUSB.

48. William Ogden interviewed by Loren Pennington, May 15, 1972; and George Hupp interviewed by Loren Pennington, June 17, 1971, Local 5 Papers. Also, George Hupp interviewed by Janet Weaver, December 4, 1978; and Raymond Berndt interviewed by Janet Weaver, April 1, 1980, IUSB.

49. This analysis is made by Bert Cochran in his astute *Labor and Communism*, (Princeton, 1977), 156–96 and 248–78. Also, see Nelson Lichtenstein, *Labor's War at Home: The CIO in World War II* (New York, 1982); and Roger Keeran, *The Communist Party and the Auto Worker Unions* (Bloomington, Indiana, 1980).

50. George Hupp interviewed by Loren Pennington, May 19, 1972, Local 5 Papers; George Hupp interviewed by Janet Weaver, December 4, 1972, IUSB; Raymond Berndt interviewed by Janet Weaver, April 1, 1980, IUSB; and Lester Fox interviewed by Janet Weaver, March 5, 1979, IUSB.

51. White, *The Automobile Industry Since 1945*, 12–14.

52. *Annual Stockholder's Report (1950)*, Supporting Documents, Box 15, SP. Also, "Production Cut for Studebaker," *South Bend Tribune*, Clipping Book 87, SP.

53. "Vance Attacks Defense Policy," *South Bend Tribune*, November 19, 1951, Clipping Book 87, SP.

54. The quotation is attributed to Cole by Cannon and Fox, *Studebaker: The Complete Story*, 210–211.

55. The decline in sales is discussed in Hendry, "One Can Do A Lot of Remembering," 247. Also quite useful is the insightful discussion of Studebaker in these years in Beatty, Furlong, and Pennington, *Studebaker: Less Than They Promised*, 28.

56. "Studebaker Production Cut," *South Bend Tribune*, Clipping Book 87; "Studebaker Idles 14,000," *South Bend Tribune*, June 7, 1951, Clipping Book 87; Board of Directors Meeting, June 22, 1951, Supporting Documents, Box 15, SP.

57. Vance's value to the corporation was evidenced in that he received a higher salary ($150,000) than did Paul Hoffman ($100,000), who returned to Studebaker on March 1, 1953. *Time*, February 2, 1953, Box 152, Paul Hoffman Papers, in Truman Library; Harold S. Vance to Paul G. Hoffman, February 6, 1953, Box 150, Paul Hoffman Papers, in Truman Library. Also, see "Vance Denies Turning Down ODM Offer," *South Bend Tribune*, January 1, 1953, Clipping Book 87, SP. Hoffman's salary was discussed in Special Board of Directors Meeting, February 4, 1953, Supporting Documents, Box 16, SP.

58. Clipping, *Road and Track*, April 1953, Box 152, Hoffman Papers.

59. *Magazine of Wall Street*, May 31, 1952, Clipping Book 87, SP.

60. "Excerpt of Letter from Iowa Dealer," March 24, 1954, Box 150, Hoffman Papers. On the design of the 1953 coupes see Cannon and Fox, *Studebaker: The Complete Story*, 231–37.

61. Macdonald, *Collective Bargaining*, 268–70; Herbert O. Brayer, "Why Studebaker Laid Off 6,200 Production Workers," *American Business*, October 1953, 16–17; and Board of Directors Meetings, March 27, 1953; May 22, 1953; June 26, 1953, and September 9, 1953, Supporting Documents, Box 16, SP.

62. Earlier Vance had expressed concern that the corporation was relying too heavily on defense contracts. In 1953 he noted that although the company finished the year with over a $14 million profit, close to half of the company's total sales came from the government. This figure is cited by Cannon and Fox, *Studebaker: The Complete Story*, 225. Archival records do not reveal an exact figure for military sales. See, however, "Statistical Summary of Finances," Supporting Documents, Box 17, SP.

63. "Statistical Summary," Studebaker Annual Report (1953), Supporting Documents, Box 17, SP.

64. Ford's comeback is traced in William B. Harris, "Ford's Fight for First," *Fortune* 50, September 1954, 123–27, 194–202. For later accounts, see Lacey, *Ford: The Men and the Machine*, 401–76; and David Halberstam, *The Reckoning* (New York, 1986).

65. "Battle of Big Wheels Rages in Detroit," *The Providence*, June 11, 1954, Box 45, Hoffman Papers; and J. J. Nance to F. J. Walters, C. E. Briggs, October 12, 1953, James J. Nance Papers, Series I, Box 3, SP.

66. Board of Directors Meeting, May 24, 1954, Supporting Documents, Box 7; and Annual Stockholders Report (1953), Supporting Documents, Box 7, SP.

67. Figures for profits are found in Lawrence J. White, *The Automobile Industry Since 1945*, 14.

68. Vance, for his part, opposed such talk of merging Studebaker with another independent. Since 1948 he had rebuffed offers to discuss possible mergers with Willys-Overland (1948), Kaiser-Frazer (1949), and Packard (1949). He turned down Packard simply by saying, "It is going to take a new miracle if Packard is to regain a good position in the higher price field." In early 1953, the new president of Packard, James J. Nance, reopened the possibility of merging with Studebaker, but Vance once again rejected the proposal by persuading his board that Studebaker was going to have a good year in 1954. The loss of $8.3 million in the first quarter of 1954 convinced the board otherwise. Board of Directors Meeting, May 28, 1948, Supporting Documents, SP; Harold S. Vance to Paul G. Hoffman, May 5, 1949, Box 150, Hoffman Papers.

69. "Battle of Big Wheels Rages in Detroit," *Providence News*, August 22, 1954, Box 45, Hoffman Papers.

70. Langworth, *Studebaker: The Postwar Years*, 42; William B. Harris, "The Breakdown of Studebaker-Packard," *Fortune*, October 1967, 222.

71. Transcript of Annual Meeting of the Stockholders, April 27, 1954, Supporting Documents, Box 17, SP.

72. Board of Directors Meeting, November 20, 1953, Supporting Documents, Box 16, SP.

73. Peterson also felt that Hoffman's return to Studebaker had diminished his chances of assuming the presidency of the corporation. H. S. Vance to Paul Hoffman, February 27, 1953, Box 150, Hoffman Papers.

74. Anna Rosenberg, Memorandum, "The Studebaker Cost Conscious Program," December 22, 1953, Box 151, Hoffman Papers; and Anna Rosenberg, "Memorandum on Labor," May 15, 1954, Box 152, Hoffman Papers. Also, Macdonald, *Collective Bargaining*, 270–75.

75. Meetings of the Executive Committee of Local 5, February 11, 1954; February 24, 1954; February 25, 1954; and March 4, 1954, Box 10, Local 5 Papers.

76. Macdonald, *Collective Bargaining*, 260–64.

77. Harold S. Vance to Paul G. Hoffman, February 2, 1949, Box 150, Hoffman Papers; T. Forrest Hanna interviewed by Loren Pennington, June 17, 1971, Local 5 Papers; and "Studebaker Halts," *Business Week*, January 29, 1949, 75.

78. "80 Leave Work and Idle 8,000," *South Bend Tribune*, January 6, 1951; "7000 Reported Idle in Strike at Studebaker," *South Bend Tribune*, July 17, 1951.

79. For Studebaker's strategy in these negotiations, see Board of Directors Meeting, April 28, 1954, Supporting Documents, Box 17, SP.

80. The international's interest in addressing problems at Studebaker is

discussed in the Executive Committee Meeting, June 18, 1954, U.A.W. Local 5 Papers.

81. Macdonald, *Collective Bargaining*, 277–78.

82. "Selling A Pay Cut to Workers," *Business Week*, August 21, 1951, 124.

83. "This Is Why Studebaker Is Compelled to Terminate Its Present Labor Agreement," *South Bend Tribune*, August 8, 1954, Box 152, Hoffman Papers. Hoffman later thanked F. A. Miller, editor of the *South Bend Tribune*, for his favorable coverage of the prolonged negotiations. Paul G. Hoffman to F. A. Miller, August 20, 1954, Box 45, Hoffman Papers.

84. The details of the meeting were recounted in "Studebaker Weekly News," UAW-CIO Local 5, August 12, 1954, Box 151, Hoffman Papers; and Paul G. Hoffman to C. Braker Motor Company, August 12, 1954, Box 152, Hoffman Papers.

85. The formation of Packard-Studebaker was not a merger per se. Packard in effect acquired the assets of Studebaker in exchange for $3.5 million in shares of common stock. Special Directors Meeting, June 22, 1954, Supporting Documents, Box 17, SP.

86. *Financial World*, October 4, 1954, Box 42, Hoffman Papers.

87. L. R. Scafe to H. S. Maynard, August 13, 1954, Box I, H. S. Maynard Papers.

6. Studebaker Attempts to Reverse Course, 1954–1957

1. "Editorial," *Spotlight*, October 1954, 19. Also see "Huge Welcome Given to Nance," *Studebaker News*, October 1954, Box 152, Hoffman Papers. For a detailed account of the declining years of Studebaker-Packard, see James A. Ward, *The Fall of the Packard Motor Car Company* (Stanford, 1995).

2. "President's Report to the Board of Directors," April 18, 1955, Board of Directors Meetings, December 17, 1954, January 20, 1956; and Memorandum, Studebaker Product Committee, "Studebaker versus Competitive Models," June 18, 1956, Series II Box 16, Nance Files, SP.

3. White, *The Automobile Industry Since 1945*, 15.

4. Flink, *The Automobile Age*. Also, Tom Mahoney, *The Story of George Romney: Builder, Salesman, Crusader* (New York, 1960).

5. Paul Hoffman to James J. Nance, January 20, 1955, Box 46, Hoffman Papers.

Of course, not all were so optimistic. As one old observer of the auto industry, L. R. Scafe, remarked, "If he [Hoffman] and Nance think they can pull Packard and Studebaker out of the hole by consolidation, they are sadly mistaken: That is a dead duck." L. R. Scafe to H. S. Maynard, September 14, 1955, Box 1, H. S. Maynard Papers.

6. The consolidation of Packard and Studebaker called for a reclassification of Packard stock, authorizing $6.4 million in shares instead of $14.9 million in shares under the merged corporation. This allowed the new consolidated company to offer one share for every five shares of older stock. This accounted for $2.8 million in shares, with the $3.5 million of Packard shares being used to acquire Studebaker assets at a one to one-and-one-half ratio. This meant that for every 100 shares of Studebaker stock the shareholder would receive 150 shares of the consolidated Studebaker-Packard Corporation. This arrangement was determined by the estimated worth of each corporation, but it is important to note that the consolidation was hurried and arranged without a detailed financial investigation by any of the parties in-

volved in the transaction. Special Board of Directors Meeting, June 22, 1954, Box 7, Supporting Documents, SP. "Value Line Report," August 2, 1954, Series I, Box 17, Nance Files, SP. Regular Board of Directors Meeting, May 28, 1954, Box 17, SP; and W. R. Grant to J. Nance, August 4, 1954, Box 13, Nance Files Series I, SP. Also, Richard M. Langworth, *Studebaker: The Postwar Years* (Osceola, Wisconsin, 1979), 74.

Under Michigan law, the Studebaker-Packard combination was not a merger per se, but an acquisition of Studebaker assets by the Packard Corporation. The arrangements in this purchase, as worked out by New York financial interests, imparted 55% control of the common stock to Studebaker shareholders, while offering 33% more market value for their new shares over their old ones.

Still the merger that Vance had so adamantly resisted, until the first quarter closing which revealed an $8.3 million loss, clearly benefited Studebaker shareholders—at least in the short run. Clipping, "Studebaker & Packard Will Combine," *Wall Street Journal*, June 23, 1954; "Packard, Studebaker Merger Confirmed," *Journal of Commerce*, June 23, 1954, Box 151, Hoffman Papers.

7. Langworth, *Studebaker: The Postwar Years*, 72.

8. This description is quoted in a personal note sent to Nance by the head of Packard sales, Patrick Monaghan to James J. Nance, March 11, 1955, Series II, Box 14, Nance Files, SP.

9. On National Cash Register's role in training many executives see Sealander, *Grand Plans*.

10. "Linking the Last of the Independents," *Business Week*, June 26, 1954, Box 151, Hoffman Papers. For an excellent discussion of the electrical industry see Chandler, *Strategy and Structure*, 363–70.

11. "Old Auto Maker Started Humbly," *New York Times*, June 23, 1954, Box 151, Hoffman Papers.

12. Carl C. Harrington, "Packard's Year of Decision," *Mill and Factory*, April 1955, Box 46, Hoffman Papers.

13. Nance's career at Packard before the merger is found in "Statement Before Kilgore Committee, U.S. Senate," June 30, 1955, Series II, Box 13, Nance Files, SP; "Studebaker & Packard to Merge," *New York Times*, June 23, 1954, Box 151, Hoffman Papers. "Nance Scores First Profit for Merged Auto Firms," New York Journal-American, April 24, 1955, Series II, Box 10, Nance Files, SP; and Langworth, *Studebaker: The Postwar Years*, 74–75.

14. Dan O'Madigan, Jr., to J. J. Nance, December 6, 1955, Series II, Box 3, Nance Files; Annual Stockholder's Report (1955), Director Meetings Files (12/17/54–1/20/56), SP.

15. James J. Nance to Louis C. Doner, August 8, 1955, Series II, Box 11, Nance Files, SP.

16. Robert F. Lanzilloti, "The Automobile Industry," in Walter Adams, ed., *The Structure of American Industry* (New York, 1971), 271.

17. Hoffman added that this attitude on the part of the American public "does not make sense. The American public could travel in much smaller, lighter cars, but the American public won't travel in smaller, lighter cars . . . everyone who has tried it has found out." Transcript, Annual Meeting of Stockholders of the Studebaker Corporation, April 27, 1954, Supporting Documents, Box 17, SP.

Only a few months later the corporation addressed the question of putting out a small car modeled after the British Hillman. Hoffman once again re-

plied, "There just is not a sufficiently large market for this type of car in America to justify our putting one in production." Paul Hoffman to Edward B. Reed, July 22, 1954, Box 45, Hoffman Papers.

18. James J. Nance to T. K. Quinn, February 8, 1953, Series I, Box 4, Nance Files, SP.

19. Nance informed his staff that "Mr. Lieb of E. F. Hutton told me that the prospects of SPC were considered better than AMC by businessmen, but less so by the public. AMC has sold the public that they have something in the Rambler. . . . It points up the need for us to get across our corporate image." James J. Nance to Patrick Monaghan, August 1, 1955, Series II, Box 4, Nance Files, SP.

20. James J. Nance to Eugene DuPont, May 28, 1953, Series I, Box 2, Nance Files, SP. "Linking the Last of the Independents," *Business Week*, June 6, 1954, Box 151, Hoffman Papers.

Nance's own key financial adviser, W. R. Grant, had confidentially written to him that "there is room for not more than four companies in the automobile industry in the next decade." Grant urged Nance to pursue a merger with AMC with the understanding that the government would approve such a merger as a way of relieving the Eisenhower administration of "a very real problem should there be a succession of failures of small independents in the industry." For this same reason, Grant believed, "both GM and Ford are secretly cheering the mergers that have been undertaken to date in hope that this would remove the plight of independents from the public and the private eye." W. R. Grant to James J. Nance, August 10, 1954, Series I, Box 13, Nance Files, SP.

21. Memorandum, W. R. Grant to J. J. Nance, August 10, 1954, Series I, Box 13, Nance Files, SP.

22. James J. Nance to Edwin Foster Blair, February 17, 1955, Series II, Box 9, Nance Files, SP; and Memorandum, Confidential Memo on American Motors, James J. Nance to W. R. Grant, November 1, 1954, Series I, Box 13, Nance Files, SP.

23. "Transcript of Press Conference with George Romney," October 14, 1954, Series I, Box 6, Nance Files, SP.

24. Langworth, *Studebaker: The Postwar Years*, 82–84. Also, see James J. Nance to George Romney, October 27, 1954, Series I, Box 6, Nance Files, SP; and W. R. Grant to James J. Nance, April 13, 1955, Series II, Box 2, Nance Files, SP.

25. "Organizational Manual Studebaker-Packard," November 17, 1955, Series II, Box 2, Nance Files, SP; and E. W. Reilley to J. J. Nance, July 29, 1954, Series I, Box 21, Nance Files, SP.

26. Memorandum, James J. Nance to Members of the Operating Committee, January 18, 1955, Series II, Box 3, Nance Files, SP.

27. Memorandum, V. L. Casson to James J. Nance, January 2, 1956, Series II, Box 7, Nance Files, SP.

28. While Vance and Edward Mendler, representing Studebaker in the negotiations, told Packard that the break-even point was 165,800 units, a detailed survey of Studebaker showed that the actual break-even point was 286,256 units. W. R. Grant to James J. Nance, June 22, 1955, Series II, Box 2, Nance Files, SP.

29. W. R. Grant to James J. Nance, July 16, 1954, Series I, Box 13, Nance Files, SP; also, James J. Nance, "Letter to All Studebaker Employees," March 2, 1956, Series I, Box 13, Nance Files, SP; and Board of Directors Meeting, November 14, 1954, Supporting Documents, SP.

30. J. J. Nance to C. P. Monaghan, October 18, 1954, Series I, Box 13, Nance Files, SP.

31. James J. Nance to H. O. Peterson, vice president, Benton and Bowles, June 16, 1955, Series II, Box 9, Nance Files, SP; E. W. Reilley to James J. Nance, July 24, 1954, Series I, Box 23, Nance Files, SP; and James J. Nance to Patrick Monaghan, March 7, 1955, Series II, Box 4, Nance Files, SP.

32. E. J. Grary to H. E. Churchill, August 30, 1955, Series II, Box 3, Nance Files, SP.

33. For instance, by January 1955 former Ford or Packard men had been appointed to head operations, General Manager of the Body and Assembly Group, and Sales. In this latter position, William A. Keller, who had been with Ford, named other former Ford and Packard men to the executive sales team. Most telling was the resignation of E. E. Richards, a vice president with Studebaker since 1947, as Treasurer of the consolidated company in May 1955. Nance directed his assistant W. R. Grant to meet with Richards to draft a news release that provided "some sort of a story as to his reasons for retiring other than that which he has stated." See *Studebaker News*, January 1955, Box 152, Hoffman Papers. Also, G. Van Ark to James J. Nance, January 30, 1953, Series I, Box 13, Nance Files, SP; Memorandum, E. J. Grary to H. E. Churchill, August 30, 1955, Series II, Box 3, Nance Files, SP; and James J. Nance to W. R. Grant, May 31, 1955, Series II, Box 2, Nance Files, SP.

34. Memorandum, G. Van Ark to James J. Nance, February 25, 1955, Series II, Box 7, Nance Files, SP.

35. Signs of what were to come were first evidenced in the Nash-Kelvinator division when George Romney renegotiated its contract with a well-entrenched, and militant, union. The Detroit Kelvinator plant was well known as a "loafer's paradise," even among labor. Workers at the plant often took paid time from the line to get haircuts, cook food, or play dice. In renegotiating the contract, Romney willingly accepted three long strikes lasting thirty-six days, thirty-four days, and a final strike of sixty-five days. In the end he won a new contract that instituted more disciplined work standards.

36. The discussion of AMC relies on Edwards, *Dynamics of the United States Automobile Industry*, 66, 65, and 67; and Macdonald, *Collective Bargaining*, 291–306.

37. See "Transcript of Press Conference with George Romney," October 14, 1954, Series I, Box 6, Nance Files, SP.

38. As one Studebaker man remarked, these new managers were "castoffs, incompetents and very young men, some undoubtedly with high future potentialities [*sic*], but completely lacking in experience, particularly automotive." As a consequence, "chaos" was created. "Nobody knew who his boss was—foremen and superintendents were bewildered and disheartened. Instructions given by these supposedly accredited management representatives were countermanded by the hordes of new so called production experts. Is it any wonder eighty-five wild cat work stoppages developed?" Edward C. Mendler to Paul C. Hoffman, November 13, 1956, Box 47, Hoffman Papers.

39. Edward C. Mendler to Paul C. Hoffman, November 13, 1956, Box 47, Hoffman Papers.

40. "New Company Discards Old Traditions," *Studebaker News*, March 16, 1955, Box 152, Hoffman Papers.

41. "Nance Outline to Foremen—14 Point Program of Progress," *Studebaker News*, December 1954, Box 152, Hoffman Papers.

42. Board of Directors meeting, March 18, 1955, Supporting Documents, Box 17; and Preliminary Minutes, January 21, 1955, Board of Direc-

tors Meetings, December 17, 1954 and January 20, 1956, SP. Also, Executive Committee of Local 5, January 13, 1955; and Lester Fox to Raymond H. Berndt, January 21, 1955, Local 5 Papers. Other expressions of workers' discontent can be found in "Sorry He Voted for Pay Cut A Year Ago," *Des Moines Sunday Register*, July 24, 1955, Series II, Box 9, Nance Files, SP; James J. Nance to Louis C. Donner, Series II, Box 11, Nance Files, SP; and Unsigned to Paul Hoffman, November 23, 1955, Box 46, Hoffman Papers.

This strike, as well as the labor situation at Studebaker-Packard under Nance's regime, is discussed in Macdonald, *Collective Bargaining*, 280–83.

43. Lester Fox interviewed by Loren Pennington, Local 5 Papers.

44. Paul Hoffman to James Nance, January 20, 1955, Box 46, Hoffman Papers.

45. C. D. Scribner to R. P. Powers, March 9, 1955, Series II, Box 5, Nance Files, SP; James J. Nance to Congressman Sheppard P. Cumpacker, March 11, 1959, Series II, Box 10, Nance Files, SP; and Executive Committee of Local 5, March 10, 1955, Local 5 Papers.

46. Executive Committee of Local 5, June 30, 1955, Local 5 Papers.

47. Board of Directors Meeting, March 18, 1955, Support Documents, Box 17, SP.

48. Board of Directors Meeting, March 18, 1955, Support Documents, Box 17, SP.

49. Memorandum, W. R. Grant to James J. Nance, April 15, 1955, Series II, Box 2, Nance Files, SP.

50. Memorandum, C. D. Scribner to James J. Nance, July 28, 1955, Series II, Box 5, Nance Files, SP.

For Nance the walkout was the final test. "We have come to grips with the labor problem at South Bend," he encouragingly told one director, "and are right now having to live with the situation almost by the hour. It is too early to say what the outcome may be, but we definitely must win this one. It's a tough one, though, because it has been building up for twenty years." James J. Nance to Philip R. Clarke, Chairman of the Board, City National Bank and Trust Company, July 13, 1955, Series II, Box 10, Nance Files, SP.

51. "Studebaker Plant Resumes Output As Assembly Workers End Walkout," *Wall Street Journal*, July 21, 1955, Local 5 Papers; Edward Wrobel to Raymond A. Berndt, August 30, 1955, Local 5 Papers.

52. By late August negotiations had completely bogged down. The local membership voted for another strike, pickets went up, but once again the international intervened and called the strike illegal. The rank and file initiated their own slowdown. Monthly production fell to 3,000 but excess inventories undercut this tactic, and in fact eased the cleanup problem for Studebaker-Packard dealers.

Some in the union took more militant actions. In one case, a bomb was set off in the tool shop that blew out the windows. While no one was hurt, the shop was closed for two hours. On September 10, the union voted once again to strike, only to be denied once again by the international. William Ogden found himself under attack. At one union meeting "the crowd, surly and defiant," openly booed him for his talk of moderation. "Chronological Development of Contract Negotiations," *Studebaker News*, January 11, 1956, Series II, Box 16, Nance Files, SP.

53. C. D. Scribner to R. P. Powers, August 26, 1955, Series II, Box 5, Nance Files, SP. Also, see Executive Committee of Local 5 Papers, August 31, 1955 and September 10, 1955, Local 5 Papers. For pressure brought on

the local union see Preliminary Notes, Board of Directors Meeting, August 19, 1955, Minutes, Board of Directors Meetings (December 17, 1954–January 20, 1956), SP.

54. "Chronological Review of Contract Negotiations," *Studebaker News*, January 11, 1956, Series II, Box 16, Nance Files, SP.

55. James J. Nance to James G. Blaine, January 9, 1956, Series II, Box 9, Nance Files, SP; and James J. Nance to Hugh J. Ferry, January 9, 1956, Series II, Box 11, Nance Files, SP.

56. Lester Fox interviewed by Janet Weaver, IUSB.

57. Macdonald, *Collective Bargaining*, 282. Also, James J. Nance to Board of Directors, November 9, 1955, Box 46, Hoffman Papers.

The end brought its own set of ironies. Shortly after the contract the federal government arranged for a Japanese labor management group from the automotive industry, including representatives from Toyota, Nissan, and Isuzu, to tour Studebaker. The response of the Japanese to their tour was not recorded. Perhaps they drew other lessons from the Studebaker-Packard model than did those American observers, including Nance's board, who saw the final contract as a "victory." G. Warren Morgan to William Ogden, January 8, 1955, Local 5 Papers.

58. Preliminary Minutes, Board of Directors Meeting, September 16, 1955, SP. Memorandum, J. H. Sloan to J. J. Nance, July 1, 1955, Series II, Box 6, Nance Files, SP.

59. James J. Nance to John H. McDonough, December 2, 1955, Box 46, Hoffman Papers. Also, Langworth, *Studebaker: The Postwar Years*, 78.

60. "Since November," Nance wrote to the former president of the University of Notre Dame, John J. Cavanaugh, "we have been the well known 'sitting duck,' or like a fighter in the ring with his arms tied behind him. In slang parlance—we are getting clobbered. Everything we can think of is being tried to get financial aid. Say a prayer for us—and the thousands of Studebaker people." James J. Nance to Reverend Fr. John J. Cavanaugh, March 22, 1956, Series II, Box 9, Nance Files, SP.

61. Memorandum, J. H. Sloan to J. J. Nance, June 2, 1955, Series II, Box 6, Nance Files, SP.

62. Memorandum, W. H. Graves to J. J. Nance, December 12, 1955, Series II, Box 3, Nance Files, SP. Also see Memorandum, W. H. Graves to J. J. Nance, December 2, 1955, Series II, Box 14, SP. Another example of key personnel lost to a rival is seen in the case of Clarence E. Briggs, who left Studebaker to work for Chrysler as a special assistant to the president. James J. Nance to Clarence E. Briggs, March 21, 1955, Series II, Box 2, Nance Files, SP.

63. Memorandum, W. H. Graves to James J. Nance, October 28, 1955, Series II, Box 14, Nance Files, SP.

64. Memorandum, J. J. Nance to R. E. Bremer, August 23, 1955, Series II, Box 2; Memorandum, R. E. Bremer to J. J. Nance, August 8, 1955, Series II, Box 2, Nance Files, SP.

65. R. Blythin to James J. Nance, March 16, 1955, Series II, Box 2, Nance Files, SP; R. Blythin to James J. Nance, June 14, 1955, Series II, Box 13, Nance Files, SP; William M. Schmidt to Harold E. Churchill, September 9, 1955, Churchill Files, Series I, Box 8, SP. Also, Langworth, *Studebaker: The Postwar Years*, 80–82.

66. The decline of Studebaker under the Nance years is ably discussed by Loren E. Pennington, "Prelude to Chrysler: The Eisenhower Administration

Bails Out Studebaker-Packard" (unpublished paper, n.d.), in Studebaker National Museum. Pennington's paper should be supplemented with a detailed account of the efforts to save Studebaker-Packard in 1956, given in Roy White, "Memorandum: Studebaker-Packard Corporation Record of Efforts Directed at Preserving the Corporation, January-June, 1956," Series II, Box 13, Nance Files, SP. Strangely, Pennington's well-documented account does not use this revealing document. Also of interest is "Report," Value Line Survey (July 30, 1956), Series II, Box 13, Nance Files, SP. Worth consulting as well is Charles E. Edwards, *Dynamics of the United States Automobile Industry*, 79.

67. Richard M. Langworth offers a terse overview of this disaster in his *Studebaker: The Postwar Years*, 85-88. For a more scholarly account see Charles E. Edwards, *Dynamics of the United States Automobile Industry*, 79-82.

68. Unspecified memorandum, cited in Langworth, *Studebaker: The Postwar Years*, 80. This document is no longer located in the Studebaker Papers.

69. Courtney Johnson to James J. Nance, January 27, 1955; and James J. Nance to Courtney Johnson, January 31, 1955, Series II, Box 3, Nance Files, SP.

70. Richard Hutchinson to James J. Nance, February 9, 1956, Series II, Box 13, Nance Files, SP; and Telegram, James J. Nance to Dick Hutchinson, January 25, 1956, Series II, Box 13, Nance Files, SP.

71. W. H. Graves to James J. Nance, April 13, 1956, Series II, Box 14, Nance Files, SP.

72. Memorandum, Courtney Johnson to Frank Higgins, June 17, 1955, Box 46, Hoffman Papers; Courtney Johnson to Paul Hoffman, June 29, 1955, Box 46, Hoffman Papers. Also, Edwards, *Dynamics of the United States Automobile Industry*, 41.

73. Nance was shocked by the cancelation. He considered himself a friend of a close friend of "Engine Charlie" Wilson and a strong supporter of Dwight D. Eisenhower, having contributed money to his 1952 campaign and having joined the President for dinner as a guest at one of the general's well-known "bachelor" evenings. Nance's relations with Eisenhower are discussed in Paul J. Shine to James J. Nance, July 31, 1956, Series II, Box 16, Nance Files, SP; and Dwight D. Eisenhower to James J. Nance, February 16, 1955, Series II, Box 11, Nance Files, SP.

74. Diary of Dwight David Eisenhower, April 20, 1956, Ann Whitman File, in Dwight David Eisenhower Papers, Eisenhower Library, Abilene, Kansas, quoted in Loren Pennington, "Prelude to Chrysler: The Eisenhower Administration Bails Out Studebaker-Packard" (unpublished paper).

75. Only the summer before Nance felt fairly certain that the banks were behind him. He told Russell Forgan, "You never know, of course, whether the banks are with you when you really need them, but the reaction generally was one of reassurance. However, everywhere we went the necessity of licking the labor cost problem at South Bend was made paramount. Much to my surprise, the banks seemed to be thoroughly familiar with the South Bend labor situation and apparently recognized it as long standing." James J. Nance to Russell J. Forgan, July 26, 1955, Series II, Box 11, Nance Files, SP.

76. The following discussion relies heavily on Roy White, Memorandum, "Studebaker-Packard Corporation Record of Efforts Directed at Preserving the Corporation January-June 1956," June 1, 1956, Series II, Box 13, Nance Files, SP; and Loren Pennington, "Prelude to Chrysler: The Eisenhower Ad-

ministration Bails Out Studebaker-Packard" (unpublished paper, n.d.), in Studebaker National Museum Archives.

77. L. L. "Tex" Colbert, speaking for Chrysler, conveyed the common sentiment of those companies approached by Studebaker when he wrote, "when we examine our own situation, forward planning and effects on Chrysler's corporate structure, we are unable to see any way that the merger or acquisition you proposed could be fitted into our plans to the mutual advantage of our companies and their stockholders." L. L. "Tex" Colbert to James J. Nance, April 20, 1956, Series II, Box 10, Nance Files, SP.

78. Robert Yost Hinshaw to Ernest L. Klein, May 15, 1956, Series II, Box 16, Nance Files, SP; and Paul J. Shine to James J. Nance, June 6, 1956, Series II, Box 16, Nance Files, SP.

79. Roy White, "Studebaker-Packard Corporation Record of Efforts Directed at Preserving the Corporation," Series II, Box 13, Nance Files, SP; also, Board of Director Minutes, July 26, 1956, Series I, Box 10, Harold Churchill Files, SP; and P. J. Shine to James J. Nance, April 25, 1956, Series II, Box 16, Nance Files, SP. Nance's search for a buyout by another corporation is also discussed by William Harris, "The Breakdown of Studebaker-Packard," *Fortune*, October 1957, especially 228–30.

80. James J. Nance to C. D. Scribner, June 2, 1956, Series II, Box 13, Nance Files, SP; and C. D. Scribner to James J. Nance, June 6, 1956, Series II, Box 14, Nance Files, SP.

81. For Curtiss-Wright negotiations see Loren Pennington, "Prelude to Chrysler" (unpublished paper); and Board of Directors Meeting, June 28, 1956, July 26, 1956, and August 20, 1956, Series I, Box 10, Churchill Files, SP.

82. Board of Directors Meeting, June 27, 1956, Series I, Box 10, Harold Churchill Files, SP.

83. "Value Line Report," July 30, 1956, Series II, Box 13, Nance Files, SP.

84. The final negotiations are carefully outlined in Loren E. Pennington, "Prelude to Chrysler: The Eisenhower Administration Bails Out Studebaker-Packard" (unpublished paper), but this should be supplemented with the quite useful "Programs with Curtiss-Wright," Series I, Box 6, Churchill Files, SP. The financial arrangements with the banks and insurance companies are discussed by Charles Edwards, *Dynamics of the United States Automobile Industry*, 92–93.

85. The stockholders' meeting that October turned into one of the most acrimonious sessions in the company's history. The directors found themselves being challenged by a group of dissidents led by Detroit lawyer Sol Dann and New York bondbroker John Neville. The meeting lasted three heated days with neither side showing respect for the other. At one point Dann declared, "I'm not from New York. I am just a so-called boy from the hills, and I never went beyond ninth grade in high school." To which Louis F. Dahling, Studebaker's corporate counsel replied, "That is apparent." After three days, the Dann faction was defeated, but it had been a trying experience on both sides. The transcript of the stockholders' meeting was recorded in full in "Stockholders Meeting, October 31, 1956," in Directors Meetings File November 28, 1956–December 27, 1956, SP. Also, *Wall Street Journal*, October 10, 1956, Directors Meetings File November 28, 1956–December 27, 1956, SP.

86. James J. Nance to Paul M. Clark, January 25, 1956, Series II, Box 11,

Nance File, SP; and Memorandum, Paul M. Clark to Harold Churchill, November 15, 1957, Series I, Box 15, Churchill File, SP.

87. This point is made by Langworth, *Studebaker: The Postwar Years*, 86.

88. Edward C. Mendler to Paul G. Hoffman, November 13, 1956, Box 46, Hoffman Papers.

89. Ralph A. Vail, quoted in Langworth, *Studebaker: The Postwar Years*, 6.

7. Studebaker Halts U.S. Production, 1957–1963

1. By 1970 total U.S. sales for Volkswagen had reached an impressive 570,000 vehicles. A market was waiting to be tapped. For a readable description of the rise of Volkswagen in these years, see John B. Rae, *The American Automobile Industry* (Boston, 1984), 117–30. Also, Walter H. Nelson, *Small Wonder: The Amazing Story of the Volkswagen* (New York, 1961), revised edition (Boston, 1967).

For discussion within Studebaker concerning Volkswagen, see Minutes, Product Committee, December 28, 1956, Series I, Box 8, Churchill Files, SP.

2. Unfortunately, the Corvair tended to flip at high speeds. Finally, Simon E. "Bunkie" Knudsen, general manager of Chevrolet, was given permission to redesign the car's suspension. By 1965, however, it was too late. Ralph Nader's *Unsafe at Any Speed: The Designed-In Dangers of the American Automobile* (New York, 1965) had severely damaged the car's reputation with consumers. For a balanced discussion of the Corvair in a larger context, see James J. Flink, *The Automobile Age*, 287–93. Also, J. Patrick Wright, *On a Clear Day You Can See General Motors: John Z. DeLorean's Look Inside the Automotive Giant* (Grosse Pointe, Michigan, 1979).

3. Henry J. MacTavish to H. E. Churchill, October 15, 1956, Series I, Box 5, Churchill Files, SP.

4. The agreement called for a fifteen-year contract, or six years if Studebaker-Packard sales of Mercedes dropped to less than $50 million. For this Studebaker received a 2 1/2 percent royalty on each car sold plus purchase price. Memorandum, The Daimler-Benz Contract, February 21, 1957, Series I, Box 15, Churchill Files; and Minutes, Product Committee Meeting, November 27, 1956, Series I, Box 8, Churchill Files, SP. *Annual Report to the Shareholders* (December 31, 1956).

5. For Churchill's views of engineering see Minutes, Meeting with Staff of Advanced Engineering, May 29, 1956, Series I, Box 6, Churchill Files; and for his hands-on approach see Minutes, Executive Committee of the Board of Directors, November 14, 1958, Directors Meetings 10/30/58–4/6/59, SP. Also, "Soaring on the Wings of a Lark," *Business Week*, June 20, 1959, Series I, Box 22, Churchill Files, SP.

6. Harold Churchill to Frank J. Manheim (Lehman Brothers), July 19, 1957, Series I, Box 15, Churchill Files, SP.

7. Harold Churchill, "Statement of Studebaker Policy Regarding FEPC," May 13, 1957, Series I, Box 17, Churchill Files, SP.

8. The phaseout necessitated drastic cuts in Packard personnel. While some senior employees were given the opportunity to transfer to South Bend, the closing down of Packard meant that most Packard workers were left without jobs or pensions. In 1955 the UAW had consolidated the Packard and Studebaker pension plans into a single fund managed by Chemical Bank of New York. The closing of Packard left an unfunded liability under the Packard

plan of approximately $18 million. To rid itself of this liability, the Studebaker board created two plans, one for retired Studebaker employees and another for retired Packard employees. Then it terminated the Packard plan. The International UAW contested this separation. For its part, Local 5 opposed the International in its effort to maintain the Packard pension fund. After nearly two years of negotiations, the International UAW agreed to a compromise. In the end, Packard employees gained little. Under the terms of the final settlement reached in late 1959 only 1,946 employees were guaranteed a pension, in the amount of 85 percent of what they would have gained prior to the termination of Packard.

Churchill to Edwin Blair, January 17, 1957, Series I, Box 15, Churchill Files; Memorandum, Harold E. Churchill to Executive Committee, Board of Directors, November 2, 1959, Series I, Box 22, Churchill Files; and Memorandum, John Morse (Cravath, Swaine & Moore), October 1, 1958, Series I, Box 17, Churchill Files, SP. Also, Raymond H. Bendt to Norman Matthew, January 28, 1957, Local 5 Papers.

9. This employee program was developed by Rohrer, Hibler, and Replogle, a management consultant team. This Chicago-based firm, then consisting of forty Ph.D.s in psychology, evaluated all salaried employees at Studebaker through intensive interviews. Their main task was to improve morale among supervisors through "encouragement and recognition." They also evaluated salary and pension programs; communications; and work environment. The firm's activities are discussed in Memoranda, "Management Development Program," February 4, 1957, Series I, Box 15, Churchill Files; Rohrer, Hibler, and Replogle, Memorandum, November 7, 1956, Series I, Box 15, Churchill Files, SP.

The emergence of industrial psychology at this time appears similar to that of the 1920s, the Great Depression, and World War II, also periods of industrial unrest. While scholars such as Michael J. Piore, Charles Sabel, and Charles C. Heckscher see a cyclical pattern to industrial psychology determined by periods of industrial unrest, the consistent promulgation of industrial psychology in modern America beginning in the 1920s suggests a deeper attraction to this way of thinking than simply a reaction to industrial unrest. Moreover, given the continuous pattern of industrial unrest, it is difficult to see industrial psychology only as a means of social control. Given that industrial unrest and industrial psychology often paralleled one another, any argument linking the two in a cycle becomes circular. See Piore and Sabel, *The Second Industrial Divide*, 241. Also, Charles Chevreux Hechscher, "Democracy at Work: In Whose Interests: The Politics of Worker Participation" (Ph.D. dissertation, Harvard University, 1981).

10. "Soaring on the Wings of a Lark," *Business Week*, June 20, 1959, Series I, Box 22, Churchill Files, SP.

11. Lester Fox interviewed by Loren Pennington, Local 5 Papers. For labor problems in the early part of Churchill's administration, see William Ogden to Peter S. Barno, January 24, 1957, Local 5 Papers. Also, C. M. MacMillan to A.D. Whitney, October 25, 1957, Series I, Box 17, Churchill Files; and C. M. MacMillan to Harold Churchill, September 23, 1957, Series I, Box 17, Churchill Files, SP.

12. MacMillan felt that the loss of power had left the Ogden faction feeling desperate, as evidenced in the "vicious" campaign they had conducted against Hobart Shelton, a black divisional officer who represented an all-white Engine Plant. Shelton was independent and therefore not aligned with either

faction. Nonetheless, the Ogden faction had waged an abusive campaign against him. Memorandum, C. M. MacMillan to Harold Churchill, July 5, 1957, Series I, Box 17, Churchill Files, SP.

13. C. M. MacMillan to Edward L. Cushman, November 13, 1957, Series I, Box 17, Churchill Files, SP. His negotiating strategy is outlined in Memorandum, C. M. MacMillan to Harold Churchill, November 19, 1957, Series I, Box 17, Churchill Files, SP.

14. Although the final contract was modeled after the Ford contract reached two months earlier in September, there were fundamental differences between the two. Most notably the union agreed to allow management to suspend Supplemental Unemployment Benefits until sales reached a certain figure. For negotiations in this period, see Minutes, Executive Committee, Board of Directors (December 1, 1958) 10/30/58–4/6/59 Meetings; "Digest of Company's Opening Statement 1959 Labor Negotiations," Series I, Box 22, Churchill Files; C. M. MacMillan to T. Forrest Hanna, November 21, 1958, Series I, Box 17, Churchill Files; UAW Leaflet, "Duties of Strike Captains," November 20, 1958, Series I, Box 17, Churchill Files; and Memorandum, "Company Proposal," November 17, 1958, Series I, Box 17, Churchill Files, SP. The union perspective is found in Minutes, "Special Membership Meeting," November 23, 1958, Local 5 Papers; and Memorandum, January 23, 1958, Local 5 Papers.

For contemporary accounts of the negotiations, see "Worry Brings," *Business Week*, November 29, 1958, 126. Also, Macdonald, *Collective Bargaining*, 283–84.

15. Harold Churchill to George H. Straley, January 7, 1959, Series I, Box 22, SP.

16. Minutes, Product Meeting, November 27, 1956, Series I, Box 8, Churchill Files, SP. Also, Harold Churchill to D. R. Stuart, December 13, 1957, Series I, Box 17, Churchill Files, SP. Churchill's views on the importance of women in the market are found in Harold E. Churchill to George H. Straley, January 7, 1959, Series I, Box 22, SP.

17. Ibid. Also, P. S. Barno, "Memo: Visit to Ford Motor Company," May 16, 1957, Series I, Box 17, Churchill Files, SP.

18. The Scotsman is discussed in Cannon and Fox, *Studebaker: The Complete Story*, 255.

19. This discussion of the Lark relies heavily on Cannon and Fox, *Studebaker: The Complete Story*, 285–90. Also, Minutes, Board of Directors Meeting, March 4, 1959, 10/30/58–4/6/59 Minutes File, SP.

20. "Soaring on the Wings of a Lark," *Business Week*, June 20, 1959, 126–27, Series I, Box 22, Churchill Files, SP.

21. Ibid.

22. Ibid.

23. Memorandum, Harold E. Churchill to the Board of Directors, March 3, 1959, Series I, Box 22, Churchill Files, SP. Also, Edwards, *Dynamics of the United States Automobile Industry*, 97–99.

24. Memorandum, "Explanatory Statement as to Acquisitions Policy," Draft, January 16, 1959, Series I, Box 22, Churchill Files; and Cravath, Swaine, & Moore, "Memorandum for Members of the Board of Directors," February 2, 1959, Series I, Box 22, Churchill Files, SP.

25. Quote for Studebaker stock is found in Frank J. Manheim to Harold Churchill, November 8, 1959, Series I, Box 22, Churchill Files, SP. Evaluation of Studebaker plant and management is contained in *B. L. Thomas, V.*

P. Winn Dixie Stores, "Report on Studebaker," September 21, 1959, Series I, Box 26, Churchill Files, SP.

26. Figures for mergers can be found in Federal Trade Commission, Bureau of Economics, *Statistical Report on Mergers and Acquisitions* (Washington, D.C., August 1980). For critics of later merger movements see Robert R. Reich, *The Next American Frontier* (New York, 1983); and Barry Bluestone and Bennett Harrison, *The Deindustrialization of America: Plant Closings, Community Abandonment, and the Dismantling of Basic Industries* (New York, 1982).

27. "Happy Accumulation Eyeing Deals," *New York Herald Tribune*, March 22, 1959, Series I, Box 22, Churchill Files, SP.

28. Frank Manheim to Lehmann Partners, October 22, 1959, Series I, Box 22, Churchill Files, SP.

29. Frank Manheim to Harold Churchill, n. d., Series I, Box 22, Churchill Files; and Frank J. Manheim to Harold Churchill, November 8, 1959, Series I, Box 22, Churchill Files; SP.

30. Frank Manheim to A. M. "Sonny" Sonnabend, September 28, 1959, Series I, Box 22, Churchill Files, SP.

31. Executive Committee, Board of Directors Meeting, June 1, 1959, Series I, Box 22, Churchill Files, SP.

32. Executive Committee, Board of Directors Meeting, July 7, 1959, Series I, Box 22, Churchill Files; and Executive Committee, Board of Directors Meeting, July 20, 1959, Series I, Box 22, Churchill Files, SP.

33. De F. Billyou to Harold Churchill, June 10, 1959, Series I, Box 22, Churchill Files, SP.

34. Executive Committee, Board of Directors Meeting, July 6, 1960, Meeting File 4/28/60-12/19/60, SP.

35. Board of Directors Meeting, April 21, 1960 and May 16, 1960, Meetings File 4/28/60-12/19/60; and Memo, for Board of Directors, "Competitive Pressures on Dualed Dealers," June 20, 1960, Meetings File 4/28/60-12/19/60, SP. "The Word—Sell," *Newsweek*, June 20, 1960, Series I, Box 22, SP. The report on Volkswagen is found in Board of Directors Meeting, October 17, 1960, Meeting File 4/28/60-12/19/60, SP.

36. Executive Committee, Board of Directors Meeting, April 6, 1959, Meetings File 10/30/58-4/6/59, SP; and "Studebaker Picks New Chief," *Wall Street Journal*, September 6, 1960.

37. Executive Committee, Board of Directors Meeting, June 3, 1960 and July 6, 1960, Meeting File 4/28/60-12/19/60; and Executive Committee, Board of Directors, July 3, 1960, Meeting File 4/28/60-12/19/60, SP.

38. The industry in general had been shaken by both the resignation of Ernest Breech at Ford in July, and earlier that April the resignation of William C. Newberg, chief operating officer of Chrysler, who was forced out after it was revealed he had given contracts to supply companies in which he held significant interests. Now Francis made news by becoming head of Studebaker, albeit it was a temporary appointment.

39. Executive Committee, Board of Directors Meeting, July 6, 1960, Meeting File 4/28/60-12/19/60, SP. "Studebaker Picks New Chief; Step-Up in Mergers Likely," *Wall Street Journal*, September 6, 1960, Box 4, Conrad Family Papers, in University of Virginia. This clipping is also found in Box 41, Hoffman Papers.

40. Board of Directors Meeting, April 28, 1960, Meetings File 4/28/60-12/19/60, SP.

41. Board of Directors Meeting, June 20, 1960, Meeting File 4/28/60–12/19/60, SP.

42. Board of Directors Meeting, November 28, 1960, Meetings File 4/28/60–12/19/60, SP.

43. Board of Directors Meeting, December 5, 1960, Meeting File 4/28/60–12/19/60; and A. M. Sonnabend to Board of Directors, December 5, 1960, 1/4/61–3/28/61, SP.

44. Board of Directors Meeting, December 28, 1960, Meeting File 4/28/60–12/19/60, SP.

45. Executive Committee Meeting, January 4, 1961, Directors Meeting files, Janaury 4, 1961–March 28, 1961, SP.

46. Studebaker Corporation, *Annual Report to the Stockholders* (1961), Supporting Documents, Box 5 (April 27, 1961–December 12, 1962), SP.

47. Much of Egbert's success came from an aggressive diversification program and from the sale of property. By 1962 Studebaker had acquired CTL, Inc. (August 1959); Gravely Tractors (May 1960); Clarke Floor Machine Company (September 1960); and D. W. Onan and Sons (October 1960). In the course of the next two years Studebaker further diversified its holdings to include Chemical Compounds, Inc. (March 1961); Schaefer, Inc. and Paxton Products (March 1962); and Trans-International Airlines, Inc. (October 1962).

48. Board of Directors Meeting, July 27, 1961, Supporting Documents, Box 16, April 27, 1961–December 27, 1961 File, SP.

49. Problems leading up to the strike are traced in Board of Directors Meeting, September 28, 1961, Supporting Documents, Box 16, April 26, 1961–December 22, 1961 File; Board of Directors Meeting, December 22, 1961, Supporting Documents, Box 16, April 26, 1961–December 22, 1961 File, SP.

50. Egbert's regime is tersely summarized in Beatty, Furlong, and Pennington, *Studebaker: Less Than They Promised*, 41–47.

51. The strike was followed closely by *Business Week*. See "UAW Strikes Studebaker Packard," *Business Week*, January 6, 1962, 93; "In Business," *Business Week*, January 27, 1962, 40; and "At Studebaker Strong Medicine for Survival," *Business Week*, February 17, 1962, 34. The union's position is found in a "Telegram from the Union to Board of Directors," January 24, 1962, Board of Directors Meeting, January 25, 1962, Supporting Documents, Box 16, January 25, 1962–November 2, 1962 File, SP.

52. Board of Directors Meeting, January 25, 1962, Supporting Documents Box 16, January 25, 1962–November 2, 1962 File, SP.

53. Transcript, Annual Meeting of Stockholders, April 26, 1962, Supporting Documents, Box 16, SP.

54. "Studebaker Comes Out of a Skid," *Business Week*, March 9, 1963, 66–67. Also, "Split Personality," *Forbes*, October 1, 1963, 18; Board of Directors Meeting, February 28, 1961, Directors Meeting File January 4, 1961–March 28, 1961, SP. Egbert quotation is from Edwards, *Dynamics of the United States Automobile Industry*, 100.

55. "Studebaker Comes Out of a Skid," *Business Week*, March 9, 1963, 67.

56. Board of Directors Meeting, February 6, 1960, Supporting Documents, Directors Meetings January 4, 1961–March 28, 1961, SP.

57. Transcript, President's Report, Annual Stockholders Meeting (1962), Supporting Documents Box 16, April 17, 1961–December 22, 1961 File, SP.

58. Ibid.

59. The all-plastic car body had long been a dream of automakers. Henry Ford had experimented with a plastic car made from a mixture of soybean and wood fibers in 1929, and in 1938 General Motors had launched a plastic car research program. But it was World War II that made the use of plastic a reality with the development of plastics as substitutes for strategic metals. James Gilbert, *Another Chance* (New York, 1981), 29.

60. Transcript, Annual Stockholders Meeting (April 26, 1962), Supporting Documents, Box 16, April 17, 1961–December 22, 1961 File, SP.

61. "Plastics Ride the High Road," *Business Week*, February 10, 1962, 124–26. Quotation on sheet metal is from "Studebaker Comes Out of a Skid," *Business Week*, March 9, 1963, 67. Quotation on organized chaos is from Minutes, Executive Committee, Board of Directors Meeting, June 10, 1962, Supporting Documents, Box 16, January 25, 1962–November 2, 1962 File, SP.

62. "Studebaker Puts on a New Face," *Business Week*, September 14, 1963, 63.

63. Memorandum, To Board of Directors, May 11, 1962, Board of Directors Meeting, June 1, 1962, Supporting Documents, Box 16, January 25, 1962–November 2, 1962 File, SP.

64. Beatty, Furlong, and Pennington, *Studebaker: Less Than They Promised*, 44–46.

65. Quoted in ibid., 48.

Epilogue

1. Quoted in "Closing Wasn't a Surprise," *South Bend Tribune*, December 4, 1988.

2. "Gilbert's Angry Remark Proves Prophetic," *South Bend Tribune*, December 9, 1988.

3. This memorandum is quoted at length in Beatty, Furlong, and Pennington, *Studebaker: Less Than They Promised*, 53. This memorandum appears to have been lost in the archival records.

4. These figures are cited in Beatty, Furlong, and Pennington, *Studebaker: Less Than They Promised*, 57.

5. Merton C. Bernstein, *The Future of Private Pensions*, (New York, 1964); and Robert Metz, "Workers Finding Pensions Empty," *New York Times*, August 16, 1964, 3:11.

6. Paul Dodson, "Community Was There to Help Workers," *South Bend Tribune*, December 6, 1988.

7. External factors—including size and economy of size—were emphasized by Robert F. Lanzillotti, "The Automobile Industry," 256–301. The most detailed analysis that calculated the specific costs and benefits within a model that emphasized economies of scale is found in White, *The Automobile Industry Since 1945.*

8. Macdonald, *Collective Bargaining.*

9. Macdonald, *Collective Bargaining*, 268.

10. Raucher, *Paul G. Hoffman.*

11. Stephen Amberg, "Triumph of Industrial Orthodoxy: The Collapse of Studebaker-Packard Corporation," in Nelson Lichtenstein and Stephen Meyer, *On the Line: Essays in the History of Auto Work* (Urbana, Illinois, 1989).

12. John Bodnar, "Power and Memory in Oral History: Workers and

Managers at Studebaker," *Journal of American History* (March 1989), 1201–21.

13. Robin Hemley, *The Last Studebaker* (Saint Paul, Minn., 1992).

14. The University of Notre Dame and Studebaker enjoyed a close association throughout the company's history. In the late nineteenth century, South Bend promoted the University of Notre Dame as a regional tourist attraction. In the 1920s, Erskine served on the university's board of trustees. In exchange, Notre Dame's Knute Rockne became Studebaker's national spokesman. In the summer, Notre Dame students often went to work at Studebaker. When Studebaker closed in 1963, Fr. Theodore Hesburgh called upon the federal government to make up for the city's loss by making South Bend into a national research center.

15. "Sleek but Square—and that's why we loved the Studie," *Smithsonian*, December 1991, 44–54.

Selected Bibliography

Manuscript Collections

Albert Beveridge Papers. Library of Congress. Washington, D.C.

John Cavanaugh Papers. University of Notre Dame Archives. Notre Dame, Indiana.

Henry Cave Papers. Detroit Public Library. Detroit, Michigan.

Roy Chapin Papers. Bentley History Library, University of Michigan. Ann Arbor, Michigan.

Conrad Family Papers. University of Virginia. Charlottesville, Virginia.

Sol A. Dann Papers. Walter Reuther Library, Wayne State University. Detroit, Michigan.

Henry Ford Archives. Dearborn, Michigan.

Arthur Garford Papers. Ohio Historical Society. Columbus, Ohio.

Paul Hoffman Papers. Harry S. Truman Library. Independence, Missouri.

Indiana University Oral History Project. Indiana University. Bloomington, Indiana.

Indiana University, South Bend Oral History Project. Studebaker National Museum. South Bend, Indiana.

Henry B. Joy Papers. Bentley History Library, University of Michigan. Ann Arbor, Michigan.

Otto Kirchner Papers. Burton Collection, Detroit Public Library. Detroit, Michigan.

H. S. Maynard Papers. Burton Collection. Detroit Public Library. Detroit, Michigan.

National Automotive Historical Collection. Detroit Public Library. Detroit, Michigan.

Postmaster General Division of Motor Service, Correspondence, Record Group 28, National Archives. Washington, D.C.

William Ogden Papers. Walter Reuther Library, Wayne State University. Detroit, Michigan.

South Bend Tribune Archives. South Bend, Indiana.

Studebaker Brothers File. South Bend Library, South Bend, Indiana.

Studebaker Corporation Papers. Studebaker National Museum. South Bend, Indiana.

Clement Studebaker Papers. Northern Indiana Historical Society. South Bend, Indiana.

Studebaker-Packard Department Papers. Walter Reuther Library, Wayne State University. Detroit, Michigan.

U.A.W. Local 5 Papers. Walter Reuther Library, Wayne State University. Detroit, Michigan.

Unpublished Sources

Delaney, John Joseph, "The Beginnings of Industrial South Bend" (Masters thesis, University of Notre Dame, 1951).

Hay, David L., "Bomber Businessmen: The Army Air Force and the Rise of Statistical Control, 1940–1945" (Ph.D. Dissertation, University of Notre Dame, 1994).

Heckscher, Charles Chevreux, "Democracy at Work: In Whose Interests: The Politics of Worker Participation" (Ph.D. dissertation, Harvard University, 1981).

Pennington, Loren E., "Prelude to Chrysler: The Eisenhower Administration Bails Out Studebaker" (unpublished paper, n.d.). Studebaker National Museum Archives.

Books

Abernathy, William J., Kim B. Clark, and Alan M. Kantrow, *Industrial Renaissance: Producing a Competitive Future for America* (New York, 1983).

Adams, Charles Francis, Jr., *Railroads: The Origin and Problems* (New York, 1893).

Alderfer, E. G., *Ephrata Commune: An Early American Counterculture* (Pittsburgh, 1985).

Aldrich, Howard, *Organizations and Environments* (New York, 1979).

Amberg, Stephen. *The Union Inspiration in American Politics: The Autoworkers and the Making of a Liberal Industrial Order* (Philadelphia, 1994).

American Iron and Steel Association, *Bulletin* (n.p.p., 1887, 1883).

Anderson, Rudolph E., *The Story of the American Automobile* (Washington, D.C., 1950).

Anderson and Cooley, *South Bend and the Men Who Have Made It, Historical, Descriptive, and Biographical* (South Bend, 1901).

Andrews, Kenneth R., *The Concept of Corporate Strategy* (Homewood, 1971).

Armi, Edson, *The Art of American Car Design: The Profession and Personalities* (University Park, 1988).

Automobile Manufacturing Association, *Automobile Facts and Figures* (Detroit, 1958).

Automobile Quarterly, *The American Car since 1775* (New York, 1971).

Averich, Paul, *The Haymarket Tragedy* (Princeton, 1985).

Ayres, Leonard P., *The Automobile Industry and Its Future* (Boston, 1921).

Barnard, John, *Walter Reuther and the Rise of the Auto Workers* (Boston, 1983).

Barrett, Paul, *The Automobile and Urban Transit: The Formation of Public Policy in Chicago, 1900–1930* (Philadelphia, 1983).

Beatty, Michael, Patrick Furlong, and Loren Pennington, *Studebaker: Less Than They Promised* (South Bend, 1984).

Bendix, Reinhard, *Work and Authority in Industry: Ideologies of Management in the Course of Industrialization* (New York, 1956).

Berger, Michael, *The Devil Wagon in God's Country: The Automobile and Social Change in Rural America, 1893–1929*, (Hamden, Conn., 1979).

Berk, Gerald, *Alternative Tracks: The Constitution of American Industrial Order, 1865–1917* (Baltimore, 1994).

Bernstein, Merton C., *The Future of Private Pensions* (New York, 1964).

Bluestone, Barry, and Bennett Harrison, *The Deindustrialization of America:*

Plant Closings, Community Abandonment, and the Dismantling of Basic Industries (New York, 1982).

Bottles, Scott L., *Los Angeles and the Automobile: The Making of the Modern City* (Berkeley, 1987).

Brethren Encyclopedia II (Philadelphia, 1983).

Brierley, Brooks T., *There is No Mistaking a Pierce Arrow* (Coconut Grove, Florida, 1986).

Brilliant, Ashleigh, *The Great Car Craze: How Southern California Collided with the Automobile in the 1920s* (Santa Barbara, 1989).

Brumbaugh, Martin Grove, *A History of the German Baptist Brethren in Europe and America* (Mount Morris, Illinois, 1910; reprinted 1971).

Bury, Martin H., *The Automobile Dealer* (Philadelphia, 1961).

Byrne, John A., *The Whiz Kids: Ten Founding Fathers of American Business and How They Changed the World* (New York, 1993).

Cannon, William A., and Fred K. Fox, *Studebaker: The Complete Story* (Blue Ridge Summit, Penn., 1981).

Carlock, Walter, Alvin Faust, and Irene Miller, *The Studebaker Family in America, 1737–1976* (Tipp City, Ohio, 1976).

Carriage Builders Association, *Carriage Builders Association Reports*, XXII (Philadelphia, 1894).

Carriage Builders Association, *Twenty-First Annual Report of the Carriage Builders Association* (Philadelphia, 1893).

Carriage Builders National Association, *Third Annual Meeting* (Chicago, 1874).

Carriage Builders National Association, *Seventh Annual Meeting* (Chicago, 1879).

Carriage Builders National Association, *Eighth Annual Meeting* (Chicago, 1881).

Chandler, Alfred D., Jr., *Giant Enterprise: Ford, General Motors, and the Automobile Industry* (New York, 1964).

Chandler, Alfred D., Jr., *Strategy and Structure: Chapters in the History of the American Industrial Enterprise* (Cambridge, Mass., 1962).

Chandler, Alfred D., Jr., *The Structure of American Industry* (New York, 1971).

Chandler, Alfred D., Jr., *The Visible Hand: The Managerial Revolution in American Business* (Cambridge, Mass., 1977).

Chandler, Alfred D., Jr., and Stephen Salisbury, *Pierre S. DuPont and the Making of the Modern Corporation* (New York, 1971).

Chapman and Company, *History of St. Joseph County* (Chicago, 1907).

Chrysler Corporation, *The Story of an American Company* (Detroit, 1955).

Chrysler, Walter P., *Life of an American Workman* (New York, 1937).

Clark, Victor S., *History of Manufacturers in the United States*, II (New York, 1929).

Cochran, Bert, *Labor and Communism* (Princeton, 1977).

Cochran, Thomas C., *Railroad Leaders 1845–1890: The Business Mind in Action* (Cambridge, 1953).

Collier, Peter, and David Horowitz, *The Fords: An American Epic* (New York, 1987).

Corle, Edwin, *John Studebaker, An American Dream* (New York, 1948).

Cray, Ed, *Chrome Colossus: General Motors and Its Times* (New York, 1980).

Cumbler, John T., *The Working Class Community in Industrial America: Leisure and Struggle in Two Industrial Cities, 1880–1930* (Westport, 1979).

Davis, Donald Finlay, *Conspicuous Production: Automobile and Elites in Detroit, 1899–1933* (Philadelphia, 1988).

Dubofsky, Melvin, *American Labor since the New Deal* (Chicago, 1971).

Dubofsky, Melvin, *We Shall Be All: The Industrial Workers of the World* (Chicago, 1969).

Dunnett, Peter J. S., *The Decline of the British Motor Industry: The Effects of Government Policy, 1945–1979* (London, 1980).

Edwards, Charles E., *Dynamics of the United States Automobile Industry* (Columbia, South Carolina, 1965).

Edwards, Richard, *Contested Terrain: The Transformation of the Workplace in the Twentieth Century* (New York, 1979).

Edwards, William B. *The Story of Colt's Revolver: The Biography of Col. Samuel Colt* (Harrisburg, 1953).

Elbaum, Bernard, and William H. Lazonick, eds., *The Decline of the British Economy* (New York, 1986).

Epstein, Ralph C., *The Automobile Industry* (Chicago, 1926).

Erb, Peter C., *Johann Conrad Beissel and the Ephrata Community, Mystical and Historical Texts* (Lewiston, New York, 1985).

Ernst, James E., *Ephrata: A History* (Allentown, Pennsylvania, 1963).

Erskine, Albert Russel, *History of the Studebaker Corporation* (South Bend, Indiana, 1924).

Esarey, Logan, *History of Indiana* (Dayton, Ohio, 1923).

Exman, Eugene. *Brothers Harper: A Unique Publishing Partnership* (New York, 1965).

Federal Trade Commission, *Report of the Federal Trade Commission on Distribution Methods and Costs*, Pt. IV (Washington, D.C., 1944).

Federal Trade Commission, Bureau of Economics, *Statistical Report on Mergers and Acquisitions* (Washington, D.C., 1980).

Fine, Sidney, *The Automobile Under the Blue Eagle: Labor, Management, and the Automobile Manufacturing Code* (Ann Arbor, Michigan, 1963).

Fine, Sidney, *Sit-Down: The General Motors Strike of 1936–1937* (Ann Arbor, Michigan, 1969).

Fink, Leon, *Workingmen's Democracy, The Knights of Labor and American Politics* (Urbana, Illinois, 1983).

Flink, James J., *America Adopts the Automobile, 1895–1910* (Cambridge, Mass., 1970).

Flink, James J., *The Automobile Age*, (Cambridge, Mass., 1988).

Flint, Jerry, ed., *The Dream Machine: The Golden Age of American Automobiles* (New York, 1976).

Ford, Henry, *My Philosophy of Industry* (New York, 1926).

Frisch, Michael, *Town into City: Springfield, Massachusetts and the Meaning of Community, 1840–1880* (Cambridge, 1972).

Fry, Robin, *The VW Beetle* (London, 1980).

Gartman, David, *Auto Slavery: The Labor Process in the American Automobile Industry, 1897–1950* (New Brunswick, New Jersey, 1986).

Georgano, Nick, *The American Automobile: A Centenary 1893–1993* (New York, 1992).

Gilbert, James, *Another Chance* (New York, 1981).

Goodrich, DeWitt Clinton, *An Illustrated History of the State of Indiana* (Indianapolis, 1875).

Green, Marguerite, *The National Civic Federation and the American Labor Movement, 1900–1925* (Washington, D.C., 1956).

Greenleaf, William, *Monopoly on Wheels: Henry Ford and the Selden Patent Suit* (Detroit, 1961).

Gutman, Herbert, *Work, Culture and Society in Industrializing America, 1815–1919* (New York, 1977).

Halberstram, David, *The Reckoning* (New York, 1986).

Hall, Asa E., and Richard M. Langworth, *The Studebaker Century* (Contoocook, New Hampshire, 1983).

Harbison, Frederick H., and Robert Dubin, *Patterns of Union-Management Relations* (Chicago, 1947).

Helmers, H. O., Charles N. Davisson, and Herbert Taggart, *Two Studies in Automobile Franchising* (Ann Arbor, Mich., 1974).

Hemley, Robin, *The Last Studebaker* (Saint Paul, Minn., 1992).

Hewitt, Charles Mason, Jr., *Automobile Franchise Agreements* (Homewood, Ill., 1956).

Hidy, Ralph W., and Muriel E. Hidy, *Pioneering in Big Business, 1882–1911* (New York, 1955).

Higgins, Beldon, and Company, *Historical Atlas of St. Joseph County, Indiana* (Chicago, 1875).

Higham, John, Leonard Kreiger, and Felix Gilbert, *History: The Development of Historical Studies in the United States* (Princeton, New Jersey, 1965).

Hill, James D., *A Brief History of the Labor Movement of Studebaker* (South Bend, Indiana, 1953).

Hill, James D., *U.A.W.'s Frontier* (South Bend, Indiana, 1971).

History of St. Joseph County, Indiana (Chicago, 1880).

Hounshell, David A., *From the American System to Mass Production, 1800–1932* (Baltimore, 1984).

Howard, Timothy, *A History of St. Joseph County*, 2 v. (Chicago, 1907).

Jacoby, John E., *Two Mystic Communities in America* (Paris, 1931).

Jacoby, Sanford M., *Employing Bureaucracy: Managers, Unions, and the Transformation of Work in American Industry, 1900–1945* (New York, 1985).

Jefferys, Steve, *Management and Managed: Fifty Years of Crisis at Chrysler* (Cambridge, 1986).

Jerome, John, *The Death of the Automobile: The Fatal Effect of the Golden Era, 1955–1970* (New York, 1972).

Jodard, Paul, *Raymond Loewy* (New York, 1992).

Josephson, Matthew, *The Robber Barons: The Great American Capitalists, 1861–1901* (New York, 1934).

Katz, Harold, *The Decline of Competition in the Automobile Industry, 1920–1940* (New York, 1977).

Katzenstein, Peter, *Small States in the World Market: Industrial Policy in Europe* (Ithaca, 1985).

Keeran, Roger, *The Communist Party and the Auto Worker Unions* (Bloomington, Indiana, 1980).

Kirkland, Edward Chase, *Men, Cities and Transportation: A Study in New England History 1820–1900*, 2 vols. (Cambridge, Mass., 1948).

Klein, Walter C., *Johann Conrad Beissel, Mystic and Martinet, 1690–1768* (Philadelphia, 1942).

Kochan, Thomas A., Harry C. Katz, and Robert B. McKersie, *The Transformation of American Industrial Relations* (New York, 1984).

Kuhn, Arthur J., *GM Passes Ford, 1918–1938: Designing the General Motors Performance Control System* (University Park, 1986).

Kull, Irving S., ed., *New Jersey: A History* (New York, 1930).

Lacey, Robert, *Ford: The Men and the Machine* (Boston, 1986).

Langworth, Richard M., *The Last Onslaught on Detroit* (Princeton, New Jersey, 1975).

Langworth, Richard M., *Studebaker: The Postwar Years* (Osceola, Wisc., 1979).

Langworth, Richard M., and Jan P. Norbye, *The Complete History of Chrysler Corporation, 1924–1985* (New York, 1985).

Laux, James M., *In First Gear: The French Automobile Industry to 1914* (Montreal, 1976).

Lawrence, Paul R., and Davis Dyer, *Renewing American Industry* (New York, 1983).

Learned, Edmund, Kenneth R. Andrews, C. Roland Christensen, and William D. Guth, *Business Policy: Test and Cases* (Homewood, 1965).

Leonard, Jonathan N., *The Tragedy of Henry Ford* (New York, 1932).

Lewis, David L., *The Public Image of Henry Ford* (Detroit, 1976).

Lewis, Eugene W., *Motor Memories: A Saga of Whirling Gears* (Detroit, 1947).

Lichtenstein, Nelson, *Labor's War at Home: The CIO in World War II* (New York, 1982).

Lichtenstein, Nelson, *The Most Dangerous Man in Detroit: Walter Reuther and the Fate of American Labor* (New York, 1995).

Lichtenstein, Nelson, and Stephen Meyer, *On the Line: Essays in the History of Auto Work* (Urbana, Illinois, 1989).

Lloyd, Henry Demarest, *Wealth against Commonwealth* (New York, 1894).

Loewy, Raymond, *Never Leave Well Enough Alone* (New York, 1951).

Longstreet, Stephen, *A Century on Wheels: The Story of Studebaker* (New York, 1952).

Mahoney, Tom, *The Story of George Romney: Builder, Statesman, Crusader* (New York, 1960).

Marquis, Samuel S., *Henry Ford: An Interpretation* (Boston, 1923).

Maxim, Hiram Percy, *Horseless Carriage Days* (New York, 1937).

May, George S., ed., *The Encyclopedia of American Business History and Biography: The Automobile Industry, 1920–1980* (New York, 1989).

May, George S., *A Most Unique Machine* (New York, 1975).

Macdonald, Robert M., *Collective Bargaining in the Automobile Industry: A Study of Wage Structure and Competitive Relations* (New Haven, 1963).

McCormack, L. P., and B. Frank Schmid, *The Second Biennial Report of the Indiana Labor Commission for the Years 1899–1900* (Indianapolis, 1901).

McCraw, Thomas K., ed., *The Essential Alfred Chandler: Essays toward a Historical Theory of Big Business* (Boston, 1988).

Meickle, Jeffrey L., *Twentieth Century Limited* (Philadelphia, 1979).

Meier, August, and Elliott Rudwick, *Black Detroit and the Rise of the UAW* (New York, 1979).

Meyer, Stephen III, *The Five Dollar Day: Labor Management and Social Control in the Ford Motor Company, 1908–1921* (Albany, N.Y., 1981).

Mitchell, Daniel J. B., *Unions, Wages, and Inflation* (Washington, D.C., 1980).

Montgomery, David, *The Fall of the House of Labor: The Workplace, the State, and American Labor Activism, 1865–1925* (New York, 1987).

Morgan, Gareth, *Images of Organization* (Beverly Hills, 1986).

Moritz, Michael, and Barrett Seaman, *Going for Broke: The Chrysler Story* (Garden City, New Jersey, 1981).

Nader, Ralph, *Unsafe at Any Speed: The Designed-In Dangers of the American Automobile* (New York, 1965).

National Civic Federation, *Education, Conciliation and Industrial Peace* (New York, 1905).

Nelson, Daniel, *Frederick W. Taylor and the Rise of Scientific Management* (Madison, Wisc., 1980).

Nelson, Daniel, *Managers and Workers: Origins of the New Factory System in the United States, 1880–1920* (Madison, Wisc., 1975).

Nelson, Richard R., and Sidney G. Winter, *An Evolutionary Theory of Economic Change* (Cambridge, 1982).

Nelson, Walter Henry, *Small Wonder: The Amazing Story of the Volkswagen*, revised edition (Boston, 1967).

Nevins, Allan, *The Emergence of Modern America 1865–1878* (New York, 1927).

Nevins, Allan, *John D. Rockefeller: The Heroic Age of America* (New York, 1940).

Nevins, Allan, *Study in Power: John D. Rockefeller* (New York, 1953).

Nevins, Allan, and Frank E. Hill, *Ford: Expansion and Challenge, 1915–1932* (New York, 1957).

Nevins, Allan, and Frank E. Hill, *Ford: Decline and Rebirth, 1933–1962* (New York, 1957).

Nevins, Allan, and Frank E. Hill, *Ford: The Times, the Man, the Company* (New York, 1954).

New Jersey Senate Journal (Trenton, New Jersey, 1886).

Palmer, Bryan D., *A Culture in Conflict: Skilled Workers and Industrial Capitalism in Hamilton, Ontario, 1860–1914* (Montreal, 1979).

Parlin, Charles C., and Fred Bremier, *The Passenger Car Industry* (Philadelphia, 1932).

Pearson, Charles T., *The Indomitable Tin Goose: The True Story of Preston Tucker and His Car* (New York, 1960).

Peterson, Joyce Shaw, *American Automobile Workers, 1900–1933* (Albany, New York, 1987).

Phillips, Clifton J., *Indiana in Transition: The Emergence of an Industrial Commonwealth, 1880–1920* (Indianapolis, 1968).

Piore, Michael J., and Charles F. Sabel, *The Second Industrial Divide: Possibilities for Prosperity* (New York, 1984).

Preston, Howard L., *Automobile Age Atlanta: The Making of a Southern Metropolis, 1900–1935* (Athens, Ga., 1979).

Rae, John B., *The American Automobile: A Brief History* (Chicago, 1965).

Rae, John B., *The American Automobile Industry* (Boston, 1984).

Rae, John B., *American Automobile Manufacturers: The First Forty Years* (Philadelphia, 1959).

Rae, John B., *The Road and the Car in American Life* (Cambridge, Mass., 1971).

Raucher, Alan R., *Paul G. Hoffman: Architect of Foreign Aid* (Lexington, Kentucky, 1985).

Redlich, Fritz, *History of American Business Leaders: A Series of Studies*. Volume I, *Theory, Iron and Steel, Iron Ore Mining* (Ann Arbor, 1940); Volume II, *The Molding of American Banking: Men and Ideas, Part I, 1781–1840* (New York, 1947), *Part II, 1840–1910* (New York, 1951).

Reed, George Irving, ed., *Encyclopedia of Biography of Indiana* Vol. 1. (Chicago, 1895).

Reich, Robert R., *The Next American Frontier* (New York, 1983).

Reich, Robert R., and John D. Donahue, *New Deals: The Chrysler Revival and the American System* (New York, 1985).

Reuther, Victor G., *The Brothers Reuther and the Story of the UAW* (Boston, 1976).

Richardson, Kenneth, *The British Motor Industry, 1890–1939: A Social and Economic History* (London, 1977).

Rodgers, Daniel T., *The Work Ethic in Industrial America, 1850–1920* (Chicago, 1978).

Roeber, A. G., *Palatines, Liberty, and Property: German Lutherans in Colonial British America* (Baltimore, 1993).

Sachse, Friedrich, *The German Sectarians of Pennsylvania, 1742–1800: A Critical and Legendary History of the Ephrata Cloister and the Dunkers* (Philadelphia, 1899, reprinted 1971).

Scharf, Virginia, *Taking the Wheel: Women and the Coming of the Motor Age* (New York, 1991).

Schumpeter, Joseph A., *Business Cycles: A Theoretical, Historical and Statistical Analysis of the Capitalist Process* (New York, 1939).

Schwantes, Carlos A. *Coxey's Army: An American Odyssey* (Lincoln, 1985).

Sealander, Judith, *Grand Plans: Business Progressivism and Social Change in Ohio's Miami Valley, 1890–1929* (Lexington, 1988).

Seltzer, Lawrence H., *A Financial History of the American Automobile Industry* (Boston, 1928).

Seventh Day Baptists in Europe and America, volumes I and II (Plainfield, New Jersey, reprinted 1980).

Sloan, Alfred P., Jr., *My Years with General Motors* (Garden City, New Jersey, 1964).

Smallzried, Kathleen Ann, and Dorothy James Roberts, *More Than You Promise: A Business at Work in Society* (New York, 1942).

Sorensen, Charles, *My Forty Years with Ford* (New York, 1956).

Spero, Sterling D., and Abram L. Harris, *The Black Worker: The Negro and the Labor Movement* (New York, 1931).

Swaine, Robert, *The Cravath Firm and Its Predecessors, 1819–1948, II* (New York, 1948).

Sward, Keith, *The Legend of Henry Ford* (New York, 1949).

Tedlow, Richard S., *Keeping the Corporate Image: Public Relations and Business, 1900–1950* (Greenwich, 1979).

Thomas, Robert Paul, *An Analysis of the Pattern of Growth of the Automobile Industry: 1895–1929* (Evanston, Ill., 1966; reprint, New York, 1977).

Tolliday, Steven, and Jonathan Zeitlin, *Shop Floor Bargaining and the State: Historical and Comparative Perspectives* (Cambridge, 1985).

United Auto Workers Union, *Proceedings of the Second Convention of the International Union, United Automobile Workers of America* (Detroit, 1936).

United States Bureau of the Census, *Abstract of the Tenth Census of the United States* (Washington, D.C., 1880).

United States Bureau of the Census, *Bulletins*, 81–90 (Washington, D.C., 1905).

United States Bureau of Labor Statistics, *Welfare Work for Employees in Industrial Establishments in the United States* (Washington, D.C., 1919).

Ure, Andrew, *Dictionary of Arts, Manufacturers, and Mines* (New York, 1856).

Wallace, Anthony, *Rockdale: The Growth of an American Village in the Early Industrial Revolution* (New York, 1978).

Ward, James A., *The Fall of the Packard Motor Car Company* (Stanford, 1995).

Weinstein, James, *The Corporate Ideal in the Liberal State, 1900–1918* (Boston, 1963).

Weisberger, Bernard A., *The Dream Maker: William C. Durant, Founder of General Motors* (Boston, 1979).

White, Lawrence J., *The Automobile Industry Since 1945* (Cambridge, Mass., 1971).

Wik, Reynold M., *Henry Ford and Grass Roots America* (Ann Arbor, Mich., 1972).

Williamson, Oliver, *The Economic Institutions of Capitalism: Firms, Markets, Relational Contracting* (New York, 1985).

Wright, J. Patrick, *On a Clear Day You Can See General Motors: John Z. DeLorean's Look Inside the Automotive Giant* (Grosse Pointe, Michigan, 1979).

Yates, Brock, *The Decline and Fall of the American Automobile Industry* (New York, 1983).

Zerfass, S. G., *Souvenir Book of the Ephrata Cloister* (New York, 1921; reprinted 1975).

Articles

Bodnar, John, "Power and Memory in Oral History: Workers and Managers at Studebaker," *Journal of American History* 74:4 (March 1989).

Bourke, Robert E., "The Starlight and the Starliner: Some Recollections by a Designer," *Automobile Quarterly* X (Third Quarter 1972).

Bridges, Hal, "The Robber Baron Concept in American History," *Business History Review* 32 (Spring 1958).

Brownell, Baine A., "A Symbol of Modernity: Attitudes toward the Automobile in Southern Cities in the 1920s," *American Quarterly* 24 (March 1972).

Caves, Richard, "Industrial Organization, Corporate Strategy and Structure," *Journal of Economic Literature* 18 (March 1980).

Chandler, Alfred D., Jr., "The Beginnings of 'Big Business' in American Industry," *Business History Review* 33 (Spring 1959).

Chandler, Alfred D., Jr., "Development, Diversification and Decentralization." In Ralph E. Freeman, ed., *Postwar Economic Trends in the United States* (New York, 1960).

Chandler, Alfred D., Jr., "The Railroads: Pioneers in Modern Corporate Management," *Business History Review* 39 (Spring 1965), 16–40.

Chandler, Alfred D., Jr., "The Structure of American Industry in the Twentieth Century: A Historical Overview," *Business History Review* 43 (Autumn 1969).

Chandler, Alfred D., Jr., and Fritz Redlich, "Recent Developments in American Business Administration and Their Conceptualization," *Business History Review* 35 (Spring 1961).

Craypo, Charles, "The Deindustrialization of a Factory Town: Plant Closings and Phasedowns in South Bend, Indiana, 1954–1983." In D. Kennedy, ed., *Labor and Reindustrialization: Workers and Corporate Change* (Monograph in Labor Studies Department, Pennsylvania State University, 1984).

Cuff, Robert D., "American Historians and the 'Organizational Factor,'" *Canadian Review of American Studies* 4 (Spring 1973).

Davis, Donald Finlay, "The Social Determinants of Success in the American

Automotive Industry before 1929," *Social Science Information: Colloquium on the Global Automobile Industry* (Beverly Hills, Calif., 1982).

Davis, Donald Finlay, "Studebaker Stumbles into Detroit," *Detroit in Perspective* 4 (1979).

Dellheim, Charles, "The Creation of a Company Culture: Danbury's 1861–1931," *American Historical Review* (February 1987), 13–44.

Destler, Chester M., "Wealth against Commonwealth, 1894 and 1944," *American Historical Review* 50 (October 1944), 49–69.

Friedman, David, "Beyond the Age of Ford: The Strategic Basis of the Japanese Success in Automobiles." In John Zysman and Laura Tyson, eds., *American Industry in International Competition: Government Policies and Corporate Strategies* (Ithaca, 1983).

Galambos, Louis, "The Emerging Organization Synthesis in Modern American History," *Business History Review* 44 (Autumn 1970).

Galambos, Louis, "Technology, Political Economy, and Professionalization: Central Themes of the Organization Synthesis," *Business History Review* 57 (Winter 1983).

Griswold, Glenn, "Humanized Employee Relations: Studebaker an Example," *Public Opinion Quarterly* 4 (Sept. 1940).

Hanna, Annetta, ed., "Raymond Loewy, 1893–1986," *Industrial Design Magazine* (November/December 1986).

Heath, Perry S., "Automobile Postal Service," *The Automobile Magazine* I (February 1900).

Hendry, Maurice D., "One Can Do A Lot of Remembering in South Bend," *Automobile Quarterly* X:3 (Third Quarter 1972).

The Hub, "Trade News," September 6, 1893.

Jenks, Leland H., "Early Phases of the Management Movement," *Administrative Science Quarterly* 5 (December 1960).

Kimes, Beverly Rae, "The Big Presidents: Studebaker in the Classic Era," *Automobile Quarterly* XVIII:1 (First Quarter 1980).

Kimes, Beverly Rae, "E & M & F . . . & Leroy," *Automobile Quarterly* XVII:4 (Fourth Quarter, 1979).

Lanzillotti, Robert, "The Automobile Industry." In Walter Adams, ed., *The Structure of American Industry*, fourth edition (New York, 1971).

Lazonick, William H., "Industrial Organization and Technological Change: The Decline of the British Cotton Industry," *Business History Review* 57 (Summer 1983).

Lazonick, William H., "Theory and History in Marxian Economics." In Alexander J. Field, ed., *The Future of Economic History* (Boston, 1987).

Lichtenstein, Nelson, "Auto Worker Militancy and the Structure of Factory Life," *Journal of American History* 67 (Sept. 1980).

Lichtenstein, Nelson, "Conflict over Workers' Control: The Automobile Industry in World War II." In Michael H. Frisch and Daniel J. Walkowitz, eds., *Working Class America: Essays on Labor, Community, and American Society* (Urbana, 1983).

Lichtenstein, Nelson, "From Corporatism to Collective Bargaining: Organized Labor and the Eclipse of Social Democracy in the Postwar Era." In Steve Fraser and Gary Gerst, *The Rise and Fall of the New Deal Order, 1930–1980* (Princeton, 1989), 122–52.

Lippincott, Charles A., "Cooperator," *The Co-operator* I:7 (August 1920), 38.

Lippincott, Charles A., "Promoting Employee Team Work and Welfare without Paternalism," *Industrial Management* 71 (March 1926).

Loewy, Raymond, "Modern Living: Up from the Egg," *Time* (October 31, 1949).

Mahoney, Joseph F., "The Impact of Industrialization on the New Jersey Legislature 1870–1900: Some Preliminary Views," *New Jersey Since 1860: New Findings and Interpretations* (Trenton, 1972).

Meikle, Jeffrey, "Loewy," *Industrial Design Magazine* (November/December 1986).

Motor Vehicle Review, "A Plant Equal to Any Demand," September 5, 1899.

Pennington, Loren, "Collis P. Huntington and Peter Studebaker: The Making of a Railroad Rebate," *Southern California Quarterly* (March 1971).

Piore, Michael J., "American Labor and the Industrial Crisis," *Challenge* (March/April 1982).

Raucher, Alan R., "Paul G. Hoffman, Studebaker, and the Car Culture," *Indiana Magazine of History* 79 (Sept. 1983).

Skeels, Jack, "The Background of UAW Factionalism," *Labor History* II (Spring 1961).

Smith, Phillip H., "Auto Independents Stage a Comeback," *Commerce and Finance* XXIV (July 1935).

Strong, George, "Feed-Water Heater and Pacifier," *Journal of the Franklin Institute* 114 (Philadelphia, 1882).

Studebaker, Clement, "Early Days of the Carriage Association," *Twenty-Fifth Annual Report of the Carriage Builders National Association* (Philadelphia, 1896).

Thomas, R. F., "The Automobile Industry and Its Tycoon," *Explorations in Entrepreneurial History* 6 (Winter 1969).

Tipple, John, "The Anatomy of Prejudice: The Origins of the Robber Baron Legend," *Business History Review* 33 (Winter 1959).

Vatter, Harold G., "The Closure of Entry in the American Automobile Industry," *Oxford Economic Papers* (October 1952).

Von Dare, Gregory, "Review of Joe Sherman, *In the Rings of Saturn* (Oxford University Press, 1993)," *Motor Trends* (January 1994), 22.

Williamson, Oliver, "Emergence of the Visible Hand." In Alfred D. Chandler, Jr., and Herman Daems, eds., *Managerial Hierarchies: Comparative Perspective on the Rise of the Modern Industrial Enterprise* (Cambridge, 1980).

Woodhull, Morris, "Address," *Carriage Builders Association Reports* 24 (Philadelphia, 1897).

Woodhull, Morris, "The Progress of the Motor Vehicle," In *Twenty-Seventh Annual Report of the Carriage Builders Association* (Philadelphia, 1899).

Zeitlin, Jonathan, "Shop Floor Bargaining and the State: A Contradictory Relationship." In Steven Tolliday and Jonathan Zeitlin, *Shop Floor Bargaining and the State: Historical and Comparative Perspectives* (Cambridge, 1985).

Zey-Farrell, Mary, "Criticism of the Dominant Perspective on Organizations," *Sociological Quarterly* 12 (Spring 1981).

Index

DONALD T. CRITCHLOW is the author of *The Brookings Institution, 1916–1952: Expertise and the Public Interest in Modern America* and *America! A Concise History* (with William J. Rorabaugh). He has edited several volumes, including *Socialism in the Heartland*; *Poverty and Public Policy in Modern America* (with Ellis Hawley); *Federal Social Policy: The Historical Dimension* (also with Ellis Hawley); and *The Politics of Abortion and Birth Control in Historical Perspective*. In addition he edited with Andrzej Bartnicki a five-volume history of the United States in Polish (1995). He is currently working on a book on family planning policy in modern America. He is founding editor of the *Journal of Policy History*.